WILDERNESS

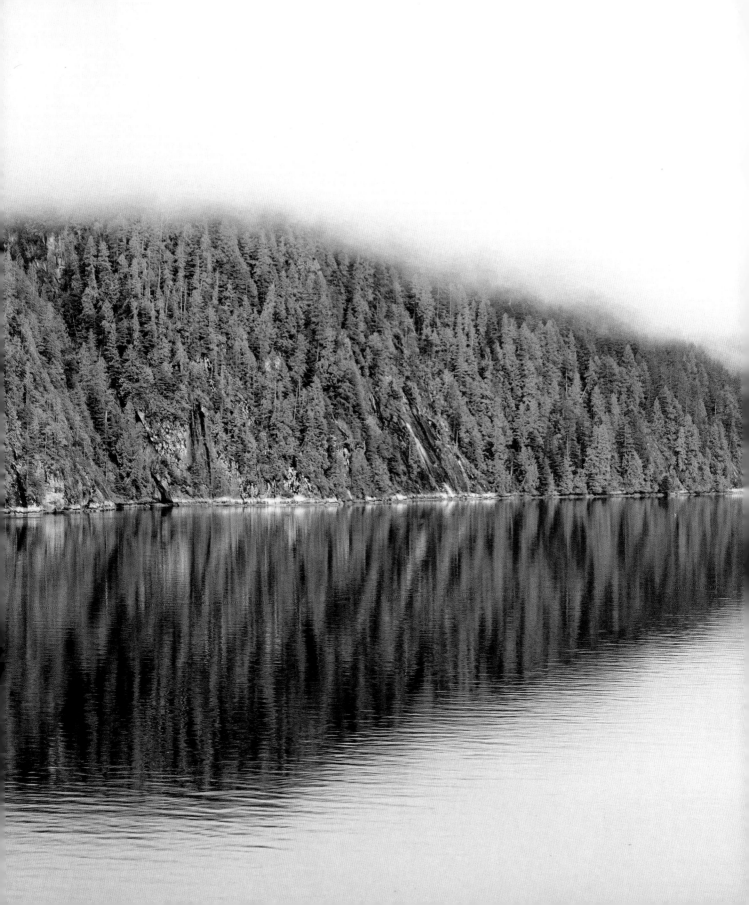

WILDERNESS

The Most Sensational Natural
Places on Earth

Penny Watson

Hardie Grant

EXPLORE

Contents

INTRODUCTION

We live in a time of dawning truths that tell us Planet Earth's greatest commodity is not its iron-ore deposits, its towering skyscrapers or its 21st-century infrastructure, rather its wilderness – the world's wildest, most wondrous and increasingly rare natural places that have endured despite humanity.

Wilderness. The word itself is powerful and emotive, conjuring images that loop on our social media feeds: misty forests, clear sparkling streams, the sun's shadow falling across a desert dune, a glistening blue Arctic peak, polar bear cubs walking across a tundra, a whale breeching the surface of a sun-flecked ocean.

That our popular culture – and imaginations – habitually freestyle to these destinations says much about their place in our psyche. In times of inner turmoil or outer chaos they are a clarion call. When we want adventure they are freedom calls to strap the walking shoes or backpack on. When we seek quietude, inner peace, renewal, they ignite a dormant instinct to be in nature; a yearning that many of us have been slow to fully understand.

Somehow, the increasing insularity and urbanity of our lives have made this call to the wild louder, stronger, more urgent. We are increasingly aware of the climate crisis and the havoc that humanity has reeked on the planet. Our mental and physical need for nature, in our own backyards as much as in wild outposts, can be read as a quiet rejection of our footprints on a fragile planet, even a call-to-arms.

But what is a wilderness?

The question has trailed me during the research and writing of this book. When first conjuring wilderness, my mind went to untamed, untrammelled places, those wild and remote destinations untouched by humanity where the modern world is out of mind and out of sight. But in the face of a climate crisis, not many such places truly exist anymore. This idea of wilderness is mostly obsolete.

I got to thinking, too, that wilderness areas cannot simply be zoos for the natural world, where we zoom in to see what our wild Earth once looked like. Wilderness areas are both those natural wondrous places captured in the cross-hairs of our binoculars, as well as those doorstep destinations that we are more likely to have intimate encounters with. They are both the places that are still wild in the traditional sense, and those that, though impacted by humanity, have a chance to regenerate, rewild and recover through our own protection, conservation and activism. This could well be the unseen role in the modern-day world of the wilderness that still remains.

The conundrum between wilderness and tourism is not lost on me. Doesn't promoting wilderness areas in the travel space jeopardise these very destinations? The answer – both yes and no, is complex. Tourism can be at once part of the problem, and a force for good. There are many destinations within this book that have relied on, do rely on or will rely on the tourism of the future for their future because of its role in providing jobs and revenue in local communities, furthering conservation efforts, funding research and spreading awareness, particularly where wildlife is concerned. Uganda's gorillas and Madagascar's lemurs come to mind.

Some destinations, such as Fiordland National Park, in Aotearoa New Zealand, are notable and included for flagging a more sustainable future for tourism. They are destinations we can learn from. Others, such as Zhangjiajie National Forest Park in China, can at once be lauded for their beauty and recognised as places where fewer people should tread. Given the complexities of the conservation–tourism dynamic in each destination, I have aimed to inspire stewardship of nature as well as the yearning to travel.

Wilderness is part travel inspiration, part lounge chair eye-candy, part battle cry. It is for those

of us who choose slow and responsible travelling, those of us who love the outdoors and natural immersion, and those of us concerned for the planet in the face of the climate crisis. It is for those in the sweet spot where all these interests intersect.

There are 40 destinations in this book that take you to some of the most sensational wilderness areas around the world in all their full-blown magnificence. The wildernesses reference many types of natural habitats, from diverse land-based environments to oceans and rivers, all remarkable, and threatened, in similar ways.

If the extreme heat and arid sands of a desert can be called a wilderness, if the coral cays and islands of an archipelago can be called a wilderness, if the wet humidity of a rainforest can be called a wilderness, then the magnitude and volume of the ocean's waves and the currents, trenches and weather systems that bring them to life also deserve a place in the canon.

Many of these wildernesses have extraordinary wildlife, ecology and biodiversity. Whether you want to armchair travel or pack your bags, these destinations include information about conservation and regeneration alongside opportunities for travellers to tread more lightly while travelling to the world's wild places.

The book is best savoured by dipping into different chapters at random. In the Southern Hemisphere, you can journey from the untamed Kimberley coastline of Western Australia and the wild Franklin River in Tasmania to the desolate Salt Flats of Bolivia, and the flourishing Pantanal wetlands of Paraguay. In the Northern Hemisphere, you can touch down in the other-worldly geology of Bisti/De-Na-Zin Wilderness and the tall trees of

California's redwood forest in the United States, and on the icy tundra of Canada's remote Churchill community – where you can marvel at polar bears in the wild.

The aquamarine reefs of Australia's Ningaloo, the white-to-the-horizon polar desert of Antarctica, the green tropical rainforests of Indonesia and the red sand landscape of Jordan's Wadi Rum are all here waiting to be explored at your leisure.

What does it feel like to completely surrender to the natural world, to bow to its power, to be humbled by its force, to know that it can overwhelm, dictate, besiege? Over time, Antarctic and Arctic expeditioners, ancient mariners and explorers of the planet's mighty mountains have all been able to describe the immensity of it, that liminal space where we humans are relegated to our rightful place as subjects of a mightier force. Natural phenomena are bewildering in their improbability. That places so other-worldly, freely delivered by nature on such a grand scale, can continuously inspire humanity says something about our ongoing connection to that which is beyond our comprehension.

These wilderness destinations still ignite such feelings within us. They evoke a sense of timelessness and are sources of healing and wellness in times of upheaval.

Wilderness is not a guidebook, more a jumping-off point for your own curiosity, interest and intrigue. Whether these wilderness destinations spark a flight of fancy and an urge to travel or not, they will give you an appreciation of nature at its most poignant, and most importantly of all, I think, a willingness to protect it. It's all we've got.

Penny Watson

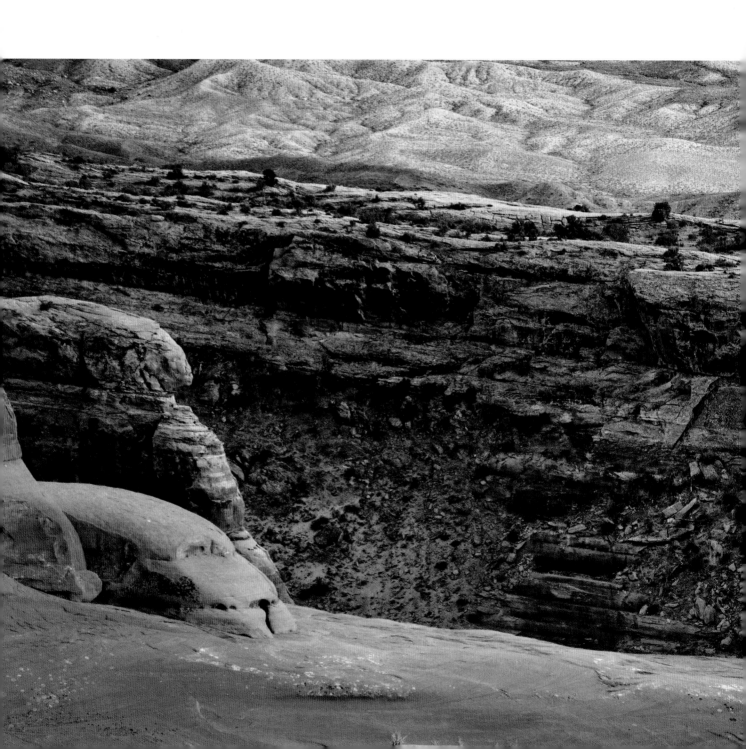

NORTH & CENTRAL AMERICA

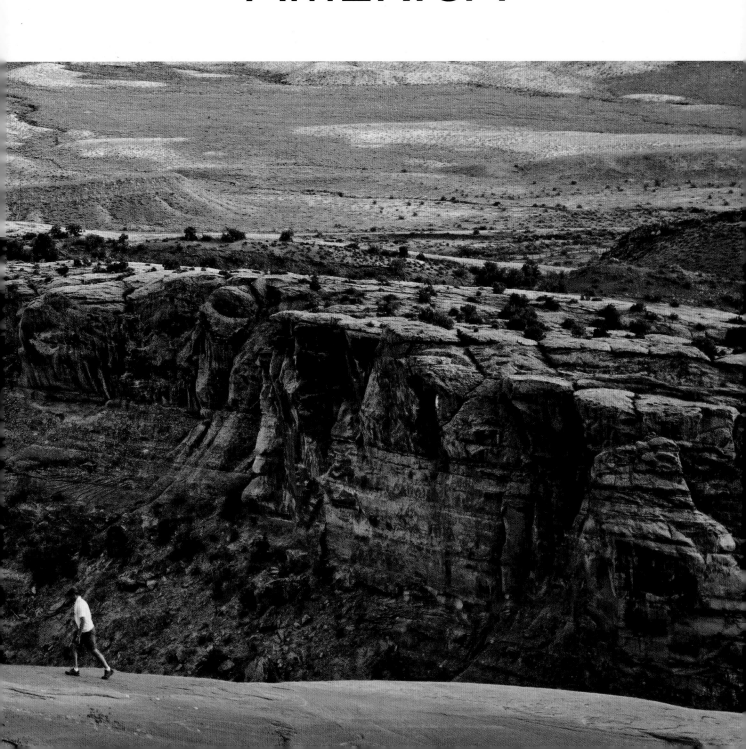

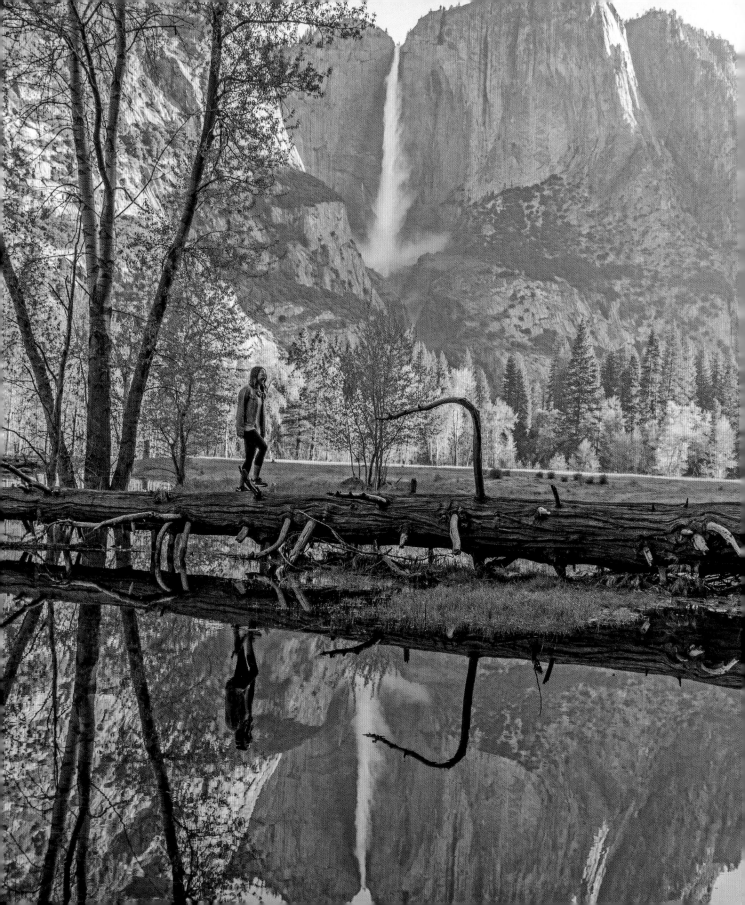

Choosing just eight wilderness destinations from the world's third biggest continent – a land that reaches from the Arctic Ocean in the north to the Caribbean in the south, was like having to choose one child to take on holiday. Taking up nearly 17 per cent of Planet Earth's land mass there are hundreds, possibly thousands, of incredibly immersive destinations that are the epitome of wild.

I chose to explore landscape extremes and habitats so diverse that the fact they inhabit the very same planet is a source of wonder and awe.

From the towering redwood woodlands and sandstone arches of the United States, and the temperate rainforests and polar bear foot-printed snowscapes of Canada, to a protected tropical island paradise in Panama, this is a showcase of some of the world's most epic wilds.

Some of these places aren't as inaccessible as you might imagine, but all will enable the traveller to experience a deep immersion in nature and a sense of wellness in wilderness, both on the doorstep and in more remote corners.

LEFT A magnificent backdrop of waterfalls, lofty cliffs and pine forests make the Yosemite Valley a popular destination.

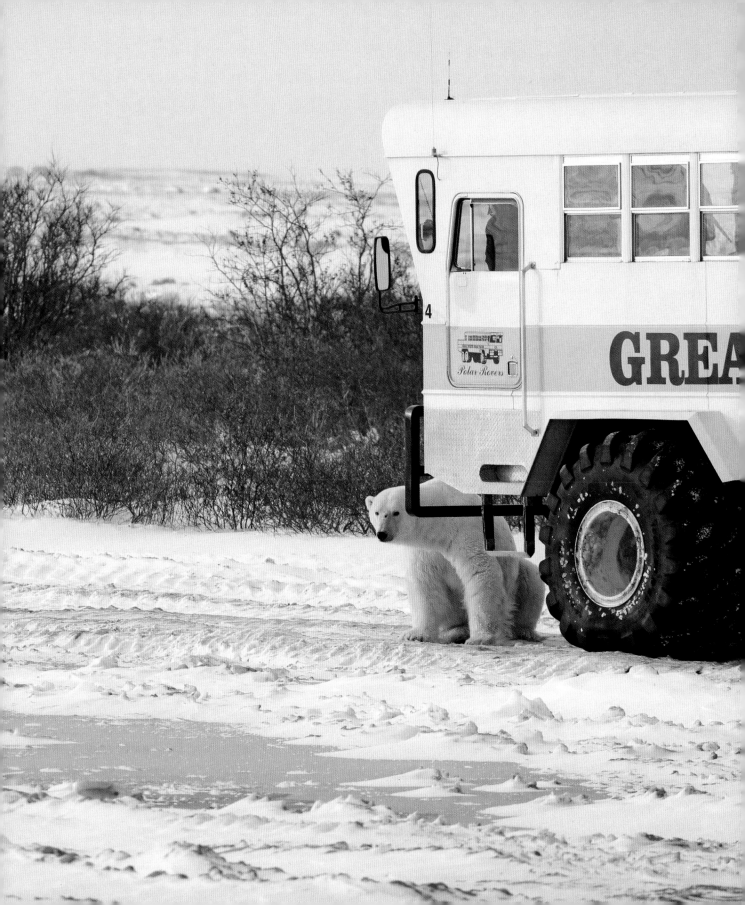

CHURCHILL

**Manitoba
Canada**

Remote and wild wilderness where polar bears roam.

Churchill is a tiny outpost in the Arctic wilds of northern Canada. When I visited it a few years back, I had my passport stamped with a blue-ink polar bear at the little one-person post office. It was unofficial, and possibly considered a defacement of a legal document, but it proudly recognised the achievement of getting to this frontier territory.

Churchill is located on the incredible tundra on the western shore of Hudson Bay, a vast seawater inlet that connects (eventually) with the Arctic Ocean. It is the long-ago home of the semi-nomadic Pre-Dorset People, the Dorset People known for their use of small tools and, about a century ago, the Thule People who are the ancestors of today's Inuit People.

There is no road access. To get to this tiny speck in the ice you need to catch a small plane, or take the 48-hour overnight train from Winnipeg, Manitoba's capital located more than 1000 kilometres (620 miles) south. With an average yearly subarctic temperature of −6°C (21°F), it is ruled by the extremes of nature. Those who visit must bow to its higher power.

The town, with a population of about 900, is worth visiting for its isolationist eccentricities and Inuit culture. A trudge through the snow (preferably in traditional Inuit caribou mukluk boots) reveals plaques and cairns detailing the historic fur trade and a series of 17 'SeaWall' murals showing off the wildlife. The Itsanitaq Museum, established in 1944, houses a rare and wonderful collection of Inuit art, adornments, tools and culture artifacts. But it is the magnetism of the surrounding natural world, part of Wapusk National Park, that attracts eco-tourists year-round from far and wide. Churchill is in a privileged locale at the juncture of three wilderness habitats and the wildlife that inhabits them is epic.

BELOW The shipwrecked MV Ithaca is one of the intriguing sights on Hudson Bay.

OPPOSITE The colourful township of Churchill sits between three wilderness habitats

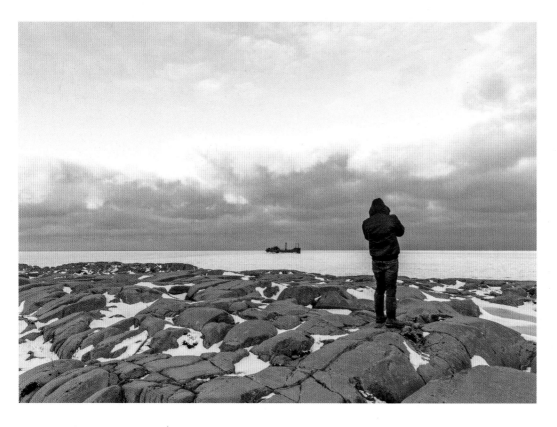

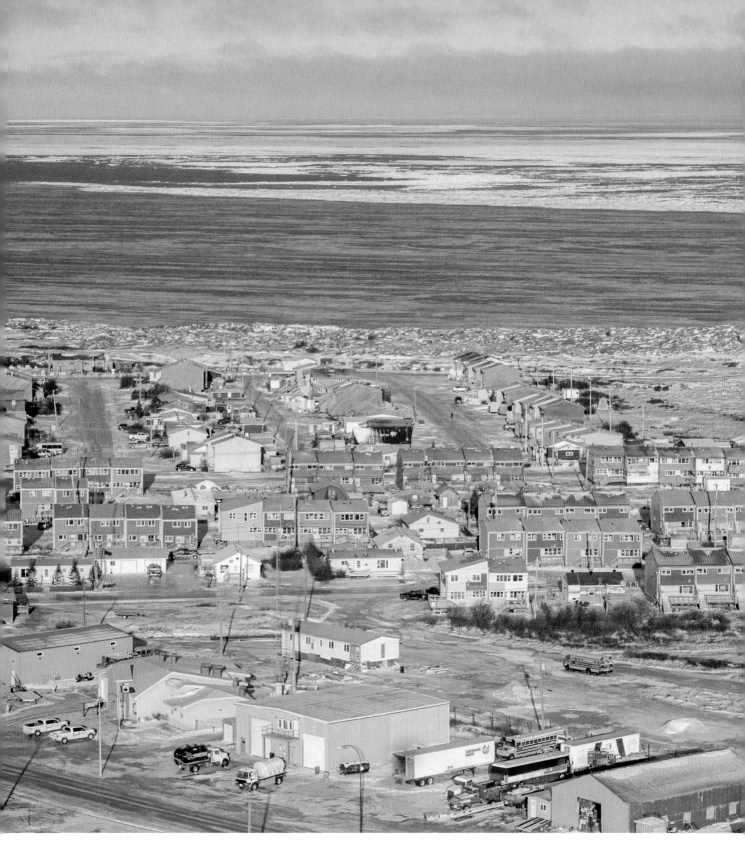

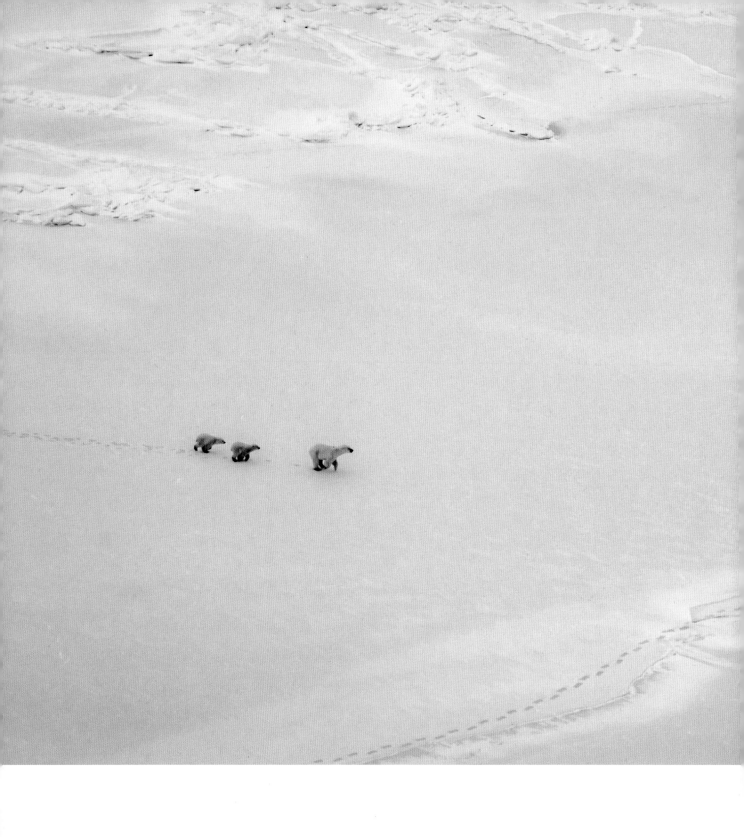

NORTH & CENTRAL AMERICA

To the north-west the shallow, bio-massive soils and white icy permafrost of the Arctic tundra are home to the arctic fox, musk ox and fantastical snowy owl. To the south is the coniferous boreal forest with its wind-bent spruce trees protecting habitats of lynx, caribou, red squirrel and woodpeckers. To the north the frigid water of the bay, which freezes over in winter and thaws in summer, is home to beluga whales and seals. The Churchill polar bears, the world's most southern population of polar bears, have a migratory path through the area to feast on these marine creatures.

Churchill has long valued its ecotourism credentials with strict guidelines and restrictions in play for companies offering polar bear experiences. Animal conservation is integrated into the visitor experience through extracurricular activities such as lectures about polar bear conservation.

The polar bear is a globally recognised threatened species and its current conservation status is vulnerable. Arctic permafrost has been diminishing for decades and according to Manitoba Conservation: 'Bear condition and productivity has declined steadily over the last decade ... as [has] the survival rate of cubs'.

Given their status, there's something very Nat. Geo. about seeing these bears, dubbed Lords of the Arctic, in the wild. From July, the bears start to gather on the lake edge preparing to hunt for seal. By October and November, with the winter coming, they're in their element. Specialist tundra vehicles that look like retro school buses have big wheels designed to keep tourists and the environment safe as they move deftly over the tundra terrain.

Full days are spent in cosy polar bear hides (with heaters) looking down a camera lens in anticipation of the bears' arrival. With more than 900 in the western bay population, they almost always do. Cubs and roly-poly babies, mothers with fur that appears yellow against the white snow and huge males, some as tall as 3 metres (10 feet) and weighing more than 600 kilograms (1320 pounds).

From July and August, a 58,000-strong population of beluga whales migrates to the estuaries of Hudson Bay to feed and mate. These ghostly white mammals look more dolphin than whale, with a top blowhole, no dorsal fin and a distinctive humped forehead. Being surrounded by a playful pod of curious beluga when kayaking the bay is not uncommon.

In the cooler months of February and March, that night sky wilderness, the aurora borealis, beckons. In temperatures that drop below −20°C (−4°F), the mid-winter midnight skies are reliably illuminated in fluorescent green and yellow paisley swirls. They are visions splendid, quite literally from another world.

The combination of wildlife, wilderness and the kind of wildness only an inaccessible frontier town can muster makes Churchill all that more special.

ABOVE Polar bear cubs follow their mother across frozen Hudson Bay in search of food

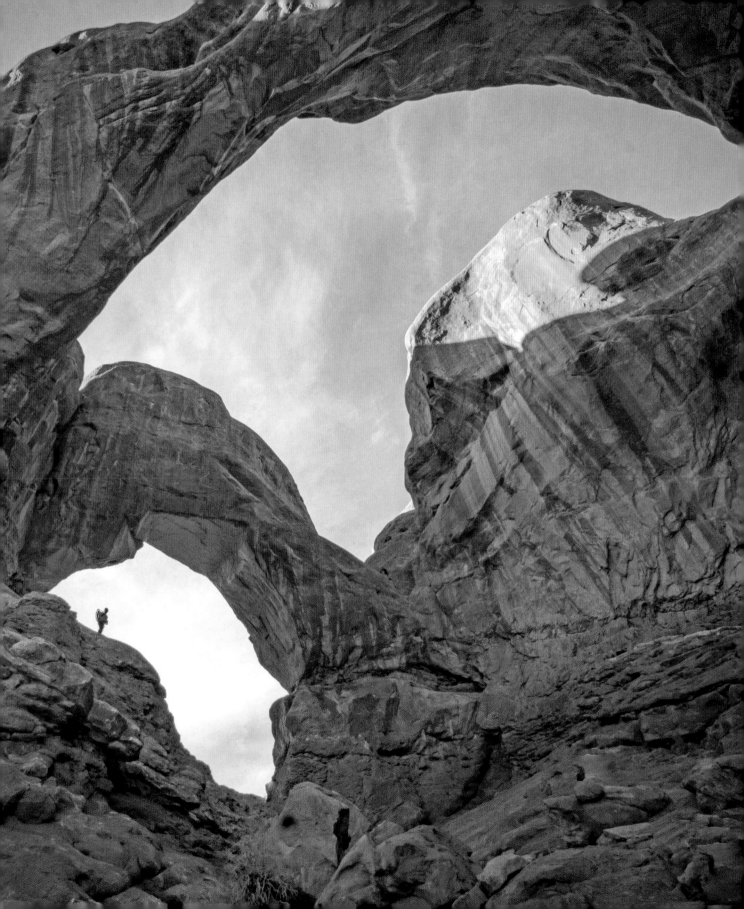

ARCHES NATIONAL PARK

**Utah
USA**

A geological playground of hoodoos, pinnacles and arches.

At Arches National Park's only accommodation offering, the campground, you can pitch a tent in a timeless setting among a sea of rock fins and crumbling domes, with chiselled blue mountains rising behind. It is a phenomenal place to stay and immerse yourself in a spectacular rock landscape where ancestral Puebloans left rock markings and drawings, and the later nomadic Ute and Paiute peoples left petroglyphs.

Back in 1925, Frank Pinkley, superintendent of Utah Park Service's south-western national monuments, suggested that this newly minted national park in Canyon Country of south-eastern Utah, just outside of Moab, be named Arches.

I'm not sure there was any other name he could have chosen. Not 'giant balanced rock park' or 'slick rock dome park', not 'spires' or 'hoodoo' or 'pinnacle park'. These spectacular rock formations are all here, along with alcoves, fins, canyons and mesas, but indeed the most fantastical formations of all the geological creativity on show are ... sandstone arches.

Across the park's 310 square kilometres (76,519 acres) there are more than 2000 (mostly) soft red sandstone arches, which is more natural arches than anywhere else in the United States, and possibly the world.

They began their life 300 million years ago when salt from an inland sea, and porous sandstone, built up again and again over 150 million years creating a geological layer cake that is still visible in the park today.

Over the following 150 million years, the perfect conditions for the creation of the arches continued when the differing density of the layers gradually caused them to bulge like folds of fabric, forming domes, peaks and valleys.

The continued erosion and weathering – whipping wind, howling rain, groundwater and ice – gradually whittled many of the domes away, leaving thin walls or 'fins' of remaining rock. These fins have since eroded in their own way, forming windows that have gradually become the aesthetically diverse and remarkable arch structures on show.

This quick run-down over the centuries makes it all sound meant-to-be, yet many of the park's arch designs are hard to credit, even for nature. Some seem impossibly engineered; others defy gravity. Some strike confidence; others trepidation. All of them inspire a reverence for Planet Earth's exceptional evolution.

Landscape Arch, for example, is 88 metres long (289 feet) but it is as narrow as a foot bridge and appears too skinny in parts. There's a reason visitors can no longer walk under it; certainly you'd be a fool to walk over it – even if it were allowed.

Breathtaking Delicate Arch, whose image graces number plates in Utah, is an upside-down U-bend span, about 18 metres tall (60 feet). Without abutments or support, it has the appearance of a folly, almost too fragile to stand. In fact, it has been sitting here, god-like on a circular rock surface that looks like a Grecian arena, for centuries.

Among the arches, other fanciful formations grab attention. Balanced Rock, a 4000–tonne boulder (4400 ton), 39 metres (128 feet) tall appears to balance on a pedestal and threatens to topple into the sand. It's a sight to behold, especially at the end of the day when the sun's golden glow usurps every other colour from the landscape – except the desert's crimson hues. One can only walk away indelibly affected.

The park's abundant desert wildlife plays second fiddle to the geology, but it is rich. Fox, cougar, peregrine falcon, collared lizard and rattlesnake live among hardy prickly cactus pears, Utah juniper, cheatgrass and saltbush. It's a harsh environment with a lot going on behind the scenes.

Less obvious to visitors are the smaller ecosystems. Take a magnifying glass to study rockpools of rainwater supporting mini worlds of tadpoles and insects. The dark soil that cracks underfoot is important too. Its water storage properties help support micro universes of bacteria and fungi that in turn protect the soil from erosion and allow more diverse plant-life.

Straying from marked trails has obvious consequences for these important ecosystems, which is why Arches' 1.2 million yearly visitors are its primary concern. Let's face it, a place like this is bound to attract the masses but scientists are monitoring the structural health of the arches to determine what effect tourism has on the health of the rocky landscape. Limiting aviation has been flagged as one aspect of managing this.

Most visitors to Arches explore the well-marked family-friendly short-to medium-length hikes. Windows Loop, a 1.2 kilometre (0.75 mile) round-trip, is a flat path that takes in the 27-metre (90-foot) span of North Window, the sculptured skyline of Turret Arch and Double Arch. The 7.2-kilometre (4.5-mile) Double O walk requires a little extra rock hopping, with a segment along a high narrow sandstone

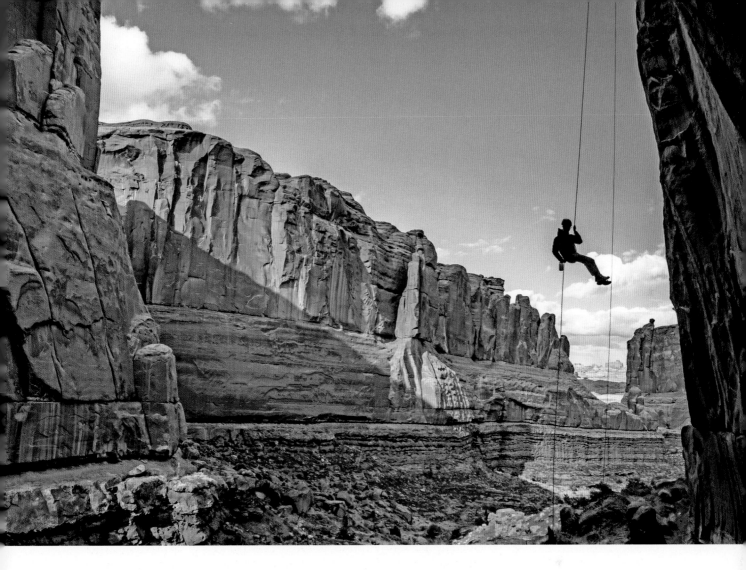

rock path. It rewards the effort with an exceptional elliptical window view of the sky from underneath.

Cycling, canyoning and rock climbing (with permits) are popular. So too is stargazing. The dense dark sky is like a snow cone at night and in 2019 Arches was certified as an International Dark Sky Park.

On a geological timescale, the park's arches will continue to form and collapse over time. Part of the fathomless beauty of these artworks sculpted by the hands of nature over 300 million years is how they enable us to ponder our own insignificance, our own small part in the planet's evolution.

With or without us, this landscape's status as a geological wilderness remains rock solid.

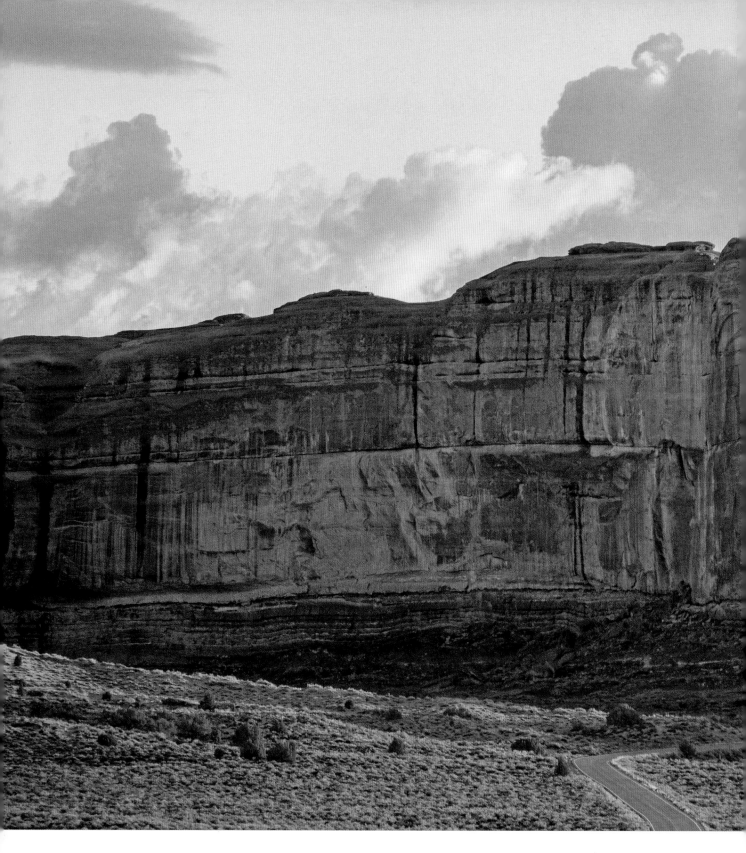

NORTH & CENTRAL AMERICA

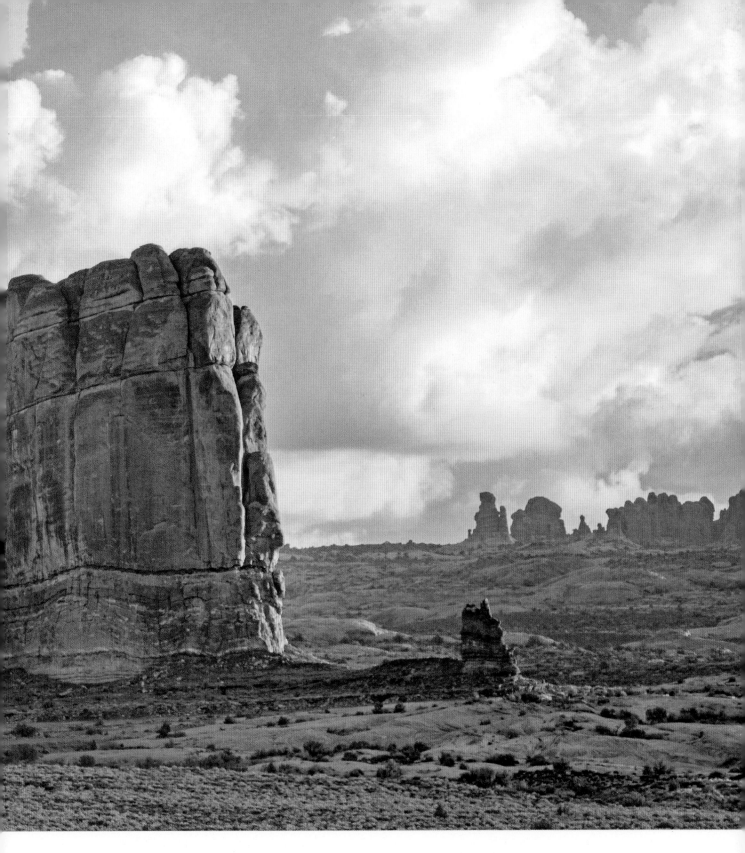

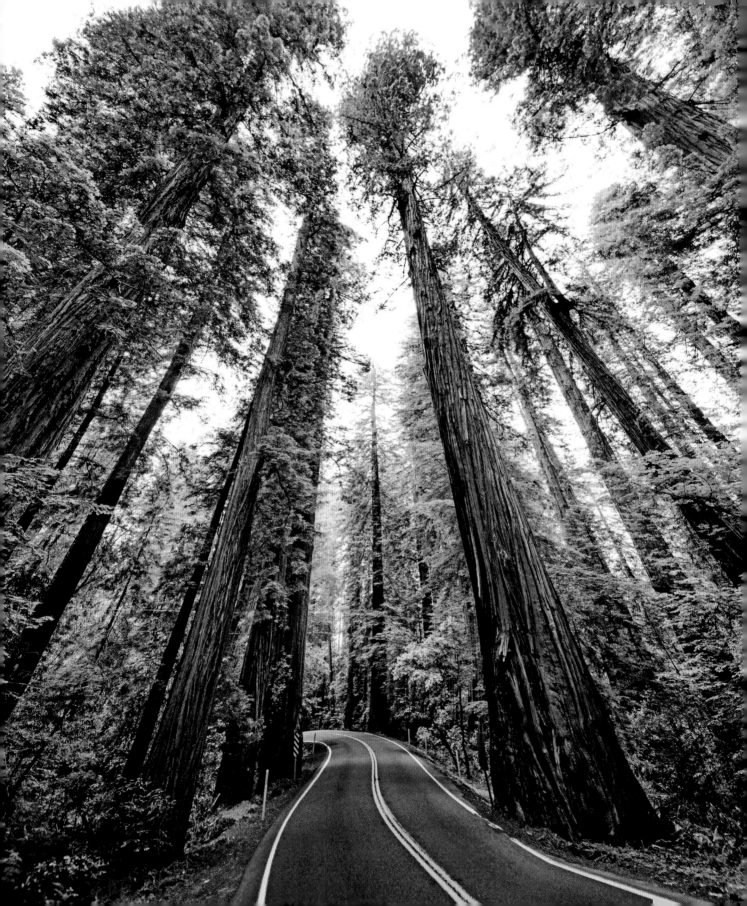

REDWOOD NATIONAL AND STATE PARKS

**California
USA**

An evergreen forest of the world's tallest and oldest trees.

Ever hugged a tree? It is one of life's most wondrous, therapeutic, mindful experiences, particularly if you find yourself alone in a garden, walking through a woodland or, in my case, forest bathing in this national park (in the tradition of Japan's shinrin-yoku practice of finding wellness through forest immersion). The heady, piquant, piney aroma, the triggered parasympathetic nervous system, the notion of just being outdoors enjoying nature's grandeur – all work towards one big fat magical natural high.

Redwood National and State Parks (RNSP), in California, give the biggest tree hugs around. The collection of conservation reserves, including one national park and three state parks, covering a total of 560 square kilometres (139,000 acres), is ground zero to pockets of the planet's last surviving coast redwoods. Try reaching your arms around the girth of these gentle giants, and you've hardly got a hold. Their enormous trunks, gnarly with vertical strands of thick fibrous bark spiralling away to the top, are so wide you'll need a dozen or more huggers to complete the circumference.

Also known as *Sequoia sempervirens,* coastal redwoods or Californian redwoods, these evergreen beauties from the cypress family are some of the tallest and oldest-known trees in the world. The oldest is thought to be more than 1200 years old. The tallest tops out at 115.5 metres (380 feet) – that's skyscraper height. Their genetic pedigree harks back to an impressive, if unfathomable, 160 million years. Further adding to their greatness, let it be known that redwood forests have starred in blockbuster movies *Jurassic Park* and *Return of the Jedi.*

The stands of redwoods found in the park areas were once prolific across California but are now only found in the foggier, wetter regions of the west

coast, north of San Francisco. From the Golden Gate Bridge, the 560-kilometre (350-mile) Redwood Highway (the northern-most leg of US route 101) shows off avenues of redwood-lined bitumen and offers tourers access to five visitor centres, trailheads and activities, including kayaking, horseriding and forest bathing.

From the base of a Californian redwood, the view upwards generates an inverse form of vertigo. The pencil-straight woody torso, offering the ultimate lesson in perspective, starts beyond the peripheral vision and narrows continuously, the twiggy branches spiralling more thinly as they approach a distant, fuzzy, green, cone canopy.

Up there in the blue sky, a lofty eyrie where clouds and birds hang out, is an ecosystem in its own right, a world of moss and lichen and a biodiverse plant-life including epiphytic ferns.

In some redwood stands the treetops offer redwood views to the horizon. In others, the scars and scorched remains of clear-felled earth, like pockets ripped off a pair of jeans, are all too common. Only 30 per cent (162 square kilometres/40,000 acres) of RNSP is old-growth redwood forests (which is 45 per cent of all remaining old-growth forest in the United States and just 5 per cent of the original virgin forest from the 1850s).

A massive 55 per cent (more than 283 square kilometres/70,000 acres) is second-growth forest, much of it inherited when the individual parks were established. Even in these protected areas, species such as the marbled murrelet seabirds and coho salmon in the park's coastal areas are endangered due to overall ecological degradation.

But the battle to save the redwoods that began a century ago continues.

In 2022, the Save the Redwoods League secured lasting protection for 212 hectares (523 acres) of redwood forest by returning guardianship of the land to the original stewards, the InterTribal Sinkyone Wilderness Council on Mendocino Coast.

The league sees the process 'as an opportunity to restore balance in the ecosystem and in the communities connected to it, while accelerating the pace and scale of conserving California's iconic redwood forests'.

The property will return to its original name Tc'ih-Léh-Dûñ, which means Fish Run Place in the Sinkyone language.

Monitoring climate change is another important consideration for trees that rely on wet habitats and a lot of water. Managing the second-growth forests – nearly half the park – is integral too. These second-growth forests have been heavily reseeded and left to fend for themselves after clear-cutting old-growth forests. Unlike their generously spaced old-growth ancestors, these forests are unnaturally dense. Their thin trunks crowd each other creating a thick canopy that blocks light to the forest floor and prevents growth.

To manage this, the Redwoods Rising habitat rehabilitation program, launched in 2018, has so far removed three-quarters of the 650-plus kilometres

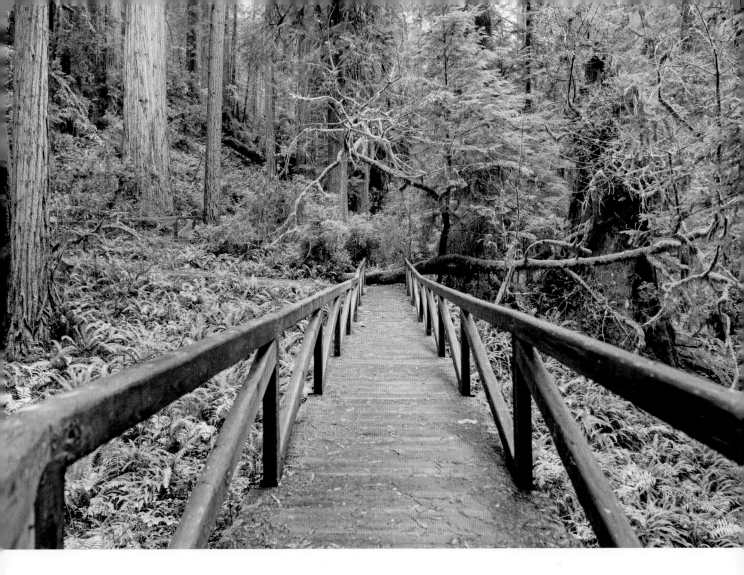

(404 miles) of old logging roads, pruned back thousands of acres of young forests and repaired the hydrology of natural water systems.

Key to both these sustainability challenges is a long-view approach, the end game of which is not for Baby Boomers, Generation X-ers or even Generation Y. Think more: Gen Z's kids.

The National Park Service says it best: 'In a few human lifetimes, these once-logged landscapes will once again have healthy streams, rivers, and be covered with old-growth redwood forests'.

For now, it's a place to hike, drive and camp among the redwoods, but it's most importantly a wilderness for forthcoming generations and an uplifting vision for the future.

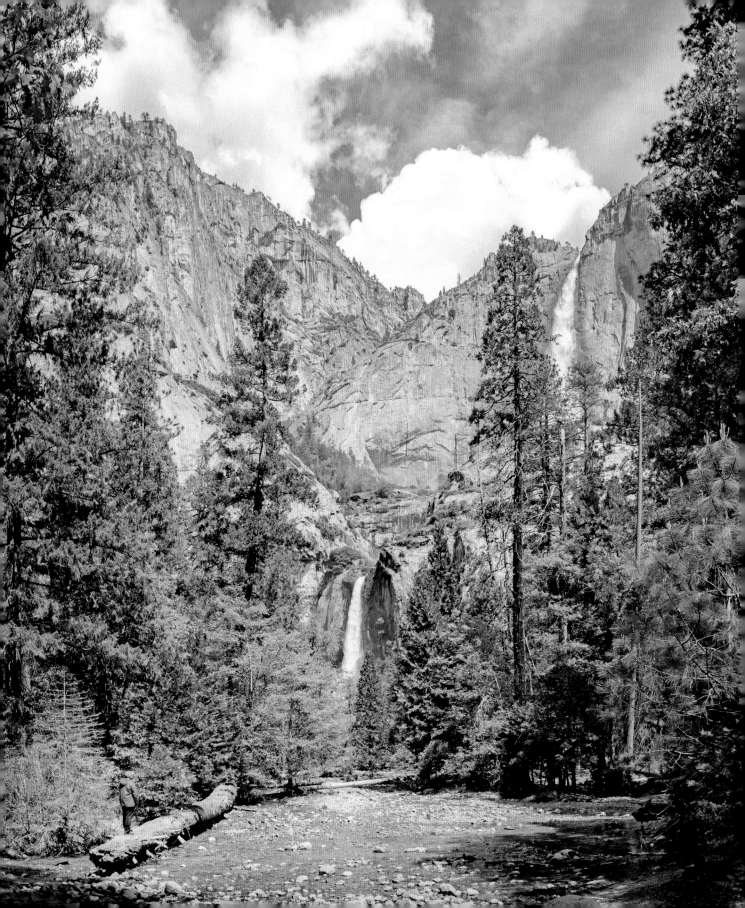

YOSEMITE NATIONAL PARK

**California
USA**

An iconic park of granite domes, sequoia trees and backcountry.

At California's iconic Yosemite National Park, visitors can apply for 'wilderness passes' for access to backcountry trails and undeveloped areas. The reason these permits are necessary is 'to help minimise human impact and provide maximum opportunity for solitude'.

Maximum. Opportunity. For solitude.

There's something about those words that brings joy to my soul and says something about what wilderness offers not just to the world, but to the individual when they find themselves in nature.

John Muir, America's most famous naturalist and the founding forefather of Yosemite National Park, knew much about solitude in Yosemite's wilderness. He studiously explored every possible trail, meadow and valley in this vast property of more than 3000 square kilometres (1187 square miles) during his lifetime.

Muir's description of the Yosemite Valley goes unbeaten when attempting to conjure the place:

'[The valley] includes the head waters of the Tuolumne and Merced rivers, two of the most songful streams in the world; innumerable lakes and waterfalls and smooth silky lawns; the noblest forests, the loftiest granite domes, the deepest ice-sculptured canyons, the brightest crystalline pavements, and snowy mountains soaring into the sky twelve and thirteen thousand feet.'

Yosemite, spread over four counties in California, is a titan when it comes to wilderness. It was World Heritage–listed by UNESCO in 1984, but its colonial-era conservation story dates to 1864 when President Abraham Lincoln preserved the land; and to 1890 when Muir helped its establishment as a national park.

Today, thanks to these key players and the Southern Sierra Miwok People, who were successful custodians of the land for millennia before colonisation, a hefty 95 per cent of the sprawling unique and diverse land is designated wilderness.

The park typically draws between four and five million tourists each year, mainly to the Yosemite Valley, the land of the Ahwahneechee People. The valley has magnificent walks and hikes through alpine scenery captured in now-famous photographs by Ansel Adams. Creeks and waterfalls are busy with raccoons and woodpeckers who are part of an iconic animal kingdom that includes black bears, cougars, river otters and black and red foxes.

Visitors can learn about Native American and gold-rush history in the museums, sign up for rafting, bike rides and rock-climbing classes, and pitch a tent in one of the campgrounds at the edge of the park like I did.

Two of the most memorable sights on my visit were the soaring granite icons of Half Dome, a smooth-topped rock spliced down the middle, and El Capitan, or El Cap, the famous vertical cliff-face topping out at 914 metres (3000 feet).

In 1868, American geologist Josiah Whitney reported Half Dome as 'perfectly inaccessible, being probably the only one of the prominent points about the Yosemite which never has been, and never will be, trodden by human foot'.

But some things have changed since Whitney's day. Today, cables embedded in the rock support hikers (lucky enough to have won one of only 250 annual lottery permits) on the last leg of the 1524-metre (5000-foot) climb rising above Yosemite Valley.

On my visit, media vans lined one of the main roads where photographers pointed their huge telephoto lenses in one direction: towards El Cap, where, if you squinted with the naked eye, you could see ant-like humans making their speck-like way up an extraordinary vertically sheered cliff-face.

Perhaps these modern-day explorers are finding their own epic slice of solid-rock wilderness. Being up there would be the very definition of solitude.

Taking up just 1 per cent of the entire park, the valley is only a sneak preview of what's on offer in the high country beyond the tourist areas. Casual hikers and drivers can access much of it via two scenic winding roads that are open when there's no snow on the road. But you'll need to be horseriding or trekking – perhaps along the lauded Pacific Crest National Scenic Trail – to go deep into the less-accessible regions.

The high country is a visual feast, pocketed with grassy meadows and alpine lakes that are stood over by white granite rock faces and girt by native wildflower fields and pine forests.

Stands of 500-strong mighty giant sequoia trees create fairytale settings, belittling all those who enter. Their coniferous pencil-straight trunks can reach 85 metres (279 feet) and their trunks are almost 8 metres (26 feet) in diameter.

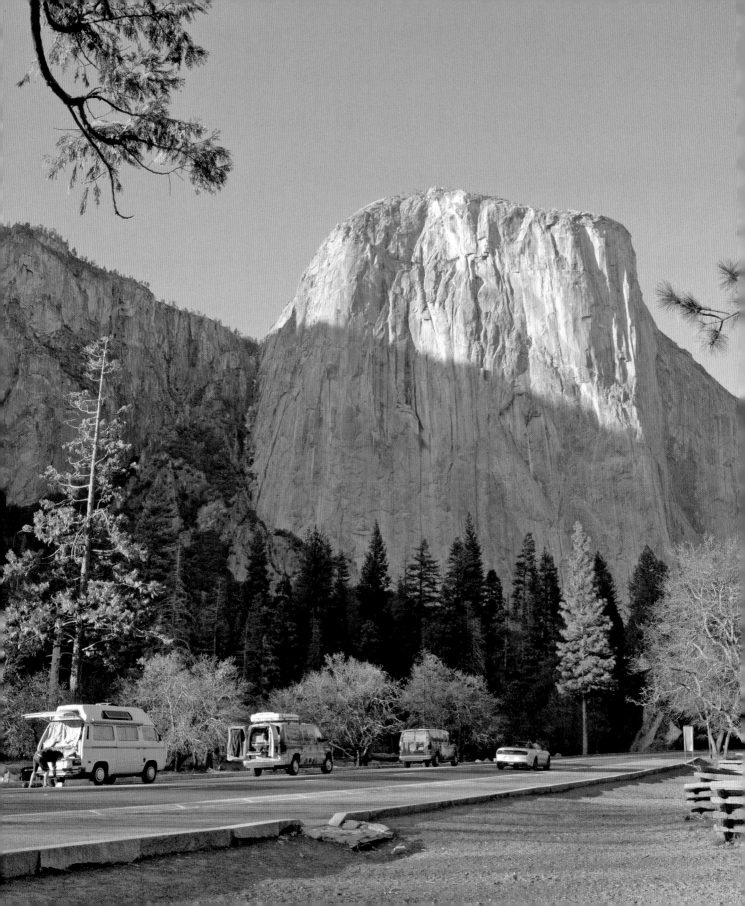

Climate change, together with drought and California's destructive wildfires, is the biggest threat to these gods of the plant world, and the national park's greatest challenge.

Yosemite's Lyell Glacier, a remnant of a more recent past, is one of the few left in the Sierra Nevada Mountains. A 2022 UN report states that 10 per cent of glaciers across the globe, including the Lyell Glacier, will recede, then be lost entirely by 2050 due to climate change.

The geological peaks, including the tallest in the park, Mount Lyell at 4000 metres (13,120 feet), look here to stay. They provide viewpoints from which to catch the retreating red orb of the sun sending its day-end luminescence over a landscape carved by glaciers, ice and erosion over 30 million years.

This is a park that will keep on giving and living in the hearts and minds of those who have visited it. Maximum. Opportunity. For solitude.

OPPOSITE Morning sun highlights El Capitan in the Yosemite Valley

BELOW Sequoias loom large in the Mariposa Grove of Giant Sequoia trees

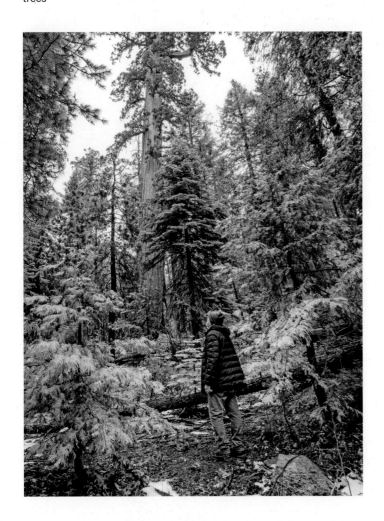

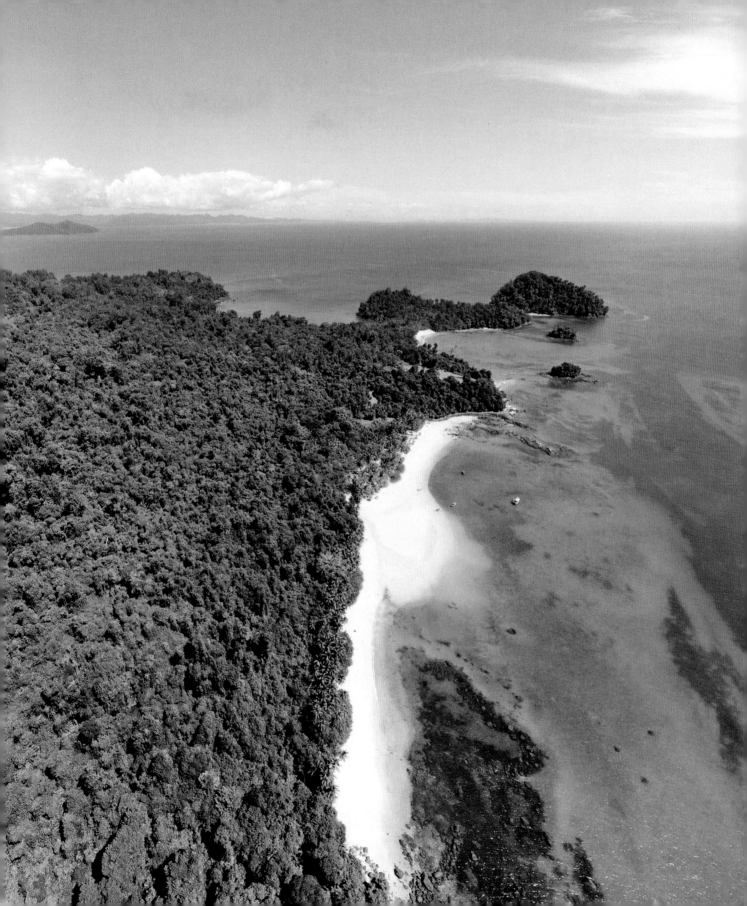

COIBA ISLAND NATIONAL PARK

Chiriquí
Panama

An island paradise of untouched rainforest, coral reefs and marine life.

If there was ever a version of hell on Earth, Panama's Coiba Island would be in the running, up there next to Tasmania's Port Arthur, Devil's Island in French Guiana, and Guantanamo Bay in the USA.

From 1919 to as late as 2004, this remote island located in the Gulf of Chiriqui, off Panama's Pacific coastline, was a penal colony, a dark and desperate place where Panama's unfortunates, from petty thieves and dangerous criminals to political prisoners, found themselves imprisoned in extreme conditions.

That many prisoners died is well known. Those who were not buried in unmarked graves on the island are said, according to Coiba National Park's webpage, to have been dismembered and fed to the sharks habitually patrolling these waters.

The conditions were reprehensible and the people of Panama still live with the horror and morbidity of this place and the ghoulish history it has witnessed, but the isolation of the island and its lack of visitors inadvertently left a pristine environment of untouched rainforest and marine life. For almost a century, Coiba's wilderness has been left to thrive unfettered. Nature, for once, has come out victorious.

In 2005, the year after the prison closed, the island was declared a UNESCO World Heritage Site, listed on account of its incredible preserved natural resources and its potential as 'an outstanding natural laboratory for scientific research'.

Today, the jungle is reclaiming all that remains of the penal colony both physically and metaphorically. Spiral snake-like vines and the shoots of tropical trees are retaking ownership of dilapidated concrete penitentiary

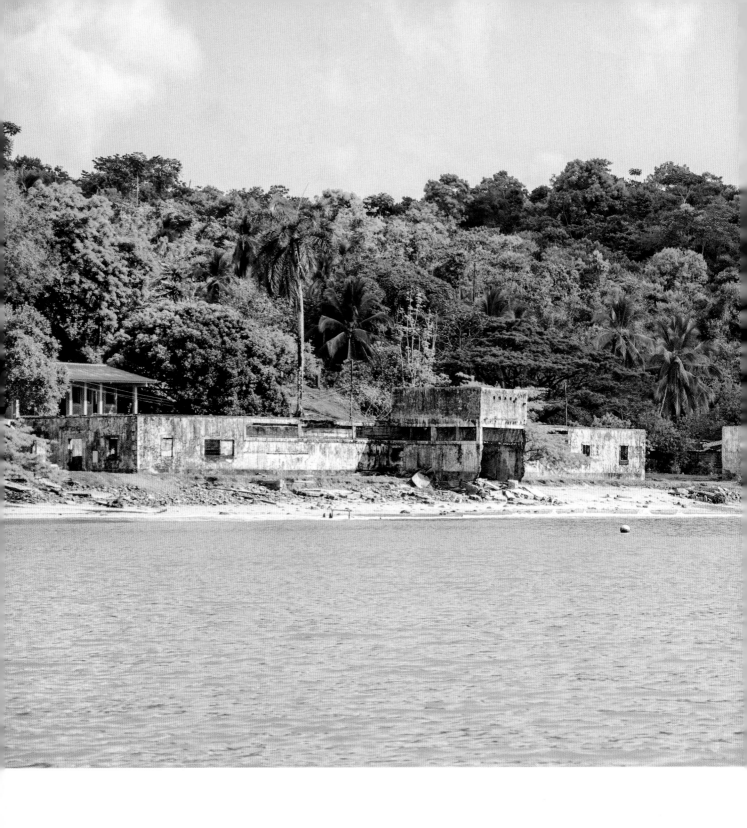

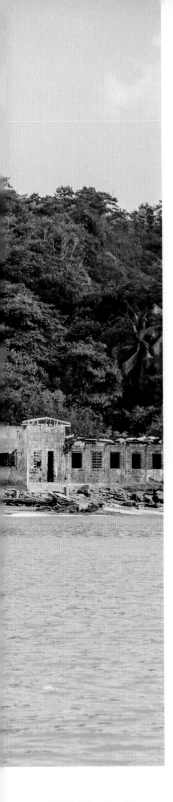

buildings. A carpet of green moss and lichen inches over a handful of neglected gravestones. The salty air adds its own layer of decomposition to the skeleton of an old wooden pier.

An estimated 80 per cent of the island remains untouched, like a biological time capsule from a century ago. In addition, the island's separation from the mainland and its location along ocean currents have ensured endemic species have prospered. It is referred to as Panama's Galápagos for a reason.

Coiba Island is the biggest of the 38 islands and islets in Coiba National Park, an archipelago and designated marine park covering 1743 square kilometres (430,825 acres).

The island's hardwood tropical rainforest, covering 194 square kilometres (47,938 acres) is now the largest virgin rainforest in the Americas and is afforded the rare accolade of being authentically 'untouched' and 'pristine'. It is home to endemic plants, mammals, bats, birds and bees, including threatened species and those found nowhere else on the planet.

Not to be outdone, the marine park is one of the largest coral reef systems in the eastern Pacific Ocean, boasting, at last count, 800 species of marine fishes, 33 species of sharks and 20 species of cetaceans.

Access to the island is via several locations on the Panamanian coast, with the closest, Santa Catalina, about 25 nautical miles away, or a 90-minute boat ride. Visitors can join one-day snorkel and kayak tours to investigate the exceptional waters around Granito De Oro island to see huge schools of pelagic fish, morro eels and turtles. Multi-day scuba diving tours go deeper exploring underwater troughs and shelves where stingrays and barracuda swim around with bottlenose dolphins, pilot whales and hammerhead sharks.

Wildlife and eco-tours on Coiba Island are equally captivating, with trails leading through mangrove glades and forests of huge wild cashew nut and balsa trees to waterfalls and thermal springs. In the dense hardwood rainforest, iguanas, capuchin monkeys and other primates swing in the trees while endangered scarlet macaws and crested eagles soar in the air.

Permit requirements might appear to limit daytrippers and overnight visitors (to the island's only accommodation option – the ranger station). But the cruise ships that visit the area are, sadly, free to offload any number of day-tripping passengers keen to wiggle their toes in the white sand. The park's growing popularity for tourists on an island with limited resources is as challenging as the illegal poaching and fishing that threaten the park's unique and abundant protected surrounding islands, reefs and waterways.

Coiba's survival, nay its ability to continue to flourish, relies on the Panama government's continued funding and commitment to conserving this unlikely wilderness. Fingers crossed it will continue to thrive *because* of human nature, rather than despite it.

ABOVE The derelict remains of the former prison on Coiba Island

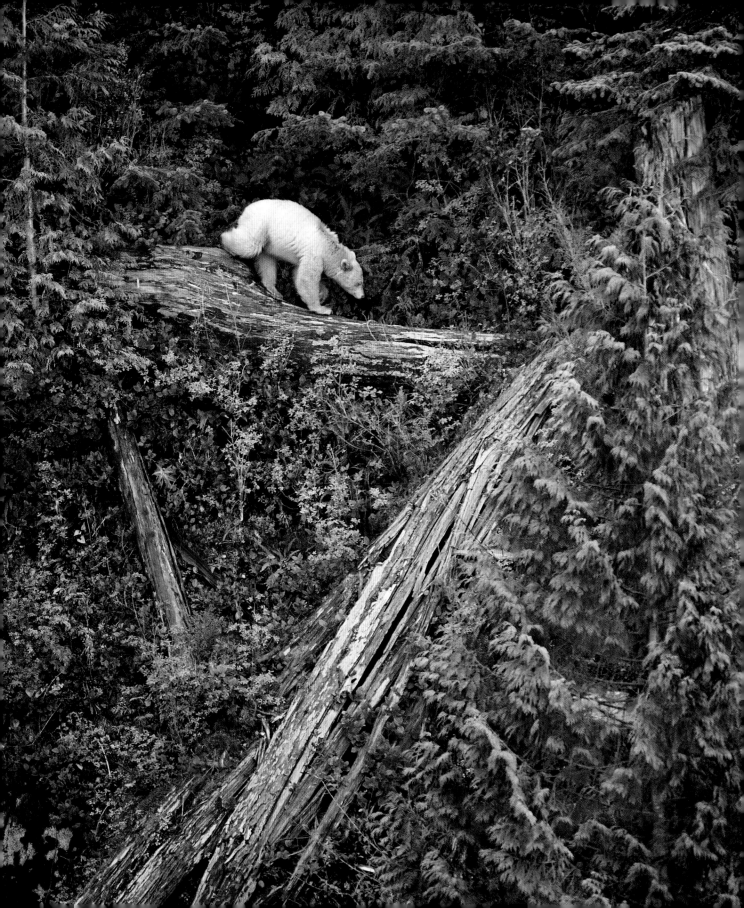

GREAT BEAR RAINFOREST NATIONAL PARK

British Columbia
Canada

A remote and isolated mountainous coastline where spirit bears roam.

From behind the sodden moss-green trunks of century-old cedar trees a ghost white figure – a spirit bear – materialises, barely there through a thick, settled mist. It pokes its nose around low-hanging branches for berries and nuts, eyes off the river rapids for the salmon that leap there.

Spirit bears, or kermode bears, are sacred to the many First Nations communities of British Columbia's central and northern coastline. And they are very rare. Their naturally creamy white coat, an ethereal marker against the deep, dark broadleaf forest, is caused by a recessive white gene in both parents. It is identified in about one in every 10 black bears.

The thought that this incredible animal is found only here in Canada's Great Bear Rainforest National Park can take your breath away.

Stretching more than 400 kilometres (250 miles) along the British Columbian coastline from Knight Inlet to the Alaska Panhandle, this remote and remarkable park is an ecological wonder. Its symbiotic land and sea ecosystems, covering 6.4 million hectares (15.8 million acres), encompass an incredible number of habitats. Mountains and valleys carpeted in one of the world's largest remaining temperate rainforests border pristine lakes, clear rivers and estuaries. Offshore is an archipelago of islands, glacier-cut fjords and inlets.

The habitat equates to an uber diversity of both plants and animals. Living alongside the spirit bear are their black bear siblings along with coastal gray wolves, cougars and cute hamster-like little American pikas. Hang around long enough and you'll spot bald eagles, rufous hummingbirds and brown bats.

In the coastal waters, known as the Great Bear Sea, kelp forests, north-western salamanders, orca, spawning salmon, sea lions, sea otters and humpback whales are just some of the species that thrive.

These sea-terrain ecosystems are intricately intertwined. Picture a grizzly bear eating mussels on the water's edge, or a spirit bear taking its nutrient-rich salmon catch from the river into the woods where its remains become fertiliser for plants.

The entire ecology is buoyed by other complex factors: tectonic plates adjusting over millennia; cool winds ascending coastal mountains to create rain, hail, snow, fog; and proximity to transitioning Alaskan and Californian currents where nutrient-rich waters promote the diverse marine ecology.

It is little wonder the park has been the inspiration and motivation behind huge conservation campaigns over the past few decades, a response to intense clear-cutting to harvest massive quantities of cedar, spruce and hemlock. When you see these forests, the thought of it makes you want to cry.

Mercifully, in 2016, after years of tense discussions, a compromise was reached between environmental organisations, the logging industry, First Nations Peoples and government. Now, about 85 per cent of the forest and 70 per cent of old-growth forest is protected from logging.

Visitors will reap rewards from this incredible legacy when they allow time to get here and stay a while – the park is massive (about the same size as Ireland) and remote. From Vancouver to the gateway of Bella Cool, it's a 12-hour drive to partake in tours to see grizzlies and and salmon spawning, nature walks and river floats. Further north, Prince Rupert, 17 hours by road, is a hub for whale-watching.

For real green immersion, sailboats and passenger ferries depart from North Vancouver Island and cruise along the scenic coastal islands and channels to waterside villages. Visitors can join kayaking and fishing trips along the coast and hike through old-growth forests at Klemtu, where the Kitasoo/ Xaixais First Nations People run Spirit Bear Lodge, a well-known community-based ecotourism venture.

And then there are the park's remote luxury lodges where grizzly bear and bald eagle sightings are a highlight. Landing on sparkling clear estuaries by floatplane is the best way to access the lodges.

Great Bear Rainforest National Park is what might be called a wellness wilderness – where you slow down, recharge and leave feeling invigorated. If you happen to see a spirit bear, you can add awe-inspired to the list too.

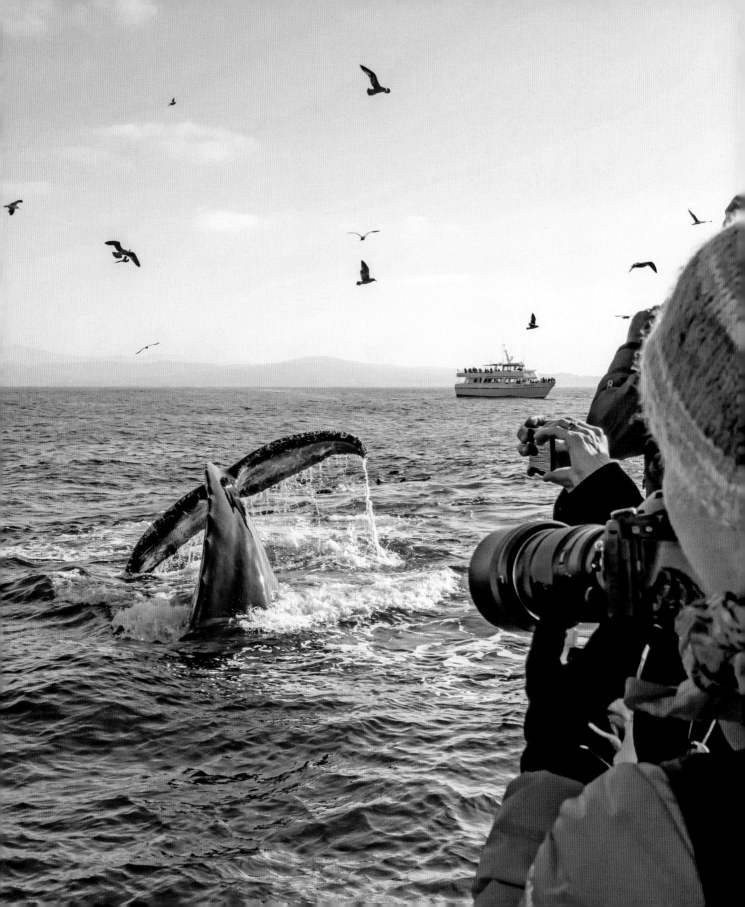

MONTEREY BAY NATIONAL MARINE PARK

California
USA

A marine sensation, home to kelp forests, an underwater volcano and blue whales.

There's good reason why Monterey Bay National Marine Park is known as the Serengeti of the Sea, or more poetically the Blue Serengeti. Like Tanzania's prized national park, with its grand migration of big cats, famous mammals and bird species, so this stretch of big blue is a magnet to an epically rich fantasy land of sea creatures, both big and small. Its blue extremes can be explored from land, by boat and, best of all, with snorkels and scuba tanks on.

In fact, according to UNESCO when surveying the site for a potential World Heritage listing, the migration of marine animals 'greatly exceeds those found on the African savannah', both in terms of numbers and diversity of species, and the distances travelled. Monterey is within the California Current Conservation Complex, which, at the time of research, has tentative status on UNESCO's World Heritage List.

That this marine oasis is on the doorstep of California, home to a densely packed human population, makes its abundance and richness more remarkable still. The marine park stretches about 444 kilometres (276 miles) from San Francisco in the north to its southern boundary at Big Sur, and takes up about one-quarter of California's extensive coastline.

Incredibly, the marine park extends an average of 48 kilometres (30 miles) offshore (covering 13,784 square kilometres or 5322 square miles in total) where it then sinks 3884 metres (12,743 feet) to the deep greeny-black depths of Monterey Canyon, a prodigious underwater abyss so big that it's beyond the average human brain to comprehend its volume. (For the curious, it rivals the Grand Canyon and is the equivalent of an unfathomable 7,469,681,093 Olympic-sized swimming pools. Add head-exploding emoji here!)

This pointed trench creates much of the magic. It abuts the coastline creating the perfect conditions for, incidentally, one of the world's biggest waves – Mavericks, known to crest at 7.6 metres (25 feet), and a seasonal upwelling of cool nutrient-rich water from deep below the ocean, allowing incredible marine food chains to prosper.

The marine life sensation begins with phytoplankton, which forms where sunlight meets these deep waters. The phytoplankton attracts schools of ethereal jellyfish and great shoals of anchovies that make mile-long dark swarms in the water. Sea lions are drawn to the anchovy degustation and dolphins soon follow. Add barnacled humpback whales and screeching seabirds into the mix and you have one of the planet's most phenomenal feeding frenzies.

The kelp forests, a carbon sink of giant algae, is another important habitat that blooms when the warm ocean currents bring nutrients from the cooler ocean depths. Along with myriad fish and invertebrate species, it's an abundant feeding ground for Monterey's famous southern sea otters. Bigger species such as grey whales use it as camouflaged protection while they wait for the right time to feed in open waters.

Davidson Seamount, an undersea volcano habitat, also adds to the drama. It is 129 kilometres (80 miles) to the south-west of Monterey and summits at 2280 metres (7480 feet), but it's a summit that is still 1250 metres (4101 feet) below the water surface. Its sloping sea floors are a paradise of coral and sponges, deep-sea fish and invertebrates.

These bio-rich aqueous environs are complemented by the coastline's other habitats: the sandy beaches where northern elephant seals nurse their young, shallows where young great white sharks hunt for fish, and wave-battered rockpools and estuaries home to a marine spectacle of crabs and lobsters, squids and clams. These habitats are easily accessed from land all along the coast, at stops on self-drive tours, on barefoot beach explorations and in coastal communities in unlikely urbanised places.

In Monterey Bay's bygone shipping ports, for example, seals and sea otters have safe harbours, and take refuge on wooden jetties, buoys and offshore rocks to the delight of snap-happy tourists.

But the real thrill happens out on the water on kayak and boat outings, scuba and snorkel dives. Local and migratory sea life in Monterey Bay includes 36 marine mammal species, 525 fish species (and counting), four different types of turtles and dozens of seabirds.

It's not an exact science determining whether some of the mammals live here and are rarely seen or if they're just passing through. But according to Sanctuary Integrated Monitoring Network, it's typical for someone living around Monterey Bay to sight 20 different mammal species over the course of a year, depending on seasonal conditions.

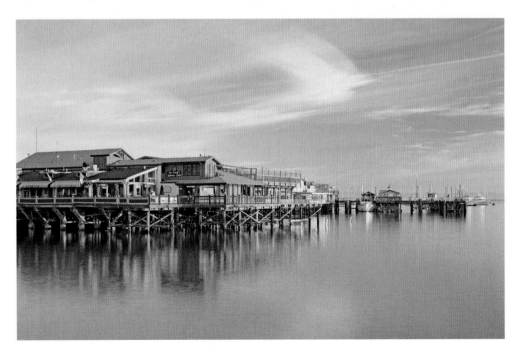

LEFT Fisherman's Wharf in Monterey

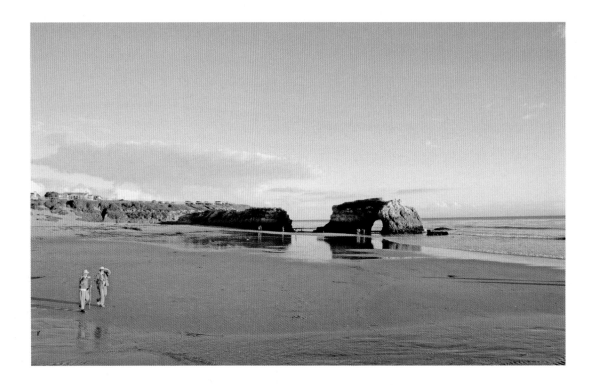

ABOVE Natural Bridges State Beach, in Santa Cruz, is one of Monterey Bay's many land-based attractions

Even if you were to see only one-third of this number, it's wildlife documentary stuff with darting pods of bottlenose dolphins, families of orcas and minke whales, just for starters.

That the marine park ensures these creatures have environmental protection and stewardship is something to be thankful for, but not taken for granted.

In 2022, the Monterey Bay national marine park community celebrated 30 years since the area was declared a marine sanctuary. In that time, its protected status was challenged in 2017 when former president Donald Trump attempted – unsuccessfully – to put gas drilling in the park back on the agenda.

His predecessor, Barack Obama, sees it differently. In his narrating of the 2022 Netflix documentary series *Our Great National Parks*, the former president talks about the need to tackle the threat of climate change by expanding and connecting our marine sanctuaries:

'... by protecting the ocean's hot spots, we can generate impact far beyond the sanctuary's borders, enriching the ocean beyond and our own lives too. Monterey Bay National Marine Park gives us hope that although human activity has harmed the ocean, as long as we make the right choices from now on, we can heal it too.'

Hear hear!

BLUE WHALE

Spotting the mother of all Earthly creatures, the blue whale, is categorised as 'uncommon', but sightings do happen at Monterey Bay National Marine Park.

On an episode of BBC's *Big Blue Live*, host Steve Backshall's response is legendary when the largest animal ever known to live on the planet – bigger even than dinosaurs – surfaces unexpectedly, mid-interview. The helicopter footage of this magnificent creature breaching the surface of the water is all the eco inspiration you need.

The blue whale is the world's largest ever animal, its long slender body can weigh 121 tonne (133 ton) and reach 30 metres (98 feet). Conversely it survives on a diet of tiny shrimp-like krill, which it consumes in gallons of gulps of seawater.

In the first 60 years of last century, blue whales were hunted to 99 per cent extinction, with a heartbreaking 360,000 slaughtered for whale oil. Their ultimate demise was halted with the International Whaling Commission in 1966, but their numbers today haven't come close to what they were. World Wildlife Fund estimates today's population is between 10,000 and 25,000 individuals, putting them in the endangered category.

On the blue whales epic migrations that span all oceans excluding the Arctic, commercial whaling is no longer an issue but other challenges have taken its place. Ship strikes, fishing net and debris entanglements and toxic waters pose the biggest problems.

Satellite tags are being used to track blue whale routes in the hope that more informed decisions can be made about protected marine areas like Monterey Bay.

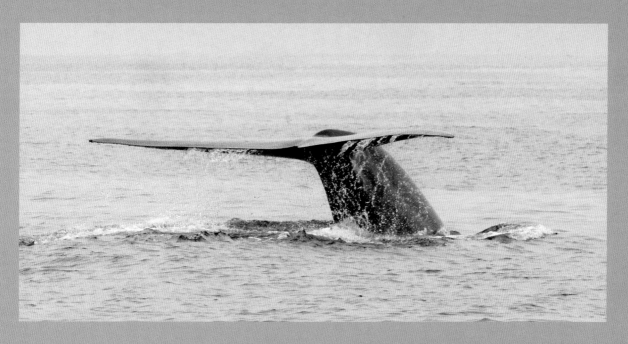

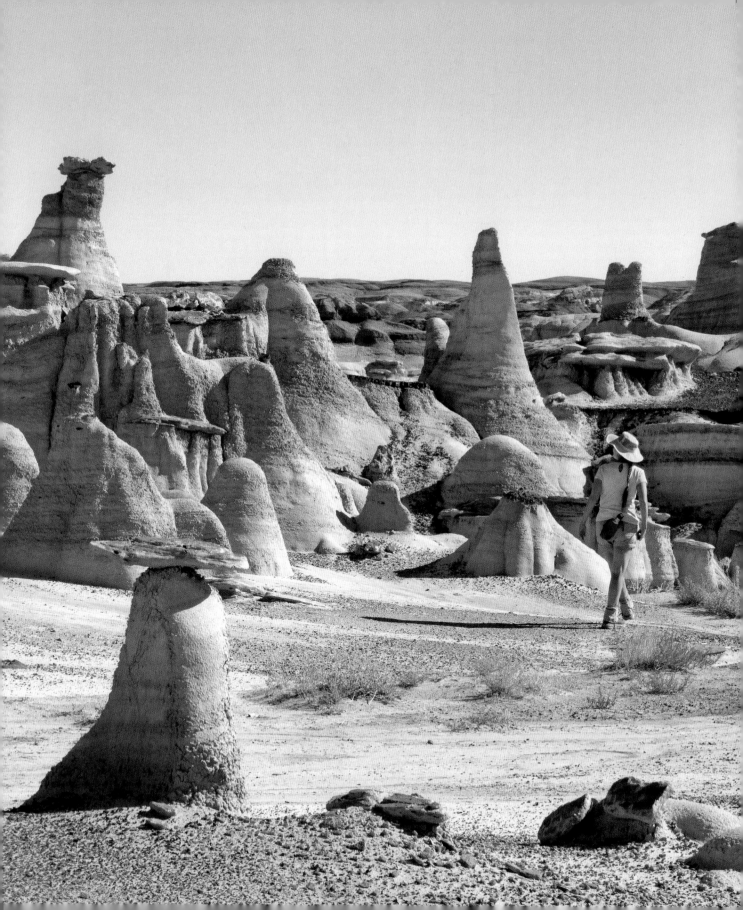

BISTI/DE-NA-ZIN WILDERNESS

New Mexico
USA

A badlands of petrified trees and sand-blasted rock sculptures.

Located in the desert of north-west New Mexico, near the town of Farmington, this remarkable natural geological theme park, a desert wilderness covering 18,000 hectares (45,000 acres), has some of the world's most unique rock formations.

Known as the Bisti Badlands, it is a place for adventurers, rough campers, photographers, paleontologists and hikers, but it was once a prehistoric inland sea, a tropical swamp land where endemic species of dinosaurs roamed among other reptiles, mammals, and towering conifers. The many petrified tree trunks found here, and the fossilised dinosaurs, including one – 9 metres long (29 feet) and said to be a distant smaller relative of the Tyrannosaurus rex – are proof.

Today this arid, sand-blasted, treeless moonscape – a badlands on account of its colourful eroding sedimentary rock layers that have evolved from evolutionary wear and tear over an epic 60 to 80 million years – couldn't be further from this vision of the past. But it is amazing all the same. A visit reveals a time capsule of epic proportions, dating back to the end of the dinosaur age.

Bisti and De-Na-Zin are adjoining parks that were protected as a joint wilderness area in 1996. The Indigenous descendants of the region are the Navajo People whose territory today lies west of the badlands. For the Navajo, 'bisti' loosely translates as 'among the adobe formations', while 'de-na-zin' is the word for animal, a nod to the crane petroglyphs also found in the area.

If we look back just 6000 years, the badlands as we see them today started forming. Sedimentary rock layers, a build-up including preserved ancient swamplands, other organic matter and red beds of burnt coal seams, have been eroded over millennia by melting ice, snow, wind and rain.

The different rates of erosion are a geological curiosity that have helped sculpt the abstract forms and unlikely shapes on show; they really are gobsmacking in their diversity.

The most surreal formations are its hoodoos. These angular mudstone plinths have ungainly sandstone saucers that appear to balance on top. They are formed when a much denser sedimentary sandstone layer, possibly including volcanic ash, sits atop mudstone layers which erode much more rapidly. Seen in their hundreds, they thrown eerie shadows imbuing the desert with an other-worldly atmosphere.

Other shapes look more like oyster mushrooms and clumps of enoki with floppy caps melting over their stems. Amid *Alice in Wonderland*'s fungal fantasy, and Luke Skywalker's hoodoos (for surely this is a land for fantasy and sci-fi fans), there are tower formations that appear hand-carved like chess pieces, with their fortified castle tops creating magical silhouettes against the sunlit sky.

Fragile low-lying oblong forms in the fantastically named 'alien hatchery' look like unearthed cracked eggs or giant extraterrestrial oyster shells that might shed a luminescent blue-green light over the desert if prised open.

There are natural bridges, passageways, crevices and other unique forms. In varying minerally colours – grey, crimson, yellow and cream – they seem to shape-shift on the landscape, their weather-moulded forms creating magic.

The almost-rectangular petrified tree trunks act as a counterpoint. They appear to 'grow' out of mudstone or lay 'felled' across the desert environment, much like they would have been 70 million years ago when first encased in a sedimentary swamp layer. So intricate is their preservation, their tree rings can be counted, and the different species identified. Many are conifers from the kind of leafy tropical jungles that the dinosaurs inhabited. The red and yellow lichen growing on the petrified tree trunks essentially consumes a mineral diet from the dinosaur age.

Other forms of life are rare here, save for a few small mammals and reptiles and a number of protected birds of prey – prairie falcons, nesting golden eagles and ferruginous hawks.

While this might be a doorstep wilderness in term of its accessibility and proximity to human populations, it is a true designated wilderness area with no marked trails, camping facilities, toilets or water.

It is thus a place for anybody comfortable in the full gamut of the elements and natural habitats, be they tropical forest, desert wilderness … or both.

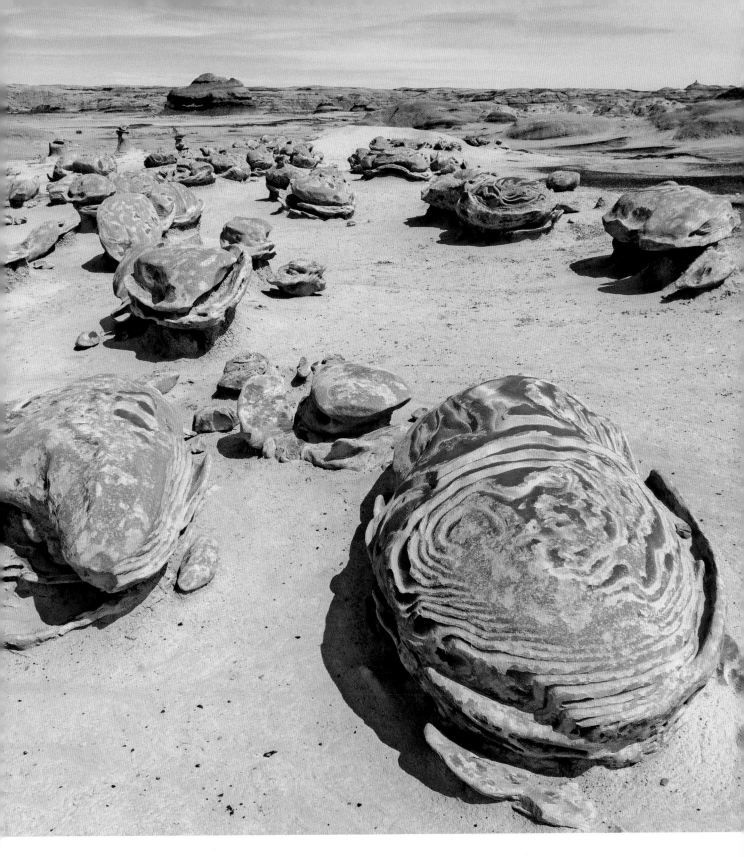

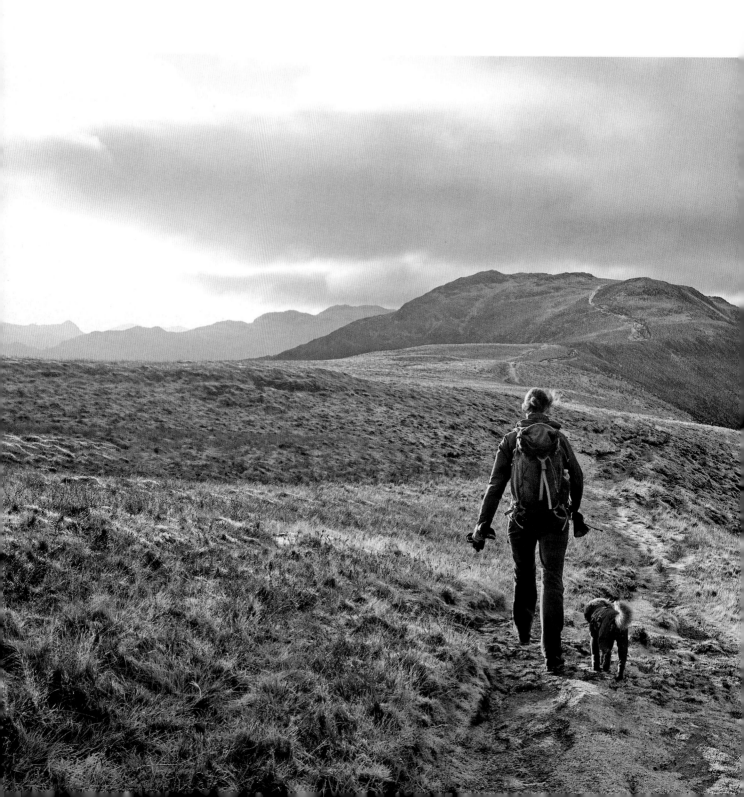

EUROPE

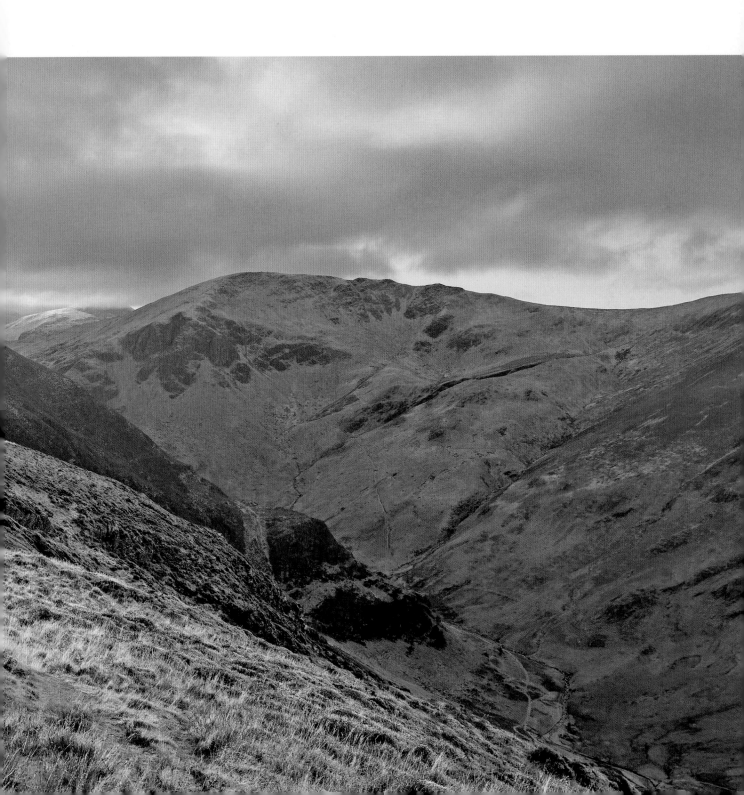

'There is no more wilderness left in Europe'. I heard this many times during my research. But I can only take heart that this means wilderness in old terms, of a wilderness being untouched by humanity, rather than the terms of this book, where wilderness can be the wild regions flourishing on our doorstep as much as those places beyond. For evidently there are many wild places for the traveller to explore.

Europe is considered a continent. It might be the second smallest continent, but it is the third most populated with some 750 million inhabitants. As the cradle of Western civilisation, it carries with it the full span of recent human history, along with its myriad traditions and cultures.

Happily, its inhabitants, while looking back on themselves, have also looked forward to ensure their outdoor cultures and traditions and a love for nature will continue through mindful conservation and sustainability. Wilderness can be found in the surviving (and rescued) tracts of untouched magical Białowieża forest in Poland and Belarus; on the icy granite massifs of the Pyrénées in France, Andorra and Spain; and in the wind-whipped wilds of Iceland and Norway. England's Lake District is one of Europe's great doorstep wildernesses and the big swells and deep canyons of Nazaré, in Portugal, can be similarly considered a wilderness, not on the doorstep, but certainly just offshore.

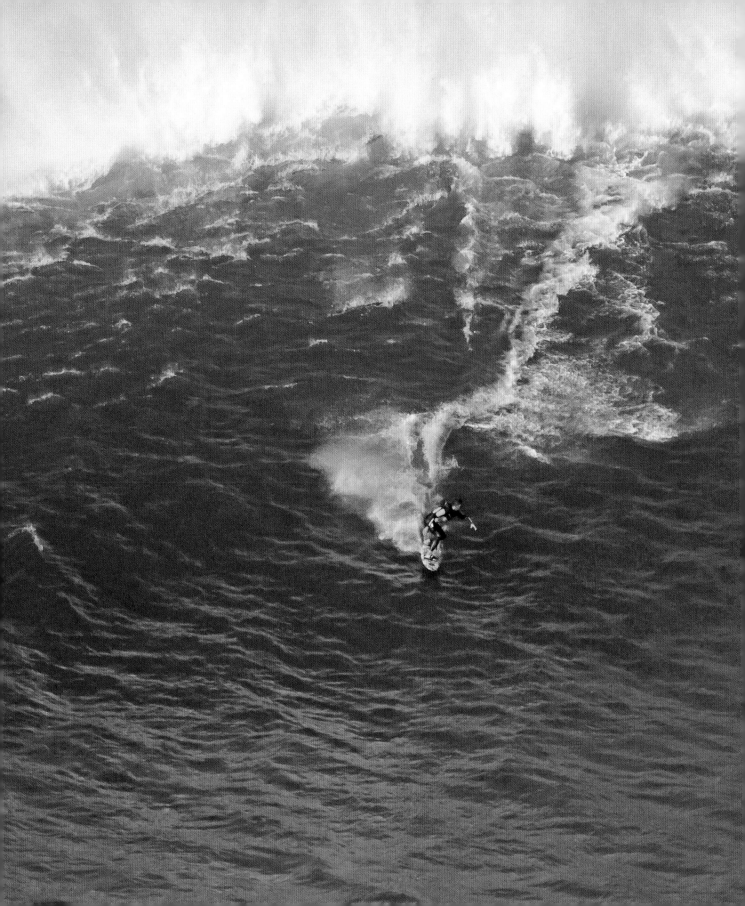

NAZARÉ

**Estremadura
Portugal**

The world's biggest wave and its undersea canyon.

Big-wave surfers braving Portugal's epic Nazaré wave understand what it feels like to be subjects of a force far greater than humankind. These ocean adventurers, attempting to master the wild at least for the length of a ride, as shown here, are seeking a connection beyond what most of us aspire to.

Nazaré isn't listed as a UNESCO World Heritage Site, but it strikes me that surfing might have a future as UNESCO Intangible Cultural Heritage, which includes 'rituals that recall the special connection between humanity and the ocean'.

When I asked a spokesperson from UNESCO, they said the idea has been circulating for years: 'In principle a country could propose a particular territory for inscription on the list because of its unusually tall waves. [And] surfing could be inscribed on the Intangible Heritage List as it's a practice.'

Swell!

Nazaré is the biggest wave in the world getting as high as 24 metres (80 feet) and sometimes freakishly reaching 30 metres (100 feet) at the top of its game. Official records from World Surf League, which runs 180 annual surf comps around the globe, confirm German surfer Sebastian Steudtner rode a world-beating 26.21-metre (86-foot) wave in 2020, and Brazilian surfer Maya Gabeira surfed a 22.4-metre (73.5-foot) beast, the largest ever surfed by a woman (and, further to above, she has since become a UNESCO Ocean Ambassador).

For the non-surfers and amateurs among us, the sheer monstrosity of waves this size is beyond comprehension. Watching these calamitous beings with a life of their own unfurl from a great height is epic enough. Seeing a minute rider hurtling down the face of a wave at 50 kilometres (31 miles)

per hour with a Niagara Falls of treacherous white water on their tail is enough to make your heart race.

Bearing witness to nature's epic scale is to also feel the subliminal weight of human frailty. What can go wrong? Ice-cold currents, undertows, rocks, rip tides and waves that roll you around like a rag doll before breaking your bones. The injuries have been serious, and tragically in 2023, while researching this book, veteran Brazilian surfer Márcio Freire became the first-known person to die on the wave. He was practising tow-in surfing.

Foreigners started visiting the Portuguese fishing town of Nazaré in the 1960s to join locals in the surf. Over the past 15 years, its eponymous big-wave has become the subject of wishlist whispering for adrenaline-junkie big wave surfers around the globe. Alongside them are the vital support crew (jet ski towers, spotters and rescuers) who get a similar rush (and risk) out of the escapades. Big-wave surfing competition event dates are confirmed when the swell is at its best. For most of us, we can only watch the action in awe.

To comprehend the size and scale of these big mommas, it helps taking a mental deep-dive to the ocean floor to picture the Nazaré Canyon, the largest submarine trench in Europe. This gigantic east–west gash stretches 227 kilometres (141 miles) along the bottom of the sea with steep escarpments and tiered sides that sink to a depth of 5000 metres (16,400 feet), reportedly the graveyard of several ships and a submarine dating back to World War II.

The western end of the canyon joins the similarly deep Iberian Abyssal Plain. The eastern end stops short of Nazaré township's coastline. According to the Nazaré Waves webpage, the canyon's sharp V-shape separates incoming waves into two, increasing their speed, power and unpredictability, and amplifying their size three-fold before they join back together. This internal tidal current then meets the opposing beach currents and the wave swells in size again.

But the canyon alone doesn't create the waves. The 'magic happens' when a winning combination of special conditions comes into play. This includes incoming waves above 4 metres (13 feet), weak wind and swells that develop from the North Atlantic in a west-north-west direction. North Atlantic storms also help.

In quieter times, Nazaré's Praia do Norte beach can be inviting, but come October, the beach is a frothy wave-dumping spectacle with the big swell starting to roll in. (Waves tend to reach full height in February and taper off in April.)

The waves break well away from the shoreline, ensuring surfers don't meet their death on the rocky foreshore. But the beach, and peninsula with funicular-accessed Fort Nazaré Lighthouse sporting a characteristic round, red iron lantern, are close enough to be crowded by onlookers with an eye on the rollers.

This is a seasonal phenomenon. Locals advise planning a two-week stay to 100 per cent–guarantee at least one day of action. Then again, there are those who stay tuned to the forecast and webcams so they can pack their bags as soon as that North Atlantic swell starts rolling in.

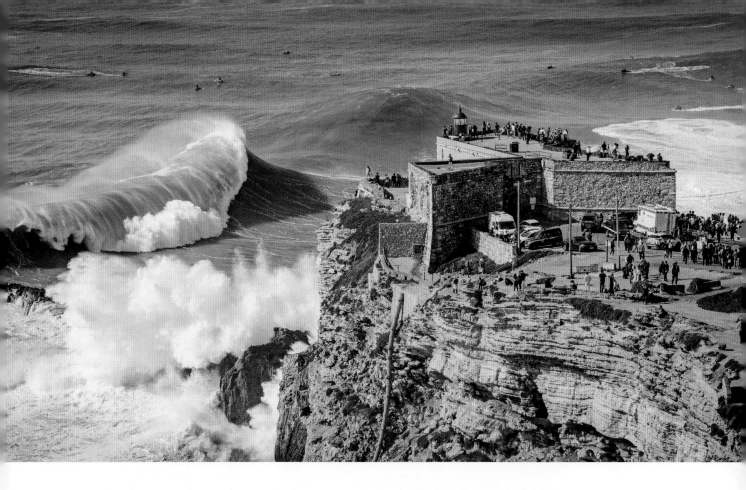

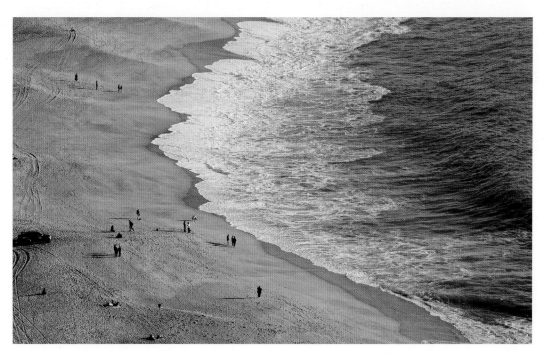

ABOVE Fort Nazaré
Lighthouse provides
a viewing platform for
seeing one of the world's
biggest waves

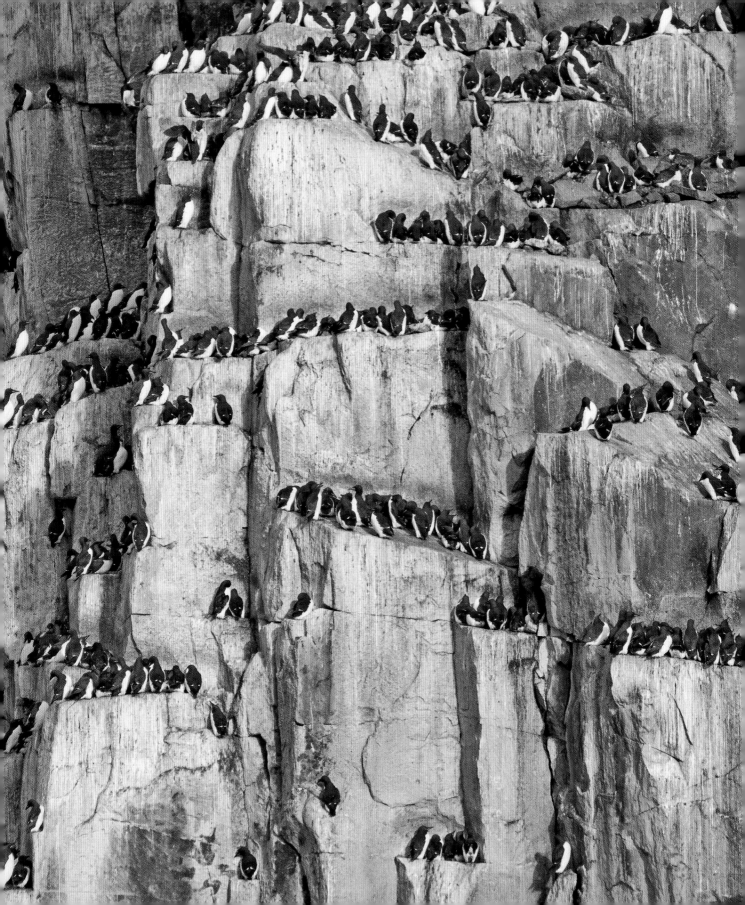

SVALBARD

Norway

An icy island wilderness where polar bears reign.

The Old Norse words *svalr* meaning 'cold' and *bard* meaning 'edge' and 'ridge', though somewhat corrupted with time, are hint enough of the location of Svalbard, an Arctic Ocean archipelago way up in the northern reaches of Norway.

This mind-bending of places, only 1311 kilometres (815 miles) from the North Pole, but 2008 kilometres (1247 miles) from Norway's capital of Oslo, is a frozen zoological wonderland in terms of the sheer scope of its wildlife – polar bears rule here, and visitors are likely to see everything that sits below this apex predator on the food chain – and some.

The landscape, sitting on the edges of Planet Earth's climatic extremities, cracks and crunches and thunders with moving glaciers, calving mountainous ice shelves and floating ice.

Its remoteness and isolation are exacerbated by its Arctic quirks: for four months in summer, the sun still shines at midnight. In winter, it doesn't shine at all for the equivalent time leaving the aurora borealis to take over the skies at any time of day. How's that for wild?

It is a place that would be mostly uninhabitable to humans, but for the Gulf Stream, a summer warming that makes tundra landscapes and the thin layer of vegetation possible. This land of ice and tundra is epically wild and unfathomable.

All Svalbard journeys begin in the frontier town of Longyearbyen on Svalbard's biggest island, Spitsbergen. It is home to a largely seasonal population of around 2500 people and, as the locals like to joke 'the world's northernmost ... micro-brewery, chocolate factory, kebab shop, etc. ...' Nearly everyone who resides in Svalbard lives in Longyearbyen, bar for the small number working at research stations and in mining settlements.

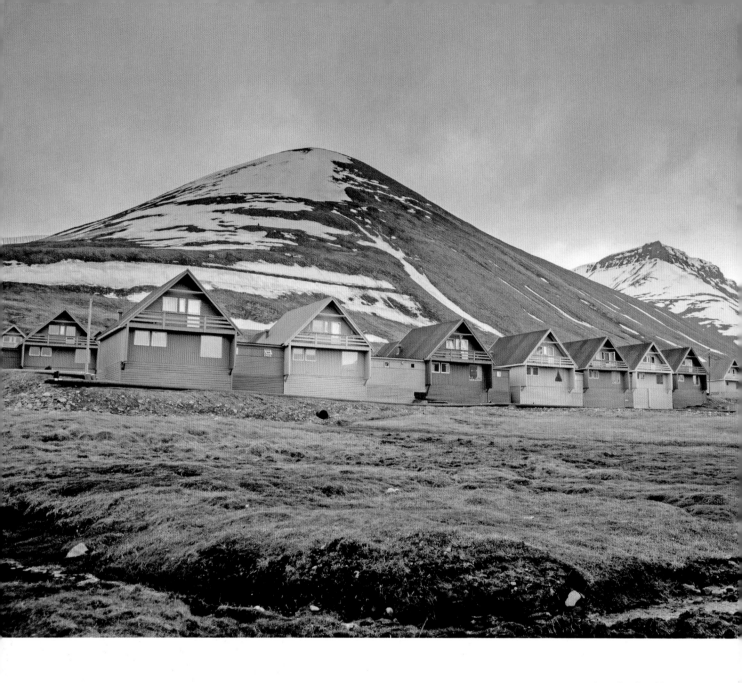

ABOVE Svalbard houses are painted in a rainbow of colours to help them stand out from the landscape, differentiate old and new buildings, and to make the long polar nights more cheerful.

Various tours by boat (in summer) and snowmobile (in winter) venture from Longyearbyen to the nearby old mining settlements of Pyramiden and Barentsburg, and on nature-immersive activities including husky rides, kayaking, fishing, hiking and ice caving. Longyearbyen is also the jumping-off point for a real immersion in the majestic wilderness beyond town, a mostly untouched landscape where humans fear to tread.

A Norwegian friend of mine, Morten Mathiesen, enthused that the feeling of being alone in a wilderness is heightened by the very real danger of a polar bear encounter. As the Longyearbyen security guards told him and his friends as they set out on a skidoo adventure: 'We'd save you, but we probably won't get there in time'.

A vast 60 per cent of this fragile archipelago is protected by national parks, nature reserves and bird sanctuaries, but increasing water and air temperatures brought about by the climate emergency are already melting glaciers and reducing snow coverage, which spells disaster for polar bears and other inhabitants. Realistically, Svalbard is already on the tipping point.

Of the 29 protected areas in Svalbard, there are seven national parks all found on Spitsbergen Island. They are accessible by boat on gobsmacking journeys past ice caps and glaciers, through drifts of floating ice.

A berth on a small boat or expedition ship (as opposed to the behemoth cruise ships whose numbers are now being capped by the Norwegian government) fits a sustainable travel philosophy and is the best ticket to see the wildlife.

Cruising not far from Longyearbyen through Isfjord, Svalbard's second longest fjord, reveals frosted mountains, and deep tracts of crystal water including Bellsund sound where whales are among bucket-list wildlife sightings. At the entrance to the fjord the coastal shores of Daudmannsøyra in Nordre Isfjorden National Park are unmissable too. Svalbard's resident polar bears – so common on road signage in Longyearbyen – are clearly visible on the rocky shores, playing fisticuffs, tending to cubs and lounging on the ice. Having binoculars at the ready can reward with sightings of ringed seals, wild Svalbard reindeer and Arctic foxes too.

In the very north, Nordvest-Spitsbergen National Park is a landmass of ancient volcano remains, glaciers and fjords along with (the world's most northern) hot springs. In these lonesome, often foreboding parts, walruses surface from the frigid waters, seals bask on ice floes and clown-faced puffins follow boats.

Cruising south, Sør-Spitsbergen National Park's freshwater ponds, tundra vegetation, black cliffs and rockeries have ensured it is a nesting ground for Svalbard's 80-something bird species, most of them migratory. Eiders and barnacle geese are among those that breed here.

In the skies above, Arctic terns are a constant, often seen protecting their nests from animals and humans alike. It strikes me that these peripatetic wanderers who cross the planet from the Artic to Antarctica each year could make appropriate totems for antipodeans, like me, who travel in the opposite direction and find themselves so far from home.

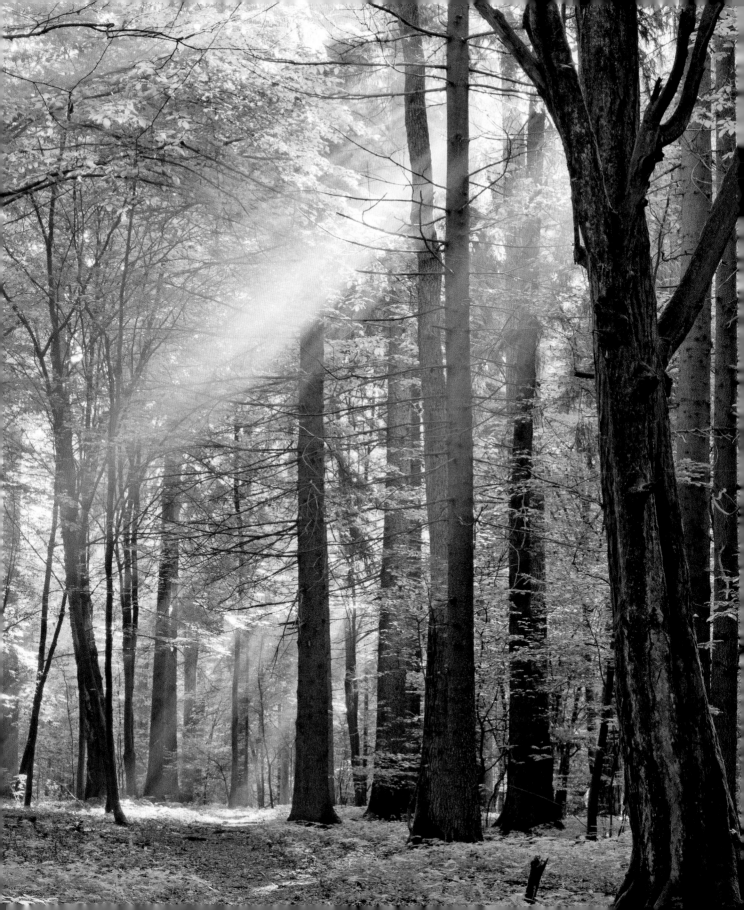

BIAŁOWIEŻA FOREST

Poland & Belarus

A time capsule for one of the planet's most ancient forests.

Picture this: 10,000 years ago the European continent was covered in primeval forest that stretched across the plains of the north-east in a kaleidoscope of earthy greenery. It abounded in conifers and broadleaf trees – oaks, spruce and pine – a veritable wooded wonderland where the continent's diverse animal species still reigned. This staggering natural-world visual, plucked from an ancient time, can still be conjured today in the blast from the past that is the Białowieża Forest.

This UNESCO World Heritage Site straddles the border of Poland and Belarus and is credited as the only remaining forest remnant true to its original heritage. Covering 3086 square kilometres (1191 square miles), roughly split 40 to 60 per cent between Białowieża National Park on the Poland side, and Belovezhskaya Pushcha National Park on the Belarus side, the forest is a living, breathing natural-world museum, a place to forest bathe amid a thriving mass of ancient naturally germinated trees, meandering waterways and swampy wetland bogs.

The forest is an exemplar of biodiversity with 59 mammal, 13 amphibian, seven reptile and more than 250 bird species. The rich fertile soils, black with microscopic organic biomass are the result of – over centuries – multiple layering of decomposing plant species, and a build-up of dead wood from naturally felled trees. Covered in mosses, lichen and delicate fungi, this ecology, home to more than 12,000 invertebrate species, is representative for the plant and animal diversity no longer existing elsewhere in Europe.

The unassuming heroes of the park are undoubtedly the herds of wild bison (about 800 in total), which were killed off in 1919 and reintroduced to the forest in 1952. According to the Polish Tourism Organization, there are only

3000 left worldwide. All of them have predecessors from Białowieża. The bison are Europe's last remaining megafauna and Białowieża is the only place where they roam wild.

Furry, humpbacked, horned and naturally shy, the bison share their habitat with wolves, whose footprints and droppings can be traced on the forest floor, alongside those of the lynx and European badger. Endangered and rare species include the pygmy and boreal owls, and white-back and three-toed woodpeckers, along with many beetle and flower species. All of them rely on this exact habitat for survival. The importance of it cannot be overstated.

While the protected parts of the forest thrive, the unprotected parts are the subject of controversy. On the Polish side, a tiresome well-worn battle between 'foresters' and 'greenies' has played out over the past decade. The former insist a beetle infestation is grounds for logging; the latter fear the impact of commercial logging on the region's flora and fauna. A 2017 order by Europe's Court of Justice sided with the greenies, ordering Poland to stop logging. It had little effect, and the terse dialogue continues. Protectors of the forest are hoping global exposure to the cause and sustainable tourism development will save the Białowieża.

On the Belarus side, Belovezhskaya Pushcha in the native Russian, has walking and hiking 'ecological trails' accessed via recreational checkpoints in different parts of the park. Designed for visitors with their own electric transport, the Green Corridor is a 20-kilometre (12-mile) route crowded with a variety of dense forest ecosystems including curly-leafed hornbeam trees. Much of the route is shrouded in a canopy of greenery that dapples the road in leafy shadows, a camouflage for deer and other fortunate forest animals.

On the Polish side, early risers have a decent chance of seeing bison from platforms at the Kosy Most bison reserve close to Białowieża village, the main tourist base. These languid creatures gather at day's end to graze in the open habitat more natural to them, before taking shelter amongst the trees.

Walking and cycling trails and boardwalks, extend from Białowieża village into the nearby pockets of actively managed forest, offering telling contrasts between these forests and the untouched natural ecology. Don't dawdle around the outskirts for too long, though. The real eye-popper wilderness is in the strictly protected zone to the north of the village where visitors can walk in an almost mystical forest, the original tract of national park, free from human intervention. No trees have been felled here, nor planted. This is as pristine as the Białowieża gets, as exemplified by the trunk of the Jagiełło Oak, a fallen tree known for its 550-centimetre (216-inch) circumference.

Further off the beaten trail, the remote north of the park has primeval woods you're likely to have to yourself. This isolated place, accessible by car, with three extensive marked walking trails, boasts valuable swampy alder forest and wetland meadows where hundred-year-old birch trees are still pin thin from having their wet roots in a boggy habitat.

A two-hour bike ride from Białowieża village along a sandy track to the nature reserves near the Polish–Belarussian border is an adventurous trip with no marked trails (and best taken with a guide), revealing a landscape of preserved old-growth forest, river country and corresponding wetland. It's a true immersion.

As it is, and given its value to the planet, the forest is on the radar to surprisingly few tourists. Those who make the effort are well rewarded with a wild, untamed primeval place where it is possible to feel like the only person on the planet.

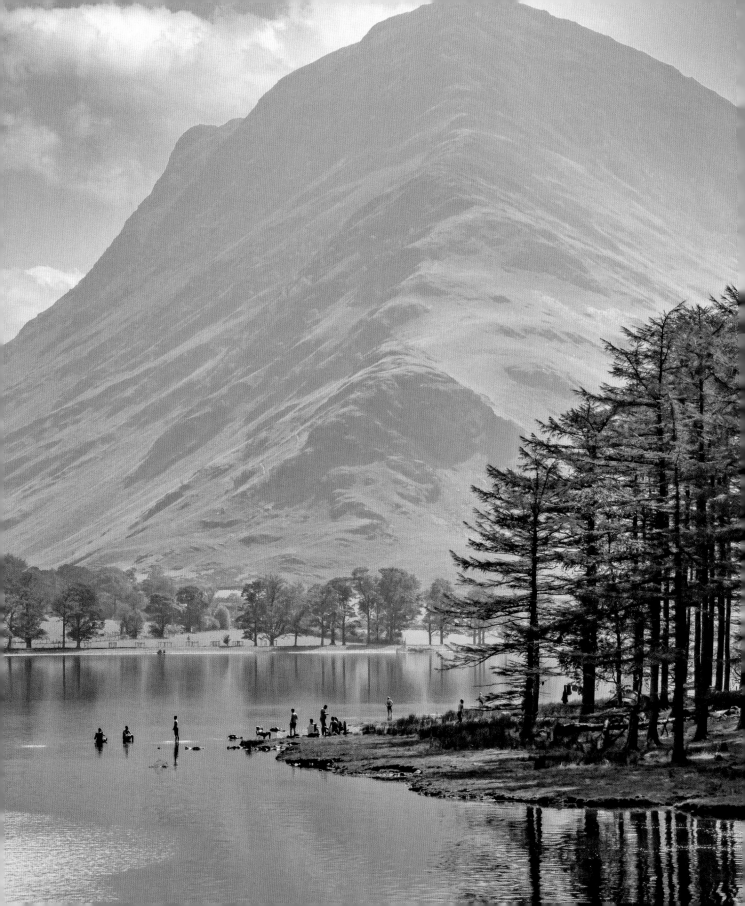

THE LAKE DISTRICT

Cumbria
UK

Rolling hills, fairytale gardens and lakes that run deep.

When history looks back on the uncertainty of the Covid years – the lockdowns, curfews, home-schooling and remote working – it might also remember the positive aspects of how it inspired populations across the world to return to nature, visit parks and green spaces and explore wild places, big and small, on their doorstep and beyond. It might recall the need to make sea changes and tree changes, to slow down, to explore your own backyard, to immerse in a destination and, while there, to experience the little things: the blossoming of a flower, the trickle of a river, the peppery aroma of first snow in a forest.

In the early 19th century, around the time of the Picturesque and Romantic movements, a similar mindset was occurring with the Lake District in Cumbria in north-west England as its muse. No one who has visited here can be immune to the charms of the verdant hills, tranquil lakes and arcadian scenes.

A cultural movement, much inspired by William Wordsworth's publication *Guide To The Lakes* in 1810, was perpetuating a newfound adoration for scenic landscapes, one that not only recognised the beauty in nature (think landscape paintings by Constable) but one that truly fostered the emotional connection between humans and the environment. As UNESCO termed it when adding the Lake District to the World Heritage List in 2017, it was an era that cherished the environment's 'capacity to nurture and uplift imagination, creativity and spirit'.

Our post-Covid years are similarly inclined. A 2021 review by the World Health Organization examining the relationship between 'green' and 'blue' spaces and mental health (where green spaces are parks, gardens, forests, grassland, etc. and blue spaces are coast, inland waters and marine environments) confirmed what we inherently know: that human beings benefit from being in nature. The Lake District has green and blue spaces in abundance.

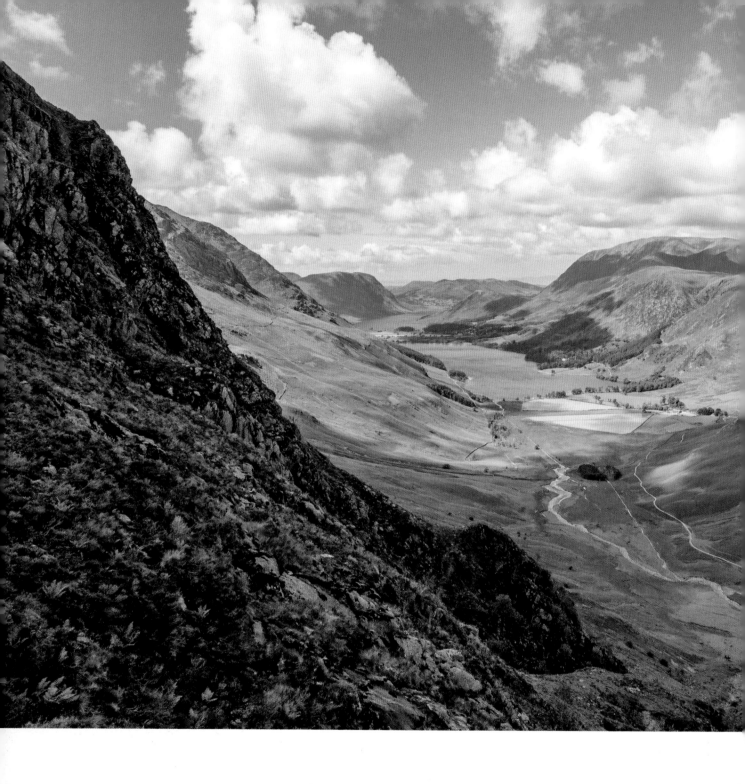

LEFT Buttermere is a famously beautiful lake set amid the Lake District's northern fells

BELOW Ancient Stockley Bridge, near Seathwaite, blends with the spectacular natural surrounds of the Lake District

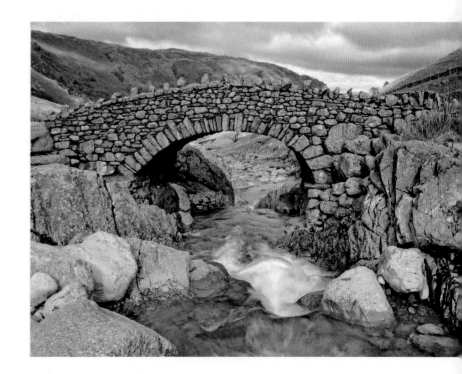

Back in the early 19th century, the thought that nature was good for one's spirit was the precursor to the concept of protecting and valuing scenic landscapes for the long-term enjoyment of all. It led to the establishment of the National Trust in the United Kingdom (which owns more than 20 per cent of the Lake District), and as expressed in nature writer Jim Crumley's 2021 book *Lakeland Wild*, likely caused a ripple of like-minded conservationism across the pond in America where Wordsworth's 'apostles' included famous nature writers Walt Whitman, Henry David Thoreau and Ralph Waldo Emerson. Emerson, in turn, captured the attention of John Muir (champion of Yosemite National Park, *see* p. 21).

Today, we've got a much bigger job ahead of us, a monumental task of repairing the planet. But places like the Lake District, which remain in step with human development while retaining a distinctive harmony with the wild, make it feel possible.

This mountainous region, covering 2292 square kilometres (885 square miles) has a central stand-alone massif of rolling volcanic black mountains and velvet green hills, the result of glaciers inching their way through the end of the last Ice Age. Their bald and bouldered peaks and cliff-faces (often illuminated dramatically by sunlight streaking through darkish clouds) fall away like a tablecloth, narrowing into softer valleys where woodlands, some ancient, most new, find a foothold in the shallow soil and protect themselves and the birdlife from the weather.

The shapes of the district's famed lakes and tarns are determined by the boundaries of the narrow flat land of the foothills. These clear, still waters run deep, all the better for mirroring the surrounding high peaks. Anyone skimming stones on the pebbly beaches of Windemere, walking the grassy shores of Ambleside or taking the cute (and sustainably responsible) little wooden ferry across Ullswater feels enveloped in nature.

The unwieldy terrain has seen a unique agro-pastoral sheep farming tradition develop, with shepherd's fell-grazing their flocks on common land. This arduous and age-old way of life – its trials and traditions beautifully bought to life in the 2015 book *The Shepherd's Life: A Tale of the Lake District* by James Rebanks – faces economic hardship. It's up there with over-tourism as one of the park's biggest challenges.

Somewhat ironically it is this farming community that has given rise to the successful juxtaposition of nature and human-built scenery that so attracts visitors. Picturesque drystone walls and immaculate hedges, full of birds' nests and squirrels, crisscross the hilly troughs and peaks of the Lake District in deference to the lay of the land. Similarly bucolic cottages, ivy-covered old farmhouses with mossy slate rooftops and characteristic stone outbuildings complement the beauty of the district. Beatrix Potter's books, set in the garden of Hill Top, her home in the Lake District, attest to gardens of rhododendrons and roses, rosemary hedges and foxgloves.

RIGHT Herdwick sheep graze in green pastures in the uplands above Ullswater

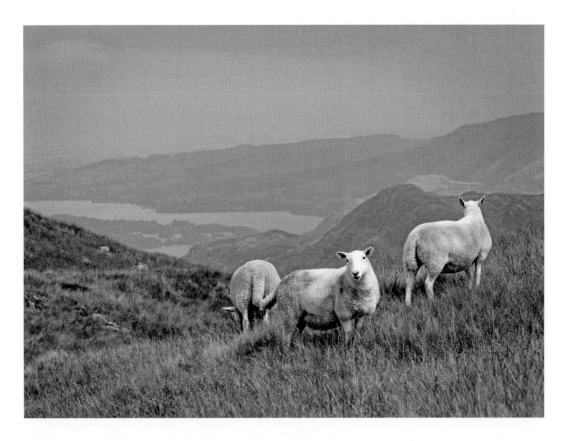

One of the most exceptional aspects of a visit to the lakes is the tradition of unrestricted access to the fells and a labyrinth network of right-of-way public footpaths, bridleways and byways. While the English think nothing of climbing over a kissing gate and strolling through somebody's back field, giving the farmer a wave as they go, it's a marvel for foreigners – a rare liberation.

The tradition, essentially giving access to 50 per cent of the terrain, has proved a great enabler. Mountaineers can strap on their boots for a remote mountainous hike in the tradition of Alfred Wainwright, another nature-lover, whose famed book *A Coast to Coast Walk*, was first published in 1973 and has been reprinted ever since. Walkers can traipse around hilltops and crags and cut across wildflower meadows, plucking apples from heavy boughs, unhindered. More sedentary types will enjoy the scenery too, knowing that a cute little public house, with pansy baskets hanging along its front, is not too far away.

For those nature-lovers seeking healing and wellness in green and blue spaces, the Lake District successfully unites wild spaces with humanity's agricultural places. It is a rare wilderness treasure indeed.

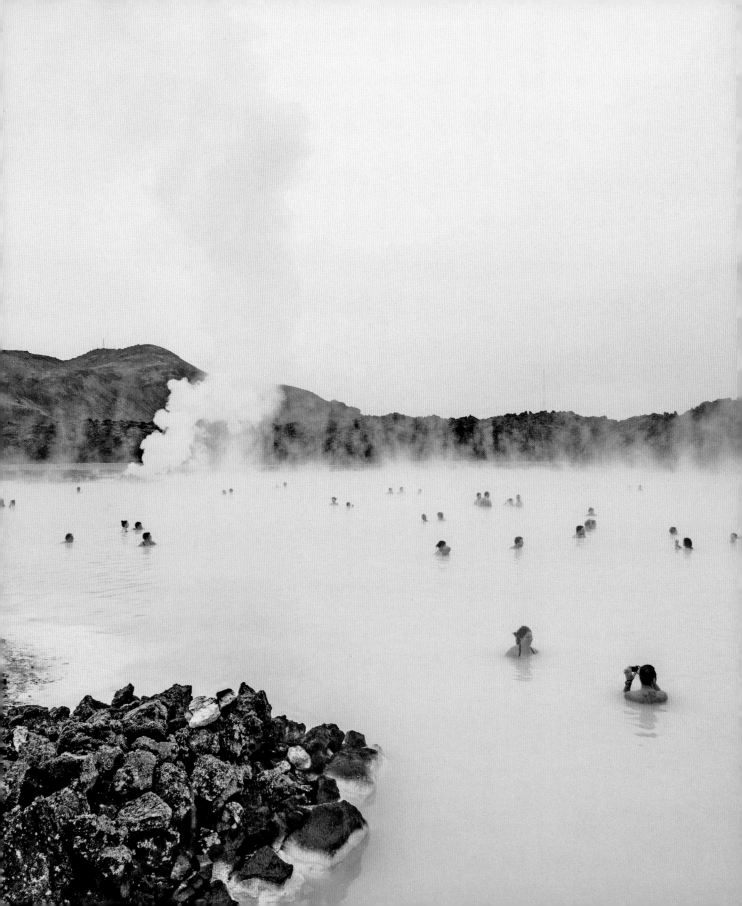

ICELAND

A wild land of ice, lava and hot-cold contradictions.

Iceland's national flag is described by local law as 'blue as the sky with a snow-white cross, and another fiery-red cross inside the white cross'. It's a telling description and appropriately symbolic of a land with a population that bends and flows, zigs and zags, sweats and shivers with an uncommon daily connection to the bountiful natural wonders surrounding it. Much of the global population could be described as living near nature. Icelanders live *of nature.* In their homeland, molten volcanoes do burn red. Snow falls and ice accumulates like a layer of white paint. Cerulean skies and moody blue mountains loom large in every direction.

Earthquakes – big and small – always tremulous, occur daily. Volcanic storms and effusions, and the expectation of them, is part of the Icelanders' mindset and they play a big part in their lifestyle. That Iceland is the least-populated country in Europe says much. According to Icelander Auðbjörg Arngrimsdottir, speaking to me about living in such extremes: 'Weather changes everything, controls everything ... it does not make us good planners, but we are good doers'.

When we discuss what's it like to live on an island of volcanoes, she says: 'It is not "if" it will happen, it is "when" it will happen. And we are prepared'.

That be the definition of living wild.

The island's geography and location have everything to do with this country's wild character. It sits lonely in the North Atlantic Sea between its closest neighbours of Greenland to the north-west and Norway and the United Kingdom to the south-east. The North Pole is just under 3000 kilometres (1864 miles) away as the crow flies. This high latitude is tempered by the Gulf Stream, so winters are chilly but summers are relatively temperate for a polar region.

Importantly, Iceland is the only landmass to straddle the Mid-Atlantic Ridge, a rift between the North American and Eurasian tectonic plates that is moving apart by 2.5 centimetres (nearly one inch) each year. This seismic and geographical wonder, sitting above sea level, is responsible for the land's wondrous volatility. Volcanic eruptions, bubbling lakes and sky-high geysers characterise the land as much as the broody mountains, slippery gem-like glaciers and black volcanic plateaus.

The Icelandic economy, built mainly off the fishing industries, collapsed in 2008. In 2010, Eyjafjallajökull's mother-of-all-eruptions sent plumes of volcanic ash across Europe shutting down air space. Enthrallingly, the coverage that the country received during this time is now referred to by Icelanders as 'Mother Nature's marketing'. It served to kick off the tourism industry. Toilets and infrastructure were built in a hurry for those now seeking the wilds of Iceland.

Then in 2020, the Covid era's lack of tourists enabled the country to quality control its offering by building paths, grading hiking tracks and constructing new facilities, restaurants and guesthouses. The unfortunate combination of events actually hit tourism in the right spot, and tourism has since become the country's main economy. As a latecomer to the industry, Iceland has the advantage of being able to mandate a sustainable approach.

It doesn't matter whether visitors head to the lesser-toured North Iceland or stick to the regions around the capital of Reykjavik – this wild land is vividly alive and ever-present. It stuns with its beauty and confounds with its hot–cold contradictions. You can be walking around freezing lakes or luminous blue glaciers in the morning, then stumbling across burping hot springs and boiling rivers by the afternoon.

The landscape of black volcanic hills covered in velour green moss and dazzling micro herbs and flowers is so alive underfoot it almost has a mystical quality. Often, it's unclear whether the camera lens is focused on hot steam curling into the air or a damp mist. The naked eye is no less helpful seeing wisps of white rising from the land from origins unknown.

Icy depths bubble like a potion cooked up by one of the local legendary trolls. Hot fumaroles impress just as much as bombastic waterfalls, some of the biggest in Europe. Gem-like glaciers plug volcano calderas that are due to erupt, threatening to melt ice into water so plentiful it could drown a city.

And, in fact, that is the expectation with Mýrdalsjökull Glacier being a prime example. Covering almost 600 square kilometres (231 square miles), Mýrdalsjökull is, in essence, a 10-kilometre (6.2-mile)-thick glacial plug over the caldera of Katla, one of the country's largest and most active volcanoes. Katla is said to erupt every 20 to 90 years, but it hasn't had a big eruption – enough to crack the ice plug – for more than a century. When it does, the carbon emissions and the potential for ash pollutants to spread across Europe and beyond will have serious environmental concerns. The floodwater, said to equal the average annual discharge of the Amazon, Mississippi and Nile

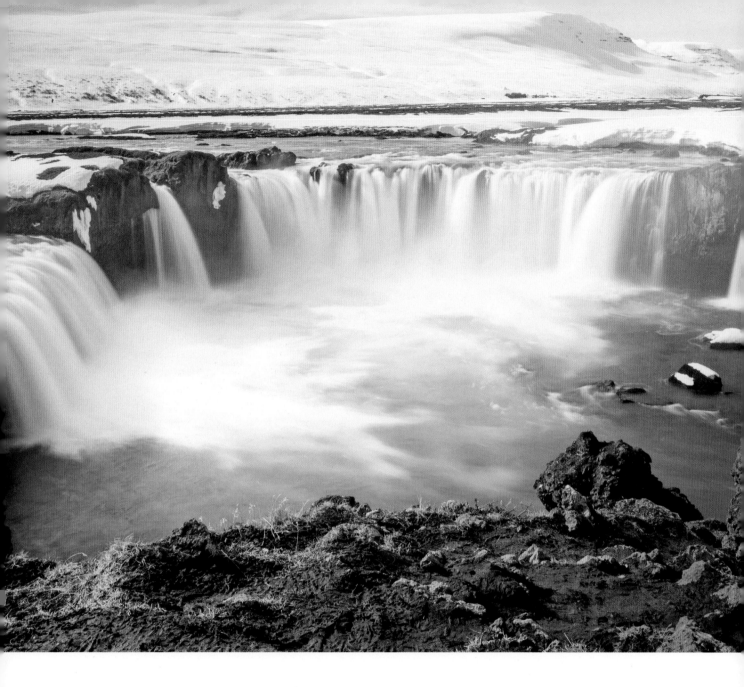

ABOVE Water from the river Skjálfandafljót feeds magnificent Godafoss waterfall in Iceland's north

rivers combined, is expected to wipe out the town of Vík í Mýrdal, 26 kilometres (16 miles) away. Residents (and guests), whose bags are already packed, will have 15 minutes to evacuate.

Living with such threats is the Icelander way of life. Travellers who come here – mere mortals – are thus kept on their toes in a land that refuses to be tamed.

A COLD-WALK, HOT-CREEK IMMERSION

The Icelandic landscape continually gives of itself like a beneficent god. Any old hiking trip reveals much: vast caldera landscapes, spurting geysers, and blue ponds with underwater crystals that look frozen but are bubbling hot and dangerously beautiful. Hikes through this precious scenery are perfect for precious one-foot-in-front-of-the-other alone time, walking meditations for zeroing in on wildflowers, circling terns, even following the track marks of a walker gone before. Being alone in the wilderness, one can indulge in the microscopic analysis of the beauty that lies everywhere.

When solo walks lead to Iceland's geothermal quirks, so much the better. My hour-long hike from the restaurant at the Reykjadalur trailhead up the Reykjadalur valley to a hot creek of the same name starts steep, but the higher it climbs the more the valley reveals its great plumes of steam rising like smoke funnels. Along the gravelly path, rivulets of hot water bubble from nowhere creating mini steam drifts. Miniature forests of tiny blooms and micro herbs scramble for a roothold on drifts of black crumbly earth that threaten to part way with the mountain face at any time.

At the top, the stream widens into a steaming creek that snakes through pastoral country. Shaggy sheep, released by farmers to the rich highlands for fattening over summer, line the path. Simple boardwalks, platforms and steps leading into the water indicate where you can immerse. Depressions in the creek bed, formed by little rock walls, make perfect places to sit so that the warm water swirls around your shoulders and makes islands of your knees.

There are 20, maybe 30, swimmers spread out along the creek when I'm there. Walkers and hikers who have stripped off parkas and jackets expose their swim-suited bodies to the cold air before dashing to the warm water. It's only 12°C (54°F) outside today, a summery day in Iceland, but the creek where I am sitting is about 34°C (93°F). Sinking into the water is a warm relief, like a hot tub on a cold day, and there's no match for the natural scenery. The dark, almost black, volcanic soils of the creek bank contrast with the verdant green of the wildflower-confettied grass that reaches up and over the surrounding hills. It comes in and out of focus between the wafts of mist rising from the eddies.

Not far upstream, the creek source streams boiling hot from a rock face, the mineral waters bubbling up from deep below the earth. The water gradually cools as it flows downstream, allowing visitors to choose their preferred temperature. On the creek's edges, slippery-smooth grey clay pans provide natural silica-rich face masks that visitors playfully apply like war paint. I prefer to let the gentle steam from the creek open my pores.

Flushed cheeks and red ears indicate it's time to swap warm water for cool air. Ghostly steam wafts from my arms as I climb the wooden stairs and head towards my little pile of clothes. Walking back through the valley I feel light-headed and buzzy, a natural high from being warmed and nurtured straight from mother nature.

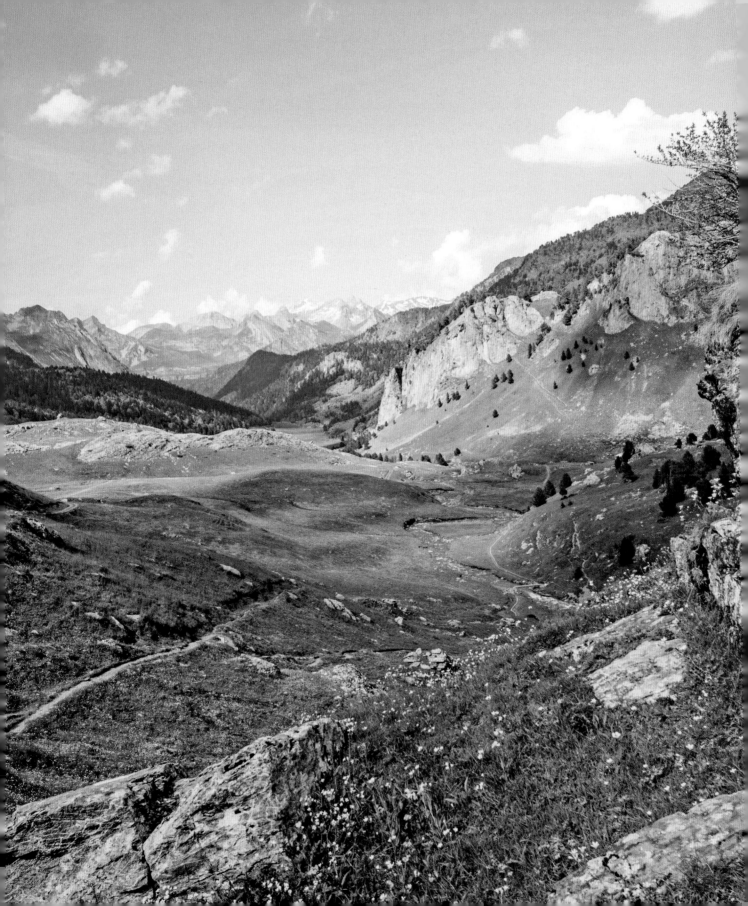

PYRÉNÉES

France, Spain & Andorra

A mountainous landscape of cirques, shepherd's huts and bears.

The Pyrénées mountain range is a wilderness that extends along the European border between Spain and France and through the small principality of Andorra. It is a peaked landscape that bridges the terrain between the Atlantic and the Mediterranean with summits kissing the clouds at heights up to 3400 metres (11,100 feet).

Millions of visitors come here to ski, cycle the vertiginous passes inspired by the Tour de France, horseride and trek some 135 trails, including those to the parks' remarkable cirques and waterfalls.

The mountain range separates the rest of Europe from the Iberian Peninsula, and France from Spain, both politically and geographically, but nature knows no boundaries. Straddling the dotted line between them is a nature-scape of rarified beauty, a UNESCO World Heritage Site of grey chiselled-granite mountain peaks and rock faces, river ravines, ridiculously high waterfalls and steep mountain passes. UNESCO rates it as having the highest degree of biodiversity conservation in Europe.

On the French side, this landscape is protected by Pyrénées National Park, established in 1967 and covering some 50,000 hectares (190 square miles). On the Spanish side is Ordesa and Mount Perdido National Park, which was established in 1918. It is one of the world's earliest national parks and a biosphere reserve covering about 156 square kilometres (60 square miles).

Together, the scenery is a veritable macrocosm of what can typically be found across the Pyrénées.

At centre-stage sits Mount Perdu (Mount Perdido in Spanish) the third tallest summit in the Pyrénées topping 3355 metres (11,000 feet). In its swishing granite skirts lie deep canyons on the Spanish side and giant cirques on the French.

Cirques are bowl-shaped landforms made during glaciation. They belittle anyone embraced in their intimidating geological hug. Gavarnie is the most impressive, a granite-walled, mostly snow-crested edifice striped with white cascading waterfalls including the spectacular Gavarnie Falls (Grande Cascade de Gavarnie in French), France's longest drop at 422 metres (1385 feet).

The top-heavy jagged rock landscape is softened at lower altitudes by rolling pine woodlands merging with fairytale gardens of downy oak, silver birch, yews and fir. Pastoral meadows are carpeted in lush grass and flowering plants, including violets, bellflowers and edelweiss. In spring, these wildflowers are often so profuse they look as though handfuls of petals have been scattered over the grass in preparation for a mountain-high wedding ceremony.

This breathtaking tract of wilderness, one of the last in France, is naturally home to the country's picture-book wildlife, some 70 different species of animals, including marmots, lynxes, red squirrels, foxes, cat-like genets, chamois (wild goats) and weasels. Pyrénéan desman, an endemic aquatic mole-like creature with webbed feet, and high-altitude-dwelling Pyrénéan *Euproctus*, an endemic salamander, make the chilled rivers and bubbling streams their home. Griffon vultures and peregrine falcons ride the alpine thermals alongside golden eagles, a fantastic predatory bird said to pick off prey bigger than themselves. Best of all, Pyrénéan brown bears have been somewhat repopulated here (*see* p. 78). They are a vote of confidence as the last remaining population in Europe.

When UNESCO declared this part of the Pyrénées a World Heritage Site in 1987, the agricultural heritage and culture were also credited. Pastoral traditions, where shepherds moved to huts in the highlands with their family flock for much of the year, is a practice once widespread in France but now only practised here (and to a much lesser degree).

The real wilderness is to be found beyond the villages in the highlands among the snow drifts and lofty mountain massifs where the shepherds, past and present, have dared to dwell. Up here, in the rarified clear mountain air, backcountry trails test the mettle of serious hikers, including those on the famed Pyrénéan Way, an epic 413-kilometre (257-mile) journey that takes between 30 and 55 days. Bivouacking (camping) trailside or bedding down in the tumbledown mountain refuges for the night is one of the thrills.

The sound of the Tramontane is another. This north wind blows from the Mediterranean and funnels along the icy mountain slopes as it passes between the Pyrénées and the Central Massif. It accelerates over the blue lakes and howls around the cirques and crags, whipping peaks and precipices before, no doubt, finding its way between the stones of those old shepherd's huts, whispering congratulations to the few among us who still brave these wilds.

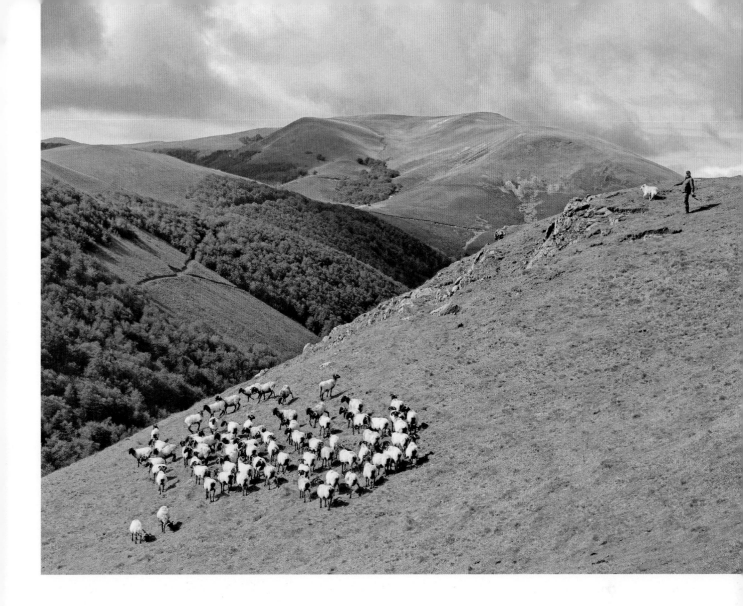

ABOVE The agricultural
heritage and pastoral
traditions of the Pyrénées
are still practiced today

THE RETURN OF
THE BROWN BEAR

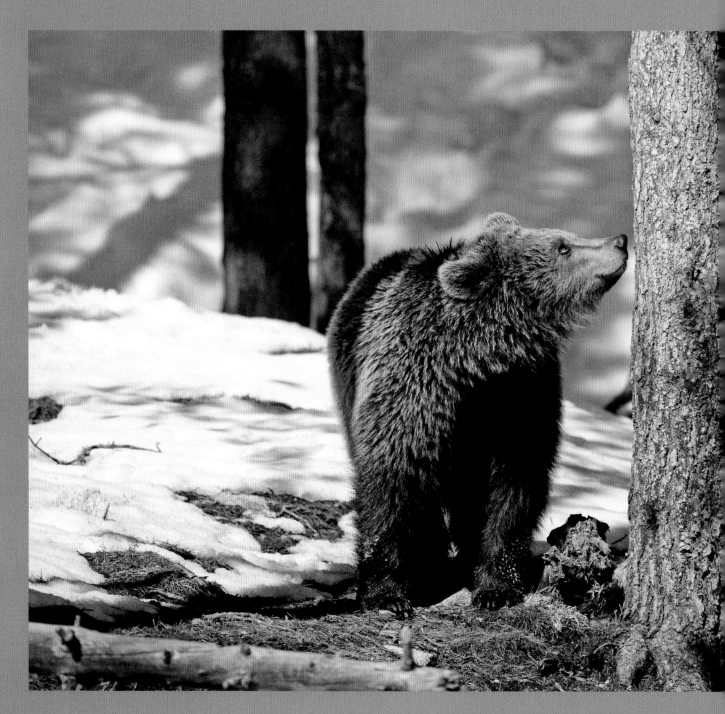

Brown bears (*Ursus arctos*) were thought to be extinct in the Pyrénées back in 1991, but today there are more roaming the woodlands, rocky gullies and meadows of this mountainous landscape than there have been for a century. At last count, in 2022, 70 individual bears had been identified, an increase from 52 in 2018, with the population spread over a 6500 square kilometre (2510 square mile) cross-border region of France and Spain.

In 1991, what was thought to be the last brown bear in the Pyrénées was killed, apparently eradicating them forever. Local farmers and shepherds, responsible for decreasing the population over decades in defence of their sheep and cattle, perhaps breathed a sigh of relief.

The growth in bear population is the result of a reintroduction program aimed at returning the bears to a habitat that has been native to the species for millennia. Indeed, *Ursus arctos* would have once been spread across much of Europe and Asia.

The reintroduction program began in 1995 when two female bears, selected from a population in Slovenia, were released. The following year, a male was introduced, and cubs soon followed.

The program has had mixed successes, especially in the initial stages with reports of bears attacking local flocks, 'difficult' bears generally misbehaving, even one bear killed 'in self-defense' when a hunter came between a mother and her cubs. Today the EU-backed LoupO project has been established to monitor brown bear and wolf populations across France, Spain and Andorra. The battle between the anti-bear groups and conservationists continues.

The Pays de l'Ours association, responsible for the reintroduction, reported the population increase of about 10 bears per year had been slow and steady with 114 newborns since the scheme was launched and a record number of 15 cubs born in 2021. The increasing problem of interbreeding and the number of male cubs born over the years (34 females, 32 males and four undetermined) meant the population was still fragile. A study has flagged 250 brown bears as a viable number in the Pyrénées.

For visitors to the Pyrénées, bears are nocturnal, regarded as shy and are not considered a threat to human beings. Their only predators in Europe, other than humans, are other bears (alpha bears kill cubs of other males during mating season). With only 70 brown bears thinly spread over such a large area, it's unlikely you'll see one. But keep your eyes peeled; they've rewilded and, praise be, they're miraculously out there somewhere.

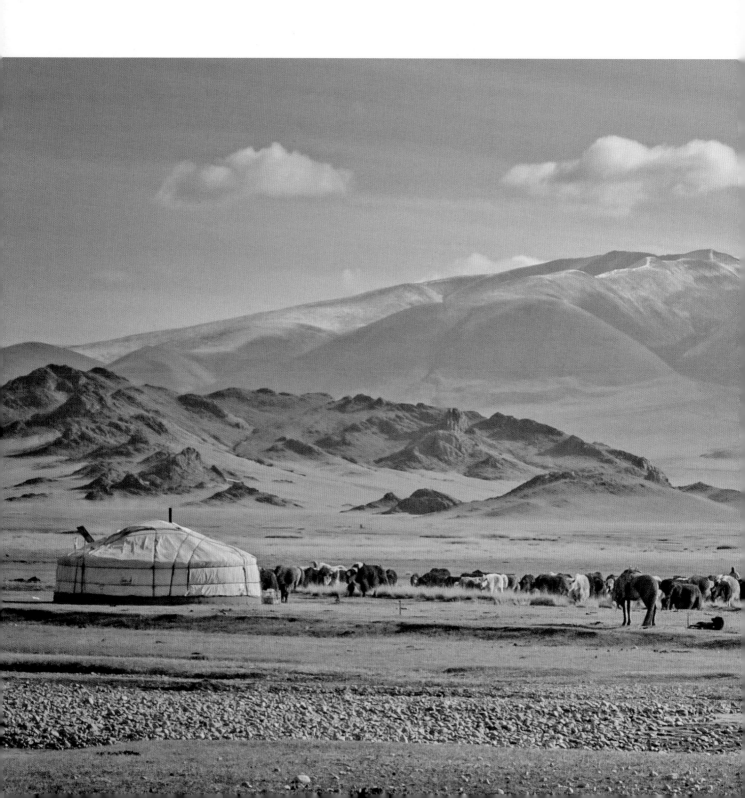

ASIA

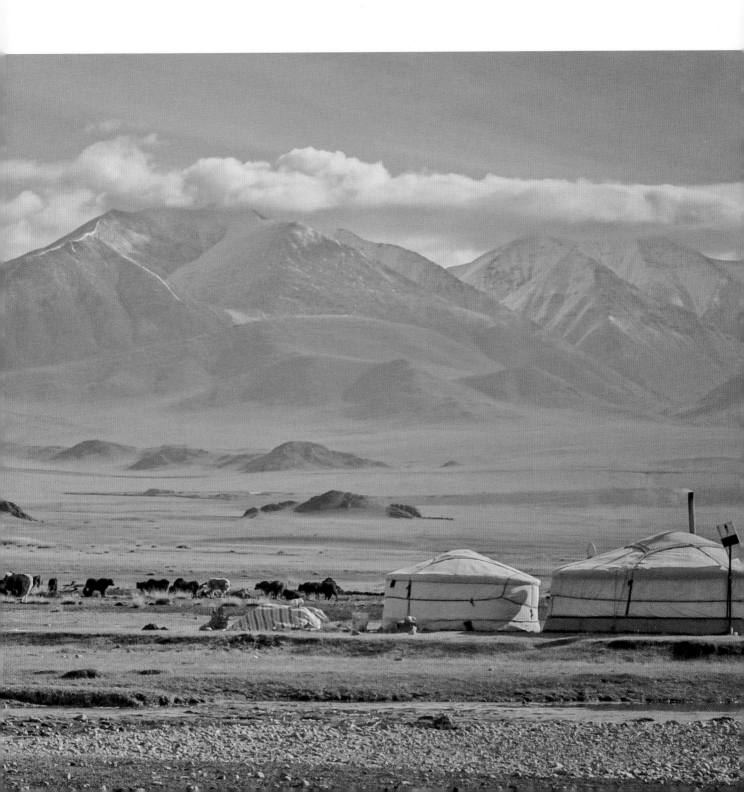

Asia is known as both a continent and a sub-region of the bigger Eurasian continent. For the purposes of exploring its wildernesses, it's the latter, a boundary formulated more by convention, historical nuances and cultural impressions rather than any geographical characteristics.

The extent of this territory is monumental, stretching vast distances from the west across to Russia, Kazakhstan, Mongolia and China, down through the other 'Stans' into Pakistan and India and across to South-East Asia.

There is phenomenal and profound beauty and diversity across this terrain, much of it remote and relatively uninhabited, some of it bearing the full weight of the world's largest populations. It has temperate and subarctic regions, peninsulas and archipelagos, deserts and oceans.

The wildernesses here cover varied habitats where biodiversity reigns. Travel from the grasslands of the Mongolian steppe and limestone karst forests of China to the mountainous Himalayan landscapes of Bhutan and rainforests of Indonesia's Sumatra. Dive deep into the paradisical West Papuan archipelago of Raja Ampat and explore ice drifts in Japan's northern Shiretoko National Park – both alluring marine wildernesses.

As with wildernesses the world over, there are conservation issues due to population growth, deforestation, climate change and other challenges. There is habitat loss and there are endangered species too, but it is not without hope as people and organisations with the planet front and foremost work to maintain and protect vast areas of wild beauty.

BHUTAN

A mountainous Himalayan kingdom covered in forest.

The Kingdom of Bhutan, as Bhutan is officially known, is a landlocked country in South-East Asia. It's also called Druk Yul, meaning the Land of the Thunder Dragon, a name that serves to further pique awe and wonderment among would-be travellers. Bhutan is blessed with heady far-off, castle-in-the-sky Himalayan views that cap off the country's own diversity of wildlife and vibrant ecosystems. The country, with just 750,000 people residing in its 38,000 square kilometres (14,700 square miles), has gained a reputation as a mythical place where happiness reigns (the government famously has a 'Gross National Happiness Index', *see* p. 88) and a rich Buddhist culture endures.

Catching sight of Everest jutting out of swirling white clouds into a brilliant blue sky says it all. Bhutan's varied and biodiverse terrain extends from the lofty heights (over 7000 metres or some 23,000 feet) of ice-capped mountains in the Eastern Himalayas of the north to the subtropical foothills in the southern region. Weaving through this peaked landscape are mountain highs, valley lows, rushing icy river systems and grassy lowlands where rice and other crops thrive.

Bhutan has the highest proportion of forest and woodland cover of all countries in Asia (70 per cent), and more than half of the ecology is protected by national parks, wildlife sanctuaries, nature reserves and biological corridors that connect different animal habitats. In this biodiverse hot spot, wildlife can be found, from golden langur primates (Bhutan's national animal) and the takin in the lowland jungle to snow leopards and Himalayan marmots living in higher alpine habitats.

That Bhutan still holds fast as a wilderness destination is due in no small part to its belated introduction to the modern world. Up until the 1950s there

OPPOSITE Bhutan's famed Punakha Dzong sits at the junction of the Mo and Pho Chhu rivers

were no public hospitals or schools. The country's first road was completed in 1962, only just predating electricity. Diplomatic relations weren't a thing until 1961 and the country didn't receive its first invited Westerner until 1974. Perhaps the biggest nod to progress came as late as June 1999, when Bhutan became the last nation in the world to turn on a TV.

Further evidence that Bhutan has been a strong believer in keeping the balance between local culture, tradition and nature and the outside world can be found in its 'sustainable development fee'. For the past 30 years, the country has been charging foreign tourists this fee for every day they spend in the country.

The upside to this slow release to modernity is coming to the fore now. Like many countries, Bhutan was closed during the Covid years but since it reopened in September 2022 the foreign tourist fee has been tripled. Tandi Dorji, Bhutan's foreign minister and chairman of the Tourism Council, said in a press release that the two years the country was closed offered the chance to reset in a way that will allow 'us to not only benefit Bhutan economically, but socially as well, while keeping carbon footprints low'.

Out of the country, the move has been seen by commentators as either a foreign money grab on one side, or a visionary concept that echoes the global movement toward relieving destinations of mass tourism. Either way, it could be key to Bhutan remaining the world's 'last Shangri-la' – another of its epithets.

For wilderness seekers, the diversity is just as good for hard-core hikes into the ice-capped peaks in the north as it is for the softer forays into the temple-dotted countryside and fertile rice-growing slopes of Western Bhutan.

Two spots are not to be missed.

In the scenic Paro Valley, dotted with traditional whitewashed timber houses and striped in rice terraces, Paro Taktsang or Tiger's Nest Monastery totally steals the show. It is one of Bhutan's most sacred Buddhist temple complexes, a red-and-gold temple that clings miraculously to a sheer cliff-face 900 metres (some 3000 feet) above the Paro Valley. The 5-kilometre (3-mile) trek to this almost mythical place above the clouds blends the spiritual world with the natural, those dramatic 5000-metre-high (16,000-foot) Himalayan peaks rewarding each mindful step.

Near the former capital of Punakha, the Dochu Pass, at 3050 metres (10,000 feet), features 108 little stupas, but the real eye-catcher is the view. From here, you can see Gangkhar Puensum, Bhutan's highest peak towering at 7570 metres (24,836 feet).

When I was there last, an American tourist who had climbed nearly every mountain we could see talked to me about Gangkhar Puensum: 'The summit is off-limits to climbers, so what you're looking at is the highest unclimbed mountain in the world'. Given the human capacity for conquering mountaintops, the view of this incredible place has stuck in my mind.

Such untouched terrain speaks wonders about Bhutan's undisputed reputation as the last remaining pristine Himalayan wilderness.

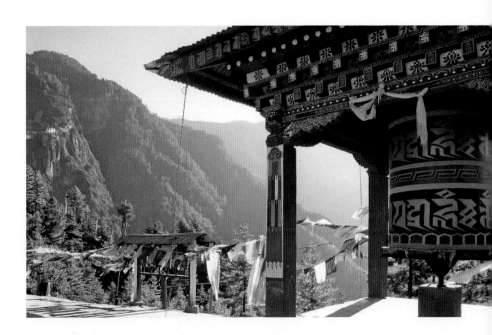

RIGHT Paro Taktsang, known as Tiger's Nest Monastery, has views across the Paro Valley.

BELOW Gangkhar Puensum, Bhutan's highest peak, can be seen from the Bhuddist stupas along the Dochu Pass

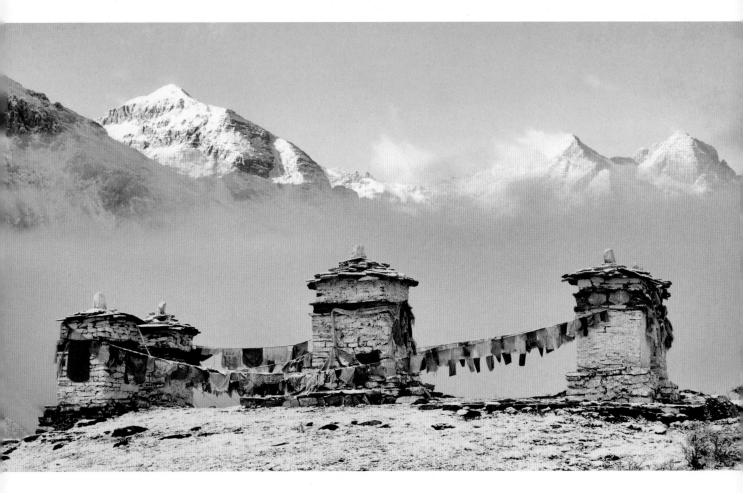

TRANS-BHUTAN TRAIL

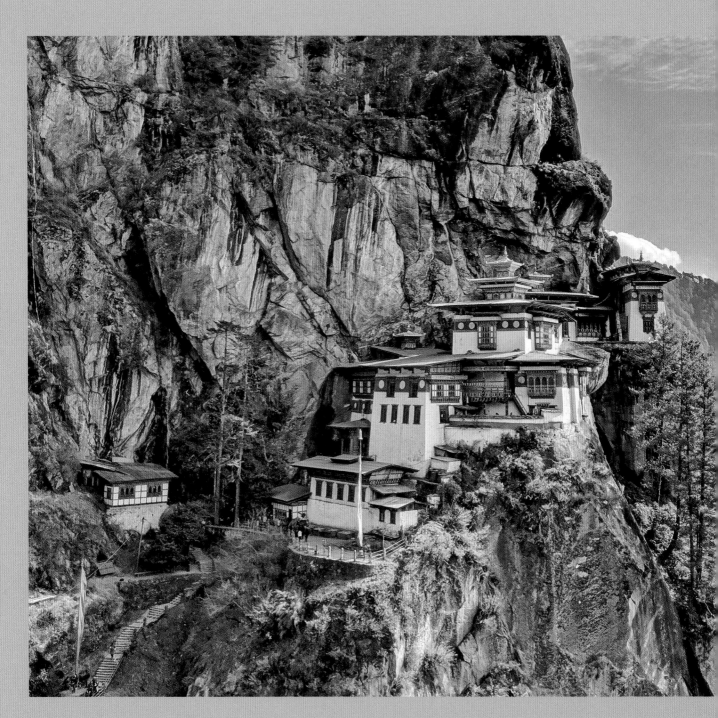

ASIA

BELOW Paro Taktsang or Tiger's Nest Monastery is one of the highlights on the Trans-Bhutan Trail

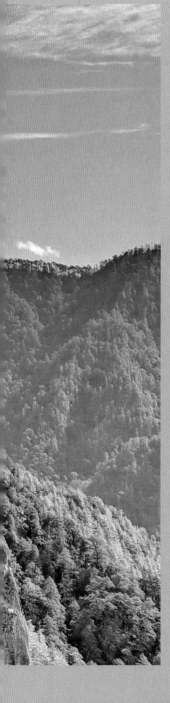

The enlightened fifth Bhutanese king, King Jigme Khesar Namgyel Wangchuck, known as the Dragon King, is renowned for his 'Gross National Happiness Index', which assesses the happiness of his people in four categories: tradition and culture, sustainable development, good governance and environment.

Given the brilliance of this concept, it's not surprising that the king and his wife, Queen Jetsun Pema, also had the vision to restore the ancient Trans-Bhutan Trail. This historic and sacred trade route, part of the storied Silk Road, dates to the 16th century when it served as the only means of east–west transport through the mountainous kingdom. It connected remote dzong (a fortified building housing a Buddhist school), served as a postal route for messages and mail, transported the royal family between fiefdoms and guided Buddhists on sacred pilgrimages to mountaintop monasteries.

By the 1960s, its importance was undermined with the construction of the national highway, and it gradually fell into disrepair.

Fast forward to March 2020, at about the time when the world was heading into the Covid-19 crisis and tourism was shut down. The non-profit Bhutan Canada Foundation, with the support of the Tourism Council of Bhutan and an army of volunteers, led the extensive two-year restoration project to clear and resurrect old paths, re-ford rivers and reconstruct river crossings. The Bhutanese would 'again walk in the footsteps of their ancestors', the king said at the time.

The Trans Bhutan Trail, stretching 400 kilometres (250 miles), opened in March 2022 for the first time in 60 years. From Haa in the west to Trashigang in the east, it traverses some of the world's best-preserved traditional cultures and ecologies.

Travellers on two feet (or two wheels in some parts) can book adventures, be they four-day getaways or 36-day (end-to-end) immersions following an adventurous path through some of the world's wildest terrain. In between high flag-strung mountain passes, rarely visited sacred sights and freezing river valley pit stops, you'll hear stories from local history, culture and customs as told by the Bhutanese people. The combination perfectly dove-tails with the king's devotion to the environment, sustainable development and his people.

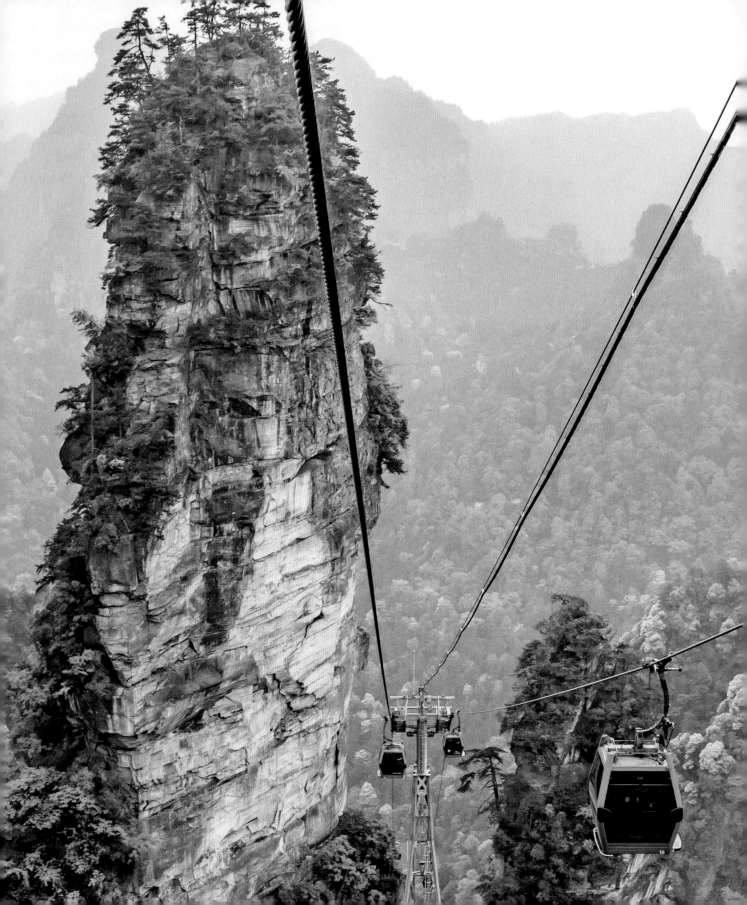

ZHANGJIAJIE NATIONAL FOREST PARK

Hunnan
China

Limestone karst forests on a cinematic scale.

'Oh my god ... You should see your faces ...'

In the movie *Avatar* (2009), this is the reaction from the chopper pilot to the crew's expressions on their initial flight through the floating Hallelujah Mountains on the legendary planet of Pandora. But it could also be the response to first encountering the colossal sandstone pillars of Zhangjiajie National Forest Park, in China's Hunan province, the destination that inspired this scene in the movie.

Whether *Avatar* is your cup of green tea or not, the James Cameron–directed animated extravaganza goes some way to evoking just how unimaginably other-worldly this wilderness area is. In the movie, the dreamlike floating mountains resemble islands in the sky, with waterfalls ending in thin air and beards of mossy vines creating bridges between landforms in flux.

In the real world, Zhangjiajie's quartzite sandstone towers, most more than 200 metres (660 feet) high, thrust and stab into the sky at jaunty angles. Their spillways, spires, caves and arches have been transformed over 30 million years by wind, ice, water and erosion to sculptures that appear, up close, to be fashioned from a milky-brown liquid that has solidified mid-trickle.

Spindly pine trees and stoic plants clutch the teetering, narrow summits and grapple for grip on tiered and jutting rock walls. Extreme precipices and overhangs fall away into the dense canopy of rich green foliage far below.

The visual magic of these karst formations can be found in other Asian destinations, including the karst systems of Guilin/Yangshou in southern China, and in Vietnam's Halong Bay where some 775 jungle-topped limestone islets and islands rise spectacularly from the surrounding ocean. Both are World Heritage Sites.

Through history the mystical landscape has become part of Chinese iconography, featuring in traditional Chinese landscape painting and other artforms. The mist and cloud cover often depicted drifting around the base of the pillars unintentionally renders them as similarly floating forms. For the Tujia People, a local ethnic minority group in the region, the scenery is the inspiration behind centuries of folklore and storytelling.

Zhangjiajie National Forest Park became China's first national park back in 1982 and is one of five specially designated nature reserves spread through Wulingyuan Scenic and Historic Interest Area, a UNESCO World Heritage Site covering 26,000 hectares (64,000 acres).

Wulingyuan's entire area has around 3100 sandstone pillars, a forest of formations that marches to the horizon. The tall broadleaf woodlands that provide groundcover – a product of the region's subtropical rains and mild temperatures – do little to disguise the height of these pillars peeking through the clouds. Seeing them from above at lookouts throughout Wulingyuan is completely captivating.

Cliff-high waterfalls and clear streams, some of them spanned by decorative arched bridges straight from those landscape paintings, provide counterpoints to the monoliths. Gorges and canyons with seemingly unreachable depths support vast ecologies home to endangered plant and animal species. According to UNESCO, threatened species including the Asiatic black bear and Chinese water deer live here, alongside South China tigers, macaques and clouded leopards.

There are plenty of viewpoints and scenic spots accessed by bridges and cable cars, often with evocative names, such as Golden Whip Stream and Five-Finger Peaks. The park's 40-something caves and two stunning natural stone bridges, including one in neighbouring Yuanjiajie Scenic Area that spans the air 357 metres (1171 feet) above the valley floor, are also a highlight. Some of these formations are on the hit-list of rock climbers globally.

In Zhangjiajie, hiking trails and quiet paths that weave through the park provide the best opportunity for truly appreciating its beauty. Unsurprisingly in a nation with a population nearing 1.5 billion, Zhangjiajie alone attracts upwards of 30 million tourists every year, a staggering stat that might give you pause before packing your bags. Unlike many national parks in China, Zhangjiajie has an entry fee with funds directed towards conservation, but the unsustainable level of tourism during pre-Covid-19 times resulted in overdevelopment of nearby towns such as Wulingyuan on the edge of Zhangjiajie.

There's no sign of the enthusiasm waning post-Covid-19. One of Zhangjiajie's pillars, in the clouds at 1080 metres (3544 feet) was, before 2010, variously referred to as the South Celestial Pillar, Qiankun Column, Southern Sky Column and the Pillar between Heaven and Earth, then renamed Avatar Hallelujah Mountain. For good or bad, that will surely link this natural wonder to Hollywood for life.

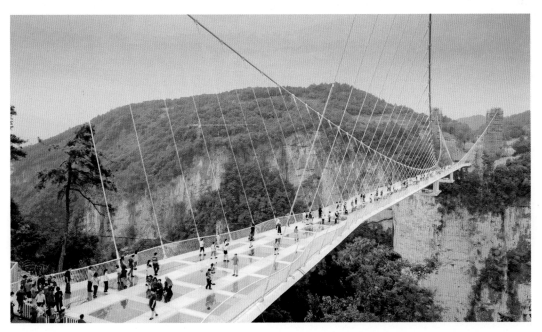

LEFT Visitors venture across the glass skywalk bridge in Zhangjiajie

SHIRETOKO NATIONAL PARK

Hokkaido
Japan

Remote ice drifts and brown bears at 'Land's End'.

Drifts of ice in the frigid blue waters off Hokkaido are like clouds smeared across a clear blue sky. The sea current swirls the chalky ice floes in big, speckled swaths of salty chunks creating an extraordinary dreamlike landscape where sea and sky meet on the horizon and become one.

It is a sight to behold.

Covering 387 square kilometres (150 square miles), Shiretoko National Park sits to the north of Shiretoko Peninsula, the northernmost point of Hokkaido, one of Japan's four main islands.

In the Indigenous Ainu language, Shiretoko means 'place where the earth protrudes' or more poetically 'Land's End', which helps conjure just how beautiful, remote and untouched it is. This dramatic, largely unspoiled volcanic place has myriad landscapes from craggy mountaintops to birch and spruce forests, floral alpine meadows, rocky rivers and thermal springs heated by lava bubbling deep within the Earth.

Aiding and abetting the incredible scenery is a healthy population of Ussuri brown bears, closely related to the North American grizzly, and considered a sacred totem to the Ainu People.

Conservation efforts have been key at Shiretoko National Park. Since 1977 the park has been protected from overdevelopment by various projects, including a reforestation scheme. The tourism concept for the park is grounded in respect for and adherence to nature. To keep the bears and habitats wild, it is the tourists (who visit in large numbers in summer and increasingly in winter to view the sea ice) who must be tamed.

The bears live here alongside 35 land mammal species (including the thriving sika deer) and 22 big-hitter marine mammal species, including orca,

OPPOSITE Shiretoko
Peninsula, a habitat of
the white-tailed eagle, is
famed for its drift ice

minke and sperm whales, Steller's sea lion, spotted seal and the endangered fin whale.

The national park is also a haven for 286 bird species. Snowy owls and red-crowned cranes inhabit the place, along with birds of prey such as white-tailed and Steller's sea eagles. Threatened species include Blakiston's fish owl, the world's largest owl species whose diet relies on the different salmonid species swimming upstream to spawn. At last count there were just 165 of them.

The park was World Heritage–listed by UNESCO in 2005, the listing noting the unique interaction between the marine and terrestrial ecosystems.

Shiretoko's Pacific Ocean boundaries, stretching along two sides, are heritage protected for 3 kilometres (1.8 miles) from shore sustaining healthy marine ecosystems. The eastern side, with magic views to Russian-administered Kunashiri Island, is the place to see pods of orcas and spot mother bears padding along the water's edge, their cubs in tow.

On the peninsula's western coastline, treacherously high cliff-faces are home to nesting birds that screech in the thermals, and to Frepe-no-taki Falls, a waterfall fed by groundwater rather than a river, so that it bubbles straight from the ground before plummeting from a great height.

Kamuiwakka Falls is another natural wonder. This thermal waterfall springing from the volcanic Io-zan mountain bubbles its sulphuric gaseous way through forests and rockpools to a granite cliff-top where it tumbles – still steaming – into the Sea of Okhotsk.

The unusual drifts of sea on this coastline are uniquely formed in lower latitudes of the Northern Hemisphere where sea temperatures are higher. The ice drifts are not only ethereally beautiful, but they also encourage spring blooms of crucial phytoplankton which support both land and sea food chains through salmon spawning. The variety of salmon species in Shiretoko reads, if you will excuse the analogy, like a sashimi menu: pink salmon, white spotted charr, masu salmon.

Much of the park's pristine state can be credited to the disquieting weather (Hokkaido is known for its long, deep, dark winters) and largely inaccessible geography.

At one of the main attractions – Shiretoko Goko Lakes – visitors explore from built elevated boardwalks or on footpaths with a guide at the helm. The unspoiled nature is spellbinding. Primeval forests, swamps and lakes with snow-topped mountains in the background present like a landscape painting.

With no roads accessing the northern tip of the park, bears are best spotted (and more safely seen) from cruise boats along the east coast. (Visitors can also snow-shoe, cycle and hike to access more untrodden paths.) The pay-off for being with dozens of snap-happy tourists is that bear sightings are mostly guaranteed. And there's nothing quite like seeing your first bear, in its own habitat, from a safe distance over the waves.

This kind of tourism – keeping the wildlife safe and the landscape intact – is a lesson in favouring wilderness over the tourist experience.

MONGOLIAN STEPPE

Mongolia & beyond

Asia's last great grassland wilderness.

Few landscapes are as ascribed to the character of an historic figure as Mongolia's grasslands are to Genghis Khan. It's thanks in part to the popular culture and legend surrounding the founding emperor of the Mongol Empire – who united the tribes of the Mongol steppe and led them to conquer and plunder Eurasia – that we have cinematic views of this wild and unkempt landscape lodged in our mind's eye.

You can almost hear the jangling of horsemen cantering across this wide, treeless plain, the grass and dirt a blur behind. You can almost see the lonesome scattering of nomadic ger tents, the hessian gussets blowing in frigid winds coming off ice-capped mountains.

These horsemen-herder traditions live on today on the magnificent Mongolian Steppe, an intact grassland and savannah that stretches its sumptuous natural-world canvas over 887,300 square kilometres (342,600 square miles). To the east it sidles up to the border with north-west China and Russian Siberia. On its western side, it hugs the north and south regions of the Gobi Desert. It covers more than half of the country.

In a 2014 UNESCO World Heritage Site submission, the Eastern Mongolian Steppe was described as the largest, most intact temperate grassland ecosystem on the planet. At the time of research, it remains on the World Heritage tentative list. The entire Mongolian Steppe is certainly one of Asia's last great grassland wildernesses, a vast rolling green that is centre stage for epic 360-degree scenery, from rocky arid deserts and fragrant conifer forests to brooding snow-capped hills, as intimidating as they are remote.

In this raw and exposed environment, 20,000 or so nomadic herder families live and work the landscape in much the same tradition as their ancestors. In an

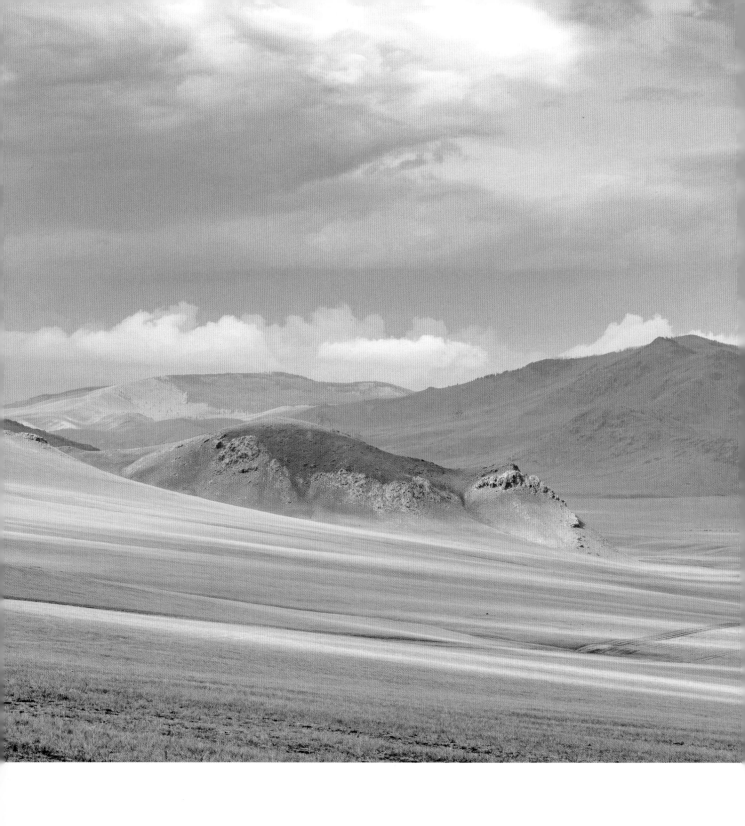

age-old cycle, they move with their sheep, horses and goats between lowland and highland pastures at the mercy of seasonal wet and dry patterns, high-altitude climates and the fragile steppe landscape.

They share their land with wolves and migratory herds of Mongolian gazelle, an endemic antelope that gathers here in its hundreds, sometimes thousands.

The region's most protected area, the Daurian Steppe region, has made it onto the UNESCO World Heritage List. This collection of designated nature reserves and biospheres occupies a swath of the eastern Mongolia Steppe that extends into Russian and Chinese territories, following the Ulz and Onon rivers on a cross-border collaboration covering 910,000 hectares (2,250,000 acres).

UNESCO hails it as illustrative of an almost untouched steppe. The ecosystem is complex and intriguing, drying out and then replenishing on a 30-year cycle. These alternating wet and drought periods have led to an eco-region with distinct habitats that support an important array of plants and animals.

On the lower slopes of the Khentii Mountain Range, threatened Mongolian marmots (known as tarbagan), which look a little like chipmunks, along with rabbit-like Daurian pika and Daurian hedgehog are endemic. Eurasian badgers, gray wolves and the comical-looking wild Pallas's cat are some of the creatures that inhabit the grasslands and forests thick with Siberian larch, birch and pine trees.

In the shallows of fresh and saline lakes and wetlands, millions of birds find a haven at the crossroads of two global migration routes. Vulnerable great bustards, swan geese and saker falcons live here along with six species of majestic cranes, including the demoiselle crane and white-maned crane, a flagship species.

On the greater Mongolian steppe, other grassland creatures have not survived so successfully among the livestock and human nomadism. Przewalski's gazelle no longer roam free here and while you'll see caravans of Bactrian camels carrying tourist luggage, they're no longer wild. Saiga antelopes and several species of birds are critically endangered.

The steppe's global warming rate is one of the world's highest. It threatens to dry up water sources, already stressed due to overgrazing. In tandem these two factors amount to a sharp decrease in grazing land.

Another challenge for this wilderness environment is the diminishing link between humans and nature. As a new generation of kids grows up in more urban environments, they become less familiar with the nomadic way of life and the pastoral system, both the knowledge and the lived experience.

While the Dauria Steppe is known as a birding destination, the Mongolian Steppe generally, particularly to the west out of Ulaanbaatar, is a playground for horseback adventures that trace the nomadic experience. Visitors journey through a vast wilderness and stay in traditional yurts under star-dazzled skies.

Travelling here is a window into an ancient way of life where wilderness and humanity still coexist.

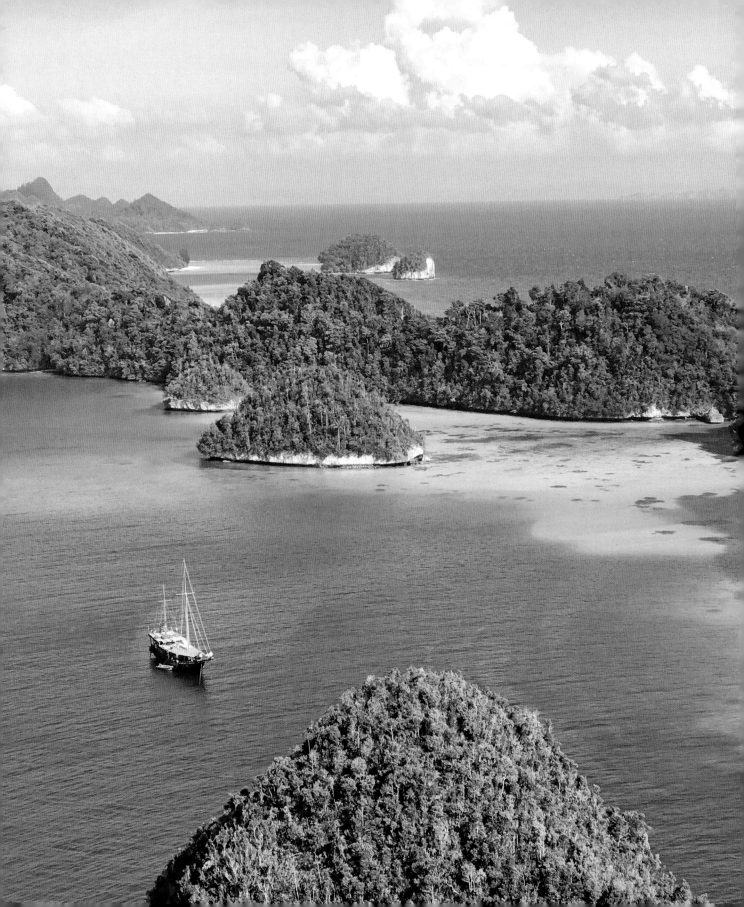

RAJA AMPAT

West Papua
Indonesia

An iconic, paradisical archipelago and the world's most remote and biodiverse marine park.

As far as tropical paradises go, Raja Ampat, in Indonesia's far-flung West Papua, is up there for tourism brochure superlatives: breathtaking marine life, picture-postcard scenery and awe-inspiring, nature-based adventures.

Picture if you will a dreamy archipelago, one that stretches 70,000 square kilometres (27,000 square miles), its turquoise-tinged waters scattered with some 1500 islands from jungle-topped volcanic rock outcrops and coral-fringed cays to sandy white knolls where idyllic beaches are striped by the shade of coconut trees. It's the stuff of magazine covers, movies and wild imaginations.

Sink below the water and the marine biodiversity is as equally incredible as the paradisiacal landscape. Raja Ampat is part of the greater Bird's Head Peninsula, which sits atop a convergence of very active tectonic plates. According to Burt Jones and Maurine Shimlock, in their well-thumbed book *Diving Indonesia's Bird's Head Landscape*, the Bird's Head is in the tectonic sweet spot where significant oceanic currents traverse the volcanic region.

This 'species factory' partially seeds the entire Coral Triangle, an immense equatorial Pacific current system that includes Borneo, the Philippines, Indonesia and the Solomon Islands. These surging tropical currents and dynamic volcanic zones have spurned unprecedented habitat growth, which in turn supports myriad sea creatures, including some 1700 species of reef fish, 700 species of mollusc and 600 species of hard coral.

Raja Ampat has had some big conservation wins. The Raja Ampat Marine Conservation Area was designated a marine park in 2009, and the following year, the whole region was declared a manta ray sanctuary, a move that

garnered global attention. In 2014, Raja Ampat became Indonesia's first shark sanctuary, one of the few on the planet.

Despite the continuing decline of manta ray populations globally, Conservation International reports that in Raja Ampat, a decade after the sanctuary was named, reef manta ray are now thriving in local waters. This sanctuary has since won, in 2022, Conservation International's gold-level Blue Park Award for exceptional marine wildlife conservation effectiveness.

In open waters that run deep, manta ray 'cleaning stations' are home to both reef mantas and bigger ocean mantas whose tip-to-tip wingspans are as big as king-bed sheets. Often, they will be there in their dozens, circling gracefully above scuba divers hovering along the sandy ocean floor.

Raja Ampat translates as Four Kings in the Indonesian language, which refers to the archipelago's four main islands of Misool, Salawati, Bantata and Waigeo. The population of around 65,000 people live in the capital of Waisai, in small towns on the main island and in villages on the archipelago's many tropical islands.

Visitors are drawn to the region for land-based activities including pre-dawn treks through dense rainforests to hear the mating call of Papua's exquisite birds-of-paradise. Zodiac and kayak tours take travellers meandering up turquoise inlets and freshwater rivers to see alluring spectacles such as Waigeo Island's Blue River, a diaphanous clear blue stretch of water weaving through the jungle vegetation. Water-based activities – scuba diving, free diving, snorkelling and kayaking – are the drawcards mostly facilitated by the archipelago's island resorts and eco-lodges.

The phenomenal underwater wonderland is abundant both in the remote regions and the more populated places. Swarming around the pylons of the wooden village jetties is an astounding number of fish. Huge clouds of giant trevally swirl in mesmerising synchronicity, smaller gatherings of clownfish and spadefish explore the coral, and big-mouthed sweetlips bob around looking for something to do.

Release a little more air from the regulator and the ocean floor reveals flat-bodied wobbegong sharks camouflaged in the mottled sand until they shimmer away. The purple curvy lips of sedentary giant clams are ready to close on any unsuspecting scuba diver appendage.

Black-tipped reef sharks enjoy the rich pickings around jetty piers and shallow waters too. They resemble great white sharks, but they're harmless, small, cute even, with amber-and-black marble patterns adorning their dorsal fins.

Big old turtles, like grandfathers of the sea, appear as quickly as they disappear, tricking the underwater eye as they are swallowed up by deeper opaque waters. Stingrays, endangered dugongs, dolphins and whales patrol these waters too.

Conservation International reports that Raja Ampat is an ocean 'bright spot', given it is, thus far, naturally resistant to coral bleaching and disease. But

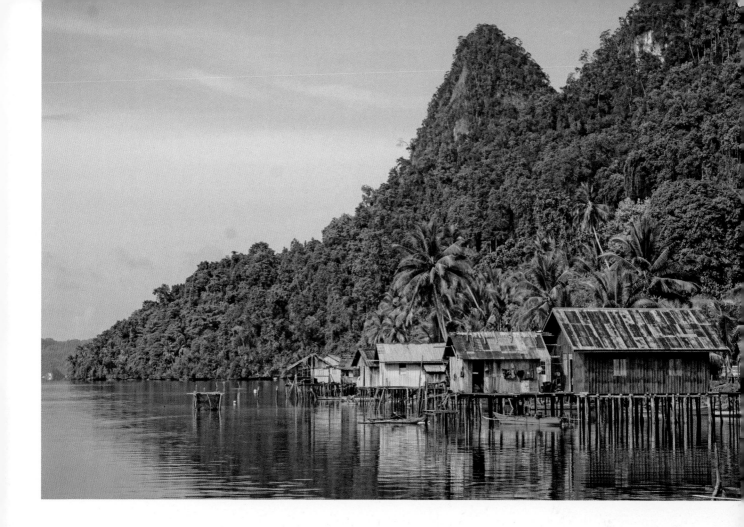

ABOVE Wawiyai is a village on Waigeo Island, one of Raja Ampat's four main islands

that other major global coral reef challenge, the crown-of-thorns starfish, is a continuing threat to the ecosystem. Based on my firsthand experience, ocean plastic is a major issue here too (*see* p. 106).

Visitors can explore the region onboard Indonesia's beautiful, traditional phinisi sailboats, still built by hand from ironwood on the Indonesian island of Sulawesi. Cruising the waters on one of these live-aboard vessels allows adventuring further afield to places like remote Blue Lagoon (*see* p. 106), where clear azure waters and luminescent sand beaches rim dramatic volcanic rock islands.

In these far-away regions, largely absent of humans, the wilderness is everywhere. Flying fish and dolphins leap alongside the boat, mangroves sink their roots into coral colonies, dugongs spout water as the morning sun hits the surface of the water.

It's a treasure of a destination both above and below the water.

BLUE LAGOON BEACH, RAJA AMPAT

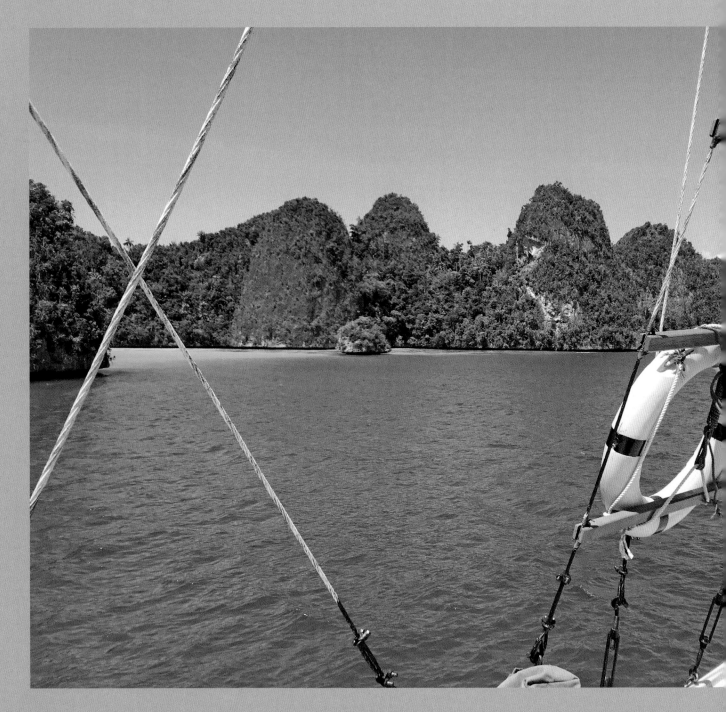

We paddle hard over white-tipped waves battling a current that wants to push and pull us elsewhere. Left, right, left, right, right, arms sore. Beyond lie calmer waters and the hint of a beach, a thin strip of sand bookended by jungle. Left, left, left, right, left.

Finally we get there, passing the tip of the island and drifting in the calmer water with the speed of our effort. Dark blue water gradually fades with the shallower water, becoming turquoise, then light blue, then sparkling and translucent, the water so clear we can see fish darting around against the white sandy bottom.

We jump out and pull the kayak from neck-high water to mid-riff to knee-high and finally to shore, on a beach with sand as white and as fine as sea salt. An Alex Garland beach. It is shaded by huge tropical trees, whose fruit and flowers we don't recognise, but whose branches provide a line to hang our wet sarongs.

Protected at each end by thinly greened rocky outcrops, the narrow strip of sand reaches 40 or 50 metres (130–165 feet). Backing it is a jungle of tall trees thick with vines so that the blueness above can only be seen in puzzle parts. Fallen leaves and branches make little ecosystems for ants, bugs and crabs. Shells dazzle with their peachy-coloured smoothness. We lie on the wet sand, the waves knocking against the moored kayak in gentle companionship, the sun on our faces.

But in Indonesia, plastic is everywhere. It is even here in the pristine beauty of Raja Ampat in the form of floating islands of water bottles, polystyrene chunks, ripped flip-flops. Sometimes it cuts the engine on our speed boat. And here too on our newfound beach, humanity's ubiquitous detritus has found a home lodged in branches and half-buried in sand.

We heave ourselves off the sand and start to emu-bob through the greenery, picking up single-use water cups, busted cigarette lighters and fishing line. At one end of the beach, we pull tattered plastic from the sharp rocky walls and pick up hundreds of bits of white polystyrene, the environmental havoc of just one ice box dashed against rocks.

When the bigger pieces have been collected, we become like bower birds zoning in on dark blue bottle lids buried in the sand, the faded pink of hard plastic splintered into myriad shards, indiscriminate processed coloured plastic that draws our eyes, like it does of the turtles and other marine animals who ingest it.

We find a beautiful smooth shell, a conch, and bury it so that the next landing of tourists fortunate enough to find our pristine beach will not take it home. As we push the boat off, we leave it perfect, pristine even, a wilderness returned.

TROPICAL HERITAGE RAINFOREST OF SUMATRA

Sumatra
Indonesia

Home to elephants, tigers, rhinos and orangutans, coexisting in three unique national parks.

If rainforests are Planet Earth's oldest living ecosystems, then the Tropical Heritage Rainforest of Sumatra is the heartbeat of an ancient world.

This landscape, covering 2.5 million hectares (6,180,000 acres), is comprised of three national parks. Though not connected, they each occupy terrain along the backbone that is Sumatra's Bukit Barisan mountain range, or the 'Andes of Sumatra'. From the highest points in each of these landscapes, the land stretches out like a long-lost magical kingdom, such is its exceptional beauty.

Mountain peaks jut into enormous cloud-streaked skies and are reflected in high-altitude glacial lakes. Fumaroles, from volcano calderas that still grumble underground, waft through the air adding an enchanting dreamlike quality. Rivers and waterways cascade over waterfalls through subalpine forests and blue montane woodlands to lower-lying mist-drenched tropical green rainforests, eventually flowing into the azure-fringed Indian Ocean. From mountaintop to ocean waves, these landscapes are something to behold.

Sumatra, lying directly on the equator, is the sixth largest island in the world. It is home to many ethnic groups, including the Javanese, Krui, Pelalawan, Petalangan, Batak and Minangkabau Peoples.

Its Tropical Heritage Rainforest was UNESCO World Heritage Listed in 2004 on account of its intact tracts of exquisite rainforest and unmatched biomass of species. Importantly, this is the only place in the world where elephants, tigers, rhinos and orangutans coexist. That each of these species is endemic is a true wildlife wonder. That each of them is critically endangered emphasises what UNESCO knew when inscribing it – that the survival of Sumatra's entire biota comes down to this place.

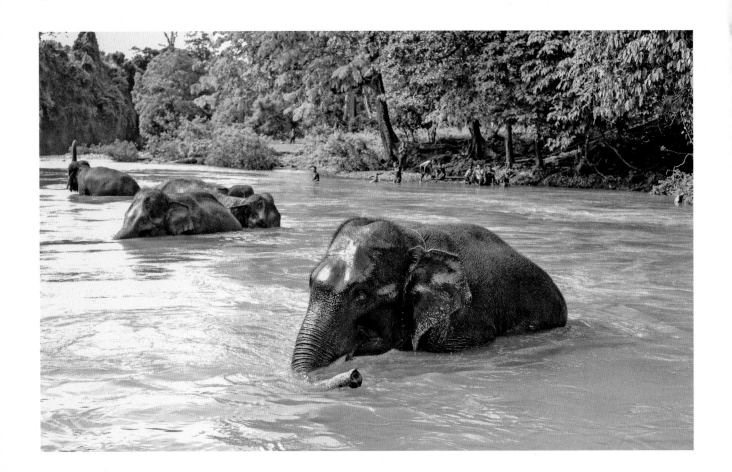

ABOVE Endangered Sumatran elephants are one of the park's key species

OPPOSITE In the north of Sumatra, near the tourist hub of Bukit Lawang, Gunung Leuser National Park is the largest wilderness area in South-East Asia.

There are three national parks here that have unique biodiversity and habitats. Combine them and it tells a rare tale of natural-world riches.

In the north lies Gunung Leuser National Park, and at 8629 square kilometres (3331 square miles), it is the largest wilderness area in South-East Asia with a steep, high-altitude mountainous landscape. A large area forms part of the bigger Leuser Ecosystem, known for its volcanoes, river systems and expanse of rainforest.

Kerinci Seblat National Park, in the central part of the island, covers 13,753 square kilometres (5310 square miles). Its loftiest point, Mount Kerinci, at 3805 metres (12,483 feet), is the highest volcano in Indonesia. Kerinci has the highest population of the elusive and endangered Sumatran tigers, putting it on the map as a centre for tiger conservation.

In the south, Bukit Barisan Selatan National Park, covering 3568 square kilometres (1378 square miles), is known for its dreamy Lake Gunung Tujuh, the highest lake in South-East Asia, and it also boasts 90 kilometres (56 miles) of Indian Ocean coastline.

Between the three national parks, some 200 mammal species live here alongside 580 bird species, many of them endemic. The key species are something to marvel at: the Sumatran orangutan, Sumatran tiger (the most endangered subspecies of tigers, with a wild population of about 400), Sumatran elephant and Sumatran rhino (only 300 remaining in the wild).

The Tropical Heritage Rainforest area is not short on magical-sounding species either, like Malayan sun bears and Sumatran clouded leopards, as well as proboscis and pigtailed monkeys and Asian tapirs. All have habitats here alongside flying foxes, Sumatran ground cuckoos, beautiful and critically endangered Rück's blue-flycatchers and white-winged wood ducks (their heads are whiter than their wings).

The plant world is similarly enviable. Of some 10,000 plant species, the most infamous is the *Rafflesia arnoldii* or corpse flower. Like something from a sci-fi novel, this rare plant grows the world's largest flower, a muddy-red five-petal bloom said to, incongruously given its elegance, smell like rotting flesh. Intriguingly, it only blossoms for a few days each year.

The dynamism and value of the Tropical Heritage Rainforest of Sumatra is somewhat overshadowed by the fact that its national parks are remnants of forests that once blanketed the entire island of Sumatra. They are now merely 'islands' of conservation in a sea of land mercilessly stripped bare by pulp and paper industries for logging, and global agribusiness for palm oil and coffee plantations. If you never drink Sumatran-grown coffee again, or eat chocolate made from palm oil, you'd be doing the planet a favour. Sadder still is that this destruction has taken place during the past 40 to 50 years.

The scars of this land are often recorded by heartbroken scribes. A 2013 article in the British *Observer* by John Vidal is particularly vivid. It describes: 'an industrial landscape of palm and acacia trees stretching 30 miles in every direction. A haze of blue smoke from newly cleared land (drifting) eastward

over giant plantations. Long drainage canals dug through equatorial swamps … excavators loading trees on to barges to take to pulp mills.'

Sadly, progress has been minimal since Vidal wrote the article. Alongside logging, agricultural encroachment – the slow and steady reclamation of small tracts of rainforest – and poaching of tiger skins, rhino horns and live orangutans are also tangible issues and challenges.

In 2020, the International Union for Conservation of Nature assessed the Tropical Heritage Rainforest of Sumatra's conservation outlook as critical, reporting: 'that environmental crimes within the World Heritage Site, such as poaching, illegal logging and encroachment, continue at very high levels and may even be increasing'.

Hope relies largely on the heft of governments and conservation groups to progress education at a grassroots level, and raise awareness about the plight of this wilderness on a global scale. Travellers, too, can raise awareness.

For the eco-travellers and responsible tourists among us, this is a trip of a lifetime. Bukit Lawang, accessible via Sumatra's largest city Medan, is a village on the edge of Gunung Leuser National Park. It is known as a conservation and eco-tourism hub (though visitors are strongly encouraged to research authentic operators before booking tours and accommodation) and a jumping-off point for orangutan treks, volcano climbs and waterfall chasing.

With limited tourism infrastructure, this is a destination for more adventurous travellers, those who don't mind – nay, those who love – rough roads, less travelled. If you're a camper, prepare for one of the wildest wilderness sleep-outs of your life, orangutans and all.

AUSTRALIA & OCEANIA

Many years ago, when I moved home to Australia after an absence of 10 years, I vowed to explore my own country, to adventure out into the far reaches of the huge island continent that had, until then, played second fiddle to the great many wonders I'd seen in the rest of the world. If I had known what I was missing, I might not have left the country in the first place. That said, Aotearoa New Zealand is so proximate to Australia, relatively speaking, that forays across the pond were inevitable.

Australia is the Earth's smallest continent, but it is breathtakingly big on wilderness. From its central red desert landscapes brimming with extraordinary native wildlife to its ancient rainforests and shimmery blue reefs, it has a diversity of flora, fauna and habitat that is unmatched. Australia is also home to the oldest continuous living culture on Earth – that of First Peoples dating back at least 65,000 years.

The Australian wildernesses I have chosen for this book come from all corners of this great land, stretching from the Kimberley coastline in the west and the Great Barrier Reef in the tropical far north right down through the Central Red Desert to the wilderness of south-west Tasmania/*lutruwita*. From the exceptional number of wilderness destinations in Aotearoa New Zealand, Fiordland National Park on the South Island, stands out for its mountainous peaks, deep tannin waters and unique wildlife.

Some of these destinations require dedicated travel, such is their remoteness; some have wild landscapes and dangerous creatures; all are worthy of your time, energy and resources. You might not be able to see them all in one lifetime but visiting one, maybe two, mindfully, and with sustainability in mind, is the new zeitgeist.

OPPOSITE Licuala fan palms make up the canopy in Daintree National Park

ULURU–KATA TJUTA NATIONAL PARK & BEYOND

Northern Territory
Australia

Red dirt desert with iconic Uluru at its heart.

Some tourist attractions are so iconic, so enigmatic, so inspiring on a human or natural-world scale that the sense of awe and wonder they inspire remains intact no matter how many selfies or hashtags or online images we've seen of it.

Uluru–Kata Tjuta, in the Northern Territory's Red Centre, is a destination that gives rise to this heady mind–body effect. I have visited Uluru three times and it never loses its surreal magic, not when the plane tips its wing to acknowledge its beauty as you fly over on arrival, not from the busy campground crammed with travellers, not when its monolith proportions take over the viewpoint of your camera wherever you're standing within a 20-kilometre (12-mile) radius.

Its Traditional Owners and Custodians are the Yankunytjatjara and Pitjantjatjara People, known as the Anangu People. Looming large on a flat landscape with a horizon line that disappears into a shimmery distance, this red mass is a very spiritual and reverential place because of this connection.

Its presence, 348 metres (1142 feet) high and some 550 million years old, is like that of a learned and wise being or mentor who has been around long before time, and will exist beyond it, beyond us. Indeed for Traditional Owners it is a place of Tjukurpa, where Traditional law, stories and spirituality are expressed in many forms.

Find Uluru on a map, and your finger lands almost directly in the centre of the massive Australian continent – Central Australia's Red Centre – a fitting locale for an adored landmark that holds a place in the heart of the Australian people. In October 1985, the Hawke government momentously returned Uluru–Kata Tjuta National Park to the Anangu People after decades of lobbying by Traditional Owners. It would be another 34 years of the same before Uluru was permanently closed to climbers, a practice not permitted under Tjukurpa law.

AUSTRALIA & OCEANIA

A referendum to adopt the Uluru Statement from the Heart, a document which enshrines a First Nations' voice in the Constitution, is expected to be held in 2023, which, if successful, will serve as an important mechanism in Australia's healing and truth-telling journey.

This extraordinary landscape exists within the Great Australian Desert, which stretches to all corners of the continent – north-west to the Kimberley, north to Kakadu, south to South Australia's Spencer Gulf and the far-west reaches of New South Wales. The desert is so big, it is credited as being one of the largest remaining intact natural places in the world – a true wilderness. It is as important to the survival of Planet Earth as the tropical jungle of the Amazon and the tundra of North America.

While the entire Great Australian Desert shares arid, remote and sparsely populated qualities, its sheer size is naturally given over to varied climatic regions, geography and landscapes. The Red Centre is one of its most alluring places. Its arid red desert plains and maroon-toned rocky canyons are no trick of the eye, no cheeky camera filter.

Native grasses, wildflowers and spinifex, adapted to the desert aridity, clutch at the dry earth, their washed-out tones like watercolour paints. Spindly ghost gums, bottle brush, desert oaks and tea tree – quintessential Australian flora

BELOW Ellery Creek Big Hole in the Western MacDonnell Ranges

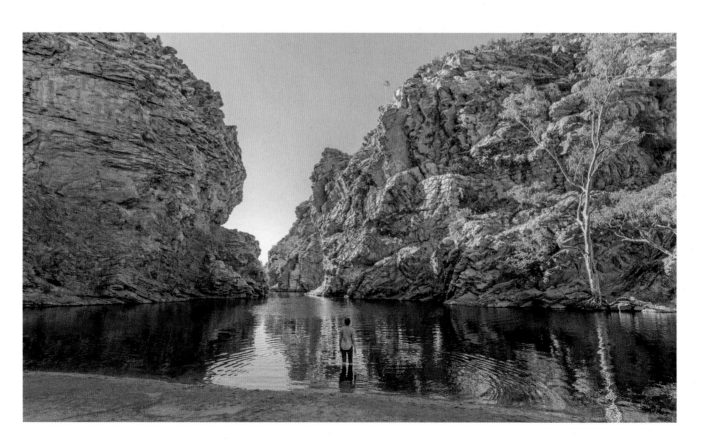

– provide dappled shade for big red kangaroos and emus. Their roots provide habitats for snakes and lizards, and nocturnal mammals including the bilby and echidna. Noisy great flocks of white cockatoos pit-stop between waterholes.

The small township of Petermann on the edge of UNESCO World Heritage-listed Uluṟu–Kata Tjuṯa National Park is a solid base from which to explore the landscape, whether on the back of a camel or with an Aṉangu guide on a native food–foraging experience or similar. A sunrise walk around the 10-kilometre (6.2-mile) base of Uluṟu, when the rock walls are rendered pink, purple and orange in the morning light, is almost as exceptional as a hike through the Valley of the Winds at nearby Kata Tjuṯa, another sacred site where great domes of red rock balloon from the flat landscape.

Venturing a little further into this astounding environment is essential to really get a sense of the wildness and magnitude of the place. The 1135-kilometre (705-mile) roadtrip along the Red Centre Way from Uluṟu to the town of Alice Springs/Mparntwe, with inroads along the way to Tjoritja/West MacDonnell National Park and Watarrka National Park/Kings Canyon, delivers on this promise especially for travellers willing to camp or stay at basic Outback resorts along the route. Four-wheel-drivers can add an adventurous detour by taking the rough Mereenie Loop (797 kilometres/495 miles in total) road past Gosse Bluff, an extraordinary crater made by a meteorite.

At Watarrka National Park, the Traditional Land of the Luritja People, Kings Canyon, covering a massive 710 square kilometres (274 square miles), has soaring sandstone walls and rugged boulder-topped peaks that drop away into a creek-bed oasis shaded by evergreen eucalypts. It's a heavenly place to lose yourself, especially on walks including easy Kathleen Springs Walk or the more difficult Kings Canyon Rim Walk, a 6-kilometre (3.7-mile) loop past rock domes and down through the creek bed.

Tjoritja/West MacDonnell National Park, the Traditional Land of the Western Arrernte People, has chasms of rock and steep gorges concealing walking trails, freshwater creeks and swimming holes that offer reprieve from the desert heat. The Finke River waterhole is one of the most spectacular. The national park is also home to the tough multi-day 223-kilometre (139-mile) Larapinta Trail. Chances are you will be the only one on it, just you and the call of the wild.

Finke Gorge National Park protects the Finke River, one of the oldest rivers in the world. It feeds the resplendent Palm Valley, a garden oasis against the rocky red canyons that has to be seen to be believed.

Hermannsburg, an historic precinct that harks back to missionary days, is another worthy stop. It is well-known as the birthplace of famous artist Albert Namatjira who founded the Hermannsburg School of art.

Wherever you travel to in the Red Centre, the desert soils are truly aflame, so rich red in iron that the rust colour remains on your windscreen long after you've driven away, and in the palm of your hand long after you've let the ancient soil pour through your fingers.

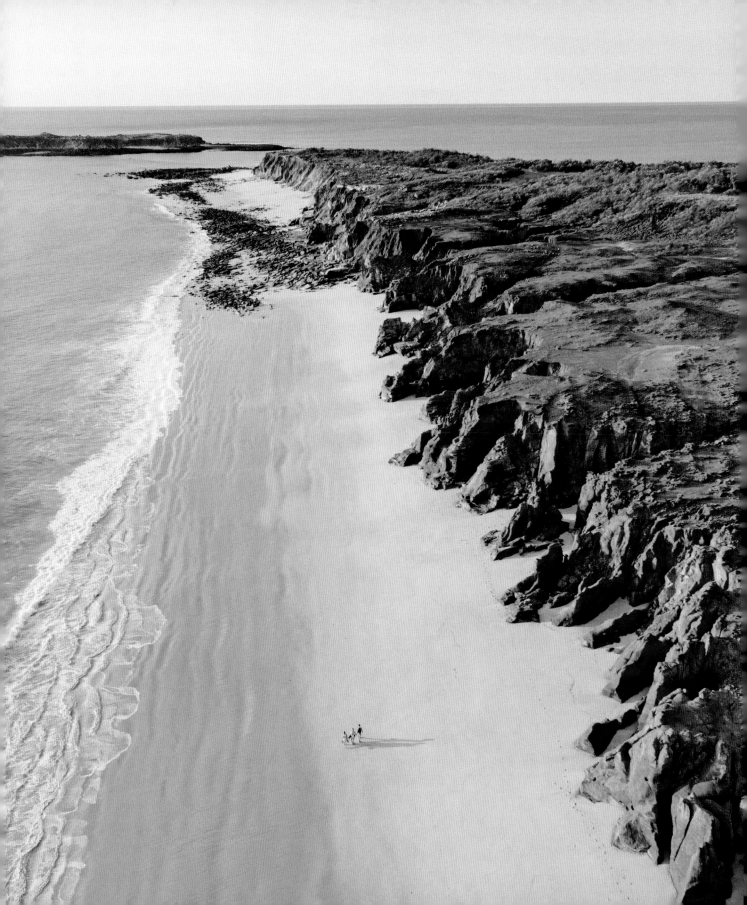

KIMBERLEY COASTLINE

Western Australia
Australia

Remote waterfalls, swimming holes and the world's biggest tides.

Tucked away in the remote north-west of Western Australia, the Kimberley region is unfathomably about three times the size of England, and its borders – the Indian Ocean to the west, Timor Sea to the north and Pilbara desert region to the east – help characterise the region's extremes of ecology, geology and biology. It is an area that is hard to get to, rugged and vast, but it is worth it for an unforgettable adventure.

When the rains are heavy in the Kimberley, it can be good news for the following season's visitors. A 'big wet' with prodigious showers sees the region's rivers, creeks and estuaries in full flow resulting in sensational waterfalls. Putting your viewfinder on one of these cascading marvels is a treat; standing under one is a slice of heaven.

Waterfall chasing is a big deal along the waterways of the Kimberley and the variety is memorable. You're as likely to see towering thin streaks of white water falling hundreds of metres into a natural rockpool as you are a great avalanche of wide water running along the rim of a rock edge, pounding explosively into the ocean below. That you can swim under some of them (those that are crocodile free) and luxuriate like a nymph on the rocky red shores is one of the Kimberley's natural drawcards.

Broome, known in the local First language as Rubibi, and on the Traditional Land of the Yawuru People, is a characterful frontier-cum-tourist town with a population of around 50,000 in high season. It's the jumping-off point for exploring the Kimberley's incredible coastline and Outback.

One of the more accessible and lesser-known destinations is Cape Leveque, on the tip of the Dampier Peninsula, whose Traditional Owners are the Bardi Jawi, Nul Nul and Jabirr Jabirr (Ngumbarl) Peoples.

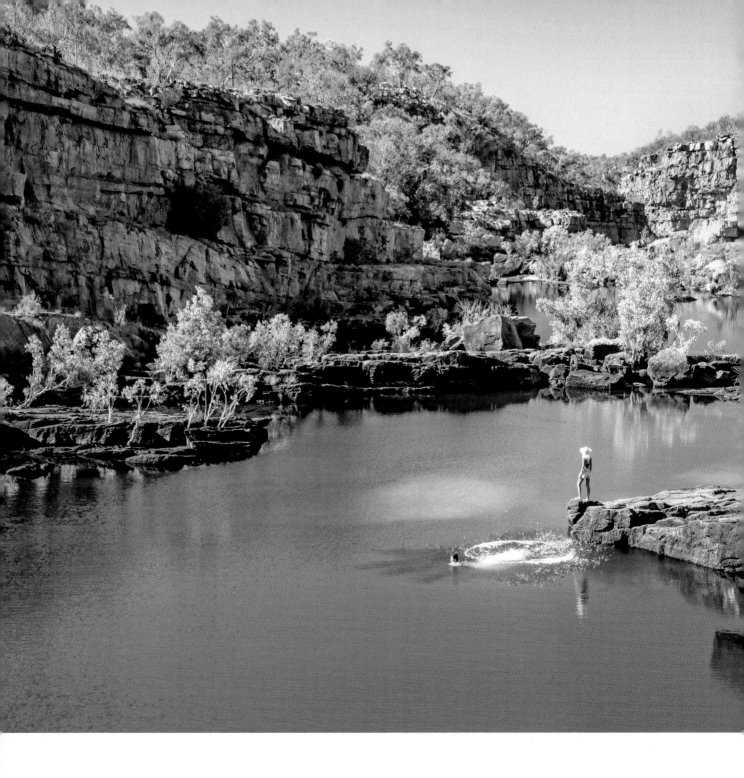

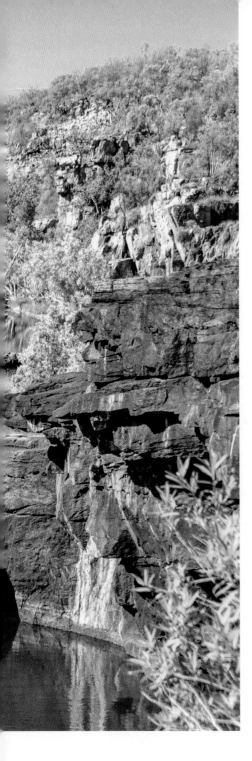

LEFT Manning Gorge is one of the many croc-free swimming holes in the Kimberley

BELOW Cape Leveque, on the tip of the Dampier Peninsula, is accessed from Broome via a long straight road to the horizon

The Dampier is an out-there place featuring red sandstone cliffs and pure white sand set off by intense azure skies is an example of the planet at its most pure and pristine. Pitching a tent at some of the Dampier's mind-blowingly scenic campsites while being immersed in cultural knowledge and experiences bestowed upon you by Traditional Owners are some of the Kimberley's highlights.

The Gibb River Road, a legendary 660-kilometre (410-mile) driving route between Derby (220 kilometres/136 miles east of Broome) and Kununurra, with its expansive cattle stations (some have accommodation and campsites), including famed El Questro, also bring visitors to these parts. The Gibb River Road has a rich culture with rock-art sites, and it is the Country of many language groups. In November 2022, an agreement was struck between the Wilinggin Aboriginal Corporation, the Western Australian Government and the G'Day Group that saw El Questro returned to its Traditional Owners.

Further north, the north-west Kimberley coastline along the Mitchell River and Prince Regent national parks is fizzing with extremes of nature. The waterways around this region are best explored by boat with popular itineraries including small-boat cruises between Broome and Darwin. Great bronze-red walls of sandstone hang like theatrical curtains along the waterways, dropping against dazzlingly turquoise waters of a colour range more often associated with an equatorial beach than a savannah landscape.

The tides, in places like Prince Regent River, are epic too – some of the biggest in the world. Depending on the season, and the time of day, the difference between high tide and low tide can be as much as 12 metres (39 feet).

Often, smaller cruise boats have been bespoke-engineered to navigate the disparity of tides along these narrow waterways. But even today, with high-tech navigational systems available, itineraries are at the mercy of the weather and tides. Those fortunate to travel during high tides and an extended wet season will be granted access – above the crocodile-prone mangroves – to trails that lead to picturesque freshwater swimming holes with a Garden of Eden ambience.

One, Camp Creek (this one in Dambimangari Country off the Prince Regent River – there are a number of 'Camp Creeks' up north), is a seemingly bottomless black circular pool, carved into the surrounding amphitheatre of dark, water-hewn rock. Its waters, like sheets of glass reflecting the puffs of cloud above, lie disconcertingly still between waterfalls that tumble into the pool at one end and disappear over the rock ledge at the other.

Along Cascade Creek, which feeds Kings Cascades in Prince Regent National Park on the Traditional Land of the Ngarinyin, Worora and Wunambul Peoples, the waterhole is like a desert oasis. It's fringed by green pandanis and shaded by young eucalypts with soft, bright-green foliage. Lotus leaves float on the water surface waiting for native frogs, and submerged rocks create eddies in the current.

The Kimberley's tidal quirks have also given rise to unique natural phenomena. Horizontal Falls – a fast-moving tidal flow through two narrow

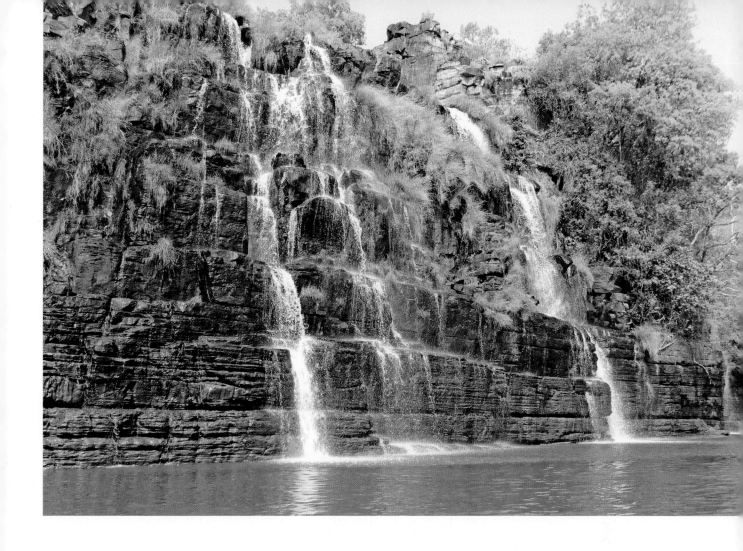

gorges – is one of the drawcard attractions in the Kimberley, and visitors can do a tour from Broome. A little less adrenaline-inducing – a little more David Attenborough – is Montgomery Reef, called Yowjab by the Dambimangari People, where the remote coral-capped limestone never fully empties as the tide goes down. The effect is of a lunar landscape above the ocean, its white-washed crevices creating a playground of currents for the greenback turtles that dip in and out of the frothy water surface.

Lower tides bring exciting times too. The long list of natural wonders in this remote north-west stretch includes beach visits, birding excursions (with croc-spotting often unwittingly thrown in), viewpoint hikes, geological explorations, whale-watching and stargazing. The First Nations rock-art caves (*see* p. 130) sitting amongst this beauty just add to the intrigue.

The Kimberley is fabulously wild and remote with scenery like no other. With time on your hands and a sense of adventure at the ready, it is not to be missed.

ABOVE Kings Cascades, fed by Cascade Creek, is one of the highlights of Prince Regent National Park

FIRST NATIONS
ART GALLERIES

BELOW Near Ubirr rock-art gallery, a lookpoint shows-off Kakadu's extraordinary landscape

Long before the ancient Egyptians invented hieroglyphs, the Gwion Gwion People, who trace their history back 40,000-plus years, were creating art on the red rock cliff-faces of the Kimberley region. What remains now is a greatly admired natural-world art gallery curated by the Traditional Owners, custodians of the oldest continuous culture on Earth. That it dates back between 17,000 and 24,000 years and we can still view it in its natural wilderness setting, is beyond incredible.

The finely depicted images show striking details of a time millennia before the present: curlicues of ochre make outlines of kangaroos and crocodiles; earthy-red streaks depict gracious human figures wearing ceremonial headdresses and holding digging sticks and boomerangs. As if that wasn't enough, the older Gwion Gwion styles have often been overlaid by later styles like the brilliant red and ochre broad strokes of the Wandjina People, painted in the past 4000 years and still practised by First Nations artists today.

Many of the rock-art sites are remote, difficult to access and not obvious to outsiders. The best way to see them is via stops on small-boat cruises that can access tricky tides and terrain (having a resident expert on board helps). One of the most memorable sites overlooks Doubtful Bay in Wunaamin Miliwundi Ranges Conservation Park on Wilinggin land, Traditional Country of the Ngarinyin People. Picture sitting under a shaded rock shelf on a high point overlooking the water, the breeze in your hair, the world's oldest exhibition space as a backdrop, its colour palette reflecting the surrounding landscape. No queueing for tickets, no handing your bag in, just a natural-world gallery.

The rock-art sites at Kakadu National Park in the Northern Territory (see p. 133) are far more accessible to tourists.

On the cave walls at Ubirr rock-art gallery, the images, painted in pigments including the long-lasting reddish iron oxide known as hematite, depict cultural traditions observed today that convey the continuous practice of social and ritual traditions for millennia.

The works, which cross three periods over the past 20,000 years, feature animated stick figures in ceremonial dress, hunters with spears, and 'x-ray' painted animal figures, including barramundi fish, goannas and long-necked turtles.

For me, seeing the image of a thylacine, a striped dog-sized predatory marsupial better known as a Tasmanian tiger, painted on a rock wall in the open air was incredible. As the name suggests, this animal is mostly associated with its endemic southern Australian island habitat of Tasmania/ *lutruwita* where it became extinct last century. But here at Ubirr, on the mainland, thousands of kilometres north, it is documented on a cave wall, in a landscape where it is believed to have become extinct between 2000 and 3000 years ago.

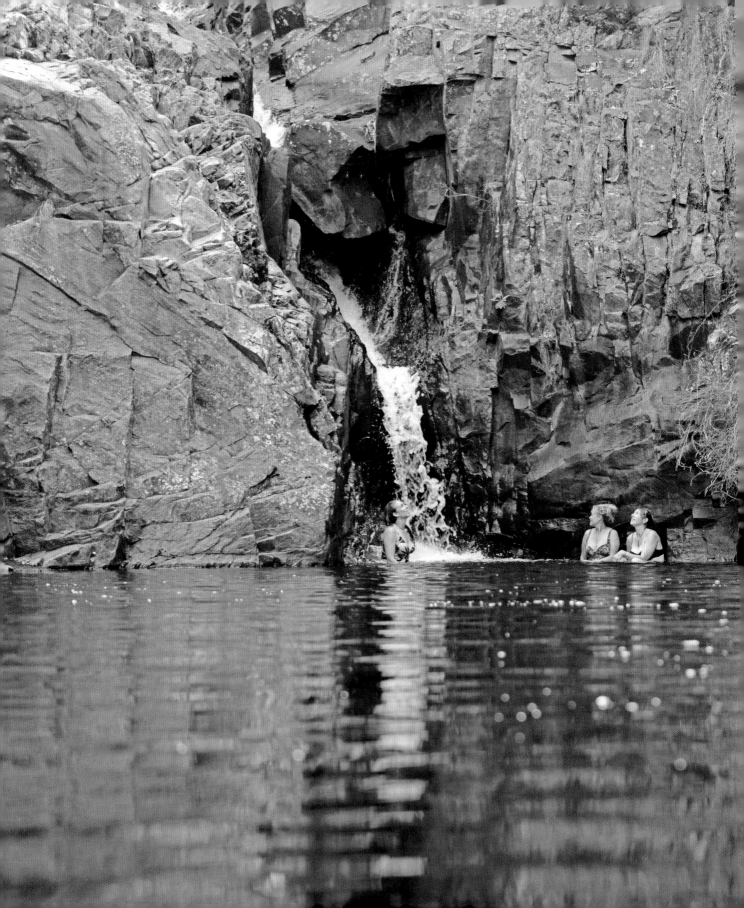

KAKADU NATIONAL PARK

Northern Territory
Australia

An ancient landscape of swimming holes and savannah plains imbued with ancestral knowledge.

Kakadu National Park is a mind-bendingly spectacular wilderness on the Traditional Land of the Bininj People in the north and the Mungguy People in the south. It is the land of one of the world's oldest continuous cultures whose connection to Country can be traced back 50,000 years and probably much longer.

The Bininj and Mungguy People's traditional ancestral knowledge – of flora, fauna, songlines, ceremonies and landscape – has been passed on through the generations. It's this profound wisdom that has shaped Kakadu today. Led by the Traditional Owners, the intermingling of ancient culture and awe-inspiring landscape adds to the beauty of the place, igniting it with an aura that taps into a deep yearning for the natural world.

Located 240 kilometres (149 miles) east of the Northern Territory's capital city of Darwin/Garramilla, Kakadu's sheer size – almost 20,000 square kilometres (7700 square miles) – equates to myriad spectacular habitats and environments within the savannah landscape.

The crimson red of desert, dirt and stone country unites with the brilliant effervescent greenery of monsoon rainforests and dynamic wetlands. Connecting these exceptional places are tidal flats, floodplains and rivers, often torrential, that run through the land like arteries, pulsing with life. (Indeed, so spectacular is the inland environment, the coastline tends to take a back seat. And that doesn't happen too often in Australia).

To travel here is to tread rock ridges and yawning canyons, bathe in freshwater swimming holes, stand under perfect waterfalls and breath in oxygen generated by millions of towering trees. Extraordinary sunsets, where cicadas

screech, frogs bellow and silhouetted waterbirds take flight against dusky skies are all part of the experience.

Kakadu's complex landscape diversity and limited impact from European settlement have resulted in the protection and conservation of a bounty of biodiverse lifeforms. The park lays claim to more than 2000 plant species and is the homeland of an incredible 280 bird species (one-third of Australia's bird species). One-quarter of the country's freshwater and estuarine fish species are found here.

Rare and endemic plants, such as the Kakadu plum and Darwin woollybutt, and animals, including the elusive black wallaroo and rare white-throated grass-wren, all flourish within this extreme natural wonderland, alongside a line-up of iconic regulars including crocodiles, pythons, frilled-neck lizards and dingoes.

For visitors, the average day might include a walk amongst spectacular savannah scenery, waterfall chasing and swimming hole immersions.

The longest drop waterfall in Kakadu is remote Jim Jim Falls/Barrk Malam, accessed via a dirt road and a 1-kilometre (0.6-mile) rock hop along a track through monsoon rainforest. It's well worth the effort. The water spills over an amphitheatre of red cliff, 200 metres (656 feet) high, into a deep circular swimming hole where deep waters run bone-chillingly cold, and the echoes of surprised swimmers rebound off the walls.

The falls at Gunlom, overlooking one of Kakadu's most epic panoramas, are closed due to an ongoing dispute between Parks Australia and Traditional Owners, due to allegations that respect for Cultural Protocol was neglected. Staying in the camping ground near the swimming holes at the bottom of the falls affords a true immersion in the savannah landscape.

The short walk to Ubirr lookout on a rocky outcrop overlooking the vast Nadab floodplains and the woodlands along the East Alligator River is well worth it for a sunset that touches on the spiritual. The idea that this green expanse, alive with the laughter of blue-winged kookaburras and the buzz of insects, is underwater come the wet season is hard to digest.

Ubirr is also known for its stunning examples of Arnhem Land rock art (*see p. 130*): timepieces that date back at least 20,000 years, providing an uninterrupted record for today's First Nations People.

The version of Kakadu you see depends on the six seasons of the Traditional Owners' calendar – the land changes dramatically as they unfold. The peaks of the seasons are the park's most dramatic.

Kudjewk the monsoon season, from December to March, is epic, a heady mix of heat and humidity punctuated by electric storms and raging floods that promote an abundance of green growth and, for many animals, a scramble to higher ground.

Kurrung, from mid-August to mid-October, is the opposite, a parched dry period of cracked earth, hungry cockatoos, dry river and creek beds, and a stillness that promotes the feeling that the land has been put on hold while it waits for the rain.

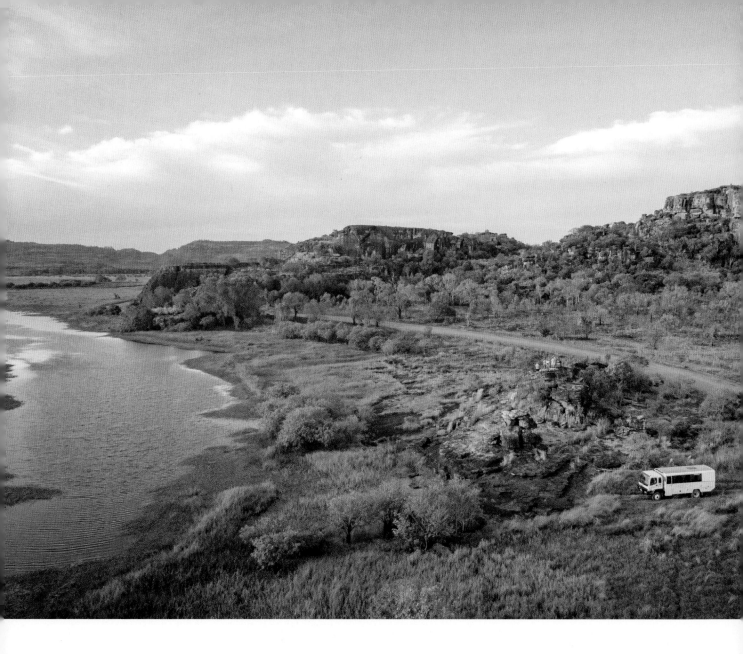

ABOVE Kakadu's complex landscapes, beauty and biodiversity have put it on the radar for adventurous tourists

UNESCO listed Kakadu as a World Heritage Site in 1981, crediting it as: 'a living cultural landscape with exceptional natural and cultural values'. This idea doesn't go unnoticed when visiting the park. Overlaid across Kakadu's natural-world epic-ness, is the multifaceted beauty, culture and stewardship of the Bininj and Mungguy Peoples. Their shared management of the park successfully combines Traditional and contemporary knowledge, ensuring the Kakadu wilderness experience is also an exceptional cultural immersion for all who come here.

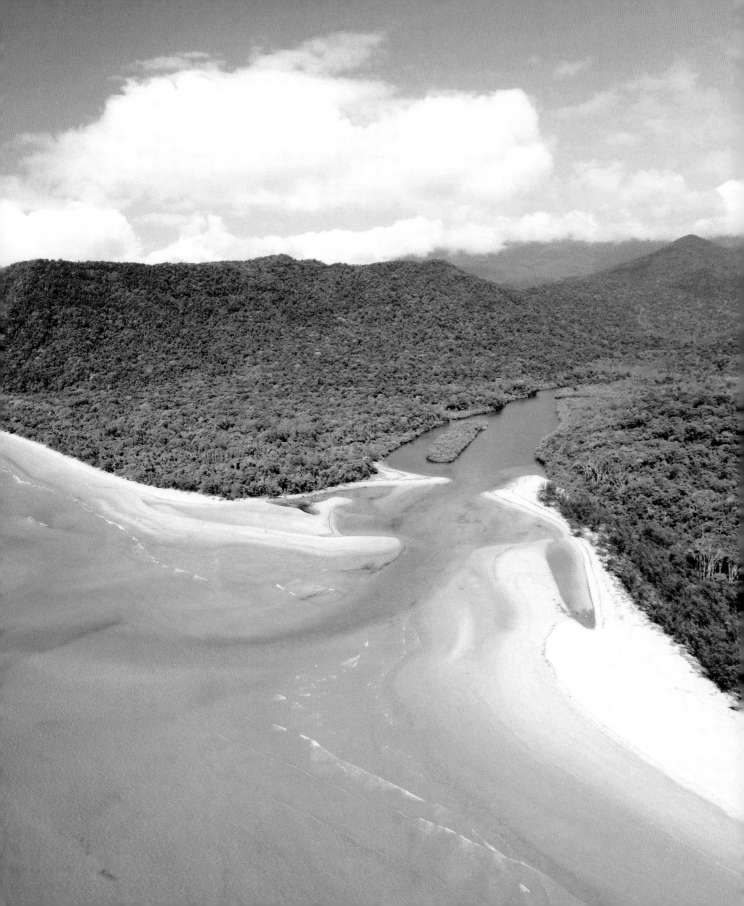

DAINTREE NATIONAL PARK

Queensland
Australia

An ancient rainforest of cassowaries, crocodiles and endless beaches.

The Daintree rainforest, on the east coast of tropical far north Queensland, has an extravagant canopy that engulfs everything in a stranglehold of soaring hardwood trunks, climbing plants and tangled vines that loop along branches where elkhorn and basket ferns stick like glue.

The rainforest here is older than the Amazon by a cool 80 million years. You heard it right: the Amazon is 55 million years old versus the Daintree's 135 million years. To labour the point, it's like the Daintree is the teenage Amazon's learned and wise old grandmother.

This natural-world intrigue, a UNESCO World Heritage Site, sits 100 kilometres (62 miles) north of the city of Cairns in the remote top right corner of Australia. The Eastern Kuku Yalanji People are the Traditional Owners who have cared for this country since time immemorial.

Covering approximately 1200 square kilometres (460 square miles), the Daintree is an encyclopedia of extraordinary flora and fauna, much of it so diverse and unique it's as beguiling seen under a microscope as it is through a pair of binoculars. You can find 20 per cent of Australia's bird species and 65 per cent of Australia's bug and butterfly species (that's a massive 12,000 insect species) here. Not to be outdone, 35 per cent of Australia's colourful frog species call the Daintree home, alongside furry marsupials and scaly reptiles, the taipan and eastern brown snakes to name but two. Similarly prolific, the Daintree River is home to an incredible amount of plant life, including some of the national park's 31 mangrove species.

Panning your camera lens around for bigger forms of life is similarly rewarding. The Daintree is a habitat for the cartoonish cassowary, a flightless wet tropics bird of similar proportions to an emu, with a coat of black glossy

feathers and an elongated neck graffitied in electric blue, red and orange. Its long eyelashes are beguiling but the dagger-like claw on its inside toe, and hard-pointed helmeted head, are straight out of the dinosaur age. Best to keep away.

Crocodiles patrol these waters too. Boat cruises along the Daintree River reveal mud banks with fresh slick marks made when crocodiles shimmy into the water. Further evidence can be found in the tiny plate-sized patch of rippled water revealing a croc's ears, eyes and nostrils. Swimming is a no-no.

The city of Cairns, resort town of Port Douglas and sugar cane–growing town of Mossman are the access points for the Daintree. They're part of the Douglas Shire region, which in 2019 became Ecotourism Australia's first certified nature destination after meeting a rigorous selection criterion. Eco-lodges, tourism operators and activities on the ground are genuinely invested in a sustainable approach.

Mossman Gorge, known as Bubu Mossman Gorge by Traditional Owners, is one such place, with an award-winning ecotourism cultural centre and an idyllic waterhole along the Mossman River. Here, mid-current, river rocks provide the perfect place to swim and relax in nature. There's also opportunity to explore the rainforest on a Ngadiku Dreamtime Walk, guided by local First Nations People.

From all three towns, a road extends north to the vehicle-accessible ferry crossing over the Daintree River. The touring route continues all the way up through the Daintree to Cape Tribulation, with rainforest on one side and pristine golden sand beaches on the other. Beyond the beach the land morphs into the opalescent blue ocean of the Great Barrier Reef (see p. 141). Visitors can be trekking through towering trees in the morning and blowing air bubbles around the coral cays of the reef come the afternoon.

At Cape Tribulation, the bitumen abruptly ends, becoming the rough-and-ready dirt Bloomfield Track up to Cooktown. You can keep driving like I did, right up to the northern-most tip of Australia, but there's plenty to keep visitors in Cape Trib. Camp on the beach, take a stroll to a lookout or hike up Mount Sorrow.

All this, in what is a relatively small area in Australian terms. To put all this wild splendour into perspective, here's a little anecdote. The park's Daintree Discovery Centre has an 11-metre (36-foot) aerial walkway that takes visitors through the mid-level rainforest to a 23-metre (75-foot) canopy tower with five viewing platforms. From up here, I'm told by a local guide, you can see a habitat that is home to more animal and plant species than there are in the whole of Europe and North America.

This is almost as hard to fathom as the Daintree's remoteness, but the combination sure makes the place feel special. Add sustainability to the equation and it's a rare trifecta, making it a wilderness to add to the top of any must-see list.

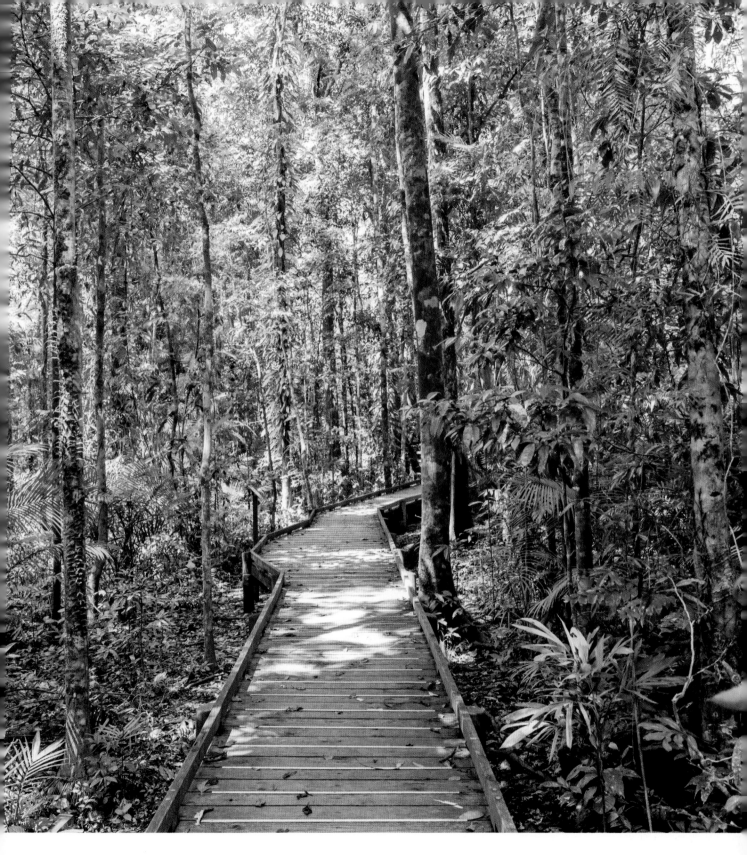

GREAT BARRIER REEF

Queensland
Australia

A world-renowned marine paradise of islands, reefs, coral and underwater art.

That most of the islands of the Great Barrier Reef are the tropical paradise variety, with endless seashell-covered sands and water like liquefied blue and green tourmalines, goes some way to explaining why the Great Barrier Reef graces magazine covers and bucket-lists across the globe.

These aqueous environs cover approximately 344,400 square kilometres (133,000 square miles), a hydrous expanse that includes more than 2900 individual reefs and a whopping 900 islands. The Traditional Owners with authority for management of this Sea Country are a diverse group of approximately 70 Aboriginal and Torres Strait Islander Custodians who actively observe and practise their Traditional cultures.

The Reef stretches more than 2300 kilometres (1400 miles) along Australia's eastern coastline, but to gain a true appreciation of the extent of this natural wonder look at a map. From the top of the north-east corner of the enormous Australian continent, this fringing turquoise smudge, the only living thing on Earth visible from space, extends – bewilderingly – almost half-way down the country.

While the beaches catch the initial attention, it's what lies beneath that clinches the deal. This is the ocean's equivalent of New York city, with the coral as the sky-scraping infrastructure housing a diversity of species from all swims of life. More than 1600 species of fish are resident here, from the Nemo celeb variety (clownfish) to the big guys: the stone-coloured potato cod and the colourful big-lipped humphead Māori wrasse can both grow more than 2 metres (6.5 feet) long.

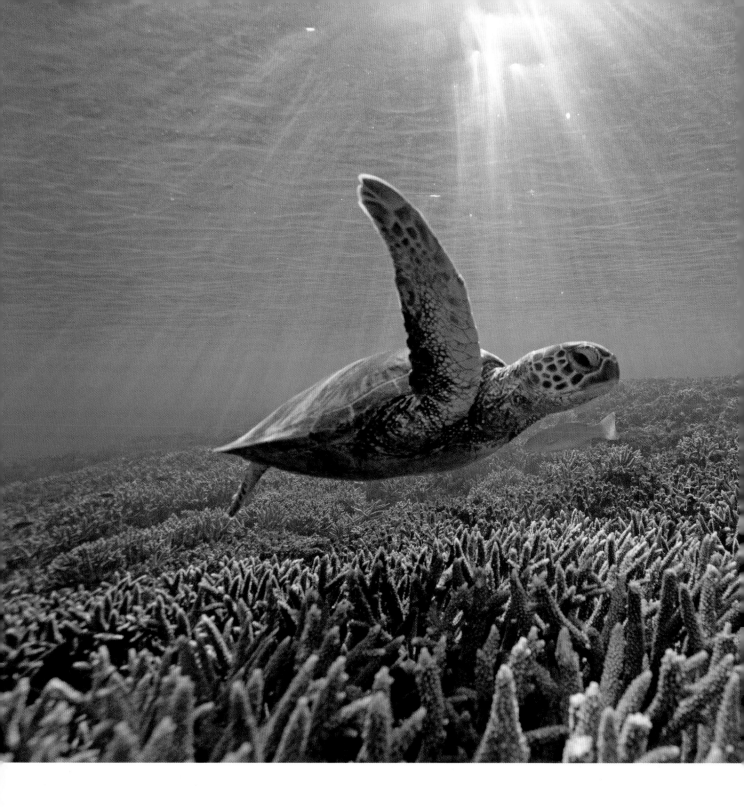

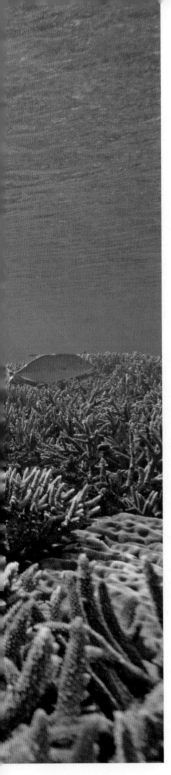

Giant clams, the size of bathtubs, are the world's biggest molluscs. They rest on the sandy ocean floor alongside camouflaged wobbegong sharks who shake themselves free and glide off into the dreamy blue when spotted by scuba divers. Six of the world's seven marine turtle species live among the many fringing reefs including the hawksbill, the loggerhead and the green sea turtle.

A mind-boggling number of humpback whales – some sources say as many as 25,000 – migrate annually from Antarctica to Hervey Bay Marine Park in the southern reef to breed. They are named for the humping motion they make when jumping in the air. They're also good tail-slappers. Dwarf minke whales are similarly beguiling with speeds of up to 30 kilometres (19 miles) per hour. Casting shadows from above, a vast number of seabirds and shore birds build their nests and roost on the islands and cays.

The Reef has four major town centres with water-based experiences that befit the diverse local environs. Cairns is the gateway to the stunning tropical north combining the 80-million-year-old Daintree Rainforest (see p. 137) with an idyllic meandering coast and luxury islands including Lizard Island with its fringing reefs and turtle habitats.

Heading about 350 kilometres (220 miles) south, coastal Townsville features a 25-minute ferry ride to picturesque Magnetic Island/Yunbenun, a hub for national park walks, beach days and wildlife spotting. Its minimal population (around 2000 people) ensures it's max on nature.

Accessible via the resort town of Airlie Beach, the Whitsundays are idolised for its reef snorkelling and spectacular silicon sands, Whitehaven Beach being its most famous – and Instagrammed – attraction. The boat-camping trail, where adventurers can be dropped off by boat to pitch tents Robinson Crusoe–style on their own dreamy island paradises, is a highlight of this island region.

The Southern Reef region, near the town of Bundaberg, has surf and plenty of opportunities for deep diving among mantas and whales. The Mon Repos Conservation Centre protects a nesting site for the largest concentration of turtles on the eastern Australia mainland. Visitors can respectfully see loggerhead turtles in their natural habitats.

This water wilderness is extraordinary, but it is also so fragile.

Its controversial future has drawn headlines for at least the past two decades. Most of the issues are human-made: land-based fertiliser run-off, coastal development, over-fishing, over-tourism and outbreaks of crown-of-thorns starfish, as well as natural occurrences like tropical storms. The big one – climate change – is causing coral bleaching. When temperatures warm, the coral stresses and expels the algae that is its life-force, bleaching it of its colour in the process.

In 2022, a report by UNESCO and the International Union for Conservation of Nature recommended that the Great Barrier Reef be placed on the 'in danger' list of World Heritage Sites, naming climate change as a 'serious challenge' to the Reef. Any future resolution, according to the report, relies on the Australian

ABOVE Six of the world's seven marine turtle species live among the Great Barrier's many fringing reefs

OPPOSITE Scuba diving
around Reef's coral
bloom sites is a highlight

government's commitment to further reducing greenhouse emissions to limit the global average temperature.

The tourist dollar will also play a part. It is vital for research funding, but it also contributes to the management costs of such a vast ecosystem. Every visitor pays an environmental management fee and there's an emphasis on booking accommodation, tours and restaurants that have eco certifications and sustainable practices. Citizen scientist apps and volunteering are also popular for sighting juvenile starfish before they reach the size where they decimate a reef.

The most visual example of sustainability in action is the new Museum of Underwater Art (MOUA) dive site in Townsville. Two hours' offshore, and weighing 158-tonne (144 ton), lies artist Jason deCaires Taylor's incredible 'Coral Greenhouse' installation. His 20 'reef guardians' – statues of people protecting the underwater world, have been submerged 18 metres (59 feet). With a visibility of 15 metres (49 feet), snorkellers can witness the surreal sight alongside deeper diving scuba divers.

The idea, explained the artist in a press release, is 'to help propagate coral while allowing scientists, marine students and tourists to engage in action-based learning on coral reef restoration and new technology'. In a neat example of how conservation can bring humans and nature together, fish diversity and coral growth around, Coral Greenhouse, has already flourished.

It could take many visits to explore this marine wilderness in full, such is its immense size and plethora of sites, activities and experiences. If carbon reduction promises are kept, it will be well worth returning to again and again.

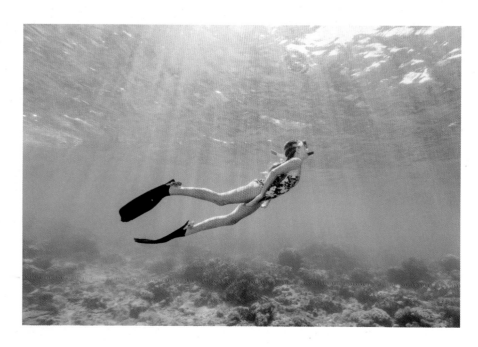

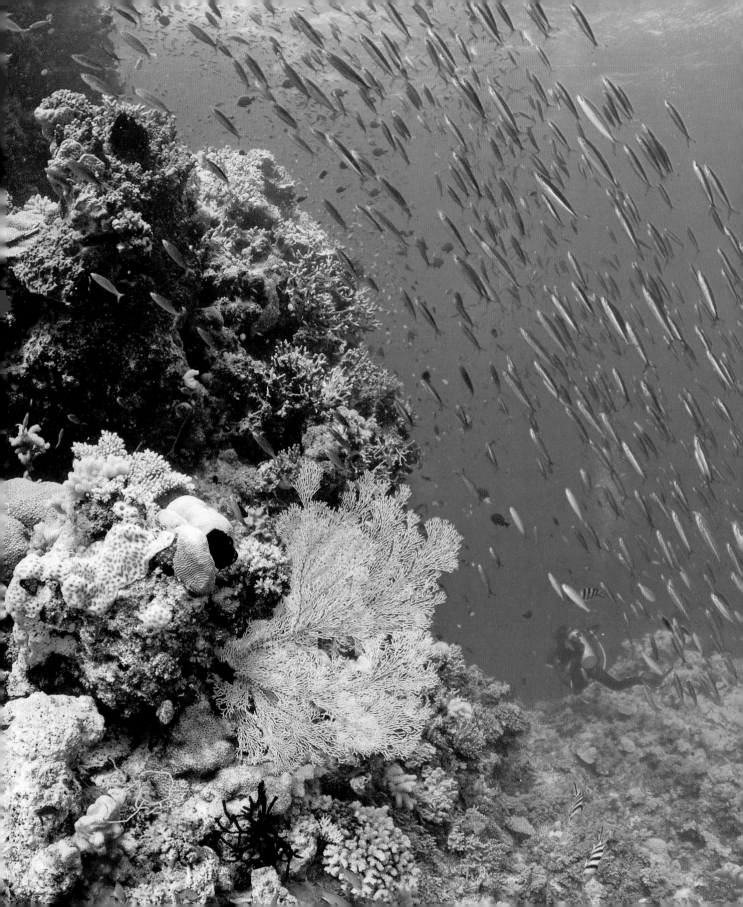

NINGALOO REEF

Western Australia
Australia

Coral reefs, an eco ethos and the big three – mantas, humpbacks and whale sharks.

It's hard to credit just how remote the UNESCO World Heritage–listed Ningaloo Reef is. Mid-way up the never-ending west coast of Western Australia, the reef's Traditional Owners are the Jinigudera Peoples of the Thanalyji, who have lived here and cared for these waters for millennia. The reef is near the tiny gateway towns of Exmouth and Coral Bay but an eye-watering 13-hour drive (1200 kilometres/750 miles) north of the nearest city of Perth. From Perth, Sydney is more than 3000 kilometres (1864 miles) east as the crow flies. In the other direction, across the endless Indian Ocean, South Africa's Cape Town is roughly 8700 kilometres (5400 miles) away.

This is surely one of the reasons Ningaloo, the largest fringing reef in the world and one of the last great ocean paradises, has only in the last decade, started to register on the travel radar of Australians. That the Great Barrier Reef (*see* p. 141) was inscribed by UNESCO as World Heritage in 1981 and Ningaloo Reef only listed in 2011 must have played a part too. Certainly, those living on the east coast have always had the Great Barrier Reef to distract them.

But this is changing. Happily, it's often a tale of responsible tourism. Ningaloo is not only a pristine wilderness, but its tourism arm also has sustainability as a priority. Human interactions with animals, such as swimming with whale sharks, are protected and managed by the Western Australia Parks and Wildlife Service, and tourism operators tend to be specialist licensed professionals with a small-group eco ethos. They are aware that Ningaloo's reputation as a world-beating nature experience is key to its success and longevity. Accommodation offerings, thus far, tend to be small scale. The coveted luxury option, Sal Salis, is an eco-camp in the coastal dunes.

But the reef has other challenges, including, at the time of research, Woodside Energy's proposed Burrup Hub deep sea gas project, which is 'the most climate-polluting project currently proposed in Australia', according to a Greenpeace press release. Coral bleaching in the northern part of Exmouth Gulf (Bundegi) due to unusually hot water being generated off Western Australia's north-west coast is another alarm bell.

Officially, the UNESCO-listed Ningaloo Coast World Heritage Area includes Cape Range National Park and Ningaloo Marine Park. The latter covers an area of more than 600,000 hectares (2300 square miles) and stretches an incredible 300 kilometres (186 miles) from Northwest Cape to Red Bluff. The wow-factor is its astounding – and pristinely protected – biodiversity, a merging of tropical species to the southern end of their range and temperate species to their northernmost point.

According to the Parks and Wildlife Service its waters are home to approximately 500 species of fin fish, 300 species of coral, 600 species of mollusc and 90 species of echinoderm. It's astounding to think how important the reef's seagrass, mangrove and coral habitats are to the health of this marine environment, and indeed marine environments globally.

What adds impact to the destination is the fact that much of this astonishing reef and marine life is located just off-shore. It is accessible direct from a string of beaches along the coastline. On any given day, snorkellers can float over a wonderland of coral and nature's own aquarium of giant clams, sea turtles and tropical fish.

Those with their sights set on bigger creatures can go further off-shore into the bigger blue. Ningaloo is becoming known as one of those Earthly enigmas where enthusiasts can set eyes on the big aquamarine three – manta rays, humpback whales and whale sharks, all in the one location. Sightings are reliable too and Tourism WA says Ningaloo has one of the highest interaction rates, sitting above the 90 per cent mark most seasons.

Exact timings depend on whether you are accessing the reef from near Coral Bay or Exmouth. But as a rough guide, mid-March to August is the time to see whale sharks migrating to Ningaloo to feed on plankton and krill.

A swim with whale sharks is particularly special. Wearing snorkel and mask, swimmers trail these gentle marine giants – the ocean's biggest fish – through the blue haze, watching as they sashay through the sun-flecked ocean depths, their enormous boomerang-shaped tail fins swaying majestically.

From June to October humpback whales pass by on their annual migration for Antarctica. Manta rays are a year-round attraction, their graceful bodies gliding through the water like billowing sheets. If these migration seasons align, you've a chance to see them all at the same time.

Ningaloo is one of those rare wildernesses, where early implementation of sustainability and conservation measures have given it a chance of success. It might be remote and tough-going to access, but the effort will be rewarded when a manta ray glides over head or a whale shark materialises in the big blue.

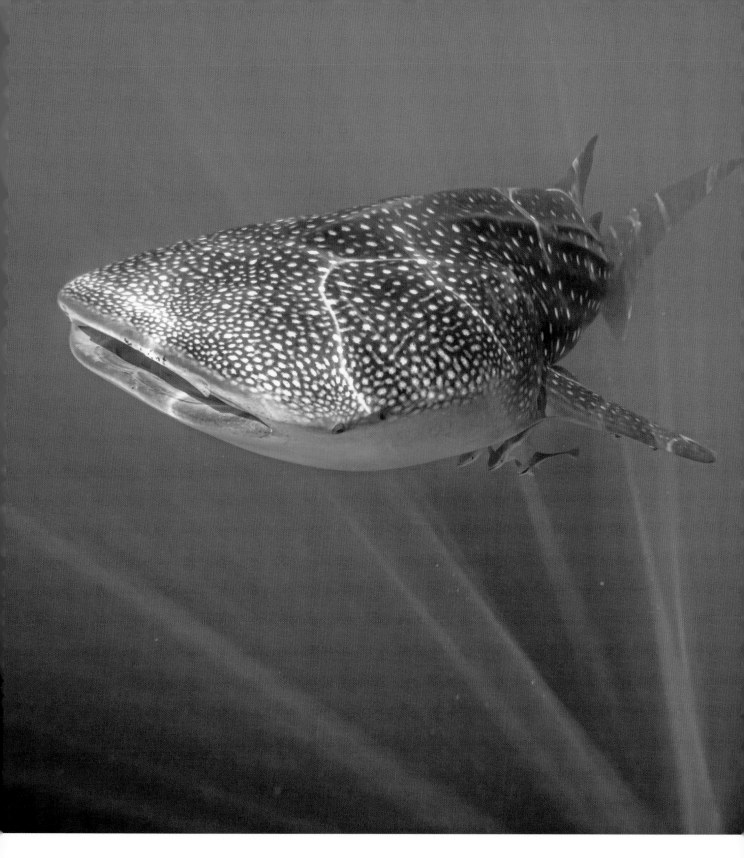

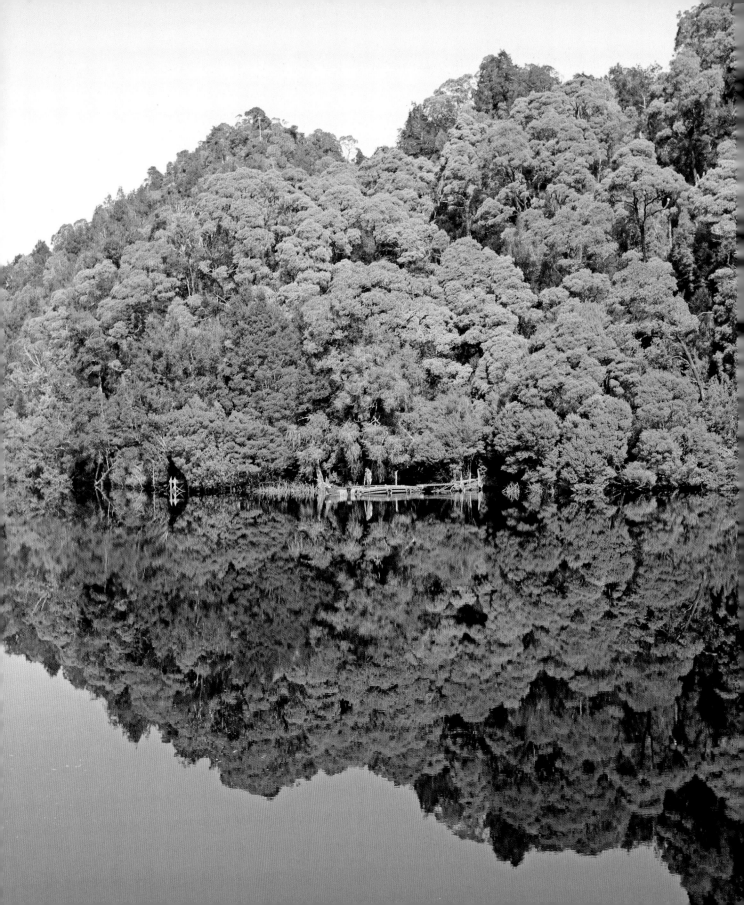

FRANKLIN–GORDON WILD RIVERS NATIONAL PARK

Tasmania/lutruwita
Australia

Wild and remote rainforest with torrential rivers and a conservation success story.

In the deep, wet temperate rainforests of Franklin–Gordon Wild Rivers National Park, in Tasmania/lutruwita's west, the herby-camphory scent of myrtle tree leaves mixes with the honeyed aroma of leatherwood flowers, a heady perfume that permeates the pure, fresh mountain air.

This sweet-smelling wooded wonderland, covering 4473 square kilometres (1727 square miles), extends to the horizon across dramatic hills and imposing mountain peaks, through some of the most inaccessible and remote country in the world. Stands of ancient Huon pines, one of the world's oldest living organisms, once logged for their rot-resistant oils and golden hue, now live here in peace alongside myriad native eucalypt species. This iconic Australian landscape is complete with iconic Australian wildlife: Tasmania/lutruwita's own devils, quolls and pademelons (similar to wallabies), alongside possums, platypus, echidna, snakes and sea eagles.

Winding and cutting through the native flora are the park's eponymous Franklin and Gordon rivers. Wild and untamed, their crystalline waters are tinged by tannins from the surrounding bush vegetation. These waterways are as intimidating as ocean swell, and not short on a deluge. With an annual rainfall of about 1900 millimetres (74 inches), this is one of the wettest places in Australia. The saturating rains feed runaway waters that surge through steep gorges and roar over rocky chasms.

Along the rivers and throughout the park, there are sites significant to Traditional Owners, the palawa kani People, including Kutikina Cave, which was returned to the First Nations Community under the *Aboriginal Lands Act* in 1995.

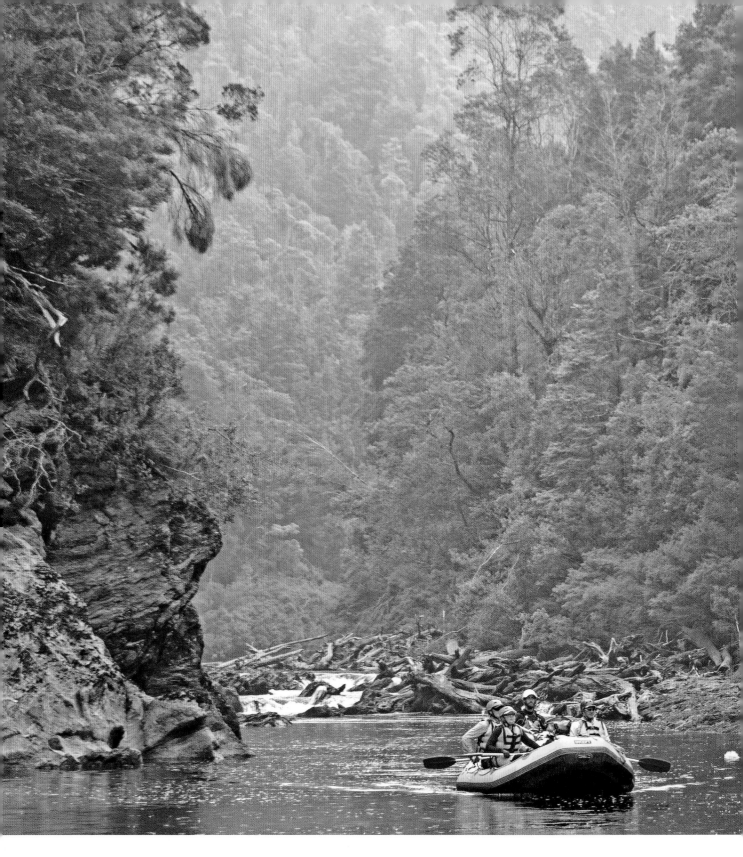

Significantly, Franklin–Gordon Wild Rivers National Park is in the heart of a vast swath of land that makes up the Tasmanian Wilderness World Heritage Area (a dual name for the property to reflect its First Nations heritage will soon be identified, according to a 2021 UNESCO report). Covering 1.5 million hectares (3.7 million acres), or an incredible one-fifth of the entire state, the area is considered one of the last great wildernesses on Earth.

The wilderness area was listed by UNESCO in 1983, an accolade that became the icing on the cake after a conservation battle, set in the Franklin–Gordon National Park, that represents the biggest environmental success story in Australian history.

Over an eight-year period during the late 1970s and early 1980s, the 'Save the Franklin' campaign, led by former Greens senator Bob Brown, then director of the newly minted Tasmanian Wilderness Society, saw protesters blockading the river in a bid to stop a dam proposed for the Gordon-below-Franklin hydro-electric power scheme.

When the Tasmanian government and big business refused to budge on the issue – against popular opinion – the protest gained Australia-wide momentum, resulting in protest marches in every capital city. As a six-year-old in regional

mainland Australia, I remember walking hand-in-hand with my dad down to the local civic centre to watch the nature documentary about the Franklin that had been created by campaigners to get the message out.

As intended, the film and photographs of this wild waterway stirred the hearts and minds of those who saw it. The successful 1983 prime ministerial election of Labor candidate Bob Hawke, who supported the protest, was considered a vote for the environment. Later that same year, a High Court decision backed the federal government's bid to preserve the wild rivers.

Well-timed for the 40-year anniversary of the success, director Kas Burgess's 2022 documentary *Franklin* tells the story of Oliver Cassidy, who follows in the footsteps of his late father's 14-day rafting adventure down the Franklin to join the blockade. The archival footage, interviews and incredible narrative make for heart-pounding viewing, especially given how epic this river trip is.

Five- to 10-day guided rafting trips, such as that traversed by Cassidy in the film, are a true immersion in the wilderness, but they're considered expeditions for experienced paddlers with guides, the right equipment and a high level of fitness. The whitewater rapids are nothing short of hardcore, the tranquil pools that come after them are always hard won by the few rafters who dare to ride them. TheTasmania Parks and Wildlife Service describes whitewater rafting here as 'highly hazardous' and advises learning about the gradings and complexities before attempting it. As the narrator in the *Franklin* film says as Cassidy sets out, 'people have died on this river'.

Another option for visitors is to pit-stop on the well-known Lyell Highway, the road that bisects the green terrain between the west coast village of Strahan and the old mining town of Queenstown (and continues all the way to the Tasmanian capital of Hobart/nipaluna). Walks, made no less beautiful for their easy access, include the flat 1-kilometre (0.6-mile) return Franklin Nature Trail (wheelchair friendly) that meanders along the riverbank; the 2.2-kilometre (1.4-mile) return Donaghys Hill stroll through rainforest to a rocky pinnacle; and the 1.4-kilometre (0.9-mile) return walk to Nelson Falls, a tranquil waterfall surrounded by moss-covered rocks. All three walks are included on Tasmania Parks and Wildlife Service's 60 Great Short Walks.

With more time and experience, the challenging multi-day Frenchmans Cap hike follows a trail through rainforests, buttongrass moorlands and alpine trees to the 1446-metre (4744 feet) white quartzite peak that the walk was named for. The stunning views of King William Range and Mount Rufus from up here are something else.

This is a rare and precious land of outstanding beauty, a world treasure. That it was saved from the bulldozers by the passion, dedication and strength of thousands of individuals makes it all the more valuable. It's a wilderness success story to be proud of and a legacy to inspire future generations to conserve wild areas.

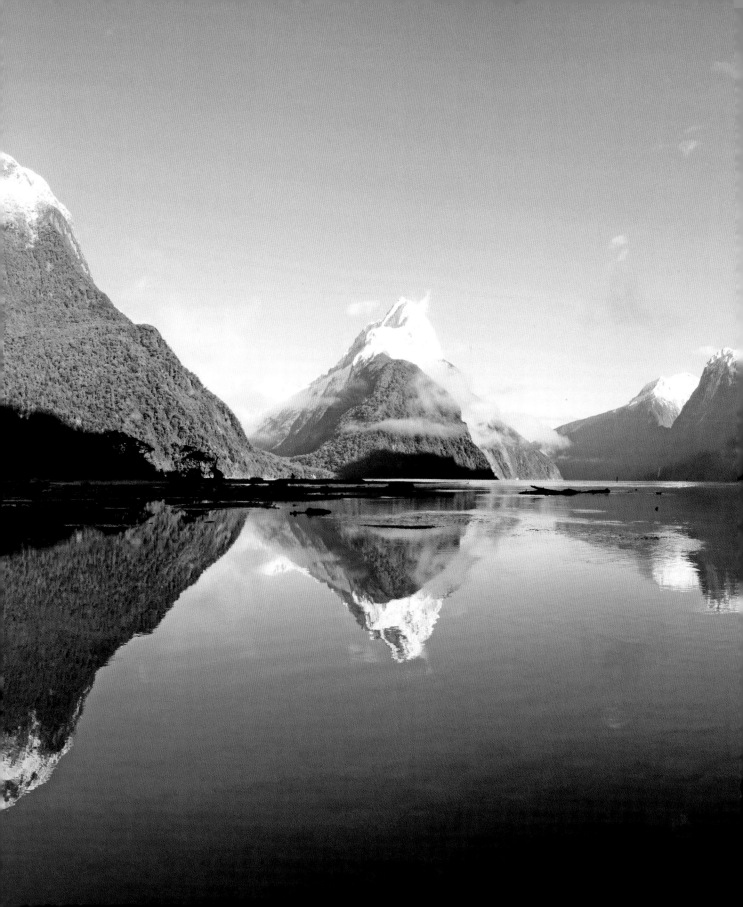

FIORDLAND NATIONAL PARK

South Island
Aotearoa New Zealand

A glacier-sculpted alpine landscape of fairytale forests and formidable fiords.

A kayak trip on the waters of Fiordland National Park reveals an amphitheatre of ancient scenery. Reflected in the tannin-tinged water are wobbly triangles of snow-capped granite mountains and clouds like puffs of mist on a mirror. From faraway heights the thin white stripes of falling water are exclamation marks against deep green vegetation. It's a heavenly view.

Covering 12,607 square kilometres (4868 square miles), Fiordland National Park, in the south of Aotearoa New Zealand's South Island, is the largest of the country's 14 national parks, covering some 5 per cent of the country. It is a raw and largely untouched landscape of glacier-scraped and sculpted alpine mountains, deep fiords (or sounds) and dense fairytale forests full of ferns, mossy tree trunks and an undergrowth of microscopic communities.

Part of Te Wahipounamu UNESCO World Heritage Site, the park's formidable beauty plays out in many ways. Mighty snow caps, from the southern part of the Southern Alps/Ka Tiritiri o te Moana to the northern Darran Mountains, rising to just over 2500 metres (8200 feet), are prone to uncontrollable avalanches. The park's rain drives hard and its rivers roar, funnelling water through canyons and over some of the highest waterfalls in the world. Its fathomless sounds – carved trenches, the creative work of glaciers that retreated at the end of the Ice Age – can reach 40 kilometres (25 miles) inland, their steep-sided U-bends and wends creating magical nature-scapes filled with rainforest, birdsong, pristine potable water and a biodiversity of plants and animals.

Te Rua-o-te-moko and Shadowland are names given to Fiordland by the Ngai Tahu Māori People. While they have always known it well, few early Ngai Tahu People opted to live in the region, given the unforgiving terrain and

inclement weather. But they did hunt seals, gather seasonal foods and search for precious takiwai, a translucent greenstone also known as pounamu or New Zealand jade. The land's legacy of impenetrability has left natural arenas that nobody has even seen; scenery so ancient and preserved that it is considered the most representative of what was once the supercontinent of Gondwana, which included Antarctica, South America and Australia.

The most well-known fiords, Milford Sound/Piopiotahi, Doubtful Sound/Patea and Dusky Sound/Tamatea, are places to encounter bottlenose dolphins, known to swim alongside kayakers, and New Zealand fur seal, once hunted for their skins but now thriving. Whales slink in these protected waters too.

On forested inclines along the watery edges there are habitats of endangered bird species endemic to Aotearoa New Zealand, including Fiordland crested penguins, flightless kakapo parrot and the infamously pesky kea. The takahē, a flightless bird thought to be extinct mid–last century, has recovered in sanctuaries around the country. Fiordland is one of the few places it exists in the wild.

In reserves throughout the park, black coral usually found at 300 metres (1000 feet), can be found at just 40 metres (130 feet) – the fiords have a discernible bottom layer of saline water and a top layer of freshwater that is naturally stained by the tannins of rotting tree trunks and leafy vegetation. This tinged top water blocks the sun's rays enabling typically deep-water creatures to live in shallower conditions. It is one of the park's marvellous natural quirks.

Kaitiakitanga, or stewardship of the natural world, has long been practised by Māori communities. Mercifully, at least one colonial had the same pioneering idea. In the late 1800s Richard Henry flagged Resolution Island within Dusky Sound/Tamatea as an ideal sanctuary for threatened species like the kakapo and kiwi. Today Dusky Sound/Tamatea is still blissfully remote and largely pristine. But the work to stymie the island's invasive non-native flora and fauna is ongoing.

Over-tourism is another Fiordland challenge. But the Covid pandemic might have set the wheels in motion for change. In 2022, the Aotearoa New Zealand government flagged Milford Sound/Piopiotahi as a possible test case for reshaping the way the country does tourism sustainably. The approach touted capped visitor numbers, limited tour buses, and visitor fees to put tourist dollars directly back to the local community as possible solutions.

Fiordland, accessible via the towns of Te Anau and Manapouri, is the most popular national park in Aotearoa New Zealand with upwards of half-a-million annual visitors. Most are magnetically drawn to the most accessible destination, Milford Sound/Piopiotahi. Among its attractions – boat tours, kayaking expeditions, walking and trekking – the 54-kilometre (34-mile) multi-day Milford Sound Track is the most well-known, attracting about 14,000 trampers (trekkers) per year.

For those seeking a little more breathing space, Fiordland has around 450 kilometres (280 miles) of other walking trails, including Kepler and Routeburn, both designated Great Walks of New Zealand. Or, get out on a kayak. Sneaking around secluded bays to slip that paddle into silky-smooth waters is a rare dip into an untrammelled wilderness.

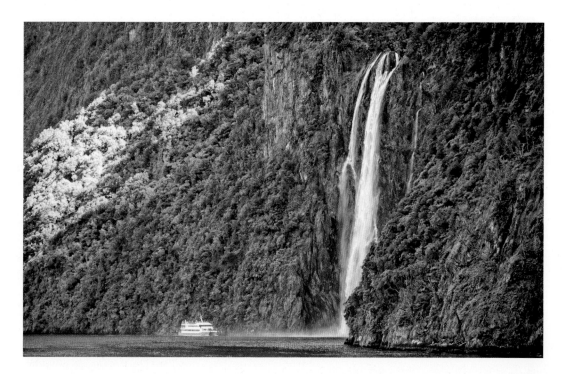

BELOW Kayaking is one of the ways to explore Milford Sound

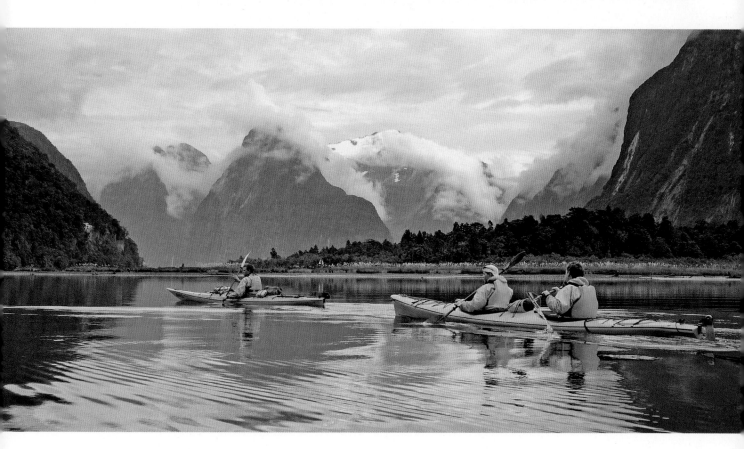

PHOENIX ISLANDS PROTECTED AREA

Kiribati

An epically remote ocean playground of deep waters, surf waves and globally important sea species facing conservation challenges.

In the remote Pacific Ocean of Polynesia, roughly halfway between Australia and Hawaii on the crossbow of the four hemispheres, lies one of the world's most magnificent intact protected marine areas, a tropical oasis of nine tiny islands with a watery underworld that tops any other in this part of the world. This breathtaking combination of marine habitats and ecosystems is known as the Phoenix Island Protected Area, or PIPA. It is part of the Pacific Island nation of Kiribati, pronounced 'Kiri-bass' in its original Gilbertese language.

This pristine ocean wilderness, covering 408,250 square kilometres (157,600 square miles), is a rare and precious ocean-scape of atolls, deep water that sinks to a profound 6000 metres (20,000 feet), glorious intact coral colonies and 14 submerged volcanoes, known as seamounts.

Swirling around these biogeographic habitats are powerful ocean currents rich in nutrients, plankton and migratory marine species. The result is a prolifically abundant marine ecosystem teeming with life. Of some 800 marine creatures – including sharks, dolphins, manta rays and sea turtles – there are 18 marine mammals, at least 200 coral species and 44 bird species. PIPA's 509 fish species are aquatic beauties, from bumphead parrotfish, triggerfish and Māori wrasse to a myriad angelfish and surgeonfish zipping around in a display of bright yellow and blue. It is known as a spawning ground for big fish such as tuna too. Profoundly important on a global scale, the fish species here are living long enough to reach the full spectrum of age and size, meaning breeding cycles are maximised.

Many of the species found here have been long gone in ocean ecosystems elsewhere. On the ocean floor, giant purple-hued clams are the size of bathtubs. On the sandy atolls and coral cays, endangered coconut crabs, the world's largest terrestrial arthropods, look like something washed up from the lost city of Atlantis. (You never forget the first time you see one.) Sea birds screech on the thermals like they are singing the praises of their paradise retained.

Scattered across the Pacific equatorial region, Kiribati includes two other archipelagos: namely the Gilbert Islands and Line Islands, which bookend the Phoenix Islands. Together, this marine-scape extends over 3.5 million square kilometres (1.3 million square miles) of astonishing deep blue, white-capped waters. The land (32 atolls and one ocean island), covering 811 square kilometres (313 square miles), is small in comparison, amounting to just 0.02 per cent of the nation, the smallest land-to-water ratio of any country in the world.

In 2008, the Kiribati Government declared the Phoenix Islands a protected area. In 2010, it was World Heritage listed. In inscribing PIPA, UNESCO described it as 'sufficiently remote and inhospitable to human colonisation as to be exceptional ... a vast wilderness domain where nature prevails and man is but an occasional visitor'.

Off the back of this global acclaim, commercial fishing activity was banned in the protected area in 2015, making this vast expanse of marine ecology a rare 'no-take zone'.

But things change. In late 2021, the Kiribati government stated in a press release that the ban 'will not be sufficient to meet the present need of the people of Kiribati now and the development needs of the country for the future'. The government would opt instead for a Marine Spatial Planning zone, which 'aims to balance, social, environmental and economic objectives' by once again allowing commercial fishing vessels into the zone.

On the ground, it's complex. Kiribati, with a remote population of almost 120,000, is not only one of the world's 'least developed countries' according to the United Nations, it is also one of the smallest and one of the countries that is worst affected by the climate crisis, the impact of which is deteriorating socio-economic conditions. Deep-sea mining proposals, illegal fishing and invasive species' removal are further challenges. Whether PIPA's World Heritage status (which focuses on the idea of the protected area being a 'no-take zone') will be re-evaluated by UNESCO is unknown at the time of research.

PIPA has no tourism infrastructure, but Kiribati, its cruise ship ports notwithstanding, could be one of the last places to open up to a sustainable adventure tourism model. Visitors are intrigued by the profound remoteness and sparkling aqueous beauty of a destination surrounded by big, deep ocean and all its wonders. It offers an untouched tropical island paradise for adventurers, slow travellers and escapists, a true antidote to the pressures of the modern world.

From the capital of Tarawa, on the main island, ferries and small domestic planes explore the many Gilbert and Line islands with their own unique

marine habitats – reefs, atolls, lagoons, tides and waves, and small village populations rich in culture.

Of the Gilbert Islands, Tabiteuea Island visitors can explore the Ten Nnabakana stone warriors and see the bones and skull of Kourabi, a well-known warrior, which are protected by the Buota villagers. On Butaritari (Makin), Abemama and Banaba islands, there are relics of Japanese occupation during World War II. The islands were invaded just after the Japanese bombed Pearl Harbor in 1941.

Off land, these virgin waters are home to some of the world's best snorkelling and scuba-diving adventures. From the Line Island of Kiritimati (Christmas atoll), visitors can immerse in a big blue of sharks and myriad colourful fish from shore, or access remote lagoons and atolls on characteristic island outrigger canoes to see mantas, sea turtles and dolphins. Sailing around these islands is equally alluring.

Surfing is also a drawcard. From October through to March, Kiribati has 24 surfable waves stretching along a 5-kilometre (3-mile) coastline. But surfers looking for crowd-free big and long breaks tend to head to the north and south of Tabuaeran (Fanning) Island, also part of the Line Islands group. This remote place is talked about in hushed tones by surfers wanting to keep its almost year-round consistent swell a secret.

The Phoenix Island Protected Area is an ocean wilderness as epic in its proportions as it is in its marine diversity. Its value to the health and biota of oceans across the planet cannot be understated.

SOUTH AMERICA

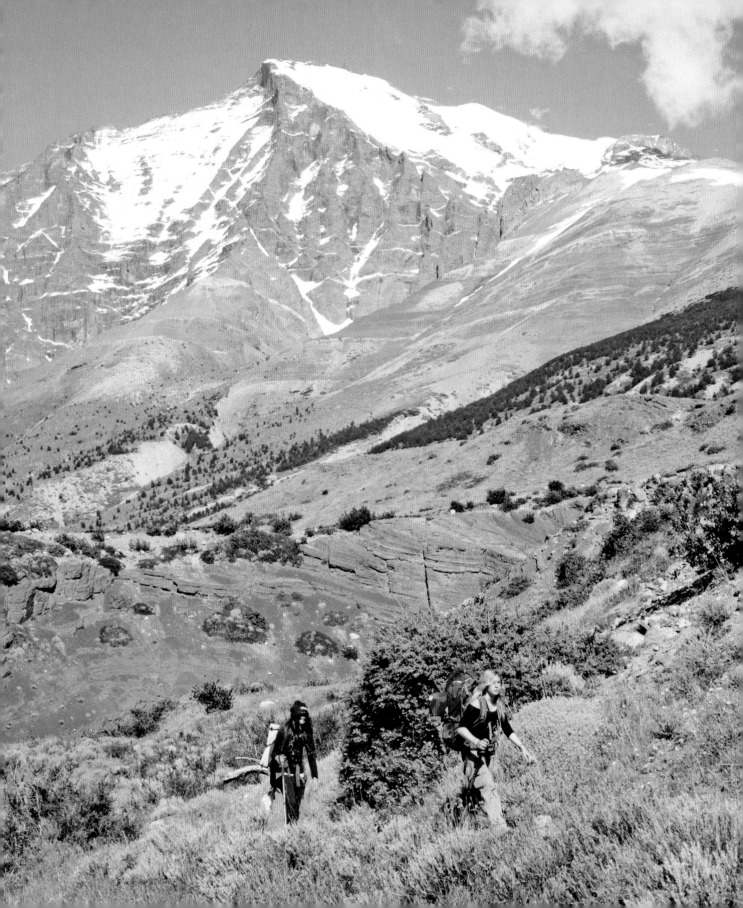

Much of South America is wild, untrammelled and often untouched. It is the world's fourth biggest continent, a vast landmass that hangs off a thin Panama isthmus like a bunch of grapes on the end of a vine. The rest of the continent is entirely engulfed by sea, from the Caribbean in the north to the Pacific Ocean on its west coastline, and the Atlantic on its north and east.

It is home to 12 countries and a population of more than 434 million people who are gifted with mesmerising coastline and an almost unfathomable array of habitats each with their own planet-sustaining biodiversity. But the continent is also fragile in the face of climate change.

The Amazon rainforest is the most well-known wilderness destination, its tangled greenery and spiderweb of waterways seguing across nine nations, but South America's jaw-dropping landscapes don't stop there. From Paraguay's ephemeral Pantanal Wetlands to the photogenic salt plains of Bolivia and wind-prone peaks of Chile's Patagonian national parks, this is a continent of staggering landscapes. Not to be outdone, Ecuador's Galápagos Islands lie offshore, an exceptional archipelago where wildlife rules.

OPPOSITE Trekking is one of the key activities in Chile's Torres del Paine National Park

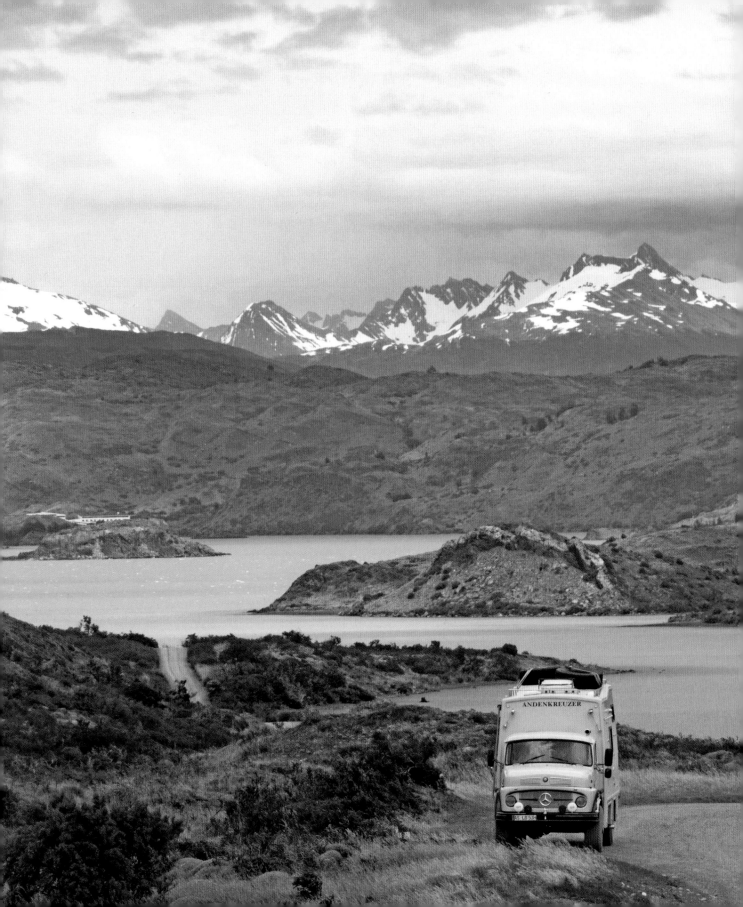

TORRES DEL PAINE NATIONAL PARK

Patagonia
Chile

Snow-capped peaks, icy lakes and Magellanic forests where pumas and guanacos roam.

There's nothing like a strong wind to make you feel at one with nature. At Torres Del Paine National Park, in Chile's end-of-the-Earth Patagonian wilderness, the Roaring Forties gale blows from the Antarctic. Its aching frigidity, at its strongest during the high tourist season, whips the hair, slaps the face and forces even the toughest of adventurers to bow protectively to its will.

This ill wind, typical in a subalpine cool climate, is the price many will gladly pay for access to one of the world's most monumental environments, a rugged expansive terrain of precipitous mountain ranges and dwarfing granite peaks formed by a process of natural glacial erosion. Deciduous Magellanic forests cover half the park, and flows from the Patagonian ice fields are responsible for slow-crawling glaciers, icy turquoise lakes and choppy rivers.

Covering approximately 6,728,744 hectares (25,980 square miles) near the closest big town of Puerto Natales, the park is named for the three humongous blue-hued granite peaks at its heart. With the tallest soaring more than 2500 metres (8200 feet), these 'towers of pain' look like scales on the back of a giant stegosaurus and appear to be conjured from a similarly distant and incomprehensible geologic period. When the incredible Andean condors, with their 3-metre (almost 10-foot) wingspans float on thermals around the cliffs and crags, it more than heightens the effect.

Neighbouring the towers along the Cordillera Paine group of mountains are the Cuernos del Paine, an equally captivating rock formation whose snow-capped cuernos or 'horns' create a heraldic illusion as they dance in the clouds. At the right angle, with an azure lake at its base, this heavenly landscape is intimidating in its grandiose scale – especially when seen at the end of the day,

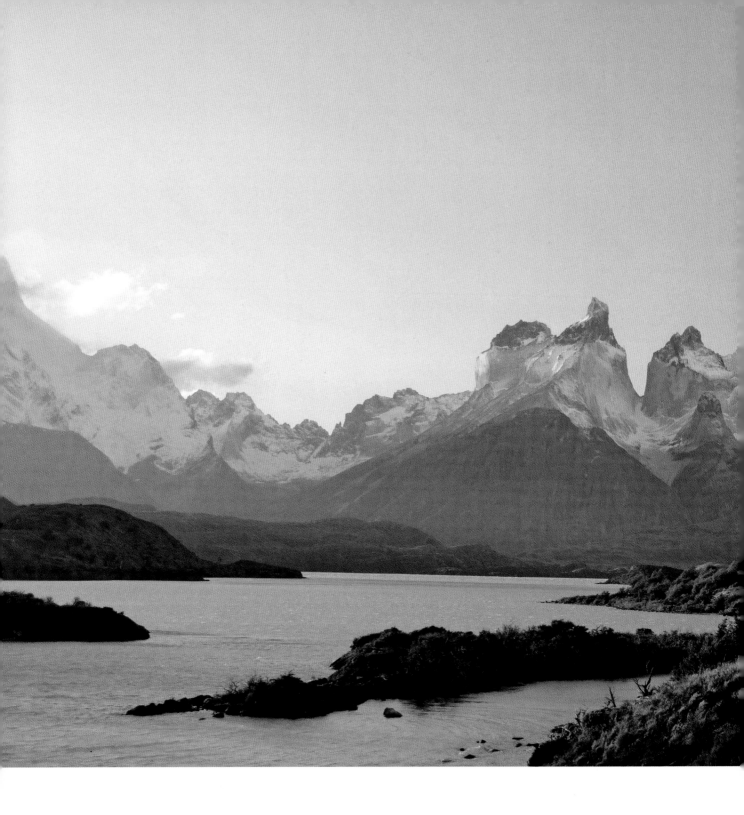

SOUTH AMERICA

glazed in the pink and lemony luminescence of a setting sun. We humans have never been better put back in our place by nature.

The park was named a Biosphere Reserve by UNESCO as far back as 1978 and has been tentatively listed for World Heritage status since 1994. It is one of a string of 24 parks that extend along Patagonia and one of 17 parks on the Ruta de Los Parques de la Patagonia touring route (*see* p. 174). Together they are said to be amongst some of the most protected natural landscapes in the world. Nevertheless, the wildlife, including the Patagonian puma, Chile's apex predator, has had a familiar battle with threats, including hunting, loss of habitat and declining food sources. Other troubled native species include the endangered llama-like guanaco, South Andean deer and Andean condor.

But the prospects of at least some of the native wildlife might be improving. Populations of guanacos and pumas are growing, and their progress is being closely monitored to understand their positive effects on the entire Patagonian ecosystem.

The Fundación Rewilding Chile has a Raptor Rehabilitation Center that returns injured condors to their natural habitat and increases community awareness about their importance in the local ecosystem. It also supports a puma conservation program, set up in 2008, which aims to promote both tolerance (puma are considered a menace by livestock owners) and public awareness, so that good tourism practices and conservation can sit side by side.

These good practices must deal with a spectrum of issues, including erosion of fragile native vegetation on walking trails, irreparable human-made fire damage and excessive visitor waste in campsites and on trails.

The mindful traveller will need to take all this into account. Torres del Paine has some of the world's best hiking, on overnight trails along the south side of the Cordillera del Paine and longer walks looping the peaks of Torres del Paine. For full scenic immersion, visitors can camp and stay overnight in refugios (eco-huts) or hostels run by local baqueano cowboys and their families. Horseback riding, kayaking among icebergs, glacial expeditions and road trips into the interior will be days well spent.

The wild weather and wondrous scenery of Torres del Paine National Park are sure to turn the heads and hearts of all those who visit. If the conservation approach turns minds too, then this remarkable wilderness will thrive.

RUTA DE LOS PARQUES DE LA PATAGONIA

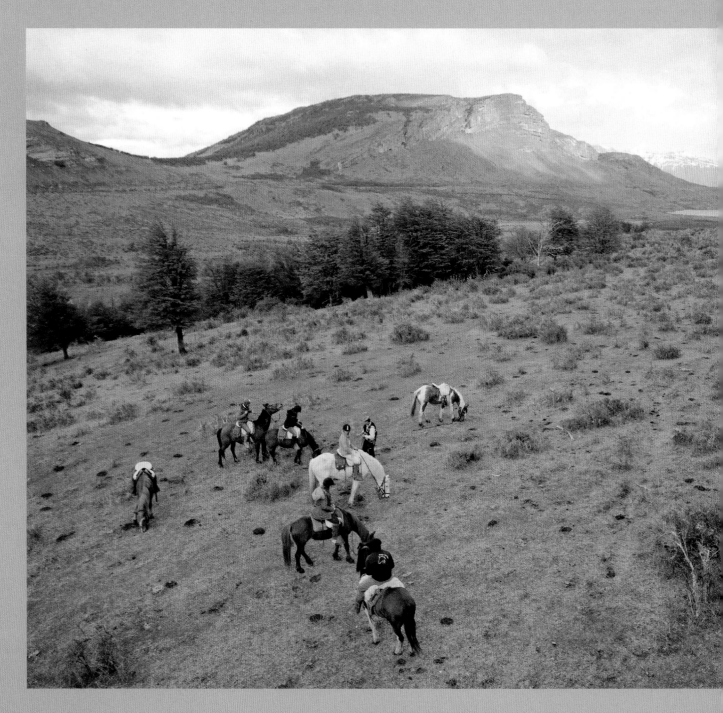

BELOW Horseriding at
Sofia Laguna Ranch,
near Torres del Paine
National Park

In April 2019, Tompkins Conservation officially handed over more than 407,000 hectares (over 1 million acres) of privately owned and fastidiously conserved wilderness to the Chilean government. The Chilean government also contributed 1,011,714 hectares (nearly 2.5 million acres) and reclassified 2,185,302 hectares (5.4 million acres) of nature reserves as national parks.

These unprecedented contributions were part of an agreement to create five new national parks (Pumalín Douglas Tompkins, Melimoyu, Parque Nacional Cerro Castillo, Patagonia and Kawésqar) and expand three others (Hornopirén, Corcovado and Isla Magdalena). Together with Torres del Paine (*see* p. 171) and eight other parks they then formed the truly awe-inspiring Ruta de los Parques de la Patagonia (Route of Parks of Chilean Patagonia). This is a driving route through Chile's green lung.

The 11.3 million hectares (28 million acres) of land over three regions is 'the equivalent of three times the size of Switzerland, or more than twice the size of Costa Rica', according to the Ruta de Los Parques's website. Ninety-one per cent of the land is protected national park territory, much of which is pristine ecosystem, a refuge for 140 species of birds and 46 species of mammals.

You can explore it along a 2800-kilometre (1700-mile) scenic, pristine and diverse route spanning the 17 national parks between Puerto Montt and Cape Horn in Chile's far south. The route connects the northern Carretera Austral, which winds its way along Chilean Patagonia, with the central Patagonian Channels and the southern Ruta del Fin del Mundo (the End of the World Route), which is where you'll find Torres Del Paine National Park (*see* p. 171). The route is an access point for exploring an unbelievable line-up of pristine environments, including lakes, glaciers, rainforests and cloud-covered valleys alongside more than 60 local communities.

The collaboration that united these parks should be held up as an exemplar of how governments and big business can come together to successfully create a more sustainable planet. Along this epic green corridor, a green lung for South America, endangered species have a chance of survival and a multitude of ecosystems have a chance to remain intact and even rewild without human hindrance. Wilderness conservation on such a phenomenal scale is a legacy the world can be proud of.

GALÁPAGOS ISLANDS

Ecuador

A Darwinian archipelago inhabited by endemic flora and fauna including marine iguanas and giant turtles.

With an impressive 97 per cent of the Galápagos protected by national park and marine reserve (Galápagos was the first-ever UNESCO World Heritage Site, inscribed in 1978), it makes sense that this archipelago in Ecuador has become a global showcase of endemic species and a world-beating conservation destination.

Way back in 1859, Charles Darwin founded evolutionary biology with the publishing of his *On the Origin of Species*, a seminal work that popularised the idea of natural selection, in short, that animal species evolve over generations to adapt and survive in their unique environments.

As is commonly known, the backdrop to the young naturalist's groundbreaker theory was Ecuador's Galápagos Islands, which Darwin had visited in 1835 while on a five-year circumnavigating expedition aboard the *HMS Beagle,* and later wrote about in *The Voyage of the Beagle*, published in 1839.

Through copious note-taking and meticulous research in the field, Darwin noticed that species of mockingbirds and finches found throughout the archipelago were unique to the individual islands they inhabited and that 'one species does change into another'.

The rest, as they say, is history. Today the archipelago's 127 islands and islets remain home to unfathomably unique ecosystems and a mind-bending array of animals.

The endemic diversity and often unusual quirks of the flora and fauna, inhabiting both land and sea, are attributed to the Galápagos's extreme isolation in the Pacific Ocean – it lies some 1000 kilometres (621 miles) west of the Ecuadorian mainland. It is also uniquely situated at the confluence of three

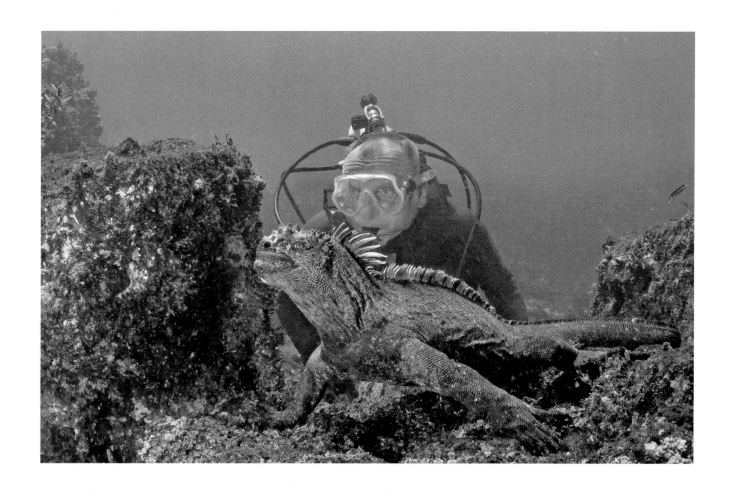

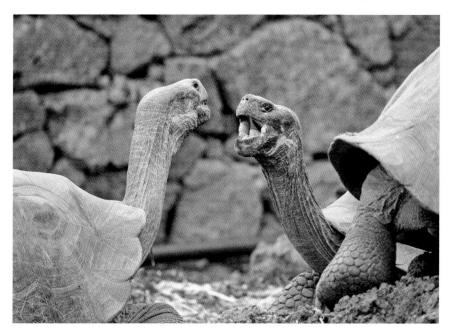

ABOVE Scuba dives in the Galápagos Islands reveal creatures such as the marine iguana

LEFT The mind-bending array of animals on the Galápagos Islands include tortoises

ocean currents, and at the apex of three tectonic plates, accounting for the islands' seismic and volcanic activity.

These factors are key to this being somewhat of a topsy-turvy world inhabited by flightless cormorants (the world's only), marine iguanas, giant tortoises (some as old as 150 years – the longest life spans of any animal on Earth) and myriad endemic species of animals, plants and birds.

Perhaps the best illustration of this point: all 36 reptile species on the Galápagos are endemic and most are considered threatened or extinct. In addition, so too are almost 20 per cent of the Galápagos's 2909 (and counting) marine creatures. They live alongside the usual (and unusual) fascination of marine life, including sea lions, whale sharks, hammerheads and manta rays.

This protection and nurturing of the natural environment serve to attract tourists but the much-needed tourist dollar is a noted conundrum and the Galápagos's biggest challenge. Tourist permits, strict quotas on different sites around the archipelago and systems for monitoring introduced species and managing waste, pollution and infrastructure all play a part in countering the problem.

Of the 19 major islands, only three are inhabited by humans. Many of the others offer a real-life Darwinian laboratory for natural-world exploration, with the different islands presenting a diversity of landscapes and wildlife. These islands are strictly controlled with limited tourists.

Like many of the animals that live here, visitors inhabit both terrestrial and marine worlds. On land, hikers traverse the rugged and arid volcanic landscapes to cross paths with giant tortoises and yellow land iguanas that look like they're from the dinosaur age. Beachcombers rock hop along white sand for a glimpse at hundreds of oily-black marine iguanas and the vibrant, red-crested male frigate birds.

On water, kayakers and boaters cruise through choppy waves where dolphins, sea tortoises and whales often break the surface. Snorkellers and divers immerse with sea turtles, tiny whizzing penguins (the world's smallest) and a universe of fish.

Visitors can also partake in naturalist-led walks, pop by the Galápagos National Park Interpretation Center to learn about the local ecology, and visit Fausto Llerena Breeding Center to get up close to species brought back from the brink of extinction.

Even walking the street on the main San Cristóbal Island provides encounters with the local fauna, the snorting sea lions lounging around being the most astounding. Wherever you are on the Galápagos archipelago, there's a sense of being immersed in an incredible landscape inhabited by endemic animals. In this age of mass extinction, that's hard to beat. Darwin would have good things to say.

PANTANAL WETLANDS

Brazil, Paraguay & Bolivia

A watery wilderness home to jaguar, caiman, wading birds and giant lily pads.

The Amazon, further north, might be better known, but the Pantanal Wetlands, bang in the heart of South America, where Brazil, Paraguay and Bolivia intersect, trump the jungle in terms of its spectacular array of biology.

This 169,968 square kilometre (42 million acre) hydrodynamic expanse of tropical wetland and flooded grass plains, most of it in the Brazilian state of Mato Grosso du Sul, supports in excess of 4700 plant and animal species. It is the world's most pristine tropical wetland and its largest, a natural phenomenon about the same size as Washington state in the United States, and slightly bigger than England.

This rich inundation of life is dependent on the mass movement of water, which occurs during the summer rainy season, from November to April. Waters in the Pantanal highlands flood into the dry lowland areas. As the water makes paisley patterns around forests and slowly seeps into shallow lakes, swamps and grassy plains, it reinvigorates the aquatic life and replenishes the soil nutrients turning the land into a flourishing paradise.

At the end of this period, from April to July, the waters ebb away, draining into the Paraguay River and its tributaries. In their wake is a watery wonderland of shallow lakes filled with hundreds of fish species and wading birds, including herons, egrets and spoonbills. A cacophony of croaking frog song fills the air while apple snails – a keystone species snorkelling away in the mud – play their part in the process of decomposition.

In the abundance of growth, tropical aquatic plants burst into life alongside semi-arid woodland plants typical in north-east Brazil. It's not uncommon to see

plate-size lily pads monopolising the surface of a lake and pink-flowering cacti in the same photo frame.

Larger mammals, having migrated to higher areas during the flooding, return to the wet, humid environment of the low-lying regions. The Pantanal is home to an estimated 10 million caiman (the largest concentration of crocodiles in the world), so it makes sense that their biggest predator, the jaguar, has put down roots here too.

Also in residence are native capybaras, which look like oversized hamsters, ocelots, anacondas and dainty marsh deer. Threatened species include beautiful maned wolves and armadillos, anteaters and otters, all the 'giant' variety. Even the birds are big here. Huge hyacinth macaws – the largest parrots on the planet, along with vultures and falcons – revel in the rich aquatic feast of flora and fauna at their disposal below.

The Pantanal supports an economy based around cattle ranching, agriculture and tourism. The one million visitors each year are never short of a wilderness experience.

From the north of Brazil, access to the wetlands is from Cuiabá and then via the Transpantaneira Highway, a 146-kilometre (91-mile) route dotted with ranch-style accommodation, eco-lodges and options for wildlife safaris, canoe trips and horseriding tours. Corumbá or Campo Grande are access points, respectively, for live-aboard riverboat cruises and the Estrada Parque, a hardy unpaved route through the southern Pantanal. To access the interior, a small plane is necessary, given the seasonal changes, extreme distances and lack of towns in the Pantanal.

The wetland is often touted as a UNESCO World Heritage Site, but in fact the listed Pantanal Conservation Area only covers 187,818 hectares (464,108 acres) or 1.3 per cent of the vast ecosystem. A small 3.7 per cent is globally significant national park and biosphere reserves while 95 per cent is privately owned, mostly by cattle ranchers.

The World Wide Fund for Nature (WWF) reports that the Pantanal remains relatively intact but that deforestation is an issue with more than 12 per cent of the forest cover already lost. If this continues, the WWF believes the Pantanal's native vegetation will disappear by 2050. Fires in recent years have also been widespread, contributing further to habitat loss.

Fortuitously, the Pantanal's natural assets are recognised by the home countries that rely on it. In 2018, Brazil, Paraguay and Bolivia signed the Trinational Initiative for the Integrated and Sustainable Development of the Pantanal, a landmark declaration agreeing to work together on issues such as pollution, water governance and climate change.

The seasonal inundation of water, the proliferation of wildlife and the aquatic paradise of plants make this one of the most magnificent ecosystems on the planet. May the round tables between its three governing nations continue.

RIGHT A jaguar stalks caiman on the edge of the Pantanal's Piquiri River

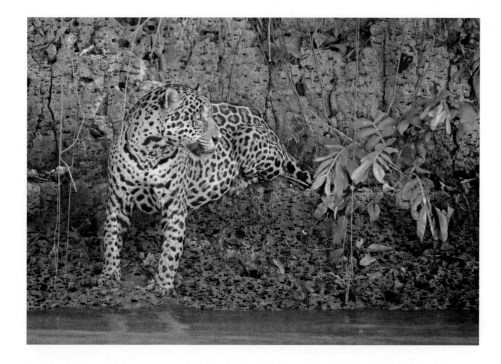

BELOW Plate-sized lily pads are a common sight on the lakes of the wetlands

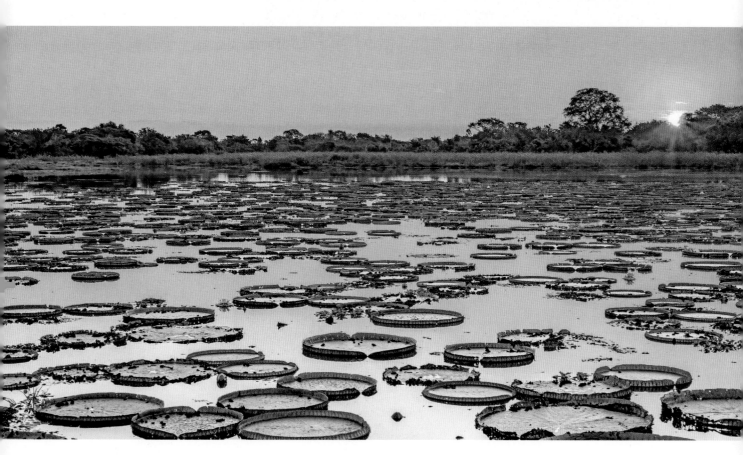

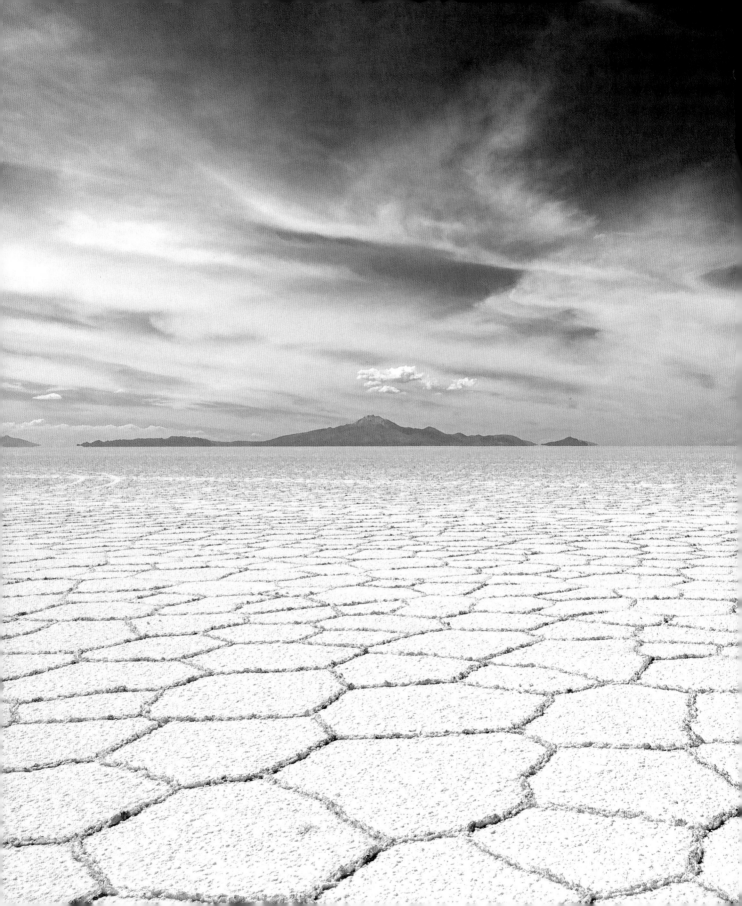

SALT PLAINS (SALAR DE UYUNI)

Potosí
Bolivia

An expansive salt desert with a magical mirrored surface.

El Salar, as it is known by the inhabitants of Uyuni, is the largest salt desert or dry lakebed in the world, a desolate and extreme environment brought into being by an astonishing thick monochromatic crust of salt. It is located more than 3000 metres (about 10,000 feet) above sea level, close to the highest, loftiest peaks of the Andes in the highlands of south-western Bolivia, near the meeting point with Chile and Argentina.

To say this wilderness is eye-catching is an understatement. The dried salt lake stretches some 10,000 square kilometres (3900 square miles), a seemingly never-ending glare of crisp, thick white salt crisscrossed with raised polygonal hive-like patterns.

In the cooler dry season, between May and November, visitors explore the terrain by car, seeing salt, like snow, extend miles and miles to far-off horizons. In the rainy season, between December and April, a thin layer of water from surrounding lakes covers the salt pan, and it has the qualities of a giant mirror stretching 129 kilometres (80 miles) across the Altiplano landscape.

The salt pan's exacting reflections have become the muse of a Google's worth of photos: tourists create various states of pose – high kicks, backbends and star jumps – and shiny four-wheel-drives (the vehicle of choice for exploring the salt plains) are seen in double below. The natural-world visuals are entrancing too. Clouds, puffed and windswept, are echoed underneath with symmetrical precision. Sunsets, blurred at the horizon line, beam magical displays of pinks and gold upon a clear blue sky. Icons of the salt plains – skinny flamingoes, and pointy snow-capped Andean mountains, unwittingly create their own stunning optical illusions.

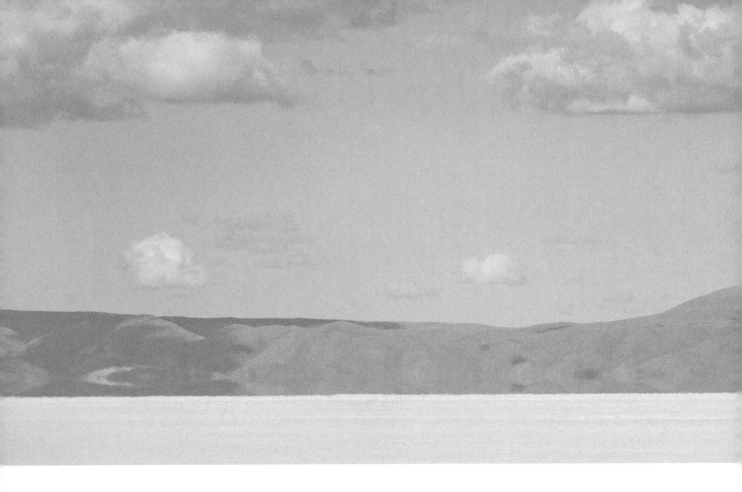

In the middle of the salt, flat black volcanic islands jut out of the white saline surrounds. The most popular is Isla Incahuasi, or 'House of the Inca' in the Indigenous Quechua language. The coral formations and fossilised seashells on Incahuasi are a hint at the 40,000-year-old past when prehistoric Lake Minchin covered most of Bolivia. Over the millennia, the lake transformed into smaller lakes filled with mineral run-off from surrounding mountains. When the waters finally evaporated, the salt residue remained.

Naturally, the salt saturation renders El Salar almost devoid of vegetation and wildlife. Slow-growing giant cacti is one of the few plants to survive on the volcanic islands, the domain of Andean fox and native viscachas (which look like rabbits). Shrubs are limited to the likes of quinoa – an important local food staple, and thola – which is used for fuel. Three species of flamingo, including the rare James's flamingo, owe their survival to the local brine shrimp.

Resting below a layer of salt, this brine is also rich in lithium, the element used to make batteries and power everything from smart phones to laptops and electric cars. Ring any alarm bells? Lithium extraction – an industrial process using large quantities of water and other chemicals – would undoubtedly have

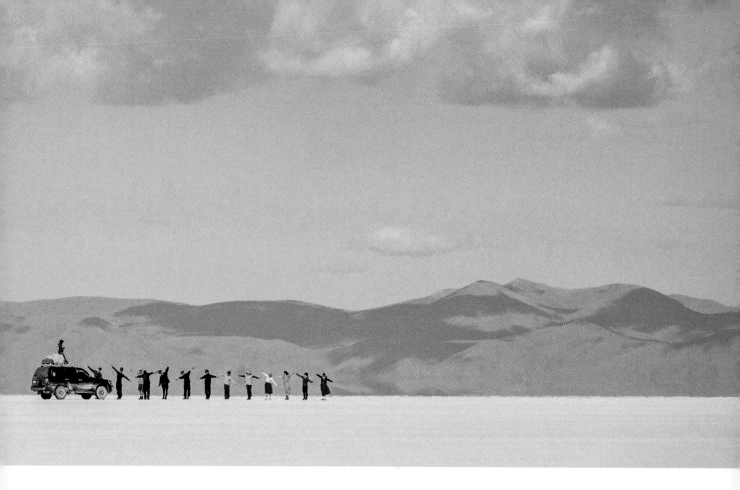

an environmental impact on the salt flats and surrounding landscape if it goes ahead. According to a 2021 article in *The New York Times* by Clifford Krauss, 'eight foreign companies have been competing ... to establish pilot lithium projects here, including four from China and one from Russia'.

That other mineral – salt – has been traditionally harvested by local Indigenous communities for centuries, the blocks of salt striped by thin layers of brown sediment that mark the rainy seasons over the years.

This abundant resource is also used to make handicrafts and souvenirs and other more ambitious creations. In the salt-processing town of Colchani, wondrous alternative hotels are made entirely of salt. Rooms have views over the salt plains to distant mountains, and guests sleep in beds made of salt, dine sitting at salt-crafted tables and chairs, and taste the salt – with its own nuanced flavour according to local people – in their Andean-flavoured meals.

Staying in a hotel made from salt is as surreal as the mirrored images and mirages of the salt plains themselves. Such a unique and other-worldly place highlights our planet's boundless capacity for diverse habitats and ecosystems, and humanity's persistent survival in them. It is wilderness sure to overwhelm.

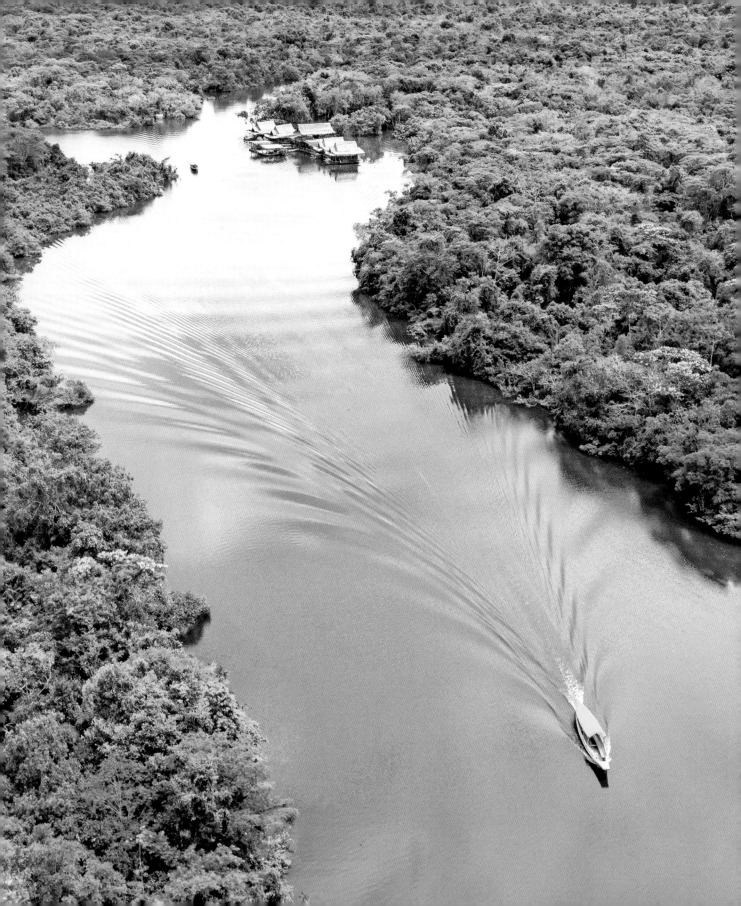

AMAZON RAINFOREST

Brazil & beyond

A ginormous jungle and river system spread across nine nations.

The Amazon rainforest is probably the planet's best-known natural-world habitat. Its alias, the Amazon jungle, still conjures – especially among children living on the other side of the planet, like mine – an inconceivable world where dolphins live in rivers, big cats prowl around dense tree canopies and pythons are camouflaged by arm-size tangled vines. It's a place that sparks curiosity and ignites a taste for adventure.

If the rest of the world somehow disappeared leaving only the Amazon rainforest, one in ten of all known species on the planet would still exist. One in ten. That's a remarkably significant biomass concentrated in one area.

As a mega carbon sink, the Amazon plays a major role in the stability and vitality of the planet. It's also huge. With the Amazon River spreading its tributary tentacles through it, the rainforest occupies 5,500,000 square kilometres (2,100,000 square miles). This evergreen collage covers almost 80 per cent of the entire Amazon Basin, which amounts to 1 per cent of the planet. The swath of ecosystems and habitats is spread across nine countries, Brazil being the largest with roughly 60 per cent and the rest shared among Bolivia, Peru, Colombia, Ecuador, Guyana, Suriname, Venezuela and French Guiana.

At the Brazilian heart of the Amazon is UNESCO's World Heritage–listed Central Amazon Conservation Complex, a collaboration of two national parks: Jaú and Anavilhanas, and two sustainable development reserves: Amanã and Mamairauá. Covering 6 million hectares (23,000 square miles), it is a microcosm of the ecosystems found throughout the Amazon.

Put a god-like magnifying glass on this conservation hot spot at the confluence of the Negro and Solimoes rivers and you'll spy wet and dry forests,

whitewater rivers, huge lakes that end in waterfalls and an archipelago of flooding swamps and waterways that protect endangered aquatic creatures.

Amazonian manatee, a grey, wrinkled freshwater species known for its friendly disposition, live in the flooded woodlands and plains. Pale pink Amazon River dolphins add a touch of the fantastical too, their uniquely long snapping beaks feeding on turtles, fish and freshwater crabs.

Prowling in rainforest habitats considered 'virtually pristine wilderness' by UNESCO is a cornucopia of animals including the endangered black squirrel monkey and comical golden-backed black uakari primate. Giant otters, jaguars and black caiman, a relative of the alligator, are regulars on the riverbanks and waterways. The treetops are lorded over by harpy eagles.

In other regions, the Amazon's rich tapestry of diversity includes the southern two-toed sloth, critically endangered caquetá tití monkey and hoary-throated spinetail bird.

In addition to this stunning diversity, the Amazon is a natural carbon sink with 76 billion tonnes (84 billion ton) of carbon stored in its rainforests. It's also responsible for creating its own water cycle. About three-quarters of its rainfall – or 20 billion tonne (22 billion ton) of water – is released into the atmosphere daily, becoming a water source recycled through other Amazon Basin habitats.

Tragically, as much as 20 per cent of the rainforest has been deforested in the past 50 years. Logging for agriculture, urbanisation and illegal trade continues to be an issue despite what we know about carbon emissions, water scarcity and climate change.

According to World Wide Fund for Nature (WWF), logging in Brazil has increased year on year for the past five years and it doesn't look like slowing. Wildfires have followed, eviscerating a heartbreaking amount of forest. The fear now is that the Amazon will soon reach a tipping point, a threshold where the rainforest will not recover and only grasslands and arid landscapes will replace it. The effect on the planet, and on the local populations who depend on the rainforest for food, water, clean air, shelter and medicine, would be catastrophic.

Brazil is first port of call for people wanting to visit the Amazon, followed by Peru, then Colombia, Bolivia and Ecuador. Accessibility and immersion levels vary between countries, but visitors can be sure of spending much of their time on boat trips along the mighty Amazon River and its tributaries, and in eco-lodges, homestays and villages thick beneath the jungle foliage.

Rainforest walks, trekking tours and explorations via canoe and kayak are essential. Following a machete-wielding guide through the jungle on paths only known to him is a memorable experience. So too are fishing for piranhas and croc-spotting by torchlight, those glistening eyes following your canoe through the pitch-black Amazon ... it's the stuff of childhood adventure stories.

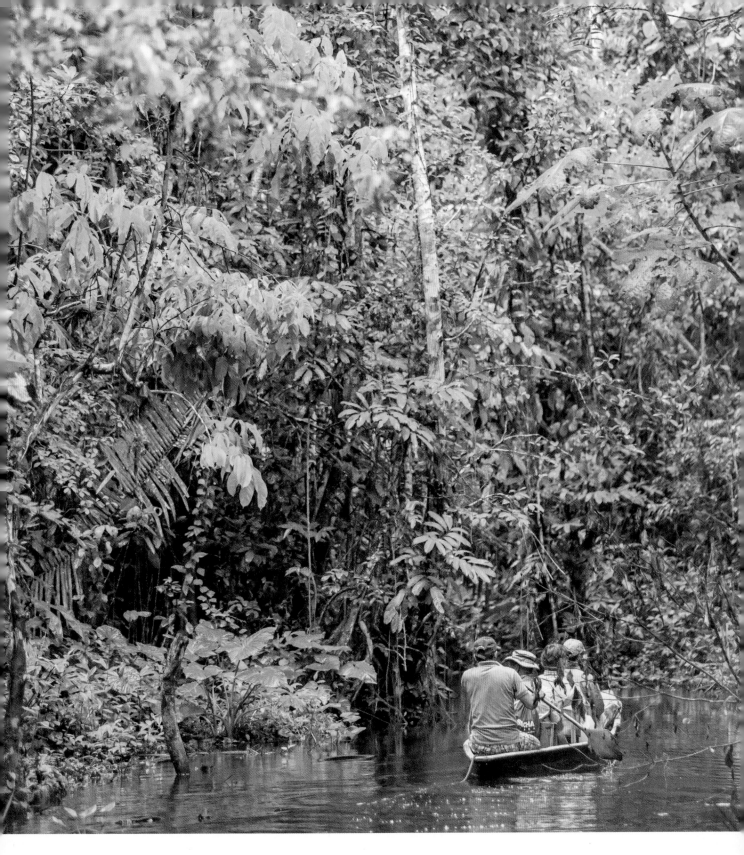

AFRICA & THE MIDDLE EAST

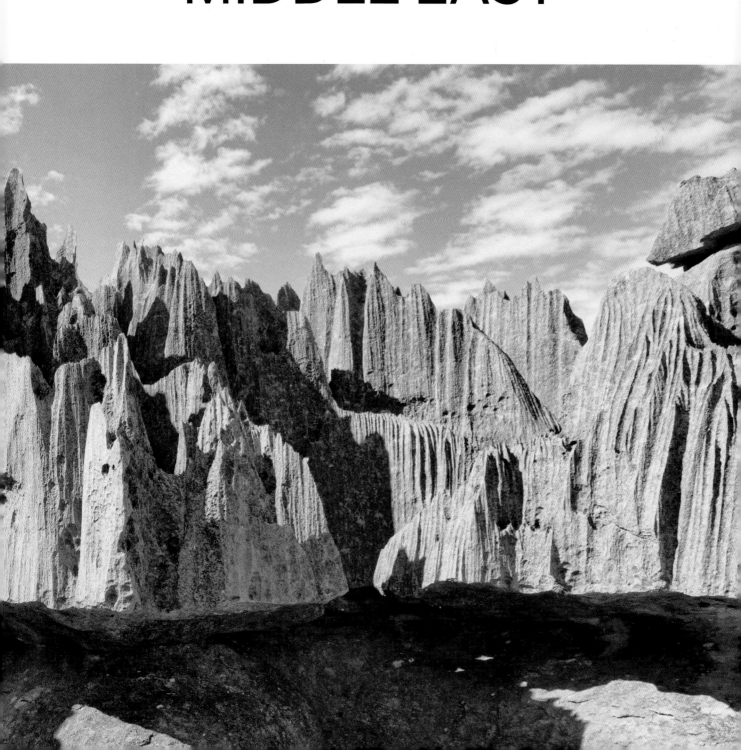

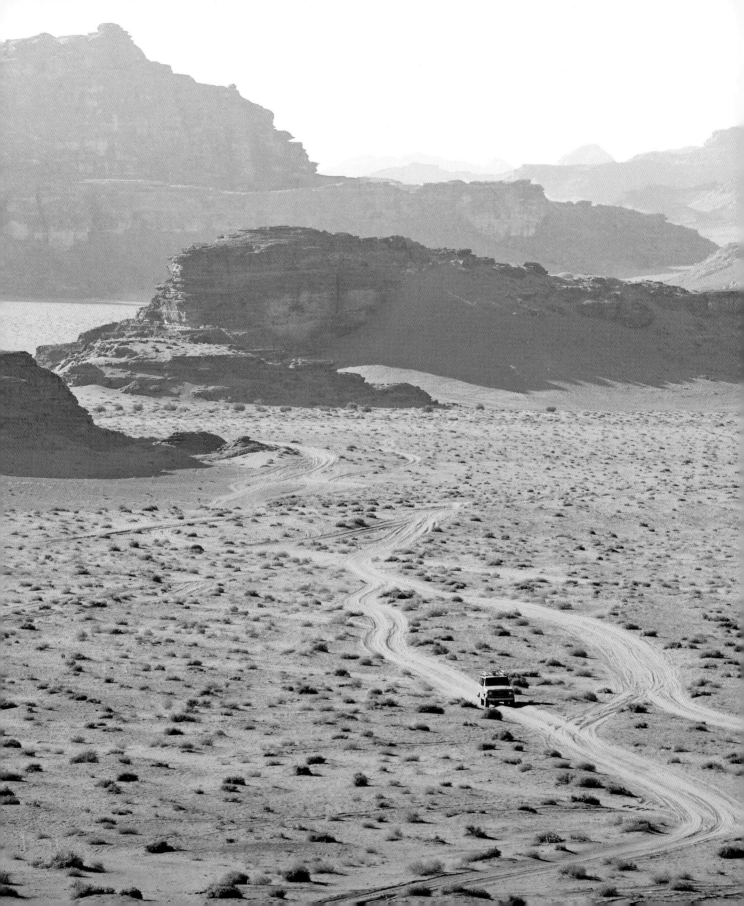

Planet Earth's second largest continent is neatly delineated, a huge landmass surrounded by five bodies of water stretching from the Mediterranean in the north right down to the South Atlantic and Indian oceans. Its 54 different countries, from large and populous Sudan and Ethiopia to small and lesser-known Burundi and Comoros, are mapped across the land like a colorful fabric, each one rich in its own cultural identity and traditions.

Africa's incredible landscapes and natural-world wonders are similarly diverse, from the hot deserts of the northern Sahara to the rainforests of the west coast and the temperate floral grasslands in the south. These wildernesses have flourished and foundered along with the world's oldest human population for more than five million years, and they continue to do so, especially where climate change is concerned.

Many of Africa's wildernesses have wildlife at their heart, from the great gathering of animals on the Okavango Delta in Botswana to Uganda's growing gorilla population and Madagascar's endangered lemurs. Tanzania's Kilimanjaro is in this chapter too, the fantastically picturesque glacier-topped mountain towering above a savannah reaching to the horizon. The delicate balance between wildlife and human populations, be they tourists or locals, is problematic in these destinations.

The deserts of North Africa extend eastwards to the Middle East, where you'll find Jordan's extraordinary desert of Wadi Rum – another place for adventure in an ancient land.

OPPOSITE The iconic red desert landscape of Jordan's Wadi Rum

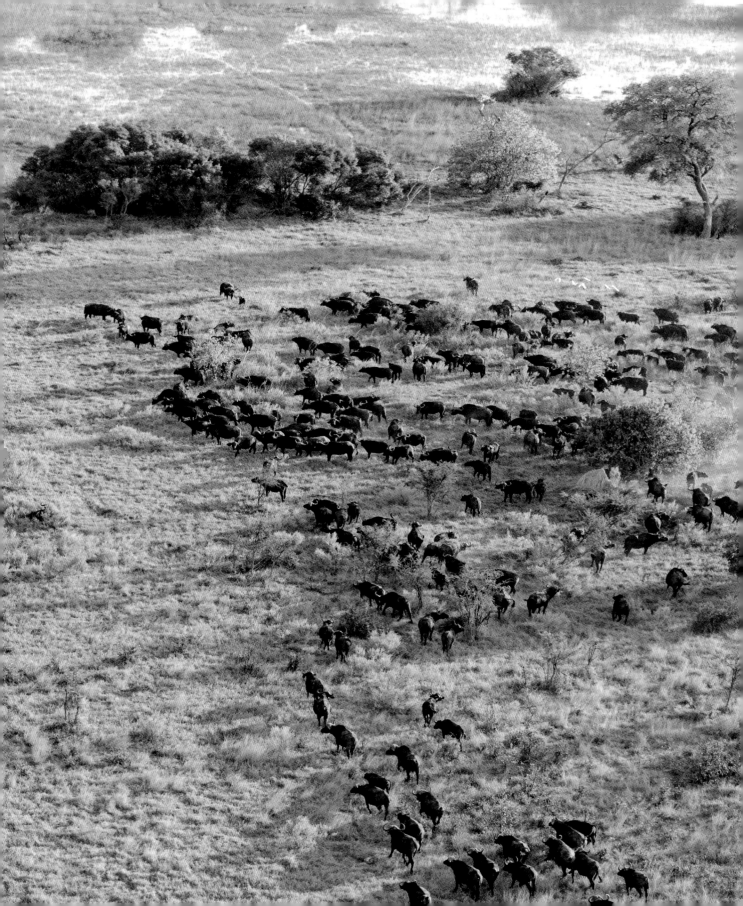

OKAVANGO DELTA

Botswana

A flooded landscape attracting rhinos, elephants, cheetah and other endangered species in one of the world's biggest animal migrations.

Lions wade through the reeds, their sandy manes dragging in the water like beards. Water buffalo, a mellow crowd with horns parted on their foreheads, flick flies in the shallows, uninterested in the long-limbed wading birds around them. In the still slick of the lake, hippo eyes and ears look like little slippery black islands, and the animals occasionally rise above the waterline to yawn, their bottom teeth, like champagne corks, bared. Elsewhere, a cheetah spreads its silken limbs along the branch of an acacia tree, eyeballing anything that moves beneath it. Herds of elephants take to higher drier ground, their thumping strides causing dirt to ripple into the air.

If ever there was a Noah's Ark of animal migration it is this one in Botswana's Okavango Delta in the heart of Africa. Such is the majesty of this animal kingdom, UNESCO recognised it as a World Heritage Site in 2014, noting it had 'some of the world's most endangered large mammals'.

The landscape is not to be outdone either. When the winter comes, the wild dust-dry Kalahari Desert is transformed by a watershed – an inundation of flooding water that filters through peat deposits, drains into Angola's Cubango and Cuito rivers, then seeps into the delta's sandy masses. The life-giving nutrient-rich waters that have travelled over six months from source to destination fill the lagoons and swamps of the Okavango, creating islands, swamp and grasslands that, from the sky, resemble green opal swirls. The landscape transformation from arid wasteland to dynamic wetland is as miraculous as it is essential. Having survived the migration across the desert and the previous dry season, Africa's iconic beasts need this inundation to hunt, drink, bath, luxuriate, even play, in the oasis of water.

AFRICA & THE MIDDLE EAST

Not surprisingly, this resilient ecosystem supports a huge biodiversity of habitats and nearly 2000 species both microscopic and huge – the most obvious of which is the African savannah (or bush) elephant. Incredibly, the delta has the world's largest population of about 130,000 elephants and is key to the survival of the species. The elephants keep company with 130 species of mammals, including the endangered African wild dog, giant ground pangolin, cheetah, black and white rhinoceros and lion.

Some 400 species of birds, 24 of them threatened species, similarly inhabit this inland delta. Picture vultures circling the huge jackalberry trees, southern ground hornbills pecking around the trunks of wild date palms, and wattled cranes throwing their elegant reflections onto still water. The list of plant, reptiles and fish that flourish in this environment is similarly impressive.

The Delta's vast size, swelling from at least 3100 square kilometres (1200 square miles) to around 7700 square kilometres (3000 square miles), and inaccessibility account for it being largely untouched by humans. It is thus one of the planet's most pristine natural environments – a wilderness by anybody's definition.

Like other countries whose waters spring beyond the national borders, the delta's long-term challenges lie beyond Botswana in neighbouring Angola and Namibia, where the rivers and lakes that feed the delta are not protected. The Nature Conservancy in Africa reports that Angola, a developing nation, has more than 50 large-scale water infrastructure projects under consideration – including dams for hydropower that threaten to divert floodwater from the delta. The answer lies in creating viable alternatives for Angola to grow and develop while conserving natural environments. In 2018, the Nature Conservancy together with Angola, Botswana and Namibia signed a 'Memorandum of Understanding' with the Permanent Okavango River Basin Water Commission to ensure this happens.

In the short term, tourism, farming and even – still – wildlife poaching are issues.

The delta itself is protected by reserves and managed parks, and tourism and development are focused on having minimal impact. Approximately 100,000 people visit the delta's 60 or so camps annually. The visitor experience includes everything from rustic bush huts, basic tents and simple guesthouses to luxury safari camps and chic eco-lodges. Wherever you stay, the focus is less about the linen thread count, more about the habitats and wildlife.

One of the oldest regions is Moremi Game Reserve, covering almost 5000 square kilometres (1900 square miles) in the east of the delta. Its conservation story harks back to 1963 when the mohumagadi (queen) of the local BaTawana People, Elizabeth Moremi, noticed the negative effects of hunting on the animal population and started overseeing its conservation. The park is named for her husband, Chief Moremi III.

Moremi's diverse landscape is head-turning, from papyrus-flanked rivers and lagoons to mopane and acacia woodlands. Visitors can spot grazing

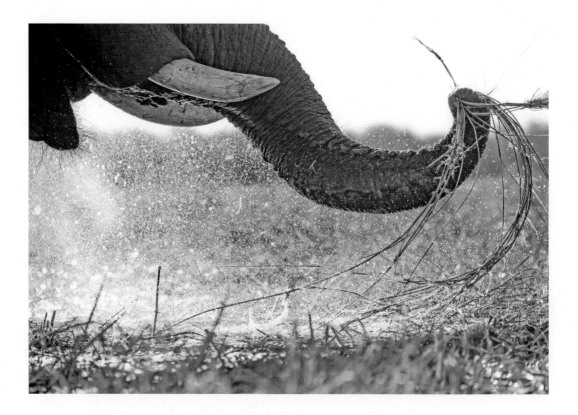

elephants from the wooden decks of their accommodation or see skinny-legged wading birds from narrow wooden boats skimming through lily pad–laden lagoons. Safari tours track cheetahs, lions and leopards in open-topped jeeps.

Neighbouring Chobe National Park, spanning 11,700 square kilometres (4500 square miles), is similarly absorbing with the highest concentration of iconic African wildlife in Botswana. Its river safaris are excellent for spotting huge concentrations of elephants, lions and zebras drawn to the permanent river water sources.

In the Okavango Delta, the wildest of animals live in the wildest of environments. If you've promised yourself a wilderness safari with an abundance of Africa's most enigmatic creatures, this is the place.

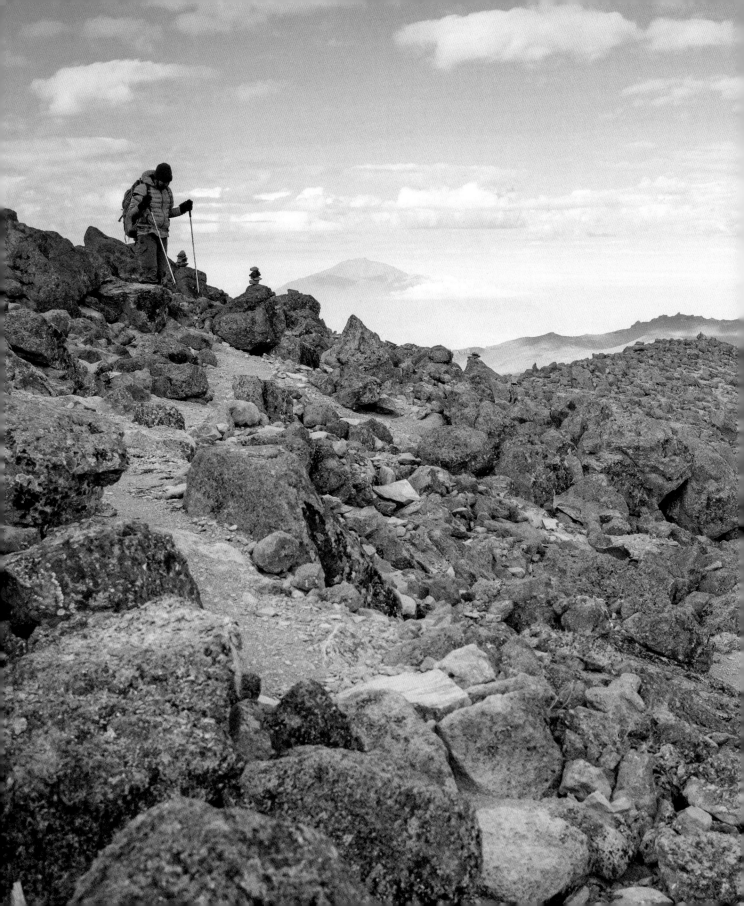

KILIMANJARO NATIONAL PARK

Kilimanjaro
Tanzania

A glacier-topped volcanic peak erupting from a savannah of wild roaming beasts.

Mount Kilimanjaro is an example of nature's grandeur surpassing our own humanity. This astounding free-standing volcanic mountain – the world's largest – rises 4877 metres (16,000 feet) above Tanzania's expansive savannah plains to a summit of 5895 metres (19,341 feet). Somewhat implausibly, given our notions of a hot, arid African terrain, Mount Kilimanjaro is snow-capped; its glistening white glacier top dances with the clouds, offering a surreal and unexpected backdrop to a typical panorama of elephant herds, flat-bottomed acacia canopies and curious giraffes.

This seismic marvel has three volcano cones: namely Kibo, which is dormant, and Mawenzi and Shira, which are both extinct. When you think about it, it is hardly surprising that it is snow-capped. Kibo, which last saw activity as long as 150,000 years ago, tops out on Uhuru Peak (Uhuru means 'freedom' in Swahili) at 5895 metres (19,341 feet). That's nearly 6 kilometres (3.7 miles) into the air, which is reaching into aviation space. Standing on its summit is the equivalent of being three-quarters of the way up Mount Everest. Kenya's mountain peaks are way below.

Kilimanjaro is protected by the eponymous national park, which occupies 1688 square kilometres (652 square miles) of Tanzania's northern Kenyan border. Another intriguing aspect to this behemoth geographical marvel, and one that helped see it World Heritage listed by UNESCO in 1987, is its distinct layering of different ecosystems experienced at varying altitudes as you walk from the savannah to the summit.

The lowlands, known as the Cultivation Zone, are home to the local Chagga People, the land distinguished by cultivated crops of banana and maize, and

coffee and pine plantations. These agriculture lands are home to farming and domestic animals: chickens, dogs and goats.

Then comes tropical montane forest, the Forest Zone, the richest habitat for flora and fauna. It's occasionally home to roaming elephants, but more often leopards, nocturnal civets and honey badgers, western black-and-white colobus monkeys and, in the camphorwood trees, Africa's beautiful sunbirds.

The trees gradually thin out to become knee-high moorland growth, the Heather–Moorland Zone, where forests are no longer supported. Instead, giant heath trees and wildflowers including the iconic protea, populate the drier soils.

Above 4000 metres (13,000 feet), the Alpine Desert Zone is denuded of trees, and the wildflowers change to hardier varieties the higher you trudge. Micro habitats of rock-covered algae and fungi and smaller unseen critters, insects and spiders, live here.

Finally, the Arctic Summit Zone, which has mighty light-refracting glacier walls that help form an icy wonderland where triangles of crystalline ice look like thousands of tiny minarets. From up here the curvature of the Earth is discernible on the horizon line. It's a sight to see.

Over-tourism and its associated pollution are some of the park's challenges, alongside illegal logging, habitat encroachment and animal poaching. Climate change is having an effect too. A 2022 *World Heritage Glacier Report*, by UNESCO and the International Union for Conservation of Nature, states that 10 per cent of glaciers across the globe, including those on Kilimanjaro, will recede, then be lost entirely by 2050. The disappearance of these glaciers is 'among the most dramatic evidence that Earth's climate is warming,' the report says. That they will melt regardless of any future climate action is an extremely sobering fact.

Kilimanjaro is one of the most popular climbing mountains in the world and thousands test their mettle on it each year. The challenges are many. Trekking through the five climate zones means trekking through weather patterns that range from hot and humid in the Cultivation Zone to freezing in the Alpine Desert and Arctic Summit zones. Rainfall and erratic weather conditions, expected or otherwise, can turn a climb into a battle against hypothermia. Altitude sickness is another major hurdle. Even with appropriate equipment, a high level of mental and physical fitness and qualified guides, the stress and discomfort of such conditions can be insurmountable.

There are seven different official routes up the mountain: the Marangu, Machame, Umbwe, Northern Circuit, Lemosho, Shira and Rongai. They are shared by some 40,000 trekkers each year. Each route has its unique pros and cons. For example, Rongai offers a true wilderness experience at the start of the climb but a tough final summit; Umbwe is remote with few crowds but has poor acclimatisation due to a steep short ascent.

The Marangu trail is supposedly the easiest walk with a gentle ascent to Uhuru Peak on the crown-shaped iced-over summit of Kibo and no special gear or technical skills are required. But about one-quarter of those who attempt

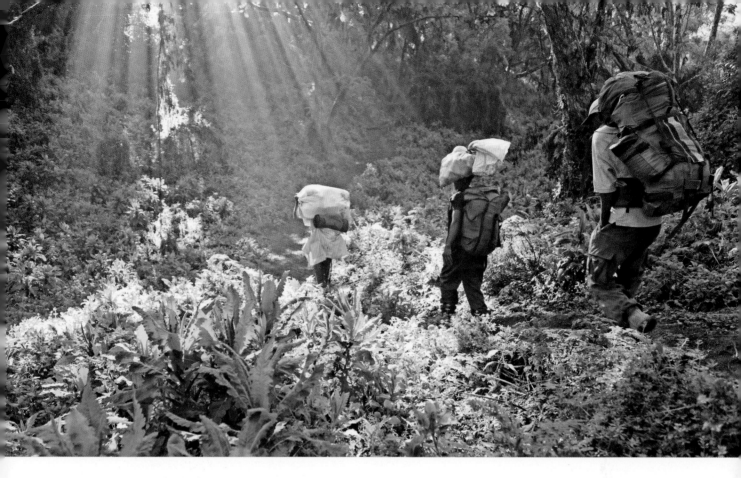

this summit don't succeed. Most who fail suffer acute altitude sickness on account of ascending in five days, rather than seven as is necessary on the other routes. They turn tail and head back down the trail before ever getting the selfie: the one with that simple wooden sign that tells you you've made it to Africa's highest point, that you're higher than anyone else on the entire African continent.

The routes with the highest success rate are the Lemosho and Machame, which take seven to eight days, thereby allowing climbers to acclimatise – a little lesson in slow travel perhaps.

The recommended time to climb is during the dry periods from December to mid-March and mid-June to October when blue sky views reach to the horizon line. The shoulder season before the rain has fewer climbers, but the risk is less reliable weather.

Of course, conquering this impossibly beautiful mountain is not essential, or even necessary. This snow-capped peak looming large in the blue sky behind the craning neck of a giraffe or the lazy meanderings of a herd of elephants is one wilderness that pays dividends from a distance.

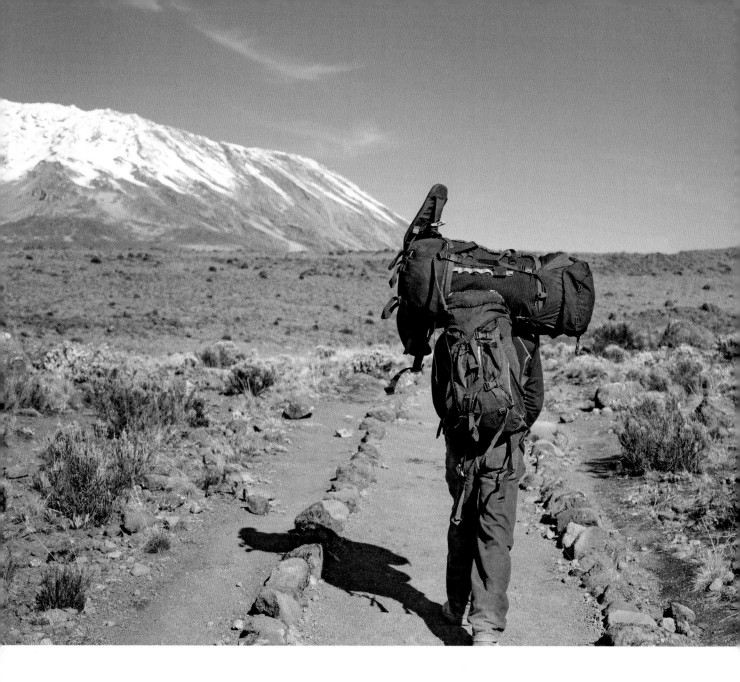

AFRICA & THE MIDDLE EAST

BELOW Giant groundsel plants are among the unique species found in Kilimanjaro National Park

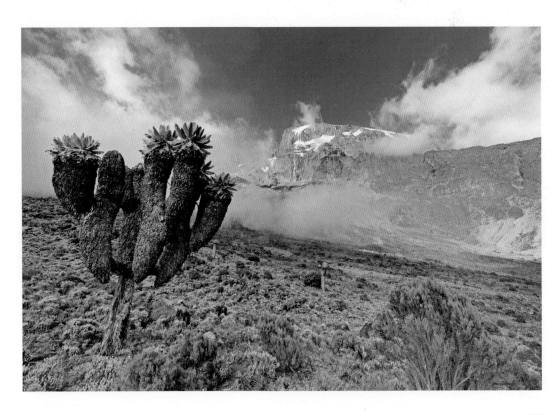

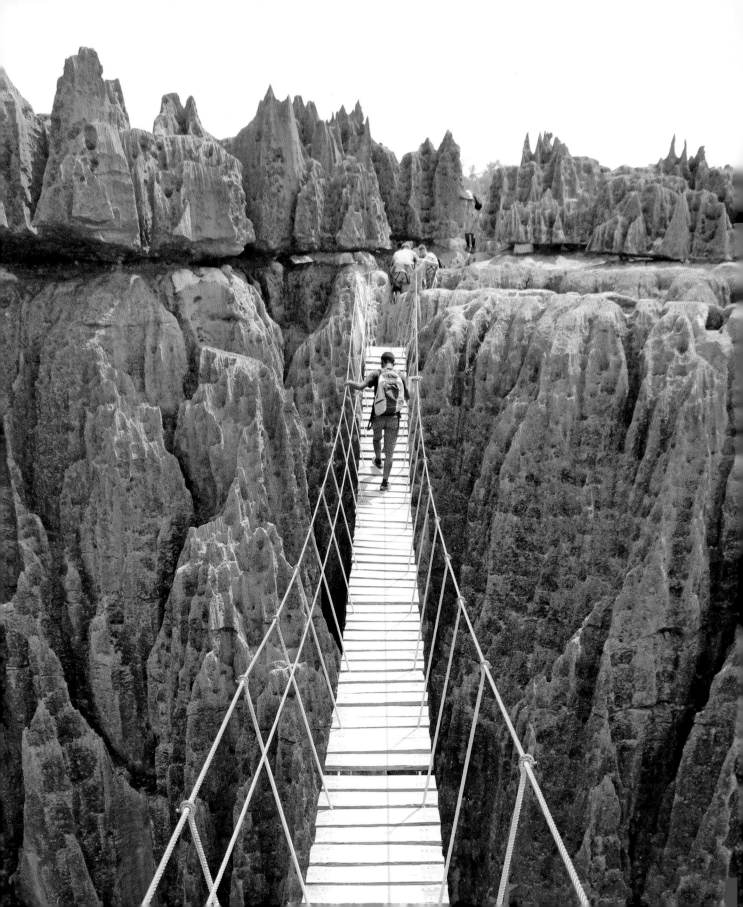

TSINGY DE BEMARAHA NATIONAL PARK

Malaky
Madagascar

A remote woodland and limestone karst landscape where lemurs nimbly tread.

It's challenging not to instantly link Madagascar, the African island nation, with the 2005 Dreamworks movie of the same name. In it, King Julien, the very amusing ring-tailed lemur protagonist, performs the hip-thrusting song 'I Like To Move It' to a writhing audience of jungle animals, gifting viewers the world over with an ear worm forever associated with the destination.

King Julien and his rendition of the Will.I.Am song also drew positive attention to Madagascar and its best-known cute-as-pie native inhabitants, lemur, of which there are 107 different species. If any animal needed positive global attention, it's this one. In 2020 the International Union of Conservation of Nature reported that almost one-third of all lemur species in Madagascar are now critically endangered. Almost all of them – 103 of the possible 107 – are threatened by extinction.

Tsingy de Bemaraha National Park, in the Malaky region on the country's west coast, is one place to see lemurs in the wild. Covering 152,000 hectares (586 square miles) and declared a UNESCO World Heritage Site in 1990, this extraordinary landscape features both mountainous wooded terrain and limestone karst forests in equal measure.

Its 80,000 hectares (309 square miles) is a land of mountaintops, canyons and gorges, all blanketed in rainforest. Deciduous dry woodlands cover the grassy savannah and lowland areas where mighty baobab trees spread giant shadows across the parched soil.

Two wild seasonal rivers – Manambolo and Tsiribihina – run through the park providing torrid waterfalls that feed the lakes, mangrove swamps and marshy plains full of fish, reptiles and birds.

But most impressive of all are the park's formidable limestone karst outcrops. This veritable forest of silvery jagged formations has peaks so pointy and razor-sharp, you'd think they were specifically made to keep barefoot *Homo sapiens* out. That the Malagasy word 'tsingy' means 'where one cannot walk barefoot' or 'tip-toes' seems to prove the point.

Like the Bisti/De-Na-Zin Wilderness in New Mexico in the USA (*see* p. 43), Tsingy's limestone landscape is a geological badlands, a terrain hewed by centuries of elemental erosion, where rain and streaming water are gradually wearing away at the big grey limestone slab. The dab hand of nature has weakened the porous stone creating caves, cathedrals, slot canyons and tunnels that have in turn fallen away leaving cities of sharp-edged pinnacles and fortress walls, sometimes more than a kilometre (half a mile) high.

Tsingy's inaccessibility certainly works in its favour for visitors looking for a real wilderness adventure. The hub village of Bekopaka, where you can find accommodation, food and guides, is accessible in the dry season only (April to November). Even in the dry season, the dirt road journey has two rough-and-ready car ferry river crossings. Those who do make the journey can climb with a guide (and a harness) to Grand Tsingy – the highest point of the limestone karst system – via a network of photogenic aerial suspension bridges and ladders. Walking to Tiny Tsingy – a labyrinth maze of limestone pinnacles – is recommended too.

The other major upside to the impenetrability of this natural-world sculpture park is the lemur population. An environment so unforgiving to humans has become one of the best places to see diverse and endemic plants and animals, including at least 11 different species of lemur.

These wet-nosed nocturnal primates with long tails, pointy noses and cutesy faces are to Madagascar what koalas are to Australia and pandas are to China. They have evolved endemically on the island and cannot be found anywhere else in the wild.

Tsingy's lemurs, including fat-tailed dwarf and Sambirano lesser bamboo lemurs, have adapted to the mountains, rivers and rocky plateau alongside 13 amphibians and 50 reptiles, including antsingy leaf chameleon, the native long-tailed skink and the newly identified leaf-tailed gecko. The endangered Madagascar fish eagle is one of more than 100 impressive bird species to train your binoculars on.

Only the hardiest animals can exist on the needle-sharp tops of the park's limestone pinnacles. The most magical to watch is the adorable, black-faced white-furred Decken's sifaka, a lemur whose ghostly, gangly form gracefully leaps between pinnacles much like monkeys in a jungle, bearing the heat and humidity of the day with apparent ease.

With 90 per cent of Madagascar's species found nowhere else on Earth, their reliance on this ecosystem is profound and worrying in equal measure. In greater Madagascar, the critically endangered status of many lemur species is blamed on hunting, and declining forest habitats – the result of logging,

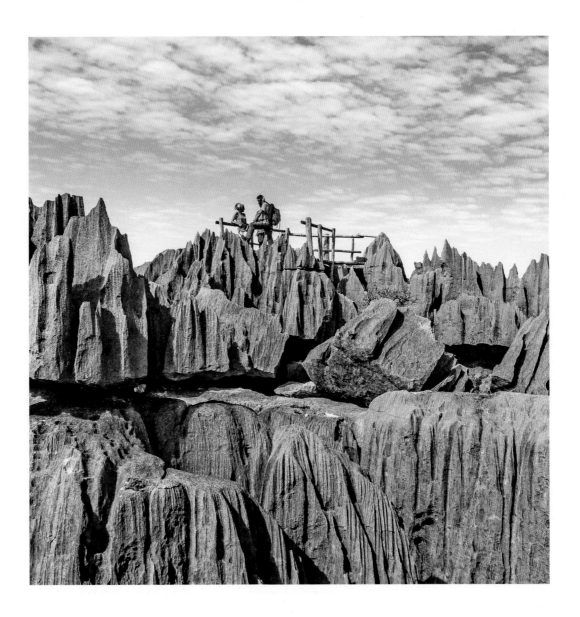

Lookout points in Tsingy de Bemaraha National Park sit atop needle-sharp limestone pinnacles

gathering wood for fuel and agricultural burn-off. In the areas bordering the park, wildfires in grazing country are also an issue.

Conservation organisations are striving to promote ecotourism as a way of stimulating local development without negatively impacting on the park. Education campaigns about protecting the park and its creatures, particularly the lemurs that encourage the much-needed tourism, are part of the strategy. It's a virtuous conservation cycle that destinations the world over are trying to get right. Sightings of red-fronted brown lemur and Decken's sifaka – the extremely cute white one with the black face – are assured, at least for now.

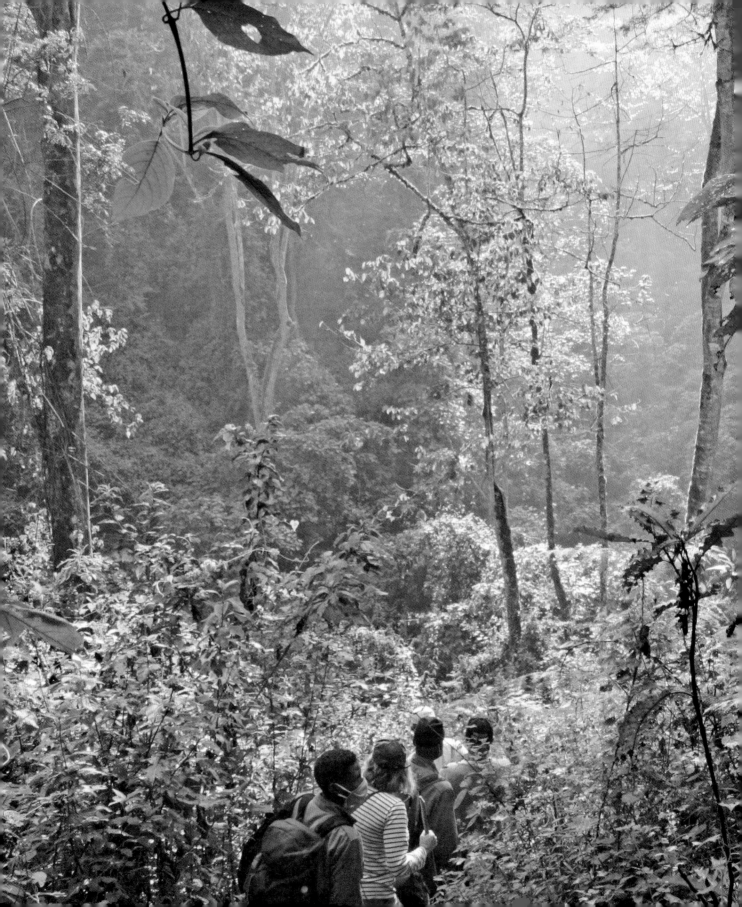

BWINDI IMPENETRABLE NATIONAL PARK

Kanungu District
Uganda

Thick misty jungle terrain that a growing number of gorillas call home.

At last count, in 2019, the global mountain gorilla population had risen to 1063, up from an estimated 400 in 2011 when the future survival of these primates was in question. Their status has since been re-categorised as endangered rather than critically endangered, which is a rare improvement in these days of disappearing species.

Of these gentle giants, 459 reside in the thick, high-altitude montane terrain of Bwindi Impenetrable National Park (part of Bwindi Impenetrable Forest), a biodiverse hot spot in south-western Uganda on the edge of the precious Albertine Rift Valley, also known as Africa's Western Rift Valley, Bwindi, means, impenetrable, in the local Lukiga language, and it is entirely fitting. The tree canopy covering the mountains and valleys is often thick with mist, imbuing the place with a dank, dark, green jungle gloom.

Covering 32,092 hectares (124 square miles), the park is resplendent with low-lying woodlands that merge with mountainous rainforest terrain dating back some 25,000 years. Carpeting the ridges and deep valleys is a camouflage of trees and plants. With 163 tree species, and hundreds of ferns and flowering plants, it is said to be the most biodiverse in East Africa. Complementing the natural oasis, five major rivers rise from the Bwindi, flowing through the dense vegetation like lifelines.

Living amid this tangle of greenery are 120 species of mammal, including elephants and antelopes and a menagerie of birds (350 species), butterflies (200 species) and reptiles, many of them endemic to the Rift region. It is definitely the place to see primates. Alongside the gorillas are chimpanzees and baboons, grey-cheeked mangabeys, L'Hoest's monkeys and blue monkeys.

Bwindi is only accessible by foot. The zigzag mountain trails that pass through cloud forests and over lofty ridges getting up to 3800 metres (12,500 feet), are barely visible, let alone way-marked or signposted. It takes the smarts of a local guide or ranger to navigate through overgrown vines and puzzles of roots, particularly in the rainy season.

But the effort speaks for itself. The only place that humans can see wild gorillas is here at Bwindi (and adjoining Sarambwe Reserve in the Democratic Republic of Congo), and at Virunga National Park, a cross-border region spanning three forest reserves in Uganda, Rwanda and the DRC. If you have the opportunity, you're one of the fortunate few.

Since the park became a UNESCO World Heritage Site in 1994, the tourist hubs of Buhoma and Nkuringo have prospered. According to the park website, funds from visitor permits that allow tourists to track gorillas 'support the community and the park mountain gorilla conservation'.

While the park and the increasing gorilla population are a conservation success story, the relationship with the neighbouring human populations is not as clear-cut. On the agricultural edge of the park are Uganda's most densely populated communities and some of the country's poorest people. The Indigenous Batwa People who have a historical claim to land rights were evicted from the park without compensation and remain dispossessed.

The gorilla trekking visitor permits, which typically include transport, meals and accommodation, are limited and expensive but they're the ticket to an encounter that would give even the most seasoned adventurer goosebumps. Of the 36 gorilla groups in Bwindi, 17 of them have been habituated, meaning they still live wild, but are accustomed to human interaction. Mountain gorillas live at altitude between 3000 and 4300 metres (9800 and 14,100 feet) and so trekkers need to be physically fit and willing to trek through thick jungle and along steep inclines. Trekking experiences take four to six hours, depending on where the gorilla group lives. The time spent with the gorillas is between one and two hours. Most tour companies offer two treks, on two different days, so guests can see the personalities of different groups – mothers with young gorillas will be more sedentary than those who like to move around in the trees, for example.

Imagine it. After waiting for half an hour on the floor of the forest, camera in hand, the 'silverbacks', the world's largest living primates, finally emerge followed by their families. They are intimidatingly big, some weighing close to 180 kilos (400 pounds), with broad shoulders, oversized hands and big brooding foreheads. But their size belies a softer nature. They are overwhelmingly gentle and communicative, their small brown faces seeking eye contact as they feed on bamboo shoots.

Bwindi's park boundary is quite literally the dividing line between the sustainability of a wilderness and the challenges of managing humanity. The key, as ever, is to find the balance. This African wilderness may well provide the opportunity.

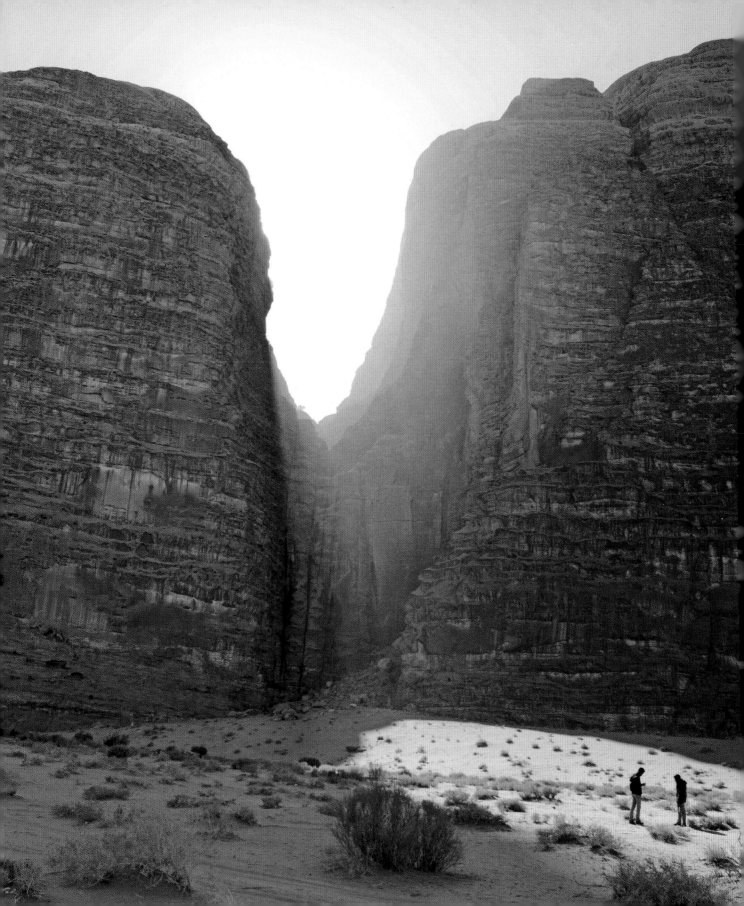

WADI RUM PROTECTED AREA

**Aqaba
Jordan**

An iconic red desert landscape where petroglyphs, camels and rock formations are found.

In southern Jordan, not far from the Saudi Arabian border, Wadi Rum Protected Area is an iconic desert landscape – famous for its rocks rising out of the sands, as well as its links with Lawrence of Arabia. It is a vast, red, sand-streaked valley of undulating hills and incredible iron oxide–laced rock formations built by nature to withstand the intensity of the desert heat. As the sun tracks its way across the desert sky, the whole scene can change from sepia to blood red to deep magenta and back again. Add a cloudless blue background and the long silhouette of a camel and this is a desert wilderness in all its glory.

Also known romantically as the Valley of the Moon, Wadi Rum is Jordan's largest wadi – or dry valley – covering 720 square kilometres (280 square miles). It runs like a red, rippled sandy sea through a panorama of diverse natural rock formations, providing the perfect gallery from which to view them.

Sandstone and granite deposits have been smoothed and sculpted into rounded bullnose mountains with slippery landslide slopes, and chiselled into sharp-edged pointy skyscrapers with near-vertical drops. From the highest point, the Jabal Umm ad Dami massif, at 1840 metres (6040 feet), you can see across the Saudi border to the Red Sea.

Hidden among these lofty rock edifices are magnificent natural arches, crags, overhangs and narrow gorges whose echoes are dampened by the soft sandy surrounds. It's a geological playground sprung from tectonic plate movement millions of years ago, and intense weathering and erosion in more recent centuries.

Wadi Rum has the writings of English officer T.E. Lawrence to thank for its largely natural state. Lawrence's 1926 historical account and memoir,

Seven Pillars of Wisdom was the basis of the 1962 film *Lawrence of Arabia*, detailing Lawrence's World War I years fighting in Damascus and Aqaba, a city 60 kilometres (37 miles) from Wadi Rum.

The film, winner of seven Oscars and still widely regarded by critics as one of the best made, gave the evocative desert landscape superstar status. Its profile encouraged the retention of the natural iconic desert setting and, in 1978, helped identify it as a potential nature reserve. Over the ensuing years, development was kept at bay with a buffer zone established to ensure cultural treasures were preserved, such as the petroglyphs and archaeological sites of the ancient Arabic Nabataeans – famed for their city carved from stone at nearby Petra – and the incredible inscriptions of the Thamudic Peoples that detail the past 12,000 years of human habitation. Their protection and nurturing ensured the Jordan government declared Wadi Rum a protected area in 1998, and in 2011 UNESCO classified it as a World Heritage Site. Wadi Rum's fame in films has continued, with it featuring in *The Martian* (2015), *Star Wars: The Rise of Skywalker* (2019), *Aladdin* (2019) and *Dune* (2021), too.

The local Zalabia Bedouin People are largely responsible for managing tourism and development. The Zweideh tribe, who live in Disi on the northern edge of the protected area, play a smaller role. The other Bedouin tribes are the Omran, Godman, Sweilhieen and Dbour Peoples. Some Zalabia still live semi-nomadically, but the majority live in the Wadi Rum village on the edge of the protected area. Their challenge is finding the balance between protecting the environment and maintaining the tourism industry that supports the livelihoods of the community.

In 2020 the International Union for Conservation of Nature rated Wadi Rum's conservation outlook as 'Good with some concerns' and reported that the small population and minimal development have seen it retain 'a relatively pristine and authentic condition'. Some of the concerns included management of illegal camps, off-road driving activities, and increased infrastructure and waste management.

According to Wadi Rum Protected Area's website, the widespread damage caused to the fragile desert ecology by allowing 'free-for-all' driving through the desert landscape has been rectified with single road networks created for tourist vehicles, thereby limiting further damage.

Wadi Rum is divided into two zones, a free access (or red desert) zone in the north where most of the tourism activities take place. The wilderness (or white desert) zone, in the south, where red iron oxide formations give way to golden scenery more typical of other deserts, is a worthy slow travel option with fewer crowds.

Though wildlife doesn't form part of UNESCO's World Heritage criteria, the desert ecosystem supports a surprising number of species. Their nocturnal habits ensure they're not often seen, but they're here. Mammal species include Asiatic jackals, Arabian red foxes and desert hedgehogs that live alongside near-extinct striped hyenas and Nubian ibex (mountain goats with

characteristic rear-facing horns). The Arabian oryx, hunted to extinction a century ago, was successfully reintroduced to Wadi Rum in 2002 and now lives in a protected area in the wilderness zone. Other desert critters, including vultures, eagles, lizards, snakes, vipers and scorpions, are here for curious minds to discover too.

Despite its popularity, Wadi Rum still feels like a marvellously wild and reckless place, free from the shackles of a built environment. Its access point, on the edge of the protected area, is the small Wadi Rum village where wandering goats and hessian tents are a contrast to the flash new sandstone visitor centre.

From near here, visitors can take a 30-minute sand trail walk to the Nabatean Temple and Ain Ash – Shallaleh or Lawrence's Spring (which features in a scene in the book and the movie) where fresh mountain water runs into a pond oasis surrounded by ferns.

Day tours from the village explore sites including the graceful natural rock arch of Burdah Rock Bridge, which you can climb and walk across; and the ancient rock drawings of Alameleh and inscriptions of Anfashieh.

Wadi Rum is also known for its trekking and rock-climbing adventures, with technical climbs such as the ridge line to Umm ad Dami Peak, and Rakhabat Canyon, which traverses a crack between two valleys and is a challenge to most serious climbers.

Spending the night in the desert in one of the Bedouin-style camps should be on every desert-lover's bucket-list. The camps range from luxury stays, with mod cons including swimming pools, to basic camps with minimal facilities, where local families will sit with you around the campfire, the desert stars shining above.

Half the fun of these adventures is the journey through the intoxicating desert landscape be it on a donkey, a camel or in a four-wheel-drive jeep with a Bedouin host in full crisp white thoab and headscarf at the wheel. Wadi Rum promises a true desert wilderness experience and a sands-through-the-hourglass journey into ancient cultures.

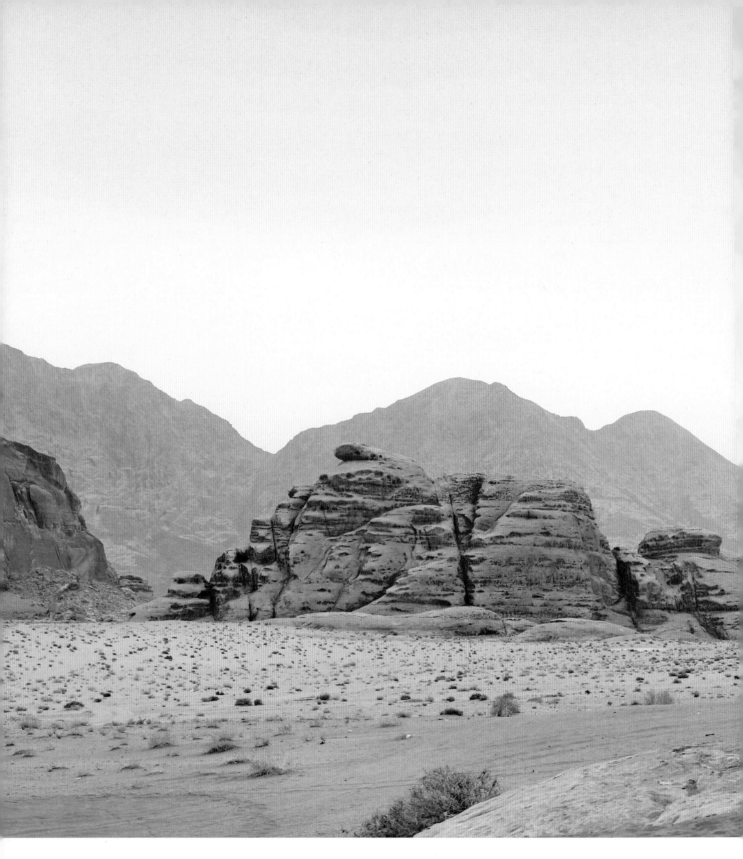

AFRICA & THE MIDDLE EAST

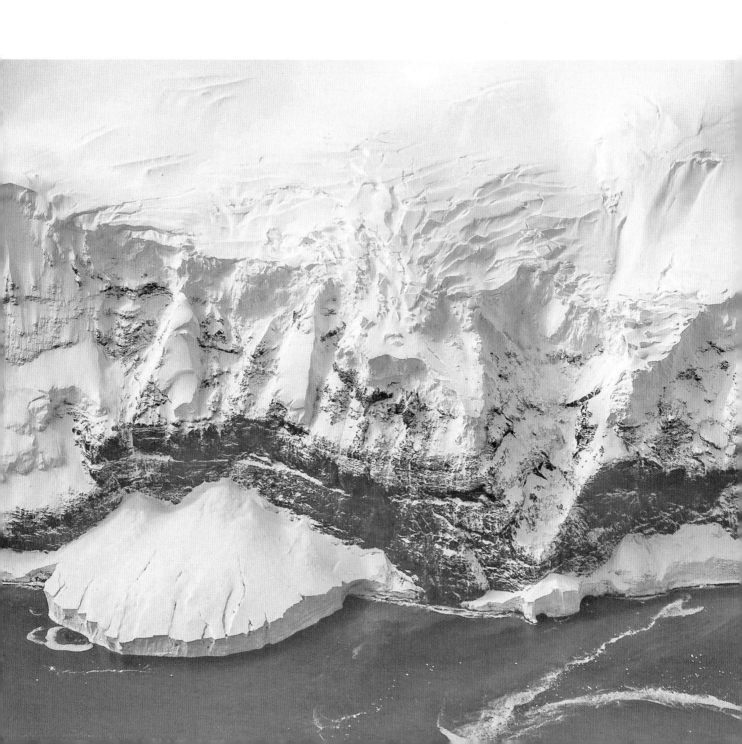

ANTARCTICA

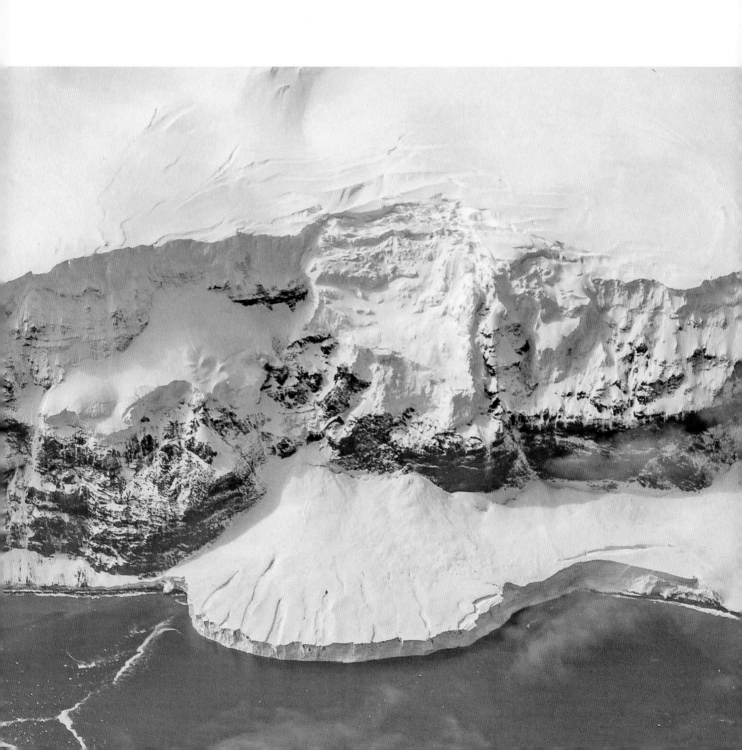

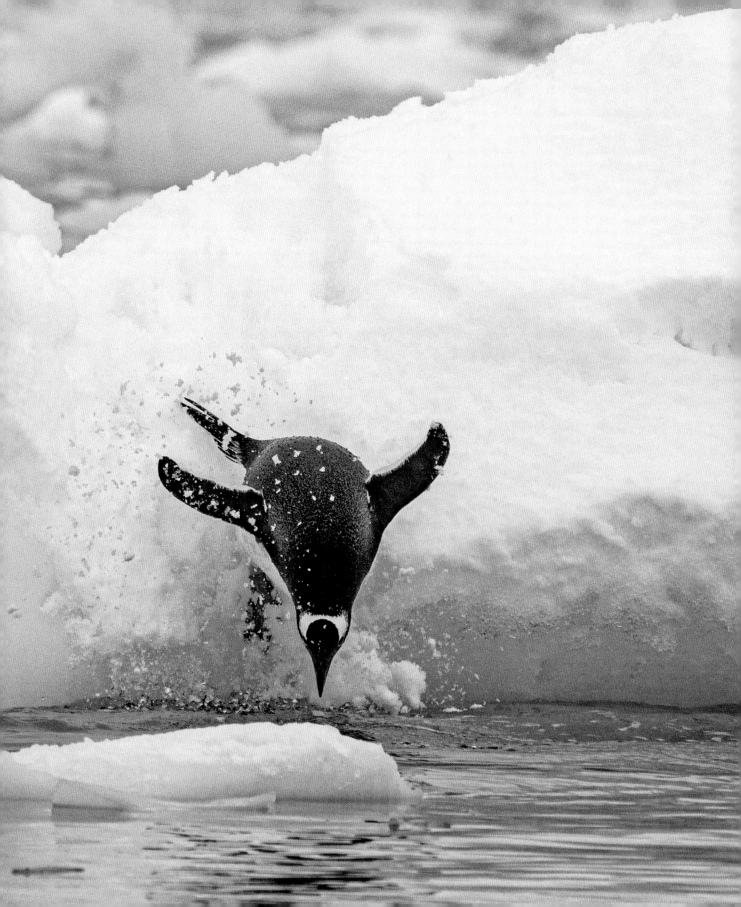

ANTARCTICA

A stark-white icy wilderness with iconic wildlife at the end of the Earth.

Polar desert. The words conjure a bone-chillingly cold and skin-parchingly dry landscape, of white ice storms that blur the horizon, of impenetrable and imposing mountains and hell-bent face-whipping wind. Antarctica, the world's most remote and least-touched wilderness, a final frontier for humanity, can be just such a place.

But on other days it's a wonder: of gem-blue glaciers, luminescent ice floes, eye-squintingly clear light and crunchy icy-sculpted snowy topography glistening as far as the eye can see.

Incredible wildlife, both marine and terrestrial, has flourished here on its own terms. Penguin rookeries dot the coastline and giant albatross soar in the sky above. Whales (which have been protected here since 1994 as part of the Southern Ocean Whale Sanctuary initiative) patrol the fathomless waters, sending occasional spouts of water into the air. Seals sunbake on great hunks of ice before slipping into the water, regaining their agility as they dart around looking for fish.

This huge continent, covering 14,200,000 square kilometres (5,500,000 square miles), occupies the southern-most curve of the planet with the geographic South Pole (quaintly denoted by a signpost) sitting just west of its centre. The entire Antarctic region, delineated by its cold-water boundary, takes up a mighty 20 per cent of the Southern Hemisphere. Antarctica itself is the fifth-largest continent, a fact often overlooked due to its location at the end of the Earth. On traditional maps, 'The White Continent', as it is sometimes known, is mostly presented as white skirting at the bottom of the globe. Upending the globe reveals Antarctica in its entirety, a roughly circular territory sitting neatly within the Antarctic Circle.

This huge area is mostly dominated by the Antarctic Ice Sheet, a single thick frozen mass stretching over the land like wedding cake icing. Averaging a depth of 1.9 kilometres (1.2 miles), it contains 70 per cent of the world's freshwater reserves. When snow and ice conditions are at their wintry coldest (the temperatures in Antarctica are the coldest on Earth – 89.2°C/−128.6°F is the record low), this remarkable ice phenomena can extend some 16 million square kilometres beyond the edge of the continent creating floating ice shelves that are tangible enough to be named (Ross Ice Shelf and the Ronne Ice Shelf are two examples). Consider this: without ice, Antarctica would be about the size of Australia; with ice, it doubles in size.

The ice sheet follows Antarctica's mountainous contours, peaking at 4000 metres (13,100 feet) near the centre of the continent. Its mountain ranges are similarly epic; the highest, Vinson Massif, tops out at 4892 metres (16,050 feet). On a good day, the views from up here – for the few who tackle the climb – are almost beyond the realms of earthly imagining. Big yawning celtic blue skies; snow as trackless and fresh as sand drifts in the desert; black rock mountain peaks, chipped and chiselled like chocolate brownies and dusted in a fine layer of icing sugar.

The surrounding Southern Ocean is equally mesmerising. An upwelling of the cold Antarctic water promotes ecosystems of algae and phytoplankton, the linchpin in the food chain for iconic Antarctic wildlife, including a plethora of fish species, whales – such as minke, sperm and humpback – and enormous leopard seals that feast on penguins.

Plants have been less adaptive, save for green and yellow lichen and moss growing on the exposed rocky regions of the coast. This delicate epically slow-growing ecology is miraculous in its own right.

Antarctica is a continent uniquely free of native human inhabitants (although seven nations stake a claim: Aotearoa New Zealand, Australia, the United Kingdom, Chile, Argentina, France and Norway), but humanity's influence has been felt from afar, especially with regards to the climate crisis.

While I was researching this book, three disheartening news reports came out of Antarctica. In late 2022, the Australian Antarctic Program revealed in a press release that the number of Adelie penguins across 52 islands near the Mawson Research Station on the East Antarctic coast has dropped by 43 per cent, 'a loss of some 154,000 breeding birds'. The decline is 'triggered by changed environmental conditions'.

At around the same time, the US Fish and Wildlife Service officially added the emperor penguin, 'a flightless bird from Antarctica' whose colonies are depicted in the lauded *March of the Penguins* film, to the threatened species' list, observing that the species 'is likely to become endangered within the foreseeable future'. It named climate change as the emperor penguin's 'most substantial threat'.

Meanwhile the CSIRO, an Australian government agency responsible for scientific research, published the 'Vulnerability of Denman Glacier' research

paper that reported that East Antarctica's Denman ice shelf, a glacier holding a volume of ice equivalent to a 1.5 metre (nearly 5 foot) rise in sea level if melted, is vulnerable to warming sea water. 'We estimate that the amount of warm water [affecting the glacier] ... is sufficient to melt 70.8 billion tons of ice each year', the paper said.

One way to support Antarctic wildlife from home is to research the seafood you eat. Patagonian toothfish and Antarctic toothfish, for example, are large, deep-sea fish found as low as 3000 metres (9800 feet) on the edge of the Antarctic shelf in some of the world's last ocean wildernesses. These incredible fish live as long as 50 years and breed quite late in life. They're often caught before they have had a chance to breed. In the 1970s, the fish were renamed 'Chilean seabass' to make them more appetising to diners. By the 1990s the sweet meat had become a menu hit and has since been fished, both illegally and legally, to within an inch of the species' life in some waters. Simply put, if you see Chilean seabass on a menu, or Patagonian or Antarctic toothfish, don't eat it.

Tourism is the next challenge. As one of the most enigmatic wilderness destinations on the planet, visiting the region has become the ultimate in bucket-list travel, with prices becoming cheaper and more ships arriving

each year. The legacy of early explorers and Amundsen, Scott, Mawson and Shackleton's expeditions echo down the ages and inspire modern-day intrepids.

The International Association of Antarctica Tour Operators (IAATO) reported 74,401 (registered member) visitors travelled to Antarctica between October 2019 and April 2020, up from 56,000 in the previous season and the most ever recorded. The numbers in the years since have been affected by the Covid-19 pandemic but are expected to continue to rise.

This figure amounts to a lot of cruise ships and plenty of wear and tear on the fragile ecosystems. There are plenty of risks too, from fuel and raw sewage pollution to non-native species invasion and animal habitat disruption.

Visitors going to Antarctica have mindful choices to make too (although not many). Ensuring that tour operators are members of the IAATO, and that – importantly – the self-managed association is following its own set of guidelines for ships and tourists (including passenger and onshore visitor limits and appropriate staff-to-passenger ratios) is a starting point. Choosing smaller expedition ships to travel on, especially those that have introduced genuine sustainability measures, is another important way travellers can help.

Most cruises to Antarctica start from Ushuaia on the southern-most tip of Argentina and venture across the Drake Passage, stopping at intriguing historical and natural world destinations along the way. The South Orkney and Falkland islands are known for their king penguin and southern elephant seal colonies, and birdlife respectively. South Georgia is the historic place famed for being the final resting place of aforementioned Antarctic explorer Sir Ernest Shackleton.

The highlight, of course, is the Antarctic Peninsula itself. Guests on bigger cruise ships can't make land, but those on smaller vessels can adventure into this epic wilderness on zodiacs, cruising across some of the most captivating marine-rich waters on the planet, with every expectation of seeing breaching whales and seals slipping through the blue depths. Stepping onto the icy shores will put colonies of penguins well within your viewfinder.

So-called 'deep-field' visitors – those few who travel to the interior – can arrive by plane, but they'll have to pay the price of staying in necessarily uber-expensive camps. From these exceptionally remote campsites, modern-day adventurers have awesome opportunities to follow in the footsteps of explorers on wilderness expeditions to the South Pole, summiting Vinson Massif, abseiling, and hiking and skiing on some of the purest, crispest, whitest snow on the planet.

Antarctica is the planet's last frontier, a wondrous white wilderness where wildlife rules. Whether the sun shines or the storms blow, this is hallowed ground. Those who stand on it are the privileged few.

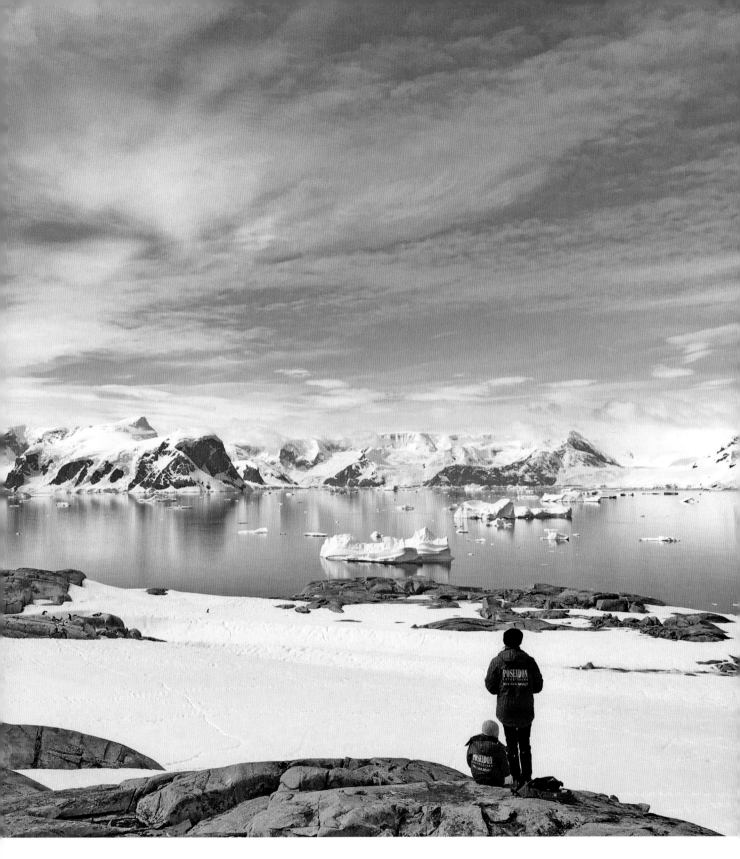

Acknowledgements

I would like to thank the brilliant team at Hardie Grant Explore, especially Melissa Kayser, who first encouraged the idea of *Wilderness*, Amanda Louey, whose calm editorial oversight was always appreciated, and Alice Barker, whose words of encouragement, incisive eye and unfailing editorial wisdom have made this a better book. Also for the talent and expertise of designer Emi Chiba, proofreader Susan Keogh, typesetters Susanne Geppert and Kerry Cooke, First Nations consultant Jamil Tye and production coordinator Simone Wall.

I am grateful also to my traveller friends and colleagues who have been encouraging from the get-go and whose votes, tips and recommendations helped me nail-down the big 40 destinations.

I completed this book during my second year in Bali where I moved mid-pandemic. A very special thank you goes to the incredible Green School community who continue to change the way my children experience education and my family experiences the world. And to our Balinese family in Pererenan who continuously nurture our hearts and our home life.

As ever, I owe the biggest gratitude to my family. Thanks to my partner Phil – my world is amazing with you in it, and to my children Digby and Eti. I dedicate this book to you in the hope that in some way it supports the wildernesses of your future.

About the Author

Award-winning Australian writer, journalist and author Penny Watson has spent much of her life travelling the world and writing about it for magazines, newspapers and the digital space. Her travels have become inspiration for subsequent books including *Slow Travel*, released in 2019, and *Ultimate Campsites Australia*, published in 2020.

In 2021, mid-pandemic, Penny followed her own Slow Travel advice and moved from a heavily locked-down Melbourne (Wurundjeri Country), Australia to Bali, Indonesia. The privilege of this life experience and the light it shed on major world issues, in particular sustainability and conservation, formed part of the motivation and inspiration behind *Wilderness*, her sixth solo travel book.

When Penny is not travelling, she resides in Bali with her husband Phil and children Digby and Eti.

Penny can be contacted via Instagram @watson_penny.

Photo Credits

Published in 2023 by Hardie Grant Explore, an imprint of Hardie Grant Publishing

Hardie Grant Explore (Melbourne)
Wurundjeri Country
Building 1, 658 Church Street
Richmond, Victoria 3121

Hardie Grant Explore (Sydney)
Gadigal Country
Level 7, 45 Jones Street
Ultimo, NSW 2007

www.hardiegrant.com/au/explore

A catalogue record for this book is available from the National Library of Australia

Hardie Grant acknowledges the Traditional Owners of the Country on which we work, the Wurundjeri People of the Kulin Nation and the Gadigal People of the Eora Nation, and recognises their continuing connection to the land, waters and culture. We pay our respects to their Elders past and present.

For all relevant publications, Hardie Grant Explore commissions a First Nations consultant to review relevant content and provide feedback to ensure suitable language and information is included in the final book. Hardie Grant Explore also includes traditional place names and acknowledges Traditional Owners, where possible, in both the text and mapping for their publications.

Wilderness
ISBN 9781741178142

10 9 8 7 6 5 4 3 2 1

Publisher
Melissa Kayser
Project editor
Amanda Louey
Editor
Alice Barker
Proofreader
Susan Keogh
First Nations consultant
Jamil Tye, Yorta Yorta
Design
Emi Chiba, Evi-O Studio
Typesetting
Susanne Geppert
Production coordinator
Simone Wall

Colour reproduction by Kerry Cooke and Splitting Image Colour Studio

Printed and bound in China by LEO Paper Products LTD.

Project Japan

Architecture and Art Media Edo to Now | Graham Cooper

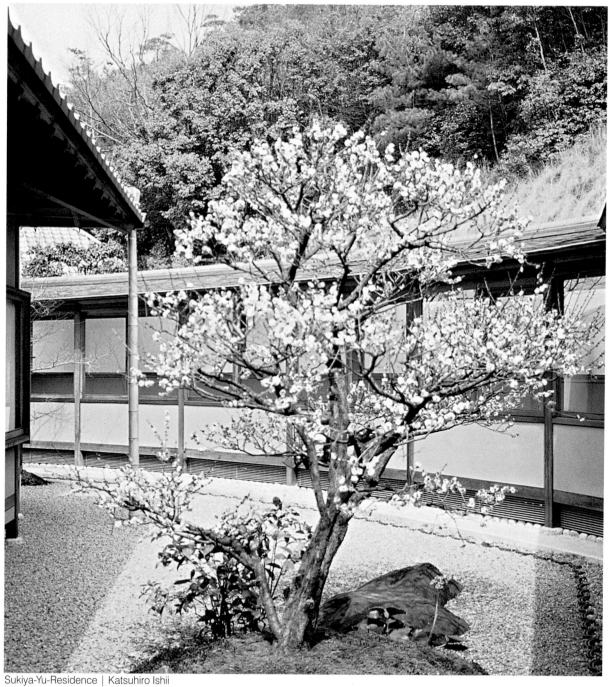

Sukiya-Yu-Residence | Katsuhiro Ishii

Project Japan

Architecture and Art Media Edo to Now | Graham Cooper

Guests
Fumihiko Maki
Kisho Kurokawa
Tadao Ando
Kengo Kuma
Makoto Sei Watanabe

images
Publishing

Published in Australia in 2009 by
The Images Publishing Group Pty Ltd
ABN 89 059 734 431
6 Bastow Place, Mulgrave, Victoria 3170, Australia
Tel: +61 3 9561 5544 Fax: +61 3 9561 4860
books@imagespublishing.com
www.imagespublishing.com

A cataloguing-in-publication entry for this title is available from the National Library of Australia

ISBN: 978 1 86470 309 2

Project concept by Graham Cooper www.grahamcooper.com

Production by The Graphic Image Studio Pty Ltd, Mulgrave, Australia
www.tgis.com.au

Pre-publishing services by Splitting Image Colour Studio Pty Ltd, Australia
Printed on 157 gsm Gold East paper by Everbest Printing Co. Ltd., in Hong Kong/China

Shrine, Tsukuda Island, Tokyo

Project Japan is dedicated to my family and to my guest contributors with whom it has been a privilege to collaborate. A special mention must go to Tadao Ando for kindly preparing the Preface and to my host, the late Dr Kurokawa, who enabled me to commence my research by generously providing a desk space and support in kind. For their sheer hard work and commitment represented within, I must express my sincere appreciation to my other guests: Fumihiko Maki, Makoto Sei Watanabe and Kengo Kuma, and to the skills and resourcefulness of the individual artists and designers. Special thanks also to Yasuto Kato and his mother Harumi who kindly allowed us to stay at their Tojuso apartment in Osaka, and to Professor Yasushi Nagasawa Sensei for his helpful support.

Contents

Introduction: Setting the Scene

The Catalogue

1

2

3

4

5

Personal Account

Appendix

1 Minamata Castle, Kyushu

2 Fushimi Inari Shrine, Kyoto

3 Itsukushima Shrine, Miyajima

4 Olympic Gymnasium | Kenzo Tange

5 Pumpkin Naoshima | Yayoi Kusama

6 Minamata Shinkansen Station | Makoto Sei
 Watanabe

7 Shinkansen Express 700 Series

8 Chichu Art Museum | Tadao Ando

6

8

7

思想なき時代を問い直す

安藤忠雄・建築家

『PROJECT JAPAN』に収められた、外側から見た日本の都市の姿は、ショッキングなまでに混沌とした様相を呈している。

確かにこの本は、あくまで Graham Cooper 氏という個人の視点で編集されており、ここで試みられているのはアートとの関わりから建築を見つめると言う、彼なりの日本の現代建築の評価だ。

しかし、結果としてこの本はそうした彼の意図を超えて、建築史上、世界でも類を見ないほど、多様な建築のあり方を許容する日本の特異な都市状況を浮き彫りにしている。

著者であり編者である Graham Cooper 氏は、日本のこの現象を、世界中から流入してきたものを何でも受け入れ、日本流にアレンジする能力に長けた、島国ならではの文化風土に着目し、解き明かそうとしているようだ。これまでも、このカオスの風景の意味づけを行おうと、さまざまな論者がそれぞれの視点を提案してきたが、Cooper 氏のそれは、長い時間をかけて自分の足と目でつぶさに見て歩いている、その一点において、他にはない説得力を持っている。

『PROJECT JAPAN』はこの混沌とした世界の中で、建築の現在と未来について、自分なりの視座を探していく手がかりとして恰好の一冊である。

私自身は、この思想の欠落した中心のない時代状況を肯定的には受け止めていない。『PROJECT JAPAN』には多様な方向性を示す現代建築と混ざって、丹下健三や菊竹清訓ら、日本近代建築の歴史をつくった巨匠たちの作品が収録されている。頁をめくっていて、ふいに登場する代々木体育館や出雲大社庁の舎を見て、彼らの先導のもと、日本の建築が活き活きと胎動していた 60 年代から 70 年代にかけて——私が建築を志した 20 代の頃を思い出した。

世界全体が多様化する一方の現代にあって、建築に普遍的な価値基準を期待するのが無意味なことは理解している。しかし、いつの時代であっても建築にはそれを生み出す建築家の思想が不可欠である。個々の思想に裏づけられ、瑞々しい生命力に満ちた建築の時代が再び来ることを期待する。

Preface: Questioning an Era without Ideas

by Tadao Ando

The views of Japanese cities from outside that are gathered together in *Project Japan* are shocking for the confusion they reveal. This book is of course written from the personal viewpoint of Graham Cooper, and what he attempts to do here is to evaluate contemporary Japanese architecture in his own way, to regard architecture through its relationship to art. In the end, however, this book transcends that objective and throws into relief the singular urban condition in Japan–one that permits diverse forms of architecture to coexist to an extent unparalleled in the history of architecture anywhere in the world.

As author and editor, Graham Cooper explains this Japanese phenomenon as a consequence of this island-nation's cultural climate, one that assimilates and arranges in Japanese fashion everything that is introduced from abroad. In the past, commentators have proposed various points of view in trying to explain that chaotic landscape. Cooper's attempt is more persuasive than others in that it is based on detailed personal observation made during many hours spent walking about.

Project Japan provides clues to those in search of a frame of reference for the current state and future prospects of architecture in this confused world. I do not see the present condition–the paucity of ideas and the absence of a centre–as something positive.

Mixed together with works of contemporary architecture that indicate diverse directions in *Project Japan* are works by masters who created the history of modern Japanese architecture such as Kenzo Tange and Kiyonori Kikutake. Turning the pages of the book and coming across the Yoyogi Gymnasium and the administration building for the Great Izumo Shrine, I remembered the 1960s and 1970s when Japanese architecture was stirring and I in my twenties was starting out on the path of architecture.

I realize that to hope for universal values in architecture today, when the entire world is undergoing diversification, is meaningless. However, architects must have ideas if they are to create architecture, whatever the period. I hope a time will come again when architecture is based on ideas and is full of vitality.

Foreword

by Graham Cooper

Japan's unique culture is directly related to the extremes of its climate, volcanic geology and terrain. Its high temperatures, rainfall and landscape have proved suitable for the growth of rice and a particular form of gregarious community and habitation. The frequency of typhoons and earthquakes and a traditional dependency on a good harvest have influenced the development of a finely tuned sensitivity to seasonal changes and natural occurrences. These volatile ecological conditions encouraged certain spiritual and religious needs which were met by Shinto and Buddhist philosophies and brought about a belief in the importance of aesthetic values in Japanese culture, such as regular festivals, the rituals of the tea ceremony and the significance of the incomplete and the unfinished. The over-populated country's relative lack of resources influenced a communal responsibility, dignity and restraint. Its isolated island status and geographical politics eventually gave rise to the need for modernisation. The cycle of natural and man-made disasters led to continuous redevelopment and urban renewal and to an abundance of challenging opportunities for the creative industries.

Project Japan represents a snapshot of outstanding creativity from an unprecedented period in post-war reconstruction. Based on personal friendships developed over the last 15 years, it explores the overlap between art and architecture in Japan, presenting the exceptionally innovative and occasionally eccentric from leading and emerging designers. Such an approach, however, tends to inevitably represent the tip of the creative iceberg rather than the considerable achievements across the construction sector as a whole. In the context of East Asia, a study that simply celebrates the individual's contribution without a wider social dimension is unlikely to fairly reflect a culture with such a unique sense of collectiveness as in Japan. For extended periods of its history, Japan has been largely devoid of contact with other cultures, leaving it more racially and ethnically homogeneous than any other major nation in the world.

Identifying exactly what is quintessentially Japanese is a formidable challenge for an outside observer, and this is why for *Project Japan* I have endeavoured to engage the views of insiders. *Project Japan* has been assembled at a critical time in the aftermath of the 1995 Hanshin Earthquake and in the wake of Japan's huge financial growth during the 1980s, known as the period of the 'bubble' economy. Whilst the excesses of commercialism favour the entrepreneurial spirit, which in the face of competition created spectacular attention-seeking design, many of the most extrovert buildings were ultimately under-utilised and stood as icons to speculation and abundance. The bubble period provided the oxygen for an extraordinary epoch when opportunistic clients, less motivated by function and the comfort of users, sought exposure in the glossy journals. Such theatrical consumerism would seem an anomaly for a culture where it is considered vulgar to stand out and to be wasteful.

Architect Shigeru Ban, expressing his views of this economic boom period, said that, "Many architects were just building monuments to show their ego." The Hanshin earthquake in Kobe rattled the very foundations of the construction industry. The instant devastation of infrastructure, accommodation and vulnerability of the inhabitants struck at the core of the design community, undermining confidence and questioning its values and integrity. Brutally sobering, the "disaster was such a psychological shock for Japanese architects that it silenced all their glib discussions of architectural theory," Ban observed. He summed up his thoughts by observing that "the earthquake made everything they had been practicing suddenly seem pointless."

Since ancient times, the Japanese are said to have loved nature profoundly and to possess a biophilic desire to live in harmony with the spirits and rhythms of the planet. They appreciate a culture of movement and flow in architecture where, like the seasons, the only constant is change. Rather than placing emphasis on the building as a permanent immovable object, such as in Western culture, in Japan it is the process of sustaining the culture through recycling the skills that is monumentalised. Based on the principle of replacing the Ise Shrine every 20 years, 'the newer the better' is a national obsession and ten years after construction some buildings are considered old. From the Meiji Restoration throughout the last century, Japan's yearning to catch up has led to constant modernisation and a rapid turnover of the built landscape.

This disposable and short-term, scrap-and-rebuild culture is ecologically harmful and must be discouraged in favour of renewable sources of raw materials. Following the extraordinary economic reconstruction since the Second World War, designers in Japan will surely adapt their considerable resourcefulness and ingenuity to focus more imaginatively on the effects the building industry has on diminishing supplies, wasted energy and carbon emissions. To succeed at this historical moment, they will need to make buildings more durable, flexible enough to accommodate change in use, and they will need to design amenities that will allow people to attain a sustainable life pattern for leisure and employment.

Introduction: Setting the Scene

One Hundred Years from Restoration to Reconstruction

Although its manufacturing expertise penetrates every corner of our lives, we remain comparatively uninformed about Japan's special cultural significance and, especially, its artistic aspirations and merits. In Europe, documentation relating to art and architecture abounds but despite considerable accomplishments, comparatively little is still known about such activities in Japan. These days, however, the country's technological and economic prowess have encouraged a surge of interest in what is happening in Japan and the unique traditions from which these achievements have evolved. Until the late 19th century, art and construction in Japan were relatively unaffected by Western influence and so, although such hybrid influences now permeate almost all aspects of their culture, the spirit and essence of Japan remains a prominent feature.

In terms of creative accomplishments, the informed Westerner will be more familiar with the work of contemporary architectural designers in Japan due to several recent publications. However, these are predominantly slight in content, and they present the work in a void as a regional variation on the mainstream international corporate style, often with little recognition of Japan's unique anthropological roots and topographical context. One way to comprehend this extraordinary phenomenon is to consider a wider view of contemporary inspiration and creative endeavours as applied to the urban condition. Japan is a strange blend of the most technically orientated population on earth entwined with the ancient customs of its ancestry. Although *Project Japan* is primarily pitched at the end of the millennium

following the post-war reconstruction and the excesses of the 1980s 'bubble' economy, the influences of heritage and the years of enforced isolation during the Tokugawa Shogunate have to be considered.

The wave of popular interest in art and architecture in Japan began during the Meiji Restoration, which refers to the restoration of the Emperor's imperial power over the shogun in 1869 at the beginning of the Meiji era (1868–1912). The Restoration followed the earlier American gunboat diplomacy that demanded the Japanese reopen their ports to foreign trade. The failing feudal junta system of the Tokugawa era, which had extended from 1603 to 1868, and the arrival of Commodore Matthew Perry and his five boats in 1853 at Shimoda on the Izu Peninsula forced Japan to catch up in the race for naval supremacy and industrialisation.

The crew of Perry's famous 'black ships' would have discovered a richly exotic existence, an enormous vibrant metropolis teeming with life. By the mid-18th century, the population of Edo (or Tokyo after 1868) was already over one million, the world's largest city population at that time, with an extraordinary density of 70,000 people per square kilometre living in the lower east marshes known as Asakusa.[1] It was a far more harmonious and mature culture than the New World from where the sailors hailed. Not surprisingly, the native Japanese distrusted such an intervention but this episode was pivotal to contemporary existence in Japan.

1 Tokyo Station | Kingo Katsuno
2 Hyòkeikan, 1909 | Tokuma Katayama

1

The Meiji Restoration was the catalyst for a period during which Japan opened its doors to the outside world. The foundation of modern Japan was laid down as it absorbed and assimilated Western culture and technology. Significantly for Japanese culture, European style architecture was a potent symbol of this Westernisation. Meiji buildings and townscapes in the exotic 'Foreign Style' reflected the vigour and optimism of the period. Such an instant entry into the Industrial Revolution was a daunting undertaking. As a result, Western-style institutional buildings such as schools, universities, hospitals and prisons were constructed, along with post offices, banks and railway stations. Examples of many of these can now be found in the Meiji Mura outdoor architectural museum near Nagoya, dedicated to preserving the few remaining buildings of this period.

To assist with the demand for the expanding civic infrastructure consistent with a modern state, such as compulsory primary education to improve levels of literacy, the government sought international expertise and specialists. During the transition Thomas Waters, an enterprising British surveyor, arrived in Kagoshima where he built a steam-powered cotton mill using local stone in which he installed spinning machines imported from Manchester. By 1871, he had supervised the building of the neo-classical Mint in Osaka, at that time the largest factory in Japan. The following year one of the recurring major fires struck the Ginza District and, as part of the consequent redevelopment, Waters designed a Regency colonnade known as Brick Town. To protect the pedestrians, he introduced a tree-lined kerbside and in 1877 gaslights were installed. Built to resist fire, Brick Town was ironically destroyed in 1923 during the Great Kanto Earthquake.

Introducing Western architecture

Josiah Conder, a young self-assured 24-year-old English architect, arrived in Japan in 1877 and was selected to design exemplar public buildings and to formulate a suitable curriculum at the Imperial University in Tokyo to nurture the new profession of architecture. From the office of the flamboyant architect and Japanese collector William Burgess, and under the influence of his own teacher, Conder designed a number of stately colonial villas featuring full-length verandas. Until his death in Tokyo in 1920, Conder erected more than 70 buildings during an exceptional career, but his decade at the College of Engineering was considered his most important contribution. A fellow of the RIBA, he lectured at the Tokyo Imperial University until 1888 and supervised his graduates on the construction of the Ueno Imperial Museum in the romantic Gothic style of his former employer. In a bid to stamp their authority on the territory of capital construction under the professional responsibility and supervision of the architect, his ex-students formed the Japan Institute of Architecture and Conder was elected the first honorary president. Later known as the father of Japanese architecture, Conder supervised a number of brick buildings in the Marunouchi district nicknamed 'a block of London'. In 1894 he was the chief architect for the Mitsubishi Number 1 Building. The three-storey structure, known as Ichigokan, was the first office building in Japan. Rather remarkably for Tokyo, although this particular Conder building was torn down in 1968 to make way for larger office space, it is currently being completely rebuilt by Mitsubishi Estate as a replica of the original to house the Ichigokan Museum of 19th Century European Art in Tokyo's Maranouchi district, due to open in 2010. The museum's curator will be Akiya Takahashi, a specialist in French art history who spent two years at the Musée d'Orsay in the 1980s before joining the National Museum of Western Art. It will have about 20 small, wood-panelled galleries totalling 800 square metres and will show temporary exhibitions, as well as works from its permanent collection – a set of about 200 posters and lithographs by Henri de Toulouse-Lautrec.

At the outset of the Meiji period, Yokohama was the main disembarkation point for Western goods and know-how, and in 1872 British engineering expertise introduced the first railway line to the port.

A former graduate of Josiah Conder, Tatsuno Kingo (1854–1919) designed the original Tokyo Station in 1914, recently partially restored to its former pre-war glory. Arranged upon a formal axis to the Imperial Palace, Tokyo Station presented a warm, brick, Edwardian facade and mansard roof as a contribution to the townscape approach. Trained in England and impressed by Norman Shaw, the eclectic designer became the first professional Japanese architect and his 1886 College of Engineering at the Imperial University was also influenced by Burgess. Further structural stability and fireproofing followed the Nobi earthquake in 1891, and consequently Tatsuno's Bank of Japan (1896) was the first building to incorporate an iron support structure. One of Tatsuno's fellow students, Tokuma Katayama (1853–1917), had also been in Europe and became the architect to the Imperial Household. By 1895, he had designed the National Museums in Nara and Kyoto, and a further example of Meiji historicism, the Hyokeikan National Museum building at Ueno (1909), again displays his expert ability to incorporate ornament. A pinnacle to ostentation, Katayama's Akasaka Detached

2

Palace (1909) was firmly criticised by the Emperor Meiji as too luxurious for his son, the Crown Prince, and has since been occupied by visiting heads of state.

However, living conditions for the commoners did not improve as industrialisation progressed. Profits were ploughed back into machinery and weapons. Industry was dominated by a few giant corporations, or *zaibatsu*, that were closely in league with representatives of the government. The quality of the ordinary workers' housing remained poor and wages low. Instead, the growth of industry brought with it a new urban elite, the educated white-collar worker known as the 'salary man'.

3 Interior, Imperial Hotel | Meiji Mura | Rebuilt 1980, FLW

4 Exterior, Imperial Hotel | Frank Lloyd Wright

5 Imperial Palace, Kyoto, 1854

6 Tokyo National Museum, Ueno, 1937 |
 Hiroshi Watanabe

7 Aichi Prefectural Government Office, Nagoya,
 mid 1930s

3

4

For centuries, this maritime culture has been enriched through the process known as Japanization, where ideas from abroad are transformed and adopted by the population. It is a refinement process, the end product of which has frequently surpassed the achievement of the original source of inspiration. However, since they were reluctantly forced to open the doors to foreign trade, the Japanese have established an insatiable curiosity for selecting the latest innovation and adapting it for their own domestic market. Since the Paris Exhibition in 1878, when *Japonisme* was briefly in vogue, there has been a dual interface between Japan and the West. In the UK, the taste for Japanese art had an important influence on the aesthetic movement and applied arts in the late 19th century. Amongst the London building fraternities at the time, John Ruskin's appeal for truth in architecture, in line with the ideals of contemporary civilisation, was influential in Japan.

By the mid-Meiji period, as progress became associated with the West, traditional Japanese builders were increasingly disenfranchised by the sudden shift from wood to masonry construction necessary for modern types of public buildings. In turn, Japanese designers became more dependent on foreign instruction. Instead of aspiring to technical development within the vernacular, the mainstream was encouraged to absorb imported styles resulting in hybrid forms essentially derived from indigenous skills and methods of joinery converted for the home market. Prior to the Meiji Restoration, apart from the temples, most edifices were not considered architecture as an independent form, but rather the arts and crafts traditionally and unselfconsciously crossed the boundaries into the domains of building and landscape. Traditional spatial awareness was threatened by the Meiji modernisation, but graphic representations of flatness and juxtapositions survived. The taste for surface pattern and emblems remained, and eventually the vernacular language of architecture would begin to reclaim its heritage.

The Great Kanto Earthquake

At the 1883 Columbian Exposition in Chicago the Japanese pavilion, a replica of the Phoenix Hall and the Nippon Teahouse, left an indelible impression on a particular young Midwest American architect. Frank Lloyd Wright (1867–1959) became an enthusiastic collector of Japonica prints and was particularly inspired by Ando Hiroshige's deep sense of space. In describing the spiritual lesson of the traditional dwelling house and the way of life it engendered, Wright observed that the native Japanese home is a supreme study in elimination, 'not only of dirt but the elimination of the insignificant'. Whilst woodblock prints were subsumed by the Impressionists, the traditional Japanese home rarely received serious consideration in the West. Nevertheless, it was to influence Wright's Prairie houses.

Wright returned for his third visit to Japan in 1917 where he designed, among other buildings, Tokyo's Imperial Hotel in 1923. It gained renown as one of the few structures to largely withstand the great Tokyo, or Great Kanto, earthquake that occurred at lunchtime on the day it opened to the public that same year. It did, however, suffer some damage; although built on a raft of floating piles, the footings were not quite substantial enough to prevent it sinking into the mud. A distinguished, low, horizontal building displaying character through its distinctive organic decoration, it was the first building in Japan by a leading foreign architect of status. With 280 guest rooms, it became a halfway house in which to meet foreigners segregated for their own comfort. In 1967, the structure finally succumbed to the demands of the property market and was demolished to make way for a new hotel tower. The central façade and lobby were saved and re-erected at the Meiji Mura museum.

Following Conder, it was Frank Lloyd Wright's assistant, the Czech-American Antonin Raymond (1888–1976), who would establish himself amongst the most influential Western designers

in Japan. Raymond, troubled by Wright's behaviour, claimed the highly individualistic mannerism of the Hotel was an expression of Wright's personal fantasies. Two years after leaving his master, Raymond set about building his own house in Azabu, Tokyo. Known as the Reinanzaka House, it was almost complete at the time of the 1923 earthquake. A fully poured, exposed concrete structure, the hillside house offered a new scale of residential living. According to Raymond, even in Europe at that time there was little in the way of such modern unadorned architecture, and the austere Rainanzaka House 'was a monolithic earthquake-proof structure in reinforced concrete, without any cement mortar or any other finish'. [2] Half a century later, reflecting on the Imperial Hotel episode, Raymond expressed a belief that Wright's motivation was relatively slight compared with those displayed daily by Japanese artists. 'It is liberating', he wrote, 'to realise the motivation behind the creative efforts in the form of novelty, astonishment, the assertion of one's own personality or to create things which no one else has done, was a minor and mean motivation'. After a successful career in Japan, he had begun to appreciate the 'existence of an age-long philosophy of life', providing the basis or 'starting point of the design of every single component of Japanese experience', which differed fundamentally from Western ideals.

By the turn of the century, the official Foreign Style architecture in Tokyo began to favour a Flemish–Prussian eclecticism, and a mixture of North German and Loire Château flavour began to emerge. In 1913, the first architectural magazine appeared and in contrast to the French-inspired Akasaka Palace, the Secession Style was promoted. The expressive style of ornament applied to government and industrial installations such as Peter Behren's pioneering AEG factory began to appeal.

As with the structure of national governance, a Germanic system of education with an emphasis on construction engineering rather than the Beaux

Arts was to become widely adopted by university departments. By 1915, the architectural section of the Tokyo Imperial University separated its Design and Structures departments, as the market for architectural work was insufficient to warrant such specialisation. A silently enforced structural bias emerged that, according to architectural historian David B. Stewart, 'remained in Japanese architectural education'. With little artistic encouragement, the newly qualified would be more technically competent and this would be reflected in the institutional practice of architecture.

At the beginning of the century, new techniques in district planning were introduced and some of the more successful Tokyo urban spaces such as the tree-lined streets of Jingu Gaien were based on Haussmann's Paris Renewal Plan. During the Taisho era, the emphasis was on the extension of infrastructure, particularly transport, to outlying districts and the provision of housing. The circular elevated railway line, the Yamanote Line, spread across agricultural land being occupied by hastily built family homes for rent to the salaried workforce.

The ethos of modernity was associated with the economic liveliness of cities and mass-produced merchandise that eliminated all but the essential. The latest international trends were promoted by the media through lifestyle magazines aimed at the successful salary man who dreamed of owning a house and garden in the countryside.

5

6

7

In the cities, urban improvements were more functional than beautiful. The thriving 'Modanizumu' era included the development of applied technology, product design, manufacturing and the continuation of popular culture, that extraordinary mass phenomena associated with the Tokugawa period. There was a conflict between structures and expression so, as building design suffered after the alienation of the carpenters, there was a technological backlash with engineers leading the march.

The early 1920s brought the growth of cinema, but the Taisho culture was almost completely destroyed by the Great Kanto Earthquake of 1923. In the 90 percent of the area destroyed by the ensuing fire, the six-year recovery program introduced a more rational street layout, waterworks and sewerage system. The main urban thoroughfares were refurbished as tree-lined roads with pavements and park systems for recreation, and an extensive subway system serving both an urban and suburban Greater Tokyo was established. Elementary schools of steel-reinforced concrete and new government-assisted apartment complexes provided a modern residential style in urban centres.

8 Tokyo Central Post Office | Tatsuro Yoshida
9 Tokyo Metropolian Festival Hall, 1961 |
 Kunio Maekawa

8

The Rise of Nationalism

After 1900, the expanding population was no longer able to depend on its own agricultural produce, and in the 1920s the foreign markets were ruined by the Great Depression. Following the invasion in 1931, Manchuria (Manchukuo) became Japan's main supply base. On the pretext of attempting to resist Western domination, this was part of an ill-fated and disastrous expansionist policy known as the Greater East Asia Co-Prosperity Sphere. Emblematic of the rising nationalism of the time, the so-called Imperial Crown Style – or *teikan yoshiki* – referred to possessing a Japanese or Oriental tiled roof. In search for a suitable expression, the old Imperial Palace in Kyoto was identified as in the spirit of the nationalist's tastes. The most quoted example of this style is the Tokyo Imperial Museum in Ueno, built in 1937 by architect Jun Watanabe (1887–1973).

In contrast to embracing discredited Nationalist doctrines, the 1930s also saw other major economies applying an industrial rationalism. A number of architects had trained under Walter Gropius preparing major reconstruction in the International Style. Some courageous designers aspired to greater objectivity and functionalism as displayed in the Cartesian form of the Tokyo Central Post Office, completed to a design by Tatsuro Yoshida (1894–1956) opposite Tatsuno's Tokyo Station in 1931. The new public utilities and communications service defiantly promoted a resplendent image of efficiency and it was here, combining functionalism with post and beam construction, where modern Japanese architecture was briefly accomplished.

In 1933 the leading German architect Bruno Taut arrived, discovering that the Katsura Detached Palace with its open-plan space, modular grid construction, exposed structure and raw finishes was compatible with the reductionism doctrines of his Central European contemporaries. Taut would identify the movement known as 'modernism', already embodied in traditional buildings for the

underlying principles of spatial grid planning, performance, austerity and system building that had centuries before been introduced to Japanese sensibilities. Although he had little affection for the shrines and temples of Nikko, Taut declared that 'the architecture of Japan is the architecture of the future'. Such buildings as the new Tokyo post offices and primary schools, praised by Taut as 'the most modern in the world', should be seen in the context of the untimely curtailment of the German modern movement following the rise of the National Socialist party. At the time, the avant-garde failed to appreciate that the less-is-more ideology it was rolling out would lead to more of the same but without the initial pristine glamour, and the style of the modern movement spread throughout the continents. Rather than any particular architectural style or form of urban design, the acquisition of Western values became the priority by which to measure progress.

Whilst much of the international chic derived from white private villas, the socially minded concentrated on the production of collective schemes. Though housing had been largely left to job carpenters after the Great Kanto Earthquake, the Dojunkai housing association was noted as the principal purveyor of public housing by the mid-1930s. It subsidised grey, reinforced-concrete housing popular with the professional classes and academics. Now, only two relatively small Dojunkai apartment buildings at Tokyo Uenoshita and Minowa remain. An early example, the famous Harajuku Apartments in Omotesando built in 1926 were in decline until taken over recently by boutiques, but they have now been controversially demolished and the site redeveloped. As a consequence of the modernisation charter and fearful of the wave of Westernisation and the loss of identity, there has been a strained relationship between the Foreign Style and the nationalist tendencies of the patricians.

Individual architecture design, associated with Western values, had only recently been introduced in the 1920s. Previously, Japanese buildings had

traditionally been built by anonymous carpenters. Consequently, a contradiction is now apparent between the intuitive native vernacular and non-contextual continental approach, between an aesthetic of impoverished accommodation derived from the weaker humble tea house, made with locally sourced materials, and the gaudy temples and robust grand palaces clad in the finest imported marble. Since procurement of foreign goods was made easier by the American occupation and the new constitution, increased international market demands for still further Western comforts surged after the war.

Post-War Reconstruction

Japan's rebirth following The Second World War as a viable democracy removed repressive obstacles to the rapid spread of progressive ideas. With the need to rebuild the country and redefine its future objectives, there was a commitment to more advanced industrial production in association with numerous outstanding artists and designers. Spanning the war years, the two modern masters of Japanese architecture, Kunio Maekawa (1905–1986) and Kenzo Tange (1913–2006) were influenced by their mentor Le Corbusier. After studying at the Imperial University, Kunio Maekawa went to work in Le Corbusier's office in Paris between 1928 and 1930, and on his return spent five years in Raymond's studio. Opening his own office in 1938, Maekawa was joined by the younger Kenzo Tange, who returned to study in 1942. A rapid economic recovery was underwritten by America's use of Japan as a supply base for operations in the Korean War from 1950 to 1953. By 1959, Le Corbusier himself was invited to design the Museum of Western Art in Ueno Park, Tokyo, to be emulated only two years later in the same concrete genre by Maekawa's design for the Tokyo Metropolitan Festival Hall.

This historic burst of reconstruction provided a timely opportunity for the enterprising Tange to apply his vision and to define the shape of post-war Japan in a modernist vein. With his unpretentious provincial profile, Tange became Japan's favourite architect and called upon other Japanese architects to adopt the ethos of a 'New Tradition'. His early preoccupations with native sources stimulated his competition entries, such as the Greater East Asia Co-Prosperity Sphere Monument located at the base of Mount Fuji that combined the Ise Shrine with Michelangelo's Capitoline Hill. It was later incorporated into his proposal for the Hiroshima Peace Centre. Following his prize-winning scheme for Hiroshima, Tange attended reconstruction meetings in 1951. The atrocious manner in which the city had been instantly annihilated was beyond any mere symbolic architectural gesture or functional rehabition of the site. As within the compound of the Ise Shrine, many Japanese cities and castle towns have restricted centres to which access by the common people is limited. Hiroshima required a new soul and a focus point for grief but the surge of international attention was not altogether appreciated by its inhabitants, whose basic needs were more practical and immediate. The Atomic Memorial Museum resting on 6-metre piloti is arranged axially to the ruins of the Atomic Dome, the remnant of the neo-classical exhibit hall that is the only surviving structure in the ground zero vicinity. Virtually a vacant island at the core of the city, it resembles the layout of the earlier memorial base at Mount Fuji. According to Tange, the philosophy contained 'a certain criticism of functionalism', and the Hiroshima project was limited to the 'most human, most essential and more future orientated'.

Utopian megastructures

Part of a concept related to overpopulation, where people re-inhabit the shorelines and industry is relocated offshore, the elevated Skyhouse (1958) was a test bed for architect Kiyonori Kikutake's (b.1928) plans for the reorganisation of Tokyo as a marine city. Maekawa's Harumi apartment building

9

with its substantial pier structure, constructed in 1958 and now demolished, was also considered a new urban prototype for the Bay Area's reclamation plan. An important platform for Kenzo Tange's address on *Man and Technology*, the World Design Conference held in 1960 in Tokyo gave rise to proposals for a new utopian urbanism. This paved the way for Tange's ambitious 1960 Tokyo Bay Plan for 10 million inhabitants that proposed a marina with its super space frame projected through the middle of the bay along a linear civic axis with the Imperial Palace, incorporating an arterial street grid layout similar to that of Kyoto.

A development of Kikutake's concept, the manifesto known as 'Metabolism' was prepared by its youngest member, the 26-year-old Kisho Kurokawa. Later, a theme committee was formed under Tange's guidance which, besides Kikutake and Kurokawa, included architects Masato Okaba and Fumihiko Maki, designers Kenji Ekuan and Kiyoshi Awazu with critic Nobuo Kawazoe. They adopted the Greek word *metabolism* for its relationship to Buddhist principles of being open to change and cyclical processes. The Metabolists proposed that architecture such as that of cities should not be regarded as a static entity, but as a biological mechanism capable of changing its space and function. The launch of their manifesto, full of youthful optimism and capturing the can-do spirit of the bullet-train age, was fuelled by a vigorous and expanding economy. Bolstered by his theoretical writings, Kurokawa captured the essence of Metabolism in his Nagakin Capsule Tower of 1972 and the 1976 Sony Tower in Osaka; both demonstrated a flexible and close relationship between humanity and technology. A common feature of off-site prefabricated pods for living and working was an exposed service shaft rising through the container decks and supporting the entire building. Unfortunately, the Sony Tower is no longer in existence and the Nagakin Tower, the first plug-in capsule structure, is currently threatened with demolition. As a result of government support for architecture to promote the construction industry abroad, Metabolism was the first modern Japanese style to have international influence. The dynamic principles of monumentalising transience in the future city as employed in Kurokawa's capsule towers would inform new high-tech icons such as the Georges Pompidou Centre in Paris and the Lloyds Insurance Building in London.

The ambitious Metabolists were, however, unable to influence the actual metropolitan expansion that was unleashed by a new wave of economic development known as the 'Japanese Miracle', an unparalleled period of industrialisation and technological progress. Apart from a few remaining buildings, the Metropolitan expressways became the nearest comparison to Metabolism and formed real monuments romanticising city life, but such resource-hungry superstructures would later fall victim to the oil crisis of the mid-1970s. The Tokyo expressways were constructed in preparation for the 1964 Olympic Games for which Kenzo Tange would build his greatest masterpiece, the National Olympic Stadium overlooking Yoyogi Park. Hung from giant pylons and suspended cables, the shell-shaped canopies of the Stadium fan out in parabolic and hyperbolic arcs over the two arenas. Resembling the pit dwellings of a Jomon settlement, merging ancient and contemporary forms of pure geometry, the stadium represents the establishment of the New Japan Style – a synthesis of modern technology and tradition without resorting to nationalistic clichés. Within the work of Tange and the Metabolists, we witness an emerging regional contemporary architecture from a combination of local tradition and universal forms.

During the 100 years from isolation to staging the Olympic Games, through the refinement process of selection and synchronization, Japan has excelled at accommodating and adapting numerous fresh approaches to fabrication using a predominately pragmatic rather than individual expression. We discover an uncomfortable coexistence of foreign references and a wide palette of tastes from polychromatic exuberance to monochromatic monotony. Additional to the eclectic layering are local specialities such as lightness, mobility and attention to minutiae multi-purposefully applied from the particular to the general form. Whilst fused with the feudal practice of its recent past, it is simultaneously technologically enlightened and futuristic. However, bemoans the architect Tadao Ando, many aspects of the Japanese way of life, such as its ancient artefacts and craftsmanship, will soon be consigned to history and lost forever to the detriment of generations to come. As we have seen, it is not only popular handicrafts, but many of the architectural gems that have been quickly disappearing since the Great Kanto Earthquake, erased from public memory. A program documenting modern movement buildings, Docomomo Japan, has assembled a hot list of 100 examples alone that are currently considered under threat.

Mass Culture and Self Restraint: a Japanese Aesthetic

1 Tian-in Teahouse, Kyoto
2 Wash basin, Roanji, Kyoto

1

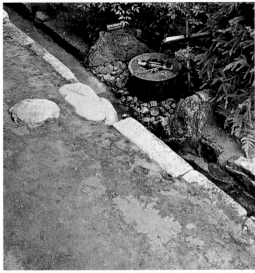

2

Hybrid culture

Not unusually amongst island cultures, it is difficult to identify which elements or processes are truly indigenous and unique to the country of origin. Coupled with traditional characteristics for the acquisition of ideas and skills from the near continent is the phenomena of hybridisation as displayed in the origins of the written Japanese language. According to architect Arata Isozaki, the modern Japanese language is rooted in the transcription of the ancient oral tradition *kojiki* and is a compound writing system incorporating Chinese characters, *kanji*, and a phonetic notation, *kana*, established in the Heien period and still in use today.[3] Transforming Chinese ideographs into the realisation of a Japanese linguistic format produces a complex relationship between a hieroglyphic pictorial code for the names of objects and a written phonetic framework for describing action and texture. The phonetic alphabet is attributed to the Buddhist monk Kobo Daishi, a renowned scholar, poet and artist. With such a compound linguistic framework, it is not surprising there are difficulties in translation with considerable scope for misinterpretation of cultural status and customs. To add a further layer of complexity, Japanese books start at the rear cover from which the pages are notated in columns, read right to left.

To become fully literate, each child is expected to learn about 2000 Chinese characters as well as Hiragani and Katakana, both alphabets of 48 characters. In numeracy, there are different symbols for numbers depending on the characteristics of objects being counted.

Acquiring language by repetitive attempts to recognise the ideographs appears to lead to a different approach to image assembly based on aggregation, classification and differentiation rather than the manipulation of word structures and meanings. Slavishly learning to read and write kanji characters by rote will naturally rely on a greater degree of graphic and spatial awareness than found in phonetic language-based cultures. The rigour of acquiring these complex notations places the priority on the more passive reading and writing skills, often at the expense of gaining confidence in verbal expression and the articulation of how and why. The reason for this incremental process of language structure, instead of one favoured form of vocabulary superseding the other, isn't clear, but as it worked for religion as it did for language. Buddhism, for instance, coexists with the native animalism of Shinto. The years of isolation led to a more ingrained and esoteric cultural entity. Classical Chinese prose and mythology was for the elite, entwined with the coarser rural vernacular of rice festivals and the gathering commercialism of the late Edo period.

Japan's ancient religion Shinto is a form of nature worship and means 'the way of the gods', known as *kami* or *Ki*. Buddhism was introduced in 552 AD and Zen, one of the later sects, was established in the 12th century and eventually adopted by the samurai warrior class. Meaning meditation, Zen emphasises self-discipline and relies on the personal transmission of truth from master to disciple. Prior to the Tokugawa Dynasty, in the age of the warrior, Japan was a failing state

dominated by regional factions (repercussions of which remain even today) and wars between feudal lords had spread throughout the country. Following the siege at Osaka castle in 1616, Japan was eventually unified. Under the great shogun Ieyasu, Tokugawa's suppressive military regime entered a period of relative peace and stability. Driven by the Chinese philosophy of Confucianism, suspicion of the barbaric foreigner and the opportunistic spread of Christianity as witnessed elsewhere on the Pacific Rim, Japan in 1639 became completely closed in a state of isolation, *Sakoku*, from the outside world.

To secure law and order, the powerful warlords of the fiefdoms, the daimyo, had to pay homage to the shogun for months at a time and to guarantee good behaviour their families had to stay permanently in Edo in *sankin kotai* – alternate attendance. The shogun's sinister ploy against the natural affection for their families impoverished the daimyo, who were forced to maintain two households and pay for regular journeys of an entire retinue. Further undermining their capacity to make mischief, they were often called upon to finance and undertake public works. One of the main features of the Tokugawan policy of national seclusion was the enforcement of the four class divisions, which in order of importance were the samurai, farmers, artisans and merchants. Based on Confucianism, the hierarchy favoured the samurai, who were highly privileged.

Towards the end of the Edo period, the economy gradually changed its currency from rice to money and drew the agricultural communities into the commodity market. The new order promoted urban life in the castle towns and many trades flocked to Edo, which empowered the merchants who were to eventually turn the tables and impoverish the finances of the samurai and feudal lords. Owing to the abolition of the daimyo attendance system and turmoil in 1862, more than half of Edo's inhabitants returned to their ancestral roots. The samurai were replaced by

the merchants, and it was not until the 1890s that the population of the new capital again reached the Edo population of a million.

The way of tea
Major cultural determinants were the ancient Jomon era, the introduction of Indian-style Buddhism, and the Chinese-style Taoism and Confucianism. The quest or path to self-enlightenment came from the South China creed of Taoism with mass obedience emanating from the Confucianism of the northern continent. In the temples, the Buddhist monks were seeking nirvana and since property cannot be taken to heaven, material possessions were rejected in favour of an austerity that they believed would promote meditation and bring heaven on earth closer to them. Harmony, respect and purity formed the three ingredients of tranquillity and these, along with ideals of frugality, provided the discipline and rules for the tea ceremony. The teahouse would provide a rustic escape hatch where the samurai could practice contemplation through the art of poverty. It was an aesthetic retreat from the distractions of the daily chores and responsibilities. Imported along the Silk Road through China, the Taoist doctrines of the tea ceremony were refined in the 16th century by Sen Rikyu, the most famous tea master of all. A wealthy businessman from Osaka, Rikyu was an unlikely aesthete who belonged to the merchant classes, the lowest of the Tokugawan castes.

The path to 'Teaism', as the authoritative aesthete Okakura Kakuzo labelled it, winds back to the 5th-century Chinese philosopher Lao Tse, the founder of Taoism. In his archaic *Book of Changes*, the wise long-eared philosopher advises that to keep a proportion of things and give place to others without losing one's own position is the secret of success in the mundane drama.[4] We must know the whole story in order to properly play out our parts; the concept of totality must never be lost in the individual. Lao Tse illustrates this by claiming that 'only in the vacuum lay the truly essential. The reality of the room was to be

found in the vacant space, enclosed by the roof and the walls, not in the roof and the walls themselves. The usefulness of the water pitcher dwelt in the emptiness in which the water might be put, not in the form of the pitcher and in the material of which it is made. Vacuum is all-potent because it is all-containing'. The art of the void is a key aesthetic component of the rock garden, a prop to transcendental meditation. Such emphasis on the void resembles the Shinto ritual of creating an empty shrine enclosure in which to invite the visiting spiritual force. Leaving a void at the core has potential to accommodate future change and is related to the principle of *ma*, the transitional pregnant pause in time and space between activities and the boundaries of objects.

A unique vocabulary of aesthetic terminology became associated with the emergence of the tea ceremony. *Wabi* means restraint and poverty, the phenomena of natural occurrences, cracks and flaws, the appreciation of imperfection and irregularity. A timeless quality, *sabi* respects the elegance of functionality, the purest commodity and the grace of ageing. *Shibui* is an expression of quality through the economy of means with simplicity preferred to ostentation.[5] Within Japanese custom, there is a time and place for each element that accommodates its highly flexible attitude towards stylistic diversity. As a consequence of such structural incompatibilities, there is little agreement or overlap of views between Western and Japanese scholars of what constitutes a masterpiece. An objective analysis to determine artistic superiority between, for instance, the merits of a painting by Rembrandt compared to the qualities of the Roanji Rock Garden would remain unresolved.

A collective consciousness
Just why the traditional attitudes and rituals are re-appropriated and still prevail is a critical issue. A penchant for aesthetic influences appears to be embedded into the shared esteem of the majority, consciously preserved due to the importance of continuing the ancestral legacy. Appealing to the

popular imagination, the historical heritage is perpetuated, particularly by the elders who value and hark back to the old order. Japan for the Westerner remains a remote and isolated inward-looking nation, opaque to outsiders, its language difficult to assimilate. Until the deployment of the atomic bomb, unlike elsewhere in the Far East, Japan itself had never been invaded. As a consequence, the importance of traditional customs and rituals to the masses haven't yet been dissipated through migration, cultural or spiritual colonialism.

To multinational players, the construction industry is regarded as a highly insular area that few have penetrated until recently, with the exception of large 'international' projects such as the Tokyo International Forum, Yokohama International Port Terminal and Kansai International Airport. The latter project was the first time that steel was imported as superstructure from abroad. However, the restrictive practices of the xenophobic dynasties and the institutionalised cartels are evidently now being slowly eroded as the global markets seep through.

Japan is a densely populated country in which overt individual freedom has been suppressed in favour of order, stability, and more civilised behaviour. The Japanese always hammer in the nail that sticks out, so rather than be highly noticeable in social situations they prefer to merge into a group. The highly homogeneous nature of Japanese society has historically flourished by promoting group activities whose interests supersede those of the self-seeking individual. The importance of belonging to a group is believed to have developed as a result of the country's dependence on agriculture in which survival from famine required communal action. Consequently, Japanese society is composed of many groups, and the devotion to social cohesion for mutual benefit and interdependency has contributed to the collective consciousness of the nation. Individuals bond through their genes and honour to their

immediate family circle, and they identify in much the same way with their company or professional colleagues who provide a strong sense of pride in being an integral part of the team. There are well-established institutional and personal codes of protocol that reinforce the pyramid hierarchy. Rigid rules maintain order and discourage individualistic discord. Social encounters amongst Japanese are based on formal rituals that govern how one politely addresses the other and in what manner one person will be placed before the other. Through the courtesy of considering the other person first, the Japanese view themselves as part of the unity. Based on what is best for the kinship or inner circle, decision-making is arrived at through group dynamics providing a balanced social etiquette, rather than favouring individual attention-seekers first.

3

3 View of Mt. Fuji, Katsushika Hokusai (1760–1849) View of Mt. Fuji from Kajikazawa, from a series of *Thirty-six Views of Mt. Fuji*, early 1830s. As a fisherman stands on a perilous promontory, his taut net cast in the rain-swollen, writhing river, man and nature are connected by the frail fishing lines.

To take major decisions, as elsewhere in Asia, the young look to the wisdom of their elders. Considering everyone to be 'a debtor to the world', the Japanese people are expected to express obligation to their superiors, to acknowledge debt to parents, teachers, employers, and to always care for and respect the elderly. When the long-suffering salary man eventually takes his turn to lead in the workplace, business decisions are based on considerable experience reflecting the job-for-life dedication to the company. Even between businesses, allegiances, loyalty and honour are so important that, until recently, the notion of transactions being agreed and verified by the use of third-party legal contracts was completely alien to the Japanese.

Much like the people, the Japanese language is always conscious of rank, and so it has different forms of addressing people according to their position or social standing. Upon meeting outsiders, the degree of humility is dependant on the other person's status within their company, so the lower the rank on their business cards the lower they bow. A most unedifying and all too common aspect of group control structures is the bullying of an individual who is different from the rest or when those trusted with authority abuse their status and coerce junior colleagues to serve their every whim.

Discipline units encourage social cohesion
The principle of emphasising the group first goes back to the repressive doctrines of Confucianism, which demanded disciplined units with respect for hierarchy and duty to the master. Heroic sentiments such as sacrificing oneself for the good of the group were exaggerated by such feudal military dictates as that of the bushido, the legendary samurai code of honour. This code embraced the notion of *seppuku*, the ritual sacrifice for the sake of honour or loyalty to one's master. *Seppuku* could be ordered by a samurai's daimyo or it could take place at the death of that master, a ritual known as *oibara*. Towards the end of the 19th century, it was estimated some 10

percent of the Japanese population still followed the samurai code and, sadly, such extremes continued to be expressed in such actions as those of the kamikaze pilots, or the Japanese troops cut off on Iwo Jima during the Second World War. Worse still, they were expressed in the actions of thousands of women and children on Okinawa towards the end of the War who were expected to commit ritual suicide rather than submit to the American invaders. As late as 1970, the famous author Yukio Mishima committed *seppuku* after failing to incite a nationalist revolt in Japan.

The traditional emphasis on social obligation over excessive individualism endorses respect for the rules and absolute obedience to the Imperial throne. Regimental and repressive obeisance to the canons of Confucianism were sustained by the perpetuated belief in the Imperial Emperor's unique ancestral lineage to God and his divine access to the will of heaven, providing an infallible core to the powerful Imperial leader as head of the nation, known as the *kokutai* system. The myth was that the Emperor's ancient ancestry was directly descended from the ancient deities and the sun goddess Amateratsu, but controversially there are scholars who now believe the Imperial Family may have instead originated from the Korean Peninsula. To reduce the possibility of future conflict, such belief structures based on religious superstitions as an essential part of national politics have now been made incompatible with the modern secular Japanese democracy.

'Avoid things that you like and turn your attention to unpleasant duties', became a Tokugawan expression of austerity. Within the historic scene-painting workshops of Kyoto, the Kano school valued discipline and adherence to the 'pattern book' instructions. Apprentices were taught skills through repetition, gradually building competence through experience in preference to youthful flights of fancy. Learning from traditional masters and instructors was preferred to artistic license or

personal vanity. Deference to the teacher, the sensei, provided continuity of the skills. Individual authorship was not seen as an asset. In a culture based on mass consciousness, intellectual property rights or determining the name of the inventor were not a priority and, as such, were largely disregarded. From his deathbed, Japan's most celebrated woodblock artist Katsushika Hokusai (1760–1849), despite a 70-year career, is reported to have appealed for a further five more years in order to become a true artist. Seemingly indifferent to commercial advantages of brand merchandising, the prolific woodblock artist changed his pen name more than two dozen times.[6] For his final book on the use of colour in 1849, Hokusai boldly declared, 'From my 90th year I shall again change my style and at the age of 100 I shall revolutionise the art world'. But Hokusai would not be granted that extra time, passing away nearly 20 years before the Meiji Restoration.

When the Meiji Restoration occurred, the 'floating world' of the late Edo Period that Hokusai had observed came to an end, to be superseded in the final decades of the 19th century by an assimilation of Western attitudes and superficial clothing. From a repressed existence based on interconnectedness, Japanese society was introduced to cultural diversity, to an era when the individual oblivious to quality was free to make their own choices largely without value judgment. The Edo culture transformed modern Tokyo in a period coinciding with Impressionism and the liberation of easel painting. Modernism is associated with the rise of the individual genius such as the egotist Le Corbusier, considered by many to be the architect of the 20th century. In the footsteps of the carpenters' tradition came the modern studio architect. In Japan, however, despite 100 years of modernising and celebrating individuality, the atelier architects are only responsible for less than one percent of construction. The rest is still produced by the house builders and contractors, the irrepressible construction companies.

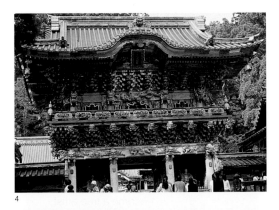

4

5

6

7

4, 6, 8　Shrines and Temples of Nikko Tosho gu,
Tochigi prefecture 1634–53.
An example of superior craftsmanship,
it contains the mausoleum of Tokugawa
Ieyasu and includes work of master builder
Kora Munehiro and the artist Kano Kanyu.
Monkey carvings, "hear no evil, see no evil,
speak no evil" are the three main principles
of Tendai Buddhism. The seated archer guards
the highly ornate ceremonial Sun Blaze Gate.

5, 7　Ise Shrine, Ise City, Mie prefecture
Built to call up the deity, the Shrine structures
were to offer prayers for a bountiful harvest.
The Ise Shrine, a distinctly simple form,
consists of the outer and inner shrine
complexes. The main shrine, the Shoden, is
an elevated structure with an entrance porch
projecting to the south side. The roof ridge is
supported by two massive central pillars. To
ensure spiritual purity, the shrines are rebuilt
on adjacent plots every 20 years. Once the
new shrine is complete, the older one is
dismantled. Photographed at the beginning of
January, 1993, immediately following the 61st
rebuilding cycle when there were still a pair of
temple compounds on each site. Going back
to 650, this ancient custom is a unique
approach of retaining craftsmanship skills
over the generations.

8

9

11

13

10

12

14

15

9 Radiation shadow of victim

10 Cenotaph to the victims of the atomic bomb
 Hiroshima | Kenzo Tange

11 Crane Tower Hiroshima | Kazuo Kikuchi

12 Turkish Peace Memorial, Nagasaki

13 Peace Statue, Nagasaki 1955 | Kitamura Seibo

14 Homeless person's bench (following 1995 Kobe
 earthquake), Nakanoshima, Osaka

15 Children's Creche, Museum of the 21st Century,
 Kanazawa

Urban Context – Ancient and Modern Cheek by Jowl

1 Tsukudashima, a cluster of Edo period homes overshadowed by the modern River City apartments

2 Driving Rain by Ando Hiroshige
The 46th station from the series 'The Fifty-Three stations of the Tokaido'. Brocade print by Hoeido. It shows a sudden storm among the bamboo groves as the road climbs along the River Suzuki over towards Kyoto. Amongst the most vivid and evocative of Hiroshige's masterpieces, it depicts a scene stressing the urgency when the thunder clouds suddenly break. The aerial view with the tossing bamboos and driving rain sheeting across the diagonal of the slope flattens the composition.

1

The Japanese miracle

Three thousand kilometres long, Japan is a mountainous archipelago containing 200 volcanoes, the highest of which is Mount Fuji at 3776 metres. Thirty of these are active volcanoes that provide hot mineral springs but also cause frequent earth tremors. The country's primary materials are stone and timber from extensive forestation. The main agricultural product is rice although most foods, including fish, and raw materials are imported. From a stable 30 million during the Tokugawa era, the population has risen to the current 127 million, providing an overall density of 342 persons per square kilometre. The mountainous terrain accounts for more than 70 percent of land, so the major cities concentrated in the Pacific coastal plains accommodate an average density of 1100 persons per square kilometre. Among the cities with a population exceeding one million are: Sendai, Saitama, Tokyo, Yokohama, Nagoya, Osaka, Kyoto, Kobe, Hiroshima, Fukuoka in Kyushu and Sapporo in Hokkaido. It is a country of extremes from humid climate and remote volcanic landscape to the densely populated Kanto plain with 40 million highly civilised and well-educated citizens.

Following the war, Japan experienced considerable social and economic transformation, and by 1970 it had asserted itself as the second-largest economy in the world. Based on manufacturing, construction, high productivity and sheer determination, Japan has been proclaimed the 'miracle economy'. The consumer-based lifestyle with home ownership and the demand for the latest brand, housing and construction have been at the heart of revitalisation. The 1980s saw exponential growth in the nation's fortunes known as the 'bubble' economy. This led to rocketing land prices and urban redevelopment on an unprecedented scale with considerable opportunities for inventive and adventurous architecture. Living beyond their means and largely independent of the world downturn, the economic bubble was inflated by speculative investment in Japan's own backyard. At the time, seven out of the ten largest banks in the world were Japanese, and they were underwriting the recovery of American inner-city decay. High prices, a drop in exports and protection from foreign infiltration all contributed to an unsustainable rise in the Japanese economy and forecasts of an economic black hole.

By the early 1990s, the situation had changed. A thorough lack of confidence had developed in the status of the Japanese economy and a withering internal market that later in the decade equated to a three-fold fall in land and property values. The fall in prices of real estate meant delinquent loans secured by highly devalued collateral continued to hold back the economy. To regain confidence within the new interconnected global 'big bang' market, the Japanese government was obliged to purge the financial sector where creative accountancy and corruption were rife. Nightly TV news coverage featured endless raid scenes by fraud squad investigators. Despite the ever-deepening recession over the decade, Japan nevertheless retained its status as the second-richest nation. Currently, with increasing competition from its

near neighbours and a decline in the 'jobs for life' prospects, there is an unprecedented trickle of professionals emigrating, with the salary man seeking employment in the Asian tiger economies such as Taiwan and Singapore.

Culture shock

Today, the visitor to Japan's shores is unlikely to witness economic hardship compared with that endured in the post-industrial wastelands that have blighted many northern European cities. In a nation far too modest to flaunt individual wealth or conspicuous consumption, there is an atmosphere of real vigour and zeal within a population where riches have flowed more evenly. The guest will benefit from the enormous pride invested in the public buildings and mass infrastructure; the Japan rail network, for instance, conveys more passengers than that in any other country. Famed for being efficient, it is so punctual you can set your watch to it. The Bullet train was first introduced in 1962 in time for the Olympic Games. Now, each evening a Shinkansen super-express departs Tokyo station every minute or so with up to 1500 passengers on board. They travel on five routes to destinations across the slopes of Japan at speeds in excess of 250 kph and, remarkably, since their introduction there has never been a single operational fatality. Boarding the Tokaido Shinkansen at Kyoto, the old capital enroute to Tokyo, passengers will speed along sections of the ancient highway immortalised by the artist Ando Hiroshige in his famous series of wood block prints known as the *Fifty-three Stages of the Tokaido*. The view through the window presents dramatically contrasting mountainous scenery and endless suburban development. Within a fine tapestry of rice fields, homes, stores and workshops scattered over the chequerboard landscape, it is the commoners' districts that demonstrate a sense of collective consciousness. Yet just a few miles from the tracks, the rural villages and mountainside retreats offer peace and tranquillity, with the occasional wild bear: a scene largely unchanged from Hiroshige's prints.

First glances of a Japanese cityscape from the elevated train offer a random array of profiles, pagoda temple roofs, timber homes and danchi apartments cheek by jowl among an assortment of monotonous office blocks, enormous warehouses and industrial plants. Upon entering the city centre, the new arrival is greeted by an instant assault on the senses. Beneath a torrent of oriental calligraphy, masses of humanity swarm in and out of nooks and crannies, side streets and alleyway cellars. Seemingly entangled in a web of overhead cables, such a cityscape might seem a scene of confusion to Western eyes but, like gazing inside a computer, it possesses its own principles of organization, order and logic known as *konton*.

To many Westerners, jet-lagged and culture shocked, the experience can be disorientating but the juxtaposition of old and new, although bewildering, is nevertheless fascinating. The streets are safe to walk at night and are amazingly litter-free. Experiencing Japan is often described as arriving on another planet. Sandwiched between mountainous silhouettes and the Pacific Ocean, cities appear layered in two-dimensional planes. Arranged along the riverbanks, a cluster of black and brown village houses of straw creep up the valley in a low, elongated configuration nesting in the mountainside. Further compressing the habitable landscape, the lower slopes are left untouched for the shrines and the spiritual *kami* forces to roam free within the dark woodlands, with the seaboard dedicated to maritime trade and the worship of the mighty yen. Due to the steep terraces and the old castle districts, the Japanese delight in the asymmetrical and that vital energy which makes major cities even more organic and dynamic.

Tokyo: the most modern city in the world

Within just over 400 years, the greater Tokyo plain expanded from an isolated fishing village known as Edo, or 'mouth of the river', into the largest registered population on earth. Ordered by the shogun to find a suitable place for an eastern

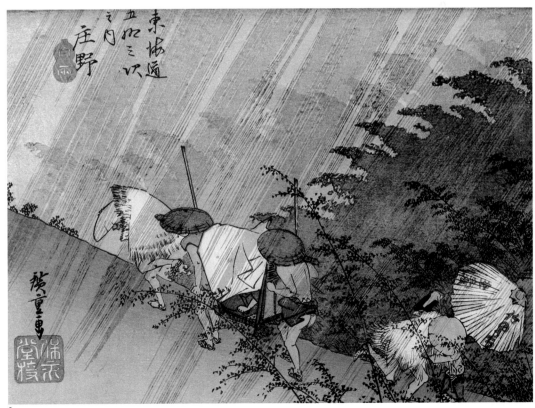

2

capital, a geomancer chose the Kanto location due to its benevolent *ki* forces.[7] A complexity of narrow winding streets and cul-de-sacs with no names or numbers gyrate outward from the Imperial Palace, arranged according to the traditional 'Edo footprint' that shielded its leaders and confused the enemy. Nowadays, should sections of the capital resemble a chaotic building site, it is because the city has remained unfinished from the Meiji Restoration, and it has been in continual and rapid reconstruction ever since the fire bombing during the Second World War when the centre suffered 95 percent destruction. From this constant renewal process throughout its turbulent history stems the opinion that buildings are an ephemeral phenomena and the city is a 'metabolic organism' in constant flux. Such biological metaphors refer to a romantic urban vision that, prior to the oil crisis, braced heavy engineering superstructure and the arterial metropolitan Shuto Expressway system, on which construction began in 1959 in preparation for the Olympic Games. Elevated over the remnants of public space and canals, this 200-mile Greater Tokyo network of megastructures is now choked with traffic and plunges the cityscape into shadow and fumes.

However, should anything threaten the fabric of Japanese cities it's the rampant commercial real estate expansion, often economic development dressed up as modernisation, that is almost as devastating as the earthquakes. One of the greatest monuments to rail travel since London's St Pancras Station, sometimes called The Cathedral of the Railway Age, the mammoth new Kyoto Railway Station with its exciting vertiginous arrival hall, but excessive Shangri-La edifices, is widely criticised by the locals. A powerful presence completely dominating and out of proportion with its unique surroundings, it divides the city and is attracting further high-rise development, destroying the grain of the surrounding area. The essence of design should lie in the subtle way it supports individual lives and community spirit without forcing it down

people's throats. Although average Japanese urban conditions would not usually be described as picturesque, it must be unsettling to have familiar landmarks constantly swept aside, deleted from communal memory. Before old and traditional Japanese neighbourhoods, such as those of Kyoto, are lost forever, the planning authorities may once again learn from the European experience, which produced such bodies as the National Trust, about the importance of conservation and restoration of heritage as a means to restoring identity and community self-esteem. According to the United Nations, 'Heritage is our legacy from the past, what we live with today and what we pass on to future generations. Our cultural and natural heritage is an irreplaceable source of life and inspiration.'[8]

These days, Tokyo is arguably the most modern city in the world and the quality of its suburban rail infrastructure is second to none. Every day, the Tokyo subway system conveys millions of passengers to and from their places of employment. Crammed full of nomadic commuters, over a dozen lines weave cross-laced beneath the cityscape. Regular as clockwork, they are rarely delayed as failure to adhere strictly to the schedules would result in instant gridlock. As though life imitates art, it is like a scene from a Manga-inspired anime. Orchestrated by platform melodies, the whole city appears to be in cinematic motion. As within a giant aquarium, the throng stream through like shoals of bait, gracefully gliding past each other in a far more orchestrated manner than the frenzy found within the London underground system. Despite their excessive use, the floors of the carriages and subway stations are impeccably clean. On some orbital services, jump seats are fitted to accommodate the daily crush, raised at peak times to convert the busy Yamanote Line trains to standing-room only. Some coaches are designated for the sole use of women passengers. Adding to the complexity, the deregulation of the railway network has led to a combined franchise system. The Hanzomon line train, for example,

3

4

5

now changes stewardship three times along a single journey in and out of Tokyo. From the west, the Tokyu line suburban train changes leaseholders at Shibuya to the Tokyo subway system and then changes companies again, exiting as a limited express to the northern districts of Saitama. An exhausting spectacle, the rush hour lasts beyond 10 p.m. as the bars empty and the workaholics stride to catch their last trains to the dormitories, draining the capital and leaving it to resemble a ghost town until the dawn chorus of crows, when each working morning the performance is repeated.

A national obsession
The streets by day are polluted by motor vehicle exhaust and air-conditioning, and at night by excessive lighting. Nondescript and repetitive during daylight hours, major transport thoroughfares gloriously transform at dusk into a retail paradise emblazoned with neon and huge LCD video screens, a fantasyland of consumers and after-work gathering dens. Much of the surroundings and pulsating skylines are owned by the large corporations, the economic powerhouses formerly known as the *zaibatsu*. Ninety percent of the urban fabric you sample is built by the major construction and engineering companies such as Mitsubishi, Kajima and Takanaka, many of whom are outsourced from the leading financial institutions. It is estimated that the construction industry accounts for a massive 20 percent of the gross national product, twice that of the UK, and much of Japan's wealth is based on land ownership and property values. The construction industry is huge and employs many thousands of architects with hundreds of graduates qualifying each year. The powerful design-and-build arms of the construction giants are part of the *zaibatsu* monopolies. Their faceless corporate clients who own most of the land are responsible for many of the anonymous façades. Facing chronic labour shortages, dramatic changes are underway in the construction industry. Replacing the missing manpower, information technology is controlling

the corporation's approach to new assembly. Fully automated off-site building construction methods and robots are dramatically reducing labour costs and delivery times.

Based on the principal of recycling the Ise Shrine every 20 years, 'the newer the better' is a national obsession.[9] Following the war, reconstruction was rushed with inadequate raw materials and craftsmanship. As a consequence, ten years after construction some buildings in Japan are considered old. With cities over-populated, land is valued far more highly than accommodation, and buildings suffer from low whole-life performance expectations. Often due to poor maintenance, they have a very short life span and quickly become obsolete. Migration from the countryside and changes to the inheritance laws in the new constitution mean homes that were once passed down through the family are now replaced every generation. As with the manufacture of consumables and disposable products, short-term scrap and rebuild may be highly profitable for the building industry, but ecologically it is very destructive and harmful. They rarely fully consider real whole-life costs such as capital and revenue, site preparations and demolition, or the true impact on the environment from embodied carbon, heating and air-conditioning and poor insulation.

Instead of throwing away, a conversion strategy would be more appropriate so that, where possible, refurbishment takes place for new use. It's about making buildings durable and flexible enough to accommodate change of use, and designing buildings to support sustainable life patterns such as living–working. Rather than emphasising the age of the building, as in the West, it is the recycling program that is monumentalised. The challenge is how to pass down skills through the generations, and how to nurture young dynamic talent in a world dominated by construction giants and business monopolies just beginning to appreciate the advantages.

6

Waves of designers

By the late 1990s, cutting-edge Japanese architects were receiving international acclaim, and the attention they received was slowly encouraging the corporations to diversify procurement methods. Out went the repetitive containers in favour of individualistic volumes by a small select number of designers known as 'atelier' architects (after the French word for artist studio), who have become responsible for giving contemporary Japanese architecture its progressive image. Atelier architects have reputations for more radical buildings; they are a new generation creating elegant, more inventive and organically formed lightweight structures. Like many contemporary modern artists, a number of atelier architects studied abroad: Fumihiko Maki, Yoshio Taniguchi, Shigeru Ban and Kengo Kuma all attended American universities.

The collapse of the bubble economy saw national and local government commissions slashed, and architects were forced to seek alternative outlets. However, restrictions imposed more recently during Prime Minister Koizumi's leadership have reduced the tendency towards open design competition for public buildings and this has reversed the market once again, placing the new small design practices at a disadvantage. As a result, the atelier architects are branching out and exporting their skills. Succeeding in major international competitions and commissions abroad are, for example: Yoshio Taniguchi (responsible for the reconfigured Museum of Modern Art in New York), Fumihiko Maki & Associates (designed Tower 4 at Ground Zero), and SANAA (won the competition for the new Louvre Museum on the northern outskirts of Paris). For the last decade, a number of artists and designers have been introduced to the shores of Britain, and some examples of their work will be presented later.

The culture of architects is often likened to the movement of waves, and Fumihiko Maki describes how different waves collide and interfere with one another, some disappearing and merging to form bigger waves. 'Every day', he says, 'we experience and participate in several waves that began in the early 20th century.'[10] The atelier architects have adopted such wave movements, but from a distinctly Japanese approach. Following the war, the first large wave includes Kenzo Tange, Kunio Maekawa, Junzo Sakakura and Togo Murano. Members of the Metabolist Group were Kiyonori Kikutake, Kisho Kurokawa and Fumihiko Maki who, with Arata Isozaki, Kazuo Shinohara and Yoshinobu Ashihara are associated with the late 1960s. Riding high in the next generation were Tadao Ando, Toyo Ito, Itsuko Hasegawa and Yoshio Taniguchi. The current wave includes Kazuyo Sejima, Shigeru Ban, Kengo Kuma and Makoto Sei Watanabe.

Beside the ripples, a system of mentors and protégés provide a form of grooming known as schools; for instance, Isozaki, Kurokawa and later Taniguchi worked in Kenzo Tange's Tokyo Bay studio. From Isozaki's office came Shigeru Ban and Makoto Sei Watanabe, whilst Toyo Ito and Itsuko Hasegawa graduated from the Shinohara laboratory at the Tokyo Institute of Technology. Riken Yamamoto graduated from Hiroshi Hara's studio at the University of Tokyo, and Kazuyo Sejima worked in Toyo Ito's office. At present, some leading-edge artists and designers claim to no longer associate themselves with the old ways or their heritage but are more influenced by their mentors or schools. The newly liberated transcultural generation like Kazuyo Sejima and her SANAA partner Ryue Nishizawa modestly simply regard themselves to be contemporary practitioners.

A vision of Japan

As Fumihiko Maki perceptively points out, architects have an obligation to involve existing craft skills in the construction industry, which is after all a way to achieve added value and to express the love of humanity through building. The future belongs to the younger generation,

7

and the challenge is how to pass down skills and to nurture young potential talent. Just beginning to appreciate the advantages, leaders everywhere often underestimate the value of the young creative community that feels disaffected. As important as the rebuilding program of the Ise Shrine is the responsibility to renew appropriate skills across the media from one generation to the next.

Just as the Japanese are noted for their punctuality and an eye for detail, they have applied a similar discipline to their cities. Historically they have little concept of open public squares; social space in the Edo townscape meant the street. Traditional city habitation evolved around the *engawa* veranda, the interface between the public carriageway and the dark private quarters within deep 'rabbit hutch' interiors. The result of a high-density population is compact urban living with an extraordinary attention to space. Like busy bees, the pressure due to confinement is the spur to a greater degree of cooperation, respect and capacity for fine detailing. As elsewhere in the world, city populations continue to expand and as the demand amongst the young to re-inhabit city centres grows, there is much the West can learn by taking a fresh look at Tokyo as a particularly advanced example of how, in future, conurbations may perform effectively.

Although, as a rule, the street was considered the public space, the nearest equivalent to the European public square are the shrine groves. *Chinju no mori*, like the village church grounds, form the green spaces of the town.[11] In Kyoto, most gardens are under the stewardship of the Temple and there are large famous Edo parks at cities such as Mito, Takamatsu, Kanazawa and Okayama. Today, there are also the great city parks like the Ueno Parks and Meiji-jingu gardens in Tokyo and every modern district has a local recreation space, a dedicated pocket park area in which to gather in case of an emergency. There are also assembly points around the railway stations and town halls that too often are dominated by parked vehicles. Following the war,

the memorial gardens in Hiroshima and Nagasaki were the first new breed of communal spaces, but more recent major programs such as the New Tokyo City Hall and the Tokyo International Forum incorporate giant public parades. The circulation and accommodation in all the large cities is provided in layers and each offers a maze of subterranean passages, a main street level, elevated gangways and highway superstructure with ever-higher rooftop terraces. The amorphous and claustrophobic underground shopping malls at key transportation hubs, such as Umeda in Osaka, are rapidly transforming into the chief fireman's worst nightmare.

It was the architect Toyo Ito, the designer of the 'Dreams' installation in the *Visions of Japan* exhibition at the Victoria and Albert Museum in 1991, who so disturbingly caught the spirit of uptown Tokyo. According to Ito, one major characteristic of the contemporary city is that each space is cut off from the next, a honeycomb cityscape fragmented into places with almost no spatial interrelationship. 'Walking through Shinjuku or Shibuya stations, two of the most complex spatial configurations in central Tokyo, is a very strange experience', he comments. 'It is an impervious, viewless world designed to make the user lose their way. Without returning to the collective existence of the past, a world without walls, the key lies in introducing new openings through the walls we have already built'. Referring to his iconic Sendai Mediatheque, Toyo Ito was attempting to close the distance between architecture and urban space. At Sendai he attempted what he calls 'Blurring Architecture', a building without rooms making the boundary between closed spaces and shared areas appear ambiguous.[12] Twentieth-century modernism, according to Ito, 'sought buildings unrelated to their localities, which could be constructed in a short time on a large scale and economically. As a result, flat buildings based on pure geometry without organic qualities came to line the streets, and the cities of the world become homogenised'. Toyo Ito believes in the creation of buildings for

7 Apartments, Ueno, Tokyo | Kiyonori Kikutake
8 Sendai Mediatheque | Toyo Ito

8

the new post-industrial age with the use of computer technology: 'One could call them new organic buildings which explore the relationship between nature and the environment.'[13]

Cool Earth 50

The design of cities and public spaces in future will be driven by society's desire for a more healthy and sustainable quality of life. At this historical peak-oil moment with the fossil-fuelled juggernaut approaching its carbon tipping point, it is timely to reconsider global warming. To raise awareness, Prime Minister Shinzo Abe launched a new climate change policy in 2007 known as 'Cool Earth 50' to halve carbon emissions by 2050. Surviving two major oil crises and falling heavy industry production, Japanese energy efficiency has improved by 37 percent over the past 30 years and although oil consumption has decreased by 8 percent, the GDP has doubled. The amount of carbon emissions by GDP of Japan is the least among the major economies. Public transportation accounts for 47 percent of all people movements, by far the highest amongst industrialised countries. With the motto of 'one person, one day, one kilogram' for reducing greenhouse gases, the government is calling upon the individual to re-examine their lifestyles and for effort and creative ideas in both the home and work-place. Specifically, they are promoting 'Cool Biz' as standard procedure, a casual dress code without a tie and jacket, to reduce the need for air-conditioning during the fierce heat of the summer.

9

10

9 Roppongi Expressway from Arc Hills, Tokyo

10 New Tokyo Metropolitan Government building, 1991 | Kenzo Tange

11 Christian Dior Omotesando | SANAA

12 Gyre Shopping Centre Omotesando | MVRDV

13 Tod's Omotesando | Toyo Ito

14 Dojunkai | Tadao Ando

15–16 Prada Building Omotesando | Herzog de Meuron

11

12

13

14

15

16

Omotesando Showcase, Tokyo

The fashionable quarter of Tokyo's Shibuya Ward boasts brand-named stores by signature architects. On parade along Omotesando is a collection of striking buildings by celebrity designers, such as the Prada Building by Herzog De Meuron. An exciting example of commercial architecture resembling a giant perfume bottle, it represents an immense advertising display. At dusk, SANAA's Christian Dior building's soft diffused screens are lit in bands like a giant lantern. Ceiling heights vary according to floor, and acrylic screens behind windows arranged like drapes create a mellow atmosphere. Since the completion of Sendai Mediatheque, Toyo Ito's buildings have changed considerably. He has been attracted by the strength of steel and its sense of substance, and is liberated by the loose-fit conditions this has achieved.

Less attention-seeking, the original Dojunkai Aoyama Apartments were built in 1927, after the Great Kanto Earthquake, as Japan's first ferro-concrete multi-family housing. They were valued not only for their historical worth, but also as an essential presence for maintaining the 'urban memory' of Tokyo. Above all, according to Tadao Ando, the rebuilding plans emphasise the continuation of that memory. Rebuilding goals include keeping the building no taller than the height of the zelkova trees lining the famous avenue, and making maximum use of underground commercial space, resulting in a building envelope where half the volume is submerged below grade.

Art in Context – an Outsider's View

There are three basic Fine Arts: painting, the making of marks upon a two-dimensional surface; sculpture, object making in the round; and architecture, building volumes with surfaces and space. 'The practitioner of one of those disciplines, who does not care for the values of the others, is not involved in the Fine Arts', wrote Bernard Cohen. Post-war prosperity and the expansion of educational opportunities raised consumer expectations about quality of life and attention to living spaces. Advances in telecommunications generated a wider availability and access to a vigorous youth culture and a greater fascination for the popular arts. The visual arts were widely broadcast to the masses, introducing many to the pleasures of producing art that enthused them by showing them another world. The radical years of the 1960s challenged established practice, and some artists were attempting to reposition art back where it belongs in the community. Contrary to market opinion, art for greater public consumption has long been high on the artistic agenda. Many of the 20th century's most renowned icons were created for locations beyond the museums. In Europe, conspicuous amongst these are Monet's *Water Lilies*, Picasso's *Guernica* and Matisse's works at Vence Chapel.

We have witnessed a century full of possibilities ranging from the extravagant excesses of political tyrants and the stunted dreams of social realism to the lone idealist.

During the age of the emancipated artist, we find a modern era dominated by the individual genius in search of the universal truth. However, re-emerging from the isolation and 'neutrality' of the art laboratory we discover a multivalent existence abundant in contradiction. The growth and developing range of art media appears to have moved on from elite utopian ideals in favour of particular aspirations to become more sympathetic to local needs and criteria. An increasing number of artists have been motivated to address the public domain and urban condition. The demand for a less hostile and more humane environment has stimulated considerable debate on art in context.

The current revival of interest in the development of the city and in architecture as the vehicle of that development has its roots in the 1980s, a time when architectural debate was exclusively for architects, and art was much less accessible than it is today. With advances in media revolution and the Internet age, the early 1980s now seem like the dark ages. So much has happened since the arrival of digital technology that now enables the artist to make a much more meaningful contribution. Empowerment through information networks has opened market opportunities once denied to the arts practitioner. In the pluralism of the Late Modern Age we are part of a globally connected society, a new hybrid condition full of uncoordinated experience and diversity of expression, often ill-conceived and poorly executed, badly located and often unnoticed, but occasionally exceptional.

Exposed as we are to the decadence of opulence and the transience of fashion, we should take heed of the painter Fernand Léger's important advice, that 'An artist should aspire to be popular, but not by means of popularising'. Léger describes two modes of plastic expression: the Art Object and Ornamental Art, 'its values rigorously relative and accommodating itself in the necessities of place'.

As such, architecture is an ornamental art form. The modernist notion that ornament is crime is itself a distraction. The removal of surface decoration emphasises buildings' volumes that would become the adornment of the city. Surface animation once skillfully applied by hand has been replaced by remarkable industrial products such as shuttered concrete, glass, and silver coatings. Structural formwork and minimal Cartesian elegance became the new decoration, and rivets and nuts and bolts became the ornament. Instead of emphasis on purposeful planning, the corporate clients are seduced by polished presentations and colourful walk-through computerised graphics that may in the end bear little resemblance to the final product. Upon completion, artificial scenes of unoccupied buildings under ideal light conditions are carefully framed by specialist photographers and the images doctored to glamorous effect for the glossy brochures. Image-based, the whole process of articulating and producing buildings is a highly illusionistic and ornamental form of media art. The style debate is, however, largely insignificant compared to the preferences and well-being of the user. By nature, people are biophilic and are attracted to natural phenomena and soothed by graphic representations of natural forms. Today's issues are no longer about the modern tastes of the designers and their clients, but more about the buildings, which do no harm to users and the natural environment while attempting to restore ecological diversity and harmony.

When on 14 August 1945, Emperor Hirohito broadcast the decision to surrender, it was the first time the Japanese had heard his voice. A year later, he made a further personal radio announcement to deny his divine status. Reducing the Emperor's authority further, the new constitution of 1947 renounced war and offered a new, fairer, social contract between leaders and people that included female suffrage. Economic redevelopment after the 1951 Peace Treaty of San Francisco meant that by the end of the decade, through hard toil, Japan had become the world's third-largest economic power. Surrounded by the wasteland and detritus of ruined cities, living in the shadow cast from weapons of mass destruction and flooded by occupational forces embarking on further war in Korea, these were desperate and traumatic times for the country. The most significant post-war projects, the ground zero parks at Hiroshima and Nagasaki, bear testament to the raw emotions and trauma of the survivors. Alarmed at establishing Japan as the front line, a further security treaty brought condemnation and distrust of American anti-communist Cold War policy, producing riots in the streets, providing further uncertainties with little hope for the future.

The late 1950s also had a special significance for younger artists rebelling against the authorities and disassociating themselves with the cultural values of pre-war Nationalism. Among the avant-garde, the umbilical cord to the traditional arts had been cut. The young radicals began a nihilistic clean slate, demonstrating that art will exist despite the most challenging and philistine of circumstances, even in a state tortuously scrambling for modernity. Revolutionary group movements such as Neo Dada, Fluxus, Art Informel and Mono Ha were producing new minimal and austere forms with the emphasis on what people did, rather than who the individuals were. Some of the most determined and robust artists moved overseas to participate in the international art movements. Amongst them, newly liberated and influential women artists such

1 Unesco University Sculpture, Shibuya | Taro Okamoto
2 St Lo Hospital Flower Sculpture, Fuji Building, Tokyo | Fernand Leger

1

2

as Yoko Ono, Yayoi Kusama, Aiko Miyawaki, and Shigeko Kubota sought refuge and recognition outside the male-dominated *kokutai* system.

It is claimed that Japanese architecture's contemporary period commenced when Kenzo Tange's iconic National Indoor Stadium attracted international attention, and from 1963 architects with newfound belief began to design without borrowing from abroad. The Olympic Games were a major milestone of Japan's post-war recovery, and they mark the birth of popular youth culture with mass euphoria demanding social change. The period of relentless reconstruction and unprecedented economic growth was fuelled by cradle-to-grave consumerism and a mania for the new. Disposable income generated a new market from a street code with youngsters checking out each other's style. The economy became driven by teenage girls pioneering the latest interactive digital devices, and society developed its own fresh anxieties for a future without purpose based

on material distraction and insatiable appetite for novelty and fixation on the cult of celebrity. Instead of citizens, Japan was becoming a nation of shoppers in danger of losing its soul.

In an age when the greatest creative energy is being applied to technological innovation, the art critic Toru Terada describes architecture as the core of contemporary art. 'We see all around us the materialisation of many new ideas through architecture as an applied science', he writes. 'The visual arts have become objects of scorn whilst architecture regarded as the science of building has largely escaped such denunciation. Whilst painting and sculpture is subjected to a barrage of media criticism, architecture is necessary for daily existence; shelter and protection are functions for which the building is respected. Today the architecture for mass accommodation: hospitals, places for learning, and transportation have large amounts of society's capital invested in them. The main reason for the flourishing state of large-scale civil engineering and building procurements is the potential for future profits. As soon as a major cultural centre or iconic monument is erected, it is allocated to the city's branding and tourism budgets. Art has been disenfranchised and impoverished by its detachment and isolation, whilst architecture driven by economic necessity is revitalised by urban renewal and commercial gain.'

3 Banner Landmark, Tower Mall, Yokohama

4 Market research has identified the early evening as most conducive for women to purchase gifts. A covered shopping mall, The Venus Fort, offers a romantic Italianate street setting that is fixed in the twilight glow of sunset.

3

4

Art and Architecture in Japan

1, 2 Western-style wedding. Yokohama International
 Port Terminal | Foreign Office Architects

1

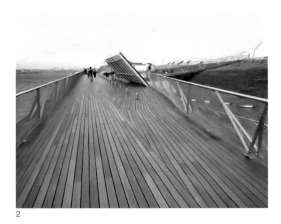

2

In 1995, with the support of an artist fellowship from the Japan Foundation, I was able to commence a fascinating journey exploring the relationship between art and architecture in the new generation of buildings in Japan. I set out to examine how artistic aspirations might be related to recent architecture and to what extent there was an ethos of collaboration between artists and architects. To this end, soon after my arrival I was able to identify and arrange interviews with over 20 leading architects, and 30 artists and curators. The architects included Tadao Ando, Fumihiko Maki, Arata Isozaki, Toyo Ito, Itsuko Hasegawa and Kazuo Shinohara. Among the artists and curators I met were Susumu Shingu, Tatsuo Miyajima, Fram Kitagawa and Fumio Nanjo. To support the research and anecdotal evidence, numerous projects were documented. Whilst residing in central Osaka, I visited the nearby traditional temple and shrine gardens of Kyoto. From the Tokyo office of my host Kisho Kurokawa, I campaigned to encourage dialogue and improve communication between young artists and architects, and I later organised roundtable discussions both in Osaka and Tokyo. A particularly timely exhibition, *Topos 1*, featuring showcase collaborations between artists and architects with Norihiko Dan as curator, provided an early point of contact and a useful source of information. In all, three versions of the *Topos* exhibition were toured over succeeding years.

I included in my study some international designers as part of the Japanese cultural landscape and a number of projects involving British contributions. Designed by Renzo Piano,

the mile-long passenger terminal at Kansai Airport, the longest building in the world, features the elegant and soothing kite mobiles of artist Susumu Shingu in the departure lounge. The curvaceous formwork by the late Arup engineer Peter Rice, fabricated in Bolton by Watson Steel, made the distinctive leading-edge section to the terminal building into a practical reality. Winners of a 1995 competition, the London-based FOA Foreign Office Architects made their debut on the Yokohama International Port Terminal, applying sophisticated computer modelling to transform the offshore pier-head into a continuous folded and bifurcated surface. The undulating anamorphic shell and timber roof terraces with a winding path of decking rising up the lawn have created a popular new form of green bridge landscape, with clear views to the historic port and the Landmark Tower.

Investigations into art in relation to architecture uncovered a range of creative experiments in the urban context, with art–media landscapes and aesthetic programs to complement urban redevelopment and innovative museum installations. Artistic contributions were generally most common in prestigious large-budget projects, either important local government offices or the headquarters of major commercial enterprises. In the private sector exceptional projects to note were the JT Japan Tobacco building by Nikken Sekkei, at the time the largest architectural practice in the world; the Landmark Tower in Yokohama by Hugh Stubbins, at 296 metres Japan's tallest building; and more modest art contributions made to the Osaka Business

Park and the Umeda Sky Building. Art is applied or purchased in a few high-status projects but not in routine construction procurement, which sadly lacks the hand of the artist and represents a lost opportunity. In retrospect, it is clear that most artist contributions occurred beyond the individual signature buildings in the larger scale townscape programs and the interstitial urban spaces. A relatively small proportion of activity belonged to the theatre of personal architectural statements while the cultural and popular arena, in remaining public domain, was more diverse and pluralistic.

The field studies included major initiatives by the Tokyo Metropolitan Government including the New City Hall, the Shinjuku I Land Projects, Tachikawa City and the Tokyo International Forum. The earliest of the Tokyo Metropolitan Government grand art initiatives, the Tokyo City Hall is a symbol of the bubble economy, an era that according to Arata Isozaki was 'devoid of cultural achievement'. In the case of the Shinjuku 'I-Land' Tower, however, architect Masaharu Rokushika from the Nihon Sekkei architectural practice and curator Fumio Nanjo have made it famous for its international collection. Within the redeveloped streets of the former American Airforce base at Faret Tachikawa, the Art Front Gallery director Fram Kitagawa introduced a public display of site-specific work by more than 100 artists including Tony Cragg, Anish Kapoor and Richard Wilson. Fram Kitagawa rejects the insular Japanese art world as 'a closed shop of artists and critics secluded in galleries and art academies'. A colossal cultural and conference centre, the Tokyo International Forum, is located next to the main railway station in Marunouchi. The design competition for the Forum was won by architect Raphael Viñoly. A New York-based Uruguayan, Viñoly commissioned a substantial feasibility study of world status artists and the Forum's curator, Tatsumi Shinoda, admires British sculpture from the 1980s. As a consequence, the Forum features a steel frame sculpture by Anthony Caro from his major solo exhibition held earlier at the Tokyo Museum of Contemporary Art,

a stone circle by Richard Long, and a relief castings installation by Richard Deacon. The Forum was developing an impressive collection of art installations, but due to the economic downturn it became the last of the mighty metropolitan government's 'Grand Projects'.

At the time of the fellowship, the Tokyo International Forum was nearing completion and I had the fortune to meet Rafael Viñoly, who later provided an insight into working at the coalface.[14] 'The amazing thing about Japan', he said, 'is that once we were able to prove our commitment, the whole country turned into an incredible machine of efficiency. Every single morning we met at the beginning of the workday for light exercise. Then the contractor would announce the basic work plan for the day. At the end of the day, around six in the evening, the same people would get together, review what had been done, and decide what was to be done the next day'. Viñoly claims there was no hierarchy, as 'architects, engineers, contractors and subcontractors all work together'. Praising the high level of commitment, he refers to a 'totally unjust competitive situation'. Japanese construction, he proceeds to observe, is a 'market of around 650 billion dollars a year which gets distributed systematically among only nine construction companies who do all the work'. Yet in spite of the lack of competition, they were very interested in performance. He enjoyed being on the same wavelength as the contractors and concludes, 'they are the best, absolutely the best'.

Unlike Viñoly, architects on meaner budgets have largely failed to engage with artists, but emerging architects outside the mainstream appear to be more artistically inclined than their European counterparts. As in the volcanic landscape, the achievements of the successful architects are accomplished on the firm foundations of the building industry pyramid. The high quality of craftsmanship and attention to detail found in the construction industry assists their creative sensitivities. Since the bubble economy, Japanese manufacturing and construction has

3

4

been committed to continuous improvement. *Kaizen*, meaning transforming value, involves teams making small scale advances in their area of work. Writing in *The New York Times*, Herbert Muschamp describes a visit to the Tokyo International Forum: 'You will want to go into the Glass Hall immediately, but first you ought to look at the fire stairs set between the concrete cubes. They are the Rolex of fire stairs, immaculately engineered cascades of open-mesh steel that rise without a crude or wasted motion. Here, we're dealing with a radically different economy of mind. The bolt beneath our feet emerged from the same aesthetic intelligence that conceived the space around it. It's almost unheard of for architects today to devote themselves to this level of detail.'[15]

A number of atelier architects are artists in their own right and may be categorised according to their aspirations. There are the romantics such as Shin Takamatsu and Atsushi Kitagawara, and then there is the more classical purity of Yoshio Taniguchi and Kazuyo Sejima who lead the new generation on elegantly light structures. More expressive urban encounters are created by interventionists such as Itsuko Hasegawa and Kazuo Shinohara. A mentor for the younger generation, Shinohara, seeks neither functional efficiency nor beauty but to capture the spiritual essence of the city and its chaos, a liberating concept of urbanism. He claims there are two types of architects, those who get involved with artists and those who are artists themselves. Some top-flight architects with unquestionable artistic credentials were not formally trained, such as RIBA gold medalist Tadao Ando who famously is self-taught, and Yoshio Taniguchi who originally studied mechanical engineering.

One of the few atelier architects who has worked with artists throughout an exceptional career is Arata Isozaki, particularly on his extraordinary installation gallery at the Nagi Museum of Modern Art. It includes the work of Shusaku Arakawa, an artist who now declares himself an architect.

Elsewhere, at the Site of Reversible Destiny in Gifu where it is difficult to identify any horizontal or vertical planes, Shusaku Arakawa is deliberately trying to challenge and disorientate visitors so that their senses will be heightened. This has perception management implications. In a strange house structure, you have a diagonal wall through a table where the artist is trying to intervene and disturb your comfort with the effect of changing your view of the world forever. Constructed in the aftermath of the bubble economy, Nagi MOCA and the Site of Reversible Destiny belong to the period of the great museum-rush in the affluent early 1990s when rural authorities were taking advantage of regional redevelopment dispensations offered for ambitious improvements in the cultural infrastructure. Many local communities, however, had little idea of how they should be used and, as a result, some gallery buildings were adapted for administration. According to a study made by curator Fumio Nanjo, too many of the earlier museums emphasised architectural statements and theatrical entrances, but were often logistically impractical and unfit for display purposes.

At the time, the architect Tadao Ando had just completed a gallery in Oyamasaki, South Kyoto, housing the Asahi Museum of Art alongside an existing monument, a so-called English-style house (actually more Alpine than Tudor) belonging to a very wealthy Japanese industrialist. In his design of the new structure, Ando was respectful of the older building and built the new gallery below grade. Now at the peak of his career, Tadao Ando has worked with such artistic giants as Isamu Noguchi, Anthony Caro and James Turrell. He believes in collaboration as a match of equal status, saying that rather than seeking harmony through compromise he tries to 'maintain a continuous rigorous dialogue with the artist and a state of tension between architecture and art'.

5

6

7

8

9

Indeed, such a duet took place in Tokyo when Caro asked Tadao Ando to design the interior and exterior settings for his sculptures in his large MOT show in the summer of 1995. One area that Caro felt was particularly successful was within an ordinary rectangular room where Ando slanted one wall, inclined inwards at an angle of 7½ degrees. According to Caro, 'It entirely altered the space of the room, and by covering the wood floor with plywood painted with an off-white cement paint and with walls the same colour, the heavy steel sculpture that up until then was shown against my intention outdoors now appeared to float, and their presentation was for the first and only time exactly as I envisaged them'. Here Anthony Caro is expressing himself in the rigorous language of a modern sculptor, just the type of critical dialogue to which Ando referred.

10

11

12

13

14

7 Glass Hall, Tokyo International Forum |
 Rafael Viñoly

8 Azabu Edge, 1987 | Ryoji Suzuki

9 Shapes of Mind Tokyo Mid Town | Kan Yasuda

10 Barcelona Ballad Tokyo International Forum |
 Anthony Caro

11 Waterfall Park, Minato, Tokyo | Masayuki Nagare

12 Mokumokuwakuwaku Yokohamayoyo |
 Hisayuki Mogami

13 Tokyo Opera City LED floor installation |
 Tatsuo Miyajima

14 Dancing of Wind, Shinjuku | Yoshino Iida

The Catalogue

Project Japan is composed of three main parts: the Introduction, the Catalogue and the Personal Account, a series of papers by the guest contributors and the author.

The following Catalogue is sub-divided into three sections.

The first section, Historical Influences, introduces a selection of classical Japanese buildings.

The second section, Building Refinement, explores a range of innovations that appear to herald a new generation of architectural forms.

The aim of section three, Art Media in Context, is to illustrate the ways and means artistic expression has contributed towards this new growth of significant structures. I have considered art within a range of recent building programs, amongst which gardens, apartments, museums, health care buildings, transport facilities and urban complexes merit attention.

Chichu Art Museum Naoashima, architect Tadao Ando

Historical Influences

Traditional icons
Selection of traditional icons (designated national treasures)

1 Inuyama Castle, Inuyama, 1537 (also known as Hakutei Castle)

2 Todaiji Temple, Nara, original 760 (recon. 1195)

3–5 Nijo Ninomaru Palace, Kyoto, 1624, Ninomaru Garden by Kobori Enshu

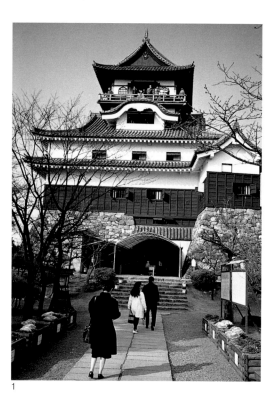

1

Amongst the historical sites of unique significance, there is a wealth of architecture that powerfully reflects the particular sensibilities of the Japanese people. Historically there are two distinct building types, the Jomon clay pit dwelling and the elevated timber store house of South Seas origin. With their earthen floors, the minka house and the urban row house for the common people descend from the clay pit dwelling, while the raised shinden were the preferred sleeping accommodation for the Hein aristocracy and the samurai. These two threads can be traced through the Meiji Restoration along with the introduction of the Western style until well after the war.

The generic building typology
The traditional house is made of wood and built to a pattern of carpentry that dates back to the 15th century. Built to provide draft ventilation as protection from hot summers, they are constructed in an open-plan 'pillar and beam' method. Small, with a limited amount of furnishings and fixtures, they offer simple tactile materials and aesthetically pleasing spaces. Common features are the entrance porch, an alcove in the living room, sliding doors and a straw *tatami* mat floor. The *tatami* determines the dimensions of each room, and house sizes are given in terms of the number of mats needed to cover the floor, as in a six-mat room or a four-and-a-half mat room. A standard straw mat measures 1.8 by 0.9 metres and is about 8 centimetres thick. The family sit and eat on them by day and sleep on them at night. Outdoor shoes are left in the entrance lobby. The simple act of removing shoes displays

respect for the host's hospitality and increases one's tactile awareness and feeling of connectivity to the space.

The overall dimensions and proportions of the house are determined by the beam spans and repeat module of the wall panels and the sliding *shoji* paper screens. The quintessential Japanese room is the *zashiki*. A formal room for receiving and entertaining guests, it contains objects of cultural and spiritual value. The only ornament is provided by a carefully selected vase, arranged plant and origami display located in the *tokonoma* alcove. These exhibits are changed according to the season, and when not on display they are stored away with bedding and clothing out of sight behind the *fushima* screens.

In their world without walls, the Japanese have a more communal way of living and individual privacy is not as highly valued as in the west. This multiple use of space has evolved over the centuries, and with this highly ordered, ritualised way of living in such a confined space comes an emphasis on universality, portability, selectivity and minimalism – all of which feature in contemporary product design. This emphasis on compact living has created a Japanese way of understanding form that operates by moving from the detail to the whole, engaging the outside from the interior. Modern-day domestic gadgets are beginning to dominate spaces, but many families try to keep one room free of clutter and furnish it in the sparse traditional style. However, as more apartment blocks are built in the city, the patterns of home-making are gradually changing.

I have arranged the first section of the Catalogue in four historical themes: Places of Ritual, including the classical shrines, temples and rock gardens from the pre-Tokugawa period; Abode of Fancy, featuring icons from the Period of Unification, the Momoyama and early Tokugawa era including the Imperial Villas, the teahouse and aristocratic *sukiya* residences; Edo Street Scene, which includes the commercial quarters of the merchants, minka and machiya homes of the late Edo period traders; and Period of Transition, which includes the post-Meiji Restoration and the transitional pre-war period.

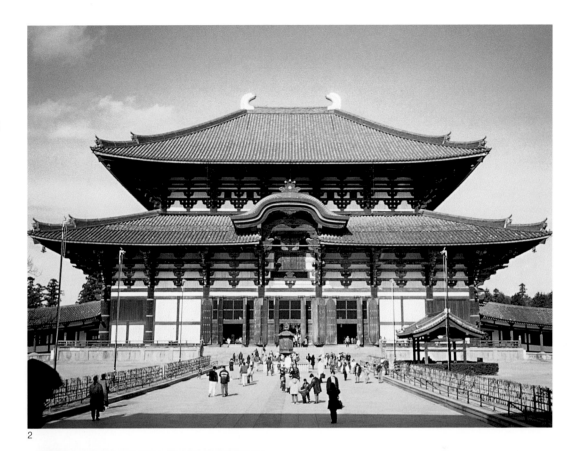

2

3

4

5

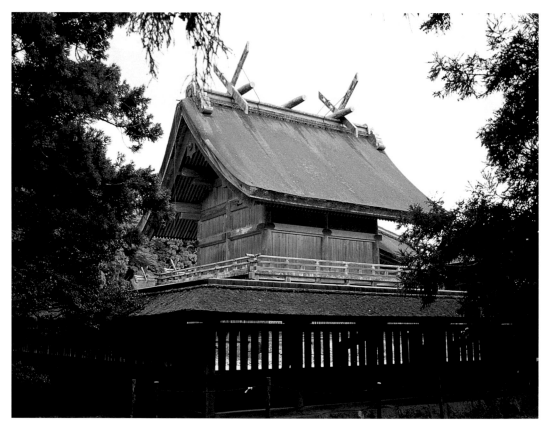

Places of Ritual

Ancient Shrines

Izumo Oyashiro, Taisha-cho, Hikawa District, Shimane Prefecture

First assembled in 950, the Izumo Shrine was constructed to glorify the achievements of the diety Okunimishi no Kami. Transmitting beliefs from ancient times to today, it is considered a supreme example of Japanese architecture and, as at Ise, the Izumo shrine was said to have been regularly rebuilt. Originally believed to be 48 metres in height, it was reduced in scale around 1200 to the present 24 metres. Last reconstructed in 1744, the main *honden* is a considerable gable entrance structure known as the Taisha Grand Shrine. The floor plan is characteristic of Shinto shrines with the central sacred *uzubashira* column measuring 1.9 metres in diameter. The Oracle Hall offers traditional prayer ceremonies for wedding and fertility rites with sacred dances performed to ancient music.

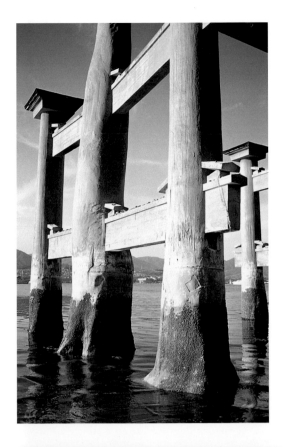
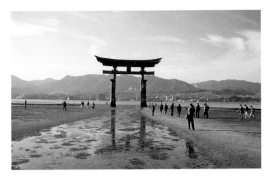
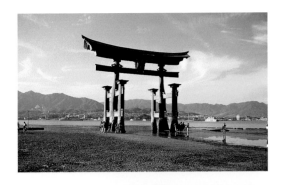

Itsukushima Shrine, Miyajima-cho, Hiroshima Prefecture

First erected in the 6th century, it displays the Japanese concept of scenic beauty. An important example of tastefully added Buddhist iconography, the Shinto shrine was first built to the present scale in 1168 by the warrior Taira no Kiyomori. Built over the sea at high tide, the main building and vermilion corridors reflect the waves and appear to float. The use of connecting corridors is reminiscent of the palatial Shinden style of aristocratic architecture.

1

Ryoan-ji Temple, Sakyo-ku, Kyoto

Originally founded in 1450, the temple grounds are now much reduced in size. A Muromachi period dry landscape garden fronting the hojo, abbot's quarters and enclosed by a low wall, the Ryoan-ji is described as the quintessence of Zen art. Designed by a famous painter and gardener, Saomi, and built by an outcast labour force that resided on the banks of the river, it measures 30 by 10 metres. Raked lines of white gravel accentuate 15 irregularly shaped rocks laid across the garden in a spatially inspired composition. Containing no greenery apart from the moss over the stones, it is considered to be the best representation of the Zen *kare sansui* style of rock garden. Against the southern light, the silhouetted rock formations enigmatically float in indeterminate space amongst the waves. It is up to each visitor to interpret what the garden signifies, but against the backdrop of trees and earthen wall the refined calmness can easily be understood as a miniaturised model of an idealised and sublime marine landscape. The unadorned walls made of clay boiled in oil that seeps out are testimony to an ancient but timeless unchanging setting. The rain-washed central band contrasts against the splash-stained lower base and the soiled engrained sheltered frieze. It is a three-dimensional scene with the clusters of rock and the spaces between displaying a sophisticated figure and ground interplay intended to induce meditation.

Garden of Shoden-ji Temple, Nishigamo, Kyoto

An Early Edo period dry landscape garden located at the base of Mount Funayama just north of Kyoto. It is said the hojo and the Karamon Chinese styled gate were recovered from the destroyed Fushimi Castle. The low, whitewashed wall delineates the bed of white river sand in the foreground and the borrowed scenery 'shakkei' of Mount Hiei is seen through a small wood to frame the view. Located east of the hojo, the flat garden measuring about 280 square metres contains rounded clusters of green pruned azaleas arranged in the traditionally lucky order of seven, five and three aligned along the whitewashed wall.

1–2, 6–7 Ryoan-ji by famous painter and gardener Saomi

3, 4–5 Shoden-ji

2

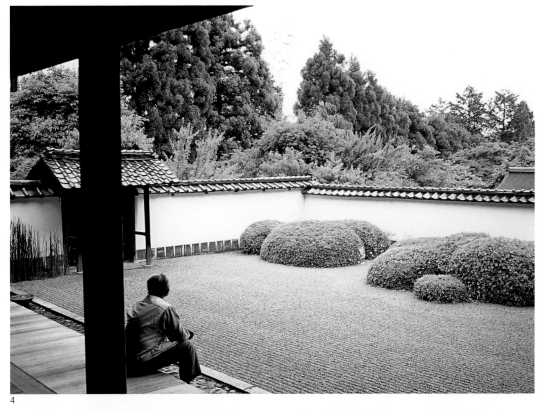

4

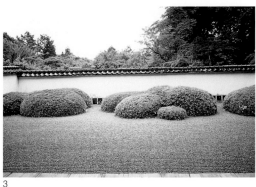

3

5

6

7

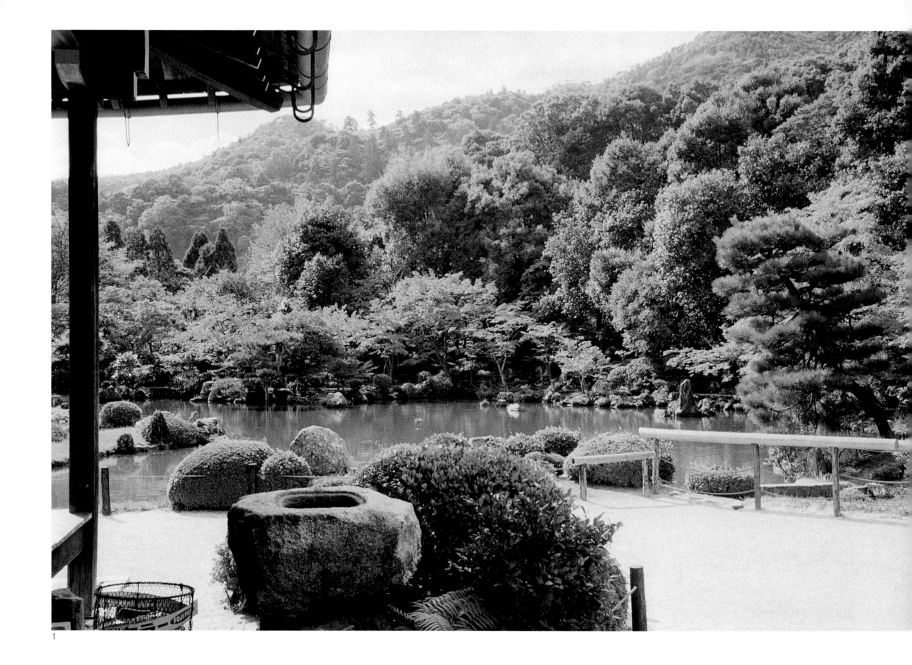

1

1, 2 Tenryu ji

3, 5 Daisen–in

4 Nishi Honganji

Kyoto Shrines

Tenryu ji, 'Heavenly Dragon Temple', Kyoto

This Kamakura period strolling garden built around 1500 by Ashikaga Takauji in memory of Emperor Go-daigo was reconstructed in 1880. Viewed from the verandah with the hills of Arashiyama for a backdrop, the strolling garden surrounds the Sogen Pond. The combination of the rocky shores and assembled dry rock waterfall formation give the effect of a refreshing mountain stream. Within the open great and lesser hojo are *fushimi* panel paintings presenting a collection of mythical lions and other auspicious beasts animated in agitated cartoon illustrations.

2

3

4

5

Daisen-in, Daitokuji Temple, Nishijin, Kyoto

The Zen temple of Daisen-in – The Great Hermit Temple – is one of the sub-temples of the Daitokuji temple compound. It is a Marumachi period *kare sansui* dry landscape garden made in 1509 by abbot Kogaku Zenji, who intended to express the spirit of Zen through the medium of rocks and sand. The *ishi-niwa* or rock garden of the Daisen-in lies within the confines of a narrow 100-square-metre space enclosed by an earthen wall. An abstracted essence of nature, the garden is a three-dimensional version of a landscape painting by Soami. Simulating a gully, a stream appears to fall from a dry waterfall, winding its way through huge boulders and dipping under a natural stone bridge. To the south of the main hall is a highly abstract raked sand garden created by Kogaku Shuko in 1513. Its austerity as a dry mountain waterscape garden is unsurpassed

Nishi Honganji, Shimokyo-ku, Kyoto

The headquarters of the Jodo Shinshu Pure Land Buddhism, the present Goei-do temple was constructed in 1634. Soon after, the *kare sansui* garden of the Momoyama era, Kokei-no-niwa (the tiger glen garden) was added to the precincts of the Hompo. It is understood the garden was originally created for the Shogun Hideyoshi's Fushimi Castle and later moved to the present site. The garden is designed to be viewed like a painting from the verandah of the Kuroshoin audience hall. A dry waterfall lies to the north with a crane and turtle island in a sea of sand. A bridge hewn out of a single stone links the two islands. A literal representation, the garden overflows with rocks and exotic plants. Austerity is replaced by ostentation.

1

2

Abode of Fancy
Ginkakuji Pavilion (Jisho –ji), Kyoto

Built in 1482 by shogun Ashikaga Yoshimasa, the silver pavilion has two floors. The upstairs is varnished in black lacquer livery and houses a Buddha statue for the Goddess of Mercy, while Jizo, the guardian Kannon of children, is enshrined downstairs. The ground floor, which commands a magnificent view of the garden beyond, was used for meditation. A late Muromachi-era strolling garden with a pond, it contains an unprecedented form of dry landscape designed by Soami, in which a Chinese lake and mountains are stylised solely in sand. The 'sea of silver sand' and the mountain rising in the centre recall the shape of Mount Fuji. From the silver pavilion, the ripples of the rake-raised sand bed and truncated cone spectacularly reflect the moonlight.

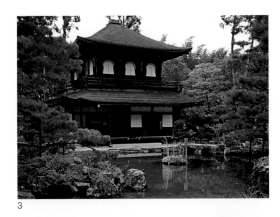

3

4

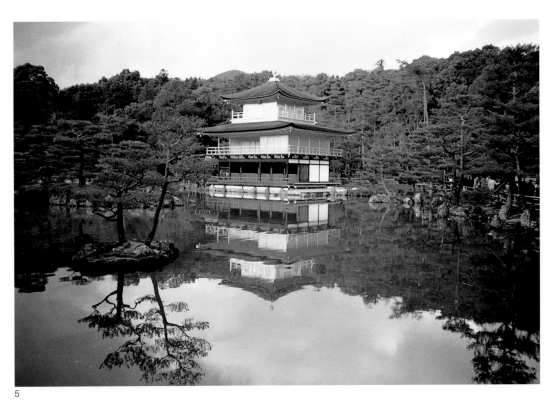

5

6

Kinkakuji Pavilion (Rokuon-ji), Kitayama, Kyoto
A Muromachi-period strolling garden, the golden pavilion is poised at the edge of Kyokoike or 'Mirror Pond'. Built in 1387 as part of a larger compound in the Chinese Sung Dynasty style by Yoshimitsu, the third Ashikaga shogun, and a variation on the Heian pond and island prototype, these villas are representative of the aristocratic Kitayama culture. The Ashikaga shogun, wanting to emphasise his cultural interest, abdicated from political and military power to retire in palatial villas to live a monastic life. The Shinden zukuri, the palace-style ground floor, offers a reception room for guests. The second-floor Buke zukuri samurai style provides a study and the third floor a private temple for meditation. The cusp bell-shaped windows of the upper floor herald the new Zen temple or Karayo style. On the shingle roof, a Chinese phoenix settles. Following an arson attack, the pavilion was rebuilt in 1953 and last gilded with a thicker gold leaf in 1987.

1–2 Ginkakuji, dry landscape designed by Soami

3–4 Ginkakuji

5–6 Kinkakuji

1

2

The Tea House

The transformation of tea into a true art form with a spiritual dimension was due to Zen monk Murata Shuko (1422–1502), a curator of Chinese art for the shogun Ashikaga Yoshimasa. They would meet at Ashikaga's Silver Pavilion and drink tea in Chinese utensils. Earlier aristocrats, who practiced at the Manshuin Lesser Shoin, had made tea in one room then served it in a larger shoin space. Wabi tea reached its maturity in the Momoyama era under Sen no Rikyu, who continued the trend towards simplicity and naturalness.

Tai-an Teahouse, Yamazaki, Kyoto

Reducing the size of the teahouse, Rikyu prepared and offered the tea in the same room. This type of rustic teahouse is known as *soan*, literally grass cottage. Located in Yamasaki, south of Kyoto, the Tai-an is the only extant soan attributed to Sen no Rikyu. Assembled in 1592, the Tai-an consists of a two-mat tearoom *chashitsu* next to a one-mat antechamber. The tearoom is entered by a low 72-centimetre crawl door, designed to force participants to bend, increasing the apparent size of the interior and reminding guests of the attitude of humility during wabi tea.

3

4

5

6

Joan Tea Ceremony House, Inuyama

The Joan was originally constructed in 1615 by tea master Oda Uraku, a disciple of Sen no Rikyu, but was relocated in the Meiji era and rebuilt below the castle in the Uraku-en gardens. Flanked on both sides by a packed earth verandah, one enters a low crawl door in the lobby that contains a large, high, flat stone on which to leave footwear. The sliding doors to the rear of the lobby lead to the *mizuya*, a place for preparing the utensils for the tea ceremony. Uraku's creativity, including the calendars pasted to the walls, can be witnessed throughout this narrow three-and-a-quarter tatami-mat structure.

The tea garden is called *roji,* which means dewy path or passage. The roji tea garden is not simply to be admired from a single viewpoint but was a rite of passage and an essential component of the tea ceremony. It was Sen no Rikyu's influence which led to the stepping stones, *tobishi,* acquiring aesthetic value independent of mere functional use. Following in the steps of the tea master, the purpose is to make visitors conscious of the occasion and the basic sensation of walking by concentrating upon the soles and feet.

1–2 Tai-an In Teahouse | Sen no Rikyu

3–6 Rikyu Joan In Teahouse, Inuyama

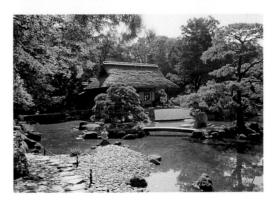
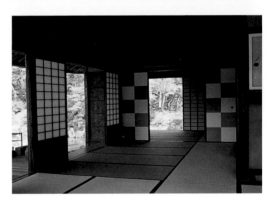

Katsura Imperial Villa, Nishikyo Ku, Kyoto

A Momoyama-period strolling garden surrounds an ornate pond. Artistic patron Prince Toshihito, well-versed in classical Chinese literature, built the estate on a floodplain over a period of several years beginning in 1616. The Katsura villa consists of three shoins in staggered succession and four tea arbours of refined taste in perfect harmony with a pond and island garden. The garden has the generous proportions of a Heian-period garden infused with the spirit of the tea The most important tea house, Shokintei ('pine and harp pavilion'), contains blue and white chequerboard screens and a tokonoma alcove. The modest *roji*, or dewy path, the determining feature of the garden, is blended into the scenery of camellias, cherry blossoms, azaleas and wisteria. The exquisite stepping stones lead the visitor past a sequence of tea arbours and unfolding scenery, providing a model for the late-Edo strolling garden. The elegantly arched stone bridge joins two islands and the trees are configured to suggest the Ama-no-Hashidate peninsula, one of the three most beautiful natural sites in Japan. It is a classic example of the technique of *shukkei*, the small-scale reproduction of real objects. Associated with the tea house, the architecture style of Katsura became known as Sukiya. The elevations of the villa are presented in an elegant echelon composition known as *ganko*, 'the formation of flying geese'. As in a scene from the *Tale of Genji*, a bamboo dais projects from the old shoin with a commanding view of the pond and garden to watch the rising moon.

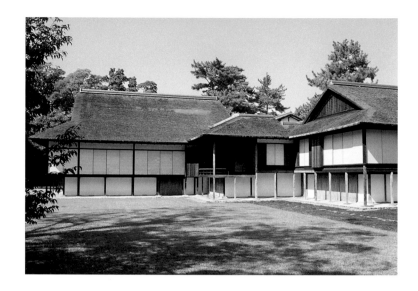

Shugakuin Imperial Villa, Kyoto

This is an Edo period strolling garden with lake built in 1659 by Emperor Gomizuno as a pleasure garden retreat. Repaired in 1824, it is situated at the foot of Mount Hiei to take advantage of the extraordinary beauty of the area and its fine views. The grounds are subdivided into three areas: upper, middle ground and lower area. The highest point of the gardens, the Kamni no Chaya, offers a splendid view over the Yokuryu-chi pond. A breezy little pavilion, the Rinuntei, occupies a little premonitory, with views over the lake to rolling landscape. Accommodating the forested hills in the background, this is the classic *shakkei* or borrowed scenery viewpoint. Overlooking the lake is the Kyusei-Tei, the raised 18-mat 'Far Away Pavilion'.

In the middle, water is drawn down from the nearby River Otowa, which meanders past the shoin. The Kyukuden Guest House, the former drawing room, was relocated from Omiya Imperial Palace. Inside, hanging in an alcove flanked by painted screens, are the Kasumidana 'shelves of mist', amongst the most splendid staggered *chigaidana* shelves in Japan. The screen decorations depict the festival floats from the Gion Matsuri and three large scaly carp painted by Sumiyoshi Gukei. Caught behind nets, it is said to stop the fish escaping at night into the pond and enjoying a noisy swim, interfering with the sleep of the guests!

Korakuen Park, Okayama

Begun in 1686 by Lord Ikeda Tsunamasa, the large Edo garden for strolling is noted for its traditional elements such as artificial lake, islands, tea houses and borrowed scenery in the spectacular form of Okayama Castle. Ryuten, the tea shop by the garden stream, is a fine example of the aesthetic of framing natural forms through right angles. It was built in the Heian style to house the Feast by the Winding Stream. A trend can be seen here towards naturalistic scenery reflected in widespread use of streams, feeder ponds and the introduction of pine, plum and cherry tree groves. Nature no longer contains a divine, cosmic or mystic message for the artist to discover and express through garden scenery (Gunter Nitschke, *Japanese Gardens*). The large Edo strolling garden becomes a like stage set providing a theme park of famous sites and a dramatic range of shrubbery and playfully contrived bridges.

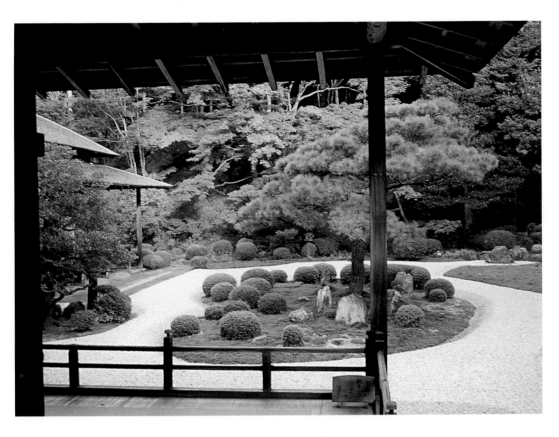

Manshu-in, Sakyo Ku, Kyoto

Closely related to the Katsura Imperial Villa, the temple was moved to the foothills of Mount Hiei by Ryosho, the son of Prince Toshihito, the builder of the Katsura. Created in 1656, the garden attached to the Manshu-in's larger and lesser shoin incorporates a dry pond garden now designated as Eminent Scenery. An Edo-period kare sansui garden, it is a dry landscape garden in the figurative style of the famous gardener Kobori Enshu. Flowing from a rock waterfall around the carpets of moss, the riverbed of white sand is best viewed from the lesser shoin. The kare sansui represents natural scenery including a rock grouping symbolising Mount Horai, a bridge of natural stone linked to Crane Island and in front Turtle Island floats in the white sand. At the rear corner of the dry landscape garden, a series of tobi-ishi stepping stones lead through the narrow strip of moss behind the shoin to a tiny rustic tea house.

1

1 Hirose House, Nihon Minka En, Tokyo

2–3 Gassho Minka, Higayashi Park, Nagoya

4–6 Kitamura House, Nihon Minka En, Tokyo

7–8 Minka House, Royal Botanic Gardens, Kew, London

2

4

5

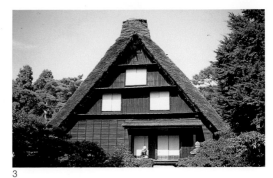

3

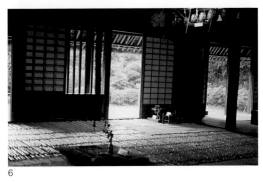

6

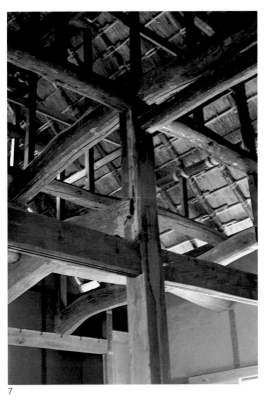

7

8

Minka Houses

Minka covers a range of residential types from the great houses of the village headman, rich merchants, and Shinto priests to the huts of the poorest farmers. Those owned by the headman began to incorporate shoin-style sitting rooms, *zashiki*, but such comforts were restricted by the rigid class system. Constructed of sturdy timber framework, the structures were resistant to earthquake damage and easy to rebuild. Differing climates gave rise to regional variation but the basic form is still that of the early Edo period.

Towards the Sea of Japan we find the Gassho ('hands in prayer' style) found in the remote Gifu village of Shirakawa. Isolated by extensive snowfall, the villagers subsisted on a cultivation of mulberry trees and rearing silkworms. The Gassho form came about to accommodate extended families living together and raising silkworms under the steep sloping roof. The farmhouse took a definitive form around the middle of the 17th century as the livelihood of the farmer stabilised. Subsequently, each district developed its own style in keeping with the natural context and other special characteristics of the area. Posts thrust directly into the ground gave way to pillars resting on base stones, and the scale became considerably larger. The original floors, consisting of woven mats over earth, became raised floors particularly in the bedroom, *nando* and *zashiki*. The large day room, the *hiroma*, had sliding doors and often a distinctive bamboo slatted floor.

The Royal Botanic Gardens Minka at Kew was originally a farmhouse built around 1900 in a suburb of Okazaki City. In 1991 the Japan Minka Reuse and Recycling Association (JMRA) acquired the house and donated it to Kew as part of the Japan Festival 2001. The dismantled timber framework was shipped, and experienced Japanese carpenters reinstated the maze of beams and intricate joints without the use of nails. Local mud wall panels and thatched roof were added, and the recycled Kew Minka was completed in November 2001.

1

Edo Street Scene

From the Heian period, the townspeople, made up of merchants and artisans, built themselves a combination of business premises and homes known as *machiya*. These townhouses were situated in outlying districts in the vicinity of markets or lined the back streets. Machiya have modest sized fronts with deep interiors and display produce facing the street. Towns were laid out in blocks known as *machi* with the merchant proprietors on the main street and the vast majority of Edo townfolk existing in row houses located in the rear alleys.

The Pleasure Quarters are also referred to as the 'blossom and willow' district. The women of the quarter lived in residences called *okiya* and went to entertain at lavish houses of assignation known as *ageya*.

Located east of Kanazawa Castle, the Higashi Pleasure Quarters still resembles its appearance of the 1820s. It was designated a Protected Area of Traditional Architecture in 1977. Along the streets can be seen projecting lattice windows and the sliding timber doors of the machiya.

2

5

6

3

4

7

1 Gion Pleasure Quarter, Kyoto

2 Machi – traditional neighbourhood street plan

3–4 Gion, Kyoto

5–7 Row Houses, Kanazawa City

Yoshijima-ke House, Takayama, Gifu Prefecture

This house is located in the narrow streets of the San-machi Suji, next to the Kusakabe Mingeikan Museum. The Yoshijima Heritage House is a fine, intimate dwelling rebuilt in 1908 in strict adherence to the older structure. The beauty of wood is shown in the timber posts and represents the renowned carpentry skills of the mountains. In comparison to the masculine style of the Kasakabe House, it is described as a structure possessing subtlety and feminine beauty. In contrast with the massive beams and thick walls of the main structure, a characteristic of Takayama town houses, the graceful lattice-work provides a radiant sense of translucent lightness.

Meguro-ku, Tokyo

Established in the late 1920s, the Meguro Gajoen was widely known as a 'modern dream palace' and was especially noted for the profusion of ornamental and decorative arts. The hotel redevelopment was to preserve and restore the folk art treasures as valued heritage for future generations. Completed in 1991, the reconfiguration of the décor to meet the needs of the information age has given a renewed status to the artworks. The new facilities include a dome-shaped atrium with a natural stream and greenery, traditional handicrafts and vividly restored panel decorations. The main route features a 100-metre gallery of carved lacquered tableau and a series of ceiling paintings. The Banqueting Suite is profusely adorned with encrusted polychromatic carvings and many kinds of specialities such as gilding, textiles and inlaid lacquerware.

1

4

5

2

3

Kurashiki

During the Edo Period, the rice was kept in the city's many storehouses or *kura*. A number of the kura survive in Kurashiki's historic Bikan district, the ancient merchant quarter.

The canal area of the city is surrounded by unique examples of 17th-century wooden warehouses painted white with traditional black tiles. Containing significant masterpieces, Kurashiki is the home of Japan's first museum of Western Art.

6

7

9

8

10

11

Ohara Museum of Art

The Ohara Museum of Art was established in 1930 by Magosaburu Ohara, the president of the Kurashiki Spinning Corporation in commemoration of the Western-style painter Torajiro Kojima. Fronted by the columns of a Grecian Temple, the collection is housed in various gallery pavilions that match the character of the exhibits. The ceramic room, in a renovated Kura storehouse belonging to the Ohara family, opened in 1961 and contains clay works by artists such as Shoji Hamada (1894–1978) and Bernard Leach (1887–1979) who participated in the Mingei folk craft movement led by Soetsu Yanagi. A celebration of the work of unknown craftsman from all regions, the Mingei valued the people's art for its natural and unpretentious qualities. Towards the rear is the wooded Shinkei-en garden featuring a pair of locally sourced tea arbours. Nearby, the former site of the red brick spinning mill was renovated in 1981 to become the present-day ivy square that houses a display of paintings by Torajiro Kojima.

1–4 Kurashiki Bikan District

5 Yakisuji process of charring timber to resist rot and insect infestation

6–9 Ohara Art Museum, ceramic plates by Shoji Hamada and Bernard Leach

10 Ohara Art Museum, polished stone by Sculpture Group Q

11 Ohara Art Museum, folded steel by Isamu Noguchi

1

5

7

2

6

3

8

4

Period of Transition: From Meiji to Modern

1 Primary School, Meiji Mura Museum

2 Ward, Japan Red Cross Central Hospital, Meiji Mura Museum

3 Kureha-za Theatre, Meiji Mura Museum

4 Central Guard Station, Kanazawa Prison, Meiji Mura Museum, 1926

5 Bank of Japan, Tokyo, 1896 | Kingo Tatsuno

6 Sumitomo Bank, Osaka | Sumitumo Eizan Design Office

7 Soldiers' Hall, Tokyo | Ryoichi Kawamoto

8 Dai-ichi Seimei Building, Hibiya, Tokyo, 1938 | Jin Watanabe

9 New Kabuki Theatre, Osaka, 1958 | Togo Murano

10 Post Office, Umeda, Osaka, 1938 | Tetsuro Yoshida

11 Kamakura Prefectural Museum of Modern Art, 1951 | Junzo Sakakura

12 Reception and Shrine Office, Izumo, Oyashiro, 1963 | Kiyonori Kitatake

13 Palaceside Building, 1966 | Nikken Sekkei Company

9

10

12

11

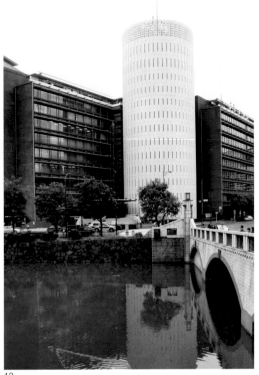

13

Building Refinement

This section considers a diversity of public buildings in the wake of the Kobe earthquake in 1995 and reflects on the continuity from the traditional through the avant-garde to a focus on the present situation at the cusp of the 21st century. I have also grouped this section into three parts: Sanctuary and Recovery, Social Infrastructure, and Signature Buildings as Regeneration.

I will review a range of programs by a dozen leading designers, including chapels, garden landscapes, housing, transport, museums and commercial edifices. As one of the aims of *Project Japan* is to illustrate the diversity of recent architecture in a multiple image format, each scheme is seen here from a series of viewpoints

As a mark of respect, Building Refinement commences with the father of Japanese modernism, the architect Kenzo Tange, and proceeds with a cross-section of familiar as well as many less well documented designs within the last decade, such as the Chapel of Light, Kobe Cardboard House, The Water-Glass House and the Sendai Mediatheque. Others, such as the Shinonome Apartments, Katta Hospital, Saitama University and Kumamoto Artpolis are important buildings of their time but are less well covered in the West.

Following the commercial excesses of the bubble economy, the early 1990s witnessed a wave of creative initiatives in the form of a rush of museum structures by city authorities eager to raise local pride and to demonstrate their regional culture. However, taking account of the economic needs to regenerate failing communities, major

developments were also devolving to the regions with an increased awareness amongst designers of the benefits of social responsibilities. The Katta General Hospital near Sendai is amongst the most innovative health facilities of recent years. A combination of spatial modelling and health care functionality is provided at human scale with each inpatient benefiting from a patio roof-garden view. Within the era of the aged society, the Saitama Nursing University stylishly offers an important education program attempting to integrate the work of nursing and therapy carers more closely in the community.

The remarkable Shinonome Canal Court project on the shore of Tokyo Bay is attempting to entice the younger generation to set up home and work more closely to the centre of Tokyo. According to Kengo Kuma, one of the designers, it is a multi-faceted network collective of residential complexes that is most appropriate to the new urban lifestyle of the 21st-century information society. Constructed on a 16.4-hectare man-made island on the site of the former Mitsubishi Steel Factory, this project was initiated by the Urban Development Corporation to demonstrate a change in the image of public housing. It is divided into a closed mid-rise section of six blocks reserved for social housing, surrounded by privately developed residential towers. Each of the six blocks was designed by a team led by internationally known architects including Riken Yamamoto (Block 1), Toyo Ito (Block 2) and Kengo Kuma (Block 3).

The architects of the Shinonome project have tried to address community in a contemporary way, to provide for communication and public interaction. The vicinity of water, the unique topography and a certain amount of isolation from the city has allowed for experimentation both in the design of the structures and in the public space that surrounds them. A feature of this public space is the 10-metre-wide, S-shaped pedestrian avenue that winds through the entire 'island' from south to north, anchored by a mall at one end and the subway station at the other. The avenue offers a distinct spatial experience with its small pocket-like parks and views to the nearby Tatsumi canal. In the design of the blocks themselves, architects have used features such as transparency and terraces to invite public interaction. The project has won a number of awards including the 2004 Award of Good Design Architecture from Japan's Ministry of International Trade and the 2006 Award of Merit from the Illuminated Engineering Society of North America.

One of the most spectacular programs of recent times has been the series of Tokyo developments along the fashionable Omotesando Avenue. Celebrated atelier designers were commissioned by international fashion brands to add glamour and street credibility to the designer label products on display. This tree-lined road has become an exciting beauty parade and a world-class display of showcase architecture.

1

1 Shinonome Canal Court project

1

2

3

4

5

6

7

1–2 Olympic Ball Games Centre

3 Peace Centre, Hiroshima

4 Shizuoka Press and Broadcasting Offices, Tokyo

5 Yamanashi Press and Broadcasting Center

6, 8 Fuji Building, Tokyo

7 Kurashiki City Hall

8

Sanctuary and Recovery

Kenzo Tange selection

Born in 1913 to a poor family in Osaka and educated at the Hiroshima High School and at the University of Tokyo, Kenzo Tange's first major commission was the Peace Memorial Park at Hiroshima's ground zero in 1949. The plan for the park was derived from the Itsukashima Shrine at nearby Miyajima and the Cenotaph was based on the roof of Haniwa terracotta funereal wares. Built on concrete pilotis, the museum building was modelled on the aristocratic shoin style of the Katsura Detached Villa. Over the next 50 years Tange continued to give form to some of the nation's most iconic buildings. The National Gymnasium Complex for the 1964 Tokyo Olympics appears to be influenced by the ancient Jomon pit dwellings. He worked on the master planning for the redevelopment of Tokyo Bay and for the 1970 World Exposition in Osaka. Through his long career, he freely moved from applying a modern elegance with timeless historical elements to the international symmetry of the new Tokyo Metropolitan Government Building (1991) and the Fuji Sankei Headquarters Building (1996). Designed as a romantic technological metaphor for the information age, it boasts the best in broadcasting systems. With its silver globe suspended high above an open core mega-structure, the Fuji TV Building incorporates distinct similarities to Arata Isozaki's earlier proposal for the new city hall. As an advanced intelligent building, the Telecom Centre provides its tenants with the latest communications and is a showcase of Japan's ultimate technological aspirations. Working part-time into his nineties, Kenzo Tange died in 2005.

Space for the Spirit | Tadao Ando

Chapel of Light, Ibaraki, 1989

The iconic cross of light for the humble neighbourhood church was the centrepiece for Ando's successful Royal Academy exhibition in 1998. Contained within a simple rectangular shell, the tomb-like chamber is animated by the pinched natural light and the black scaffolding floorboards. It is an altar to the power of daylight as a force of nature.

1

5

2

6

3

4

7

8

9

Church on the Water, Tomamu, Hokkaido, 1988

The wedding chapel part of the Hotel Alpha resort directly overlooks a picturesque lake containing a solitary steel cross. To add drama to the ceremony, the whole glazed elevation can be slid open, spectacularly connecting the service to the glade beyond.

1–4 Chapel of Light
5–9 Church on the Water, Tomamu, Hokkaido

Honpuku-ji Water Temple, Awaji
Submerged below an oval, lotus-filled pond, the Water Temple is located on the hillside behind two sweeping concrete screens. A late afternoon reddish glow washes the hall within through a crimson timber lattice.

Awaji Yumebutai, Awajishima | Tadao Ando

Opened for the Flower Expo 1999, the complex occupies a site where the hillside had been removed for landfill.
Located 16 kilometres above the epicentre of the Great Hanshin Earthquake, the theme of rebirth and reconstruction
has resulted in a memorial park to the 6434 souls who perished. Seen floating in the shallow lake, the chapel is
illuminated by harnessed natural light seeping through the cruciform window in the ceiling.

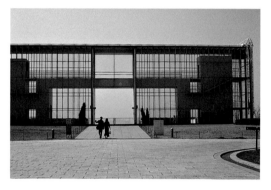

View Point Visitors' Centre | Yoshio Taniguchi

Completed in 1995, the View Point Centre is a coastal belvedere for observing the local wildlife, migrating birds and the Kansai Park surroundings. Located next to Yoshio Taniguchi's earlier Sea Life aquarium (1989), the visitors' centre is as transparent as a fish tank. Taniguchi is a specialist at the deployment of spaces with changing vistas and scales, and the introduction of natural light. Visitors stroll around looking out over the bay, animating the cage, while their behaviour in turn is monitored from the outside. The extrovert relationship between outside and inside is countered by the video chambers for more introspective activities.

As friend Fumihiko Maki explains, Yoshio Taniguchi chooses what the wall ought to be like from the given conditions of the context. The quality of the transparent walls was determined by the platform's function and also the available technology. The son of architect Yoshiro Taniguchi (1904–1979), and originally trained as a mechanical engineer, Yoshio Taniguchi first set himself the challenge of producing a highly refined homogeneous glazing bar system. A considerable number of joints were each polished with grinders by hand, 'such scrupulously performed tasks in the end account for the power of Taniguchi's architecture'. One of the most transparent buildings since Farnsworth House, the Rinkai Centre, constructed over three floorplates, is much longer. As with Mies Van Der Rohe's Germanic precision, Taniguchi's office is committed right down to the smallest detail.

Gallery of Horyuji Treasures 1999 | Yoshio Taniguchi
Located at the National Museum in Ueno Park, Tokyo,
the gallery is one of the most elegant and refined
buildings of the new Millennium in the world. Consisting
of more than 300 unique artefacts, The Horyuji Treasures,
mainly from the Nara Period (645–794), were donated
to the Imperial Household by the Horyuji Temple in 1878.

1, 2, 3, 5 Takatori Church, Kobe

4, 6–12 Kobe Paper House | Shigeru Ban

13, 14 Shared Ground Pavilion, Millennium
 Dome, London

4

1

5

6

2

3

7

8

9

Kobe Paper House | Shigeru Ban

Shigeru Ban conceived the idea of making prototypes for refugee shelters out of paper for Rwanda when the Great Hanshin Earthquake struck. At the end of January 1995, he visited a Catholic community in the Nagata district of Kobe where the Takatori Church had burnt down. After raising the funds himself, he was commuting to Kobe and with the support of volunteers assembled a new community hall. This is a 10- x 15-metre polycarbon-clad rectangular structure, incorporating 58 paper tubes in an elliptical plan covered by a canvas roof. In the meantime, he was working with former Vietnamese refugees who had lost their homes and were sleeping under canvas sheets in the local park. Sanitary conditions had to be restored and makeshift housing that anyone could assemble had to be provided. The solution was to place paper tubes butted and held together in rows by double-sided insulation tape. A double-layered tent was installed for the ceiling and roof, with plastic beer crates filled with sand bags for the foundations. Measuring 16 square metres, Paper Loghouse Number 1, the first of 30, was erected at a cost of £1500. Although the canopy roof could be opened for ventilation, the log house in practice was too hot in summer and cold in the winter.

10

13

11

12

14

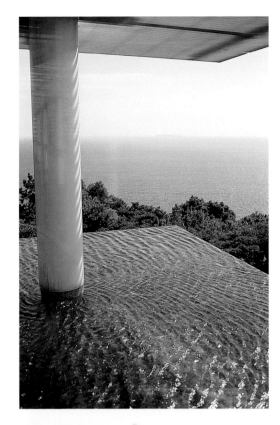
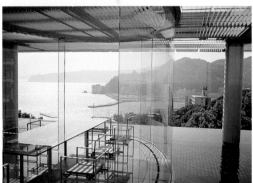

Waterglass House, Atami | Kengo Kuma

The design of this house was influenced greatly by the neighbouring 'Hyuga' Villa, the sole remaining project by Bruno Taut left in Japan. Waterglass House was also influenced by Taut's well-documented philosophies during his three-year stay in Japan, during 1933–36, in which he praised the Katsura Detached Palace. The reasoning for his commendation, according to Kengo Kuma, lies in the observation that the "Palace frames nature, yet frames by being at one with nature. Taut specifically paid attention to the mechanisms in Katsura Palace that provoked the framing of nature with nature: the eaves and the bamboo verandas. Thus, in our villa, a layer of water that gently covers the building edges signified bamboo verandas in Katsura. Moreover, a stainless louver that roofs the water signified the eaves. The water surface stretches further out and unites the surface with the Pacific Ocean and, on top of the joined surface, a glass box floats. As the box is superimposed numerous times, refraction of materials brings in all sorts of reflections. The relationship between the subject and the environment is challenged in various manners by re-defining and re-shaping the Katsura philosophy, yet always maintaining its fundamental essence."

The panel paintings in the basement are by 90-year-old screen painter Tomikichiro Tokuriki. The bulbous glass forms in the stream are by Tomohiro Kano. The client for the company house was the owner of the 'Tamagotchi' pet game.

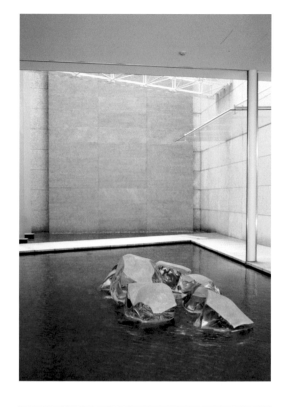

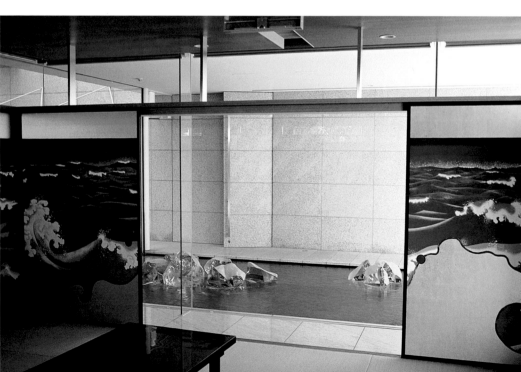

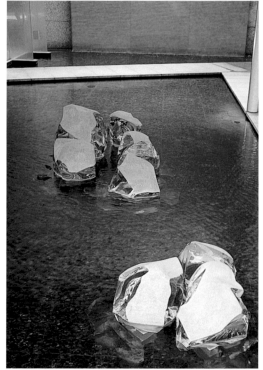

1

Social Infrastructure

Kazuyo Sejima's Kitagata apartments straddle the perimeter of the new development in the suburbs of Gifu. For daylight penetration Sejima has has minimised the width of the block, and turned each apartment unit and the garden terraces to the side so the main rooms enjoy a dual aspect. The garden terraces puncture the elevations, providing exterior space, sunlight and natural ventilation. A third of the 107 apartments are two-floor maisonettes; each room has its own door access onto the communal balconies.

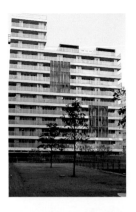

Codan Shinonome, Koutou-ku, Tokyo

Introducing new concepts to public housing, architects including Kengo Kuma, Riken Yamamoto and Toyo Ito have contributed to a mixed-use city habitation containing 1200 units with a density of 15,000 per square kilometre, one of the largest in Japan. Located on reclaimed land in the Tokyo Bay area, it combines dwellings with offices (SOHO – Small Offices, Home Offices), commercial facilities and social amenities. The Codan project aims to go beyond the Le Corbusier's 'Unity', model and is designed to support sustainable living as much as possible.

Shinonome provides multi-family living and working spaces, restoring a well-rounded quality of life for the inhabitants. The residents of this 'three-dimensional' city are envisaged to lead a 'network-type lifestyle', frequently moving from one unit to another. In this way, according to Kengo Kuma, they would spend their days moving from one location to another throughout the networked structure.

The centre of Kuma's structure features a 'communications atrium' around which the three-dimensional city is designed. Located in the centre of the whole complex, the atrium is surrounded by basic apartments (60 square metres) with annex units (25 square metres). Each annex unit can be used as a bedroom, a study, a SOHO, a store, or for a number of other purposes. Here, individual families can utilise multiple units on both sides of the communication atrium. The numerous bridges connecting the two buildings enable the inhabitants to move freely between their main homes and annexes without descending to the ground floor. All roof spaces are used as flower beds or vegetable gardens for the inhabitants, making them more productive than Le Corbusier's concrete roof terrace.

1

2

4

3

1, 2 General views of Shinonome

3, 6 Apartments | Toyo Ito

4, 5 Apartments | Riken Yamamoto

5

6

Kyoto Station | Hiroshi Hara

After Nagoya, the new Kyoto station is Japan's second-largest railway development. The station opened in 1997 to commemorate the city's 1200-year anniversary. The result of an international competition, it was described as the 'gateway to the ancient city'. The brief was threefold: to improve the transport system, to enhance the experience of the tourist, and revitalise the area. Hiroshi Hara's competition scheme featured a 'geographical concourse', a 70-metre-high and 470-metre-long glass canopy structure set aside from the engine shed and tracks. Costing 150 billion yen, the building has 16 floors, incorporating a department store, hotel, theatre, shopping mall and offices. The grand staircase and open-air amphitheatre rise above the canopy. The combination of movement and vantage point is very popular, and those who are enticed to keep climbing are rewarded with breathtaking views. A successful transport hub with one-stop shopping, its self-sufficiency suggests visitors have little reason to step outside the station mall to revitalise the surrounding streets.

Umeda Sky Building | Hiroshi Hara

Part of the stalled new Umeda City Urban Development, the 173-metre-high Umeda Sky Building offers a glimpse of a futuristic city in the air. Completed in 1993, the 38-storey twin blocks are interconnected by Hiroshi Hara's 'Mid Air Garden', a doughnut-shaped open atrium with free-standing transverse elevator shafts.

Katta General Hospital | Architecture Workshop

The low table profile slots easily into the slopes of the mountain resort. It occupies a deep plateau with small ward units distributed horizontally above the upper platform. A medium size 300-bed hospital serving Shiroishi Zao City, it is designed by Architecture Workshop, a collective made up of Koh Ishiyama, Hideto Horiike and Taro Ashihara. Conceived as a porous plate, the departments have been cleverly modelled into the simple envelope, providing a well-articulated sequence of spatial experiences. The visitor enters between the pilotis into a generous double-height volume and proceeds through a chequerboard of rooflight courtyards and terraces. With its white walls awash with sunlight, the inpatient care area is arranged as a quiet roof garden village with open vistas that borrow the surrounding mountain range. From the bed space the patient has direct access to the patios, blissfully unaware of the noise and rush beneath their rooms. The timber board floors and sliding doors are reminiscent of traditional Japanese homes. Viewed from the patient care area above, a round lawn with undulating grass ripples in the southerly rehabilitation garden. A freestanding curved wall provides a portal to the town; a symbolic 'hope wall', it screens a highway, giving scale and contrast to the mountain scenery.

Japanese Foundation for Cancer Research

Founded in 1908, the 29-bed hospital was the first in Japan to specialise in cancer. Now relocated in Ariake, it is a state-of-the-art 700-bed hospital with the latest advanced diagnostic and treatment technologies combined with a cancer research foundation. As well specialising in cancer care, it operates as a general hospital for a growing local population and offers back-up medical functions for use in times of a major disaster. The director, Tetsuichiro Muto, explained how he instructed the architects from Kenzo Tange's office to concentrate on an appealing building focusing on functional competence in preference to the spectacular. The medical aspiration was for innovative treatment and to perform multi-disciplinary tasks based on individual patient needs and organ-specific diagnosis. Benefiting from years of experience, the 11,000 new patients will attend one of four centres: the Thoracic and Gastroenterology Centres, the Prostate Disease Centre and the Women's Centre.

Entering the hospital, the spacious, open-plan hall displays a distinct lack of institutional clutter and a calm and confident atmosphere. There is a hidden order where all clinical equipment and transportation operates in its own parallel domain, so visitors don't experience the chaos normally associated with medical environments. At the rear of the ground-floor hall, flooded with natural daylight, is the comfortable local hospital service. Following initial registration, patients enter the hall and proceed to the 'automatic receipt machines' and obtain their registration pass and an individual 'PHS' pager. This miniature device allows patients to roam freely until it is their turn for counselling. The hospital is also a forerunner in the adoption of a total clinical information technology, which includes full electronic medical records.

The entrance hall is contained within a double-height ceiling and the receptions to the four main care centres are found on the second-floor mezzanine, easily accessed from the central escalator. Simplified by friendly graphics and elegant signs, wayfinding is intuitive; upon arrival, the waiting areas are spacious, comfortable and quiet. The civilised quality of these spaces is achieved by placing the patient's journey essentially through the core of the building while confining the staff circulation and service provision to the perimeter. It possible the only clinical personnel the patients may see, despite the many visitors, are the familiar kind faces and reassurances of the dedicated personal carers. With attention focused on the dignity and emotions of patients, the individual users will benefit from a sense of being unique and special.

Saitama Prefecture University | Riken Yamamoto

Department of Medical Science and Nursing Studies
This giant joint nursing school and medical university campus was designed by Riken Yamamoto, an architect of considerable social awareness who has designed 'Care Plazas' for the aged, but is more famous for his radical housing projects. A former student of Hiroshi Hara, he takes his bearings from historical Japanese residences with their transparent walls and a fluid transition between indoors and out.

The key element ordering and unifying the individually designed units is a covered gallery with open staircases. The main theme of the institution is to establish greater links between the trainee therapists and nursing profession, to break down barriers and explore ways to promote cooperation towards improved quality practice and patient care. The building itself consists of two main extended parallel academic blocks that, like a stadium, surround the communal inner recreation ground. Sandwiched between the teaching blocks are shared experimental laboratories, examination and treatment suites. Above are landscaped roof gardens containing a performance hall that open onto the grassed arena.

Signature Buildings and Regeneration

Kumamoto Art Polis (KAP)

Concerned about the migration of young gifted people from the provincial cities to the metropolis, the Governor of Kumamoto Prefecture, Hosokawa Moribiro, wanted to create a new urban culture with which the youth could identify. In the mid 1980s he invited Arata Isozaki as commissioner and they began the Kumamoto Art Polis program to promote high-quality social architecture such as public toilets and bridges. The majority of new amenities were designed for minor urban and rural districts as a catalyst to improve the quality of the built environment.

Kumamoto North Police Station 1991

In this earlier project, one of architect Kazuo Shinohara's objectives was to reduce the official formalism that characterises local authority institutions. Incorporating a complex structure, the mirror curtain wall on the west façade is meant to reflect the silhouette of the Kumamoto Castle in the distance.

Saishunkan Seiyaku Women's Dormitory 1991

The dormitory accommodates 80 female employees of a nearby pharmaceutical laboratory who, in the first year of their employment, live and study together. More emphasis was therefore given to the communal spaces than to the 20 shared living units. For privacy, the exterior of the structure is veiled in polished perforated aluminium screens and translucent glazing.

Hotakubo Public Housing 1991

Inspired by KAP demands for fresh solutions, architect Riken Yamamoto assembled the 110 apartments in a large urban configuration with the aim to provide residents with as much contact with the outside as possible.

1–3 **Yatsushiro Fire Station, Kumamoto | Toyo Ito**
Built in 1995 as a base for the regional fire fighting services, the intention was to create an open landscape space accessible to the neighbouring residents. Combining requirements allowed the emergency vehicles to be parked openly under the main accommodation elevated 6 metres above.

4, 5 **Yatsushiro Municipal Museum**
Located opposite the Matsui Castle, this is a precinct with height restrictions, so the architect reduced the apparent size by covering the main exhibition floor with an artificial mound. The ramp leads up to the second-floor entrance lobby and cafeteria and to further reduce the impact, Ito introduced multi-vaulted stainless steel canopies.

6 **Ueda Art Gallery**

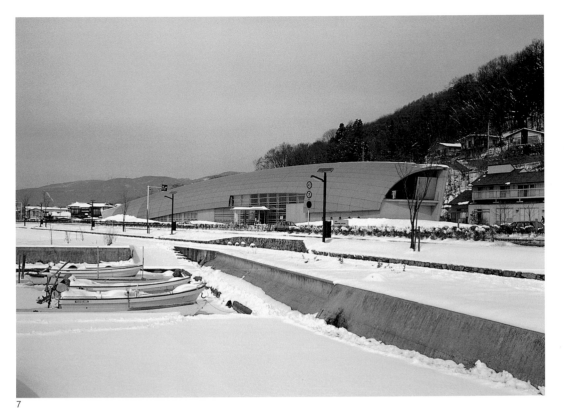

7

8

9

11

12

10

7, 8 **Shimosuwa Municipal Museum, Nagano**
Built in 1992 alongside Lake Suwa, the museum accommodates local treasures and a collection of artefacts associated with the famous local poet Akahito Shimagi. Resembling the hull of an upturned boat, the distinctive curved aluminium membrane covering the front is designed to withstand the extreme mountain climate.

9 **Guest House Sapporo Breweries**
Accommodating visitors to the vast plant, the guest house lies submerged into a conical sunken garden. Incorporating aerofoil ventilation shafts, the walls facing the plaza are masked by perforated screens to soften the elevations. For the virtual light installation by Keiichi Tahara, the blinking lights are synchronised to music. The posts contain optical glass and switch controls are arranged over the slopes.

10–12 **Oka Ku Education Centre Resort, Mount Asama, Nagano | Toyo Ito**

Sendai Mediatheque | Toyo Ito

Built along a wide zelkova tree-lined avenue in 2001, the Sendai Mediatheque is a multipurpose arts venue offering a variety of services including the latest information and communications technology, a citizens' gallery, library centre, studio and workshops.

The result of a competition chaired by Arata Isozaki for a municipal museum, the proposal was designed by Toyo Ito atelier staff member, project architect Makoto Yokomizo. With universal barrier-free access, it flexibly responds to the needs of the user. Using a fin de siècle concept, Toyo Ito breaks up the secluded rooms in favour of providing places that the individual chooses. The diverse program creates its own spatial rhythm that is defined by varying degrees of public space, communal spaces of activity and individual spaces of repose and concentration.

Fifty metres wide, there are six main floors supported by 13 steel tube lattice columns distributed across the footprint similar to the zelkova trees outside. The simplicity of the structural elements that Ito describes as plates (floors), tubes (columns) and skin (external walls) allows for a complexity of network activity. The tubes are both structures and conduits for light, telecommunications and vertical mobility including lifts and escalators. Each vertical tower varies in diameter and is independent of the exterior elevations allowing a free-form floor plan. The principle of independent service shafts liberating the floor space recalls the 'joint core system' of the Metabolists. At the Sendai Mediatheque, the public plaza has been moved inside, allowing the ground floor to read as a continuation of the surroundings. Inspired by certain plants, structural engineer Mutsuro Sasaki succeeded in making the 'seaweed' tube section columns a reality. Each level of the Mediatheque was created by a different designer, including former Toyo Ito staff member Kazuyo Sejima, who designed the seating for the second 'information' floor.

1–4 Fruit Museum, Yamanashi | Itsuko Hasegawa

5, 7 Sumida Culture Factory

6 STM House, Shibuya

3

4

5

6

7

Fruit Museum, Yamanashi | Itsuko Hasegawa

A graduate with Toyo Ito of the 'Shinohara School' in the early 1970s, Itsuko Hasegawa is guided by her strong views on contemporary urban society and an approach she describes as 'second nature'. She combines her interest in new materials and the natural environment with her concerns for the user.

Enclosed by perforated aluminium and translucent screens, the Sumida Culture Factory, completed in 1994, is intended to serve the working class district of Tokyo. Connected by bridges and arranged around an inner plaza, the three main volumes contain an assembly hall and planetarium, a library and information centre, a study and child counselling rooms.

A park for demonstrating the culture of growing fruit, the Fruit Museum is situated in the wine-growing region of Yamanashi Prefecture. The three pavilions, offering clear views of Mount Fuji, include a tropical greenhouse, an atrium for events and a workshop building. Inspired by the shapes of pollinating seeds, the volumes suggest an irregular range of shells. With the support of Ove Arup & Partners, the geometry of the three domes was generated through computer modelling. Known as the 'listening architect', Hasegawa often promotes dialogue through public consultation, inviting a wide spectrum of opinion. Her work is not considered as purely architectonic structures, but as an ephemeral human activity known as 'soft architecture'.

1, 2, 3 K Museum

4, 5 Aoyama Technical Collage

K Museum Urban Structure Museum | Makoto Sei Watanabe

The construction of Tokyo Bay began in the 1980s amid the bubble business boom. Its infrastructure nearly completed, the superstructure was halted by the recession. A huge common utilities tunnel system for pooling energy, communications and discharge – the largest of its kind in Japan – is buried beneath the bay.

Built in 1996, the K Museum rises at the heart of the vacant site. The purpose of the museum is to explain and display the infrastructure of the bay area.

Urban expansion through land reclamation has destroyed the local ecosystem. With no townscape, cultural or natural context, Makoto Sei Watanabe felt 'no one small work of architecture alone will attract throngs of visitors'. His solution was a bright light to illuminate the void and stir its surroundings to action. The planting of environmental sculptures and the waves of light emitting rods 'are etched with clear silver lines that sway in the wind'. Up to 4 metres tall, the 'Fibre Wave' carbon rod sculpture with solar cells stores energy during the day that is then released at night as a blue diode light. Like straw in the field, tall fibre rods dance freely in the wind, while the blue lights swirl like fireflies. Surrounding a base of polished black granite, cushion-shaped ceramic tiles from four different moulds are randomly laid. More recently, the bay area has become one of the most popular recreational areas of Tokyo.

1

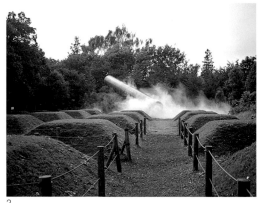

2

3

4

5

6

7

8

Fog Forest, Aria Business Park | Atsushi Kitagawara

1–3 The Fog Forest garden occupies a small northern section of the memorial park to the Emperor Showa in Tachikawa. Architect Atushi Kitagawara designed a number of versions of this landscape with the 'sculptress of mist', Fujiko Nakaya. The grid landscape of truncated grass mounds contains a metallic gauze cylinder and sunken sump tank from where the steam is timed to envelope the garden every 15 minutes.

4–5 Built in 1990, a meditation room occupies the tip of the Metro-Tour building in Tokyo and since the outside stairway has no rail and is made of glass the room would never be occupied, its use is only of symbolic value.

6–8 A contemporary version of a tea house within Aria, an industrial estate in Kofu built in 1996, it is part of an ambitious program in which the architect gives shape to an 'inexplicable vision in which a meta fictional urban becomes manifest'.

The National Art Centre, Tokyo

Completed in 2007, the National Art Centre Tokyo (NACT) was established in response to a long-standing demand for a location where the popular independent art associations could stage their annual shows. NACT is the fifth national art institution, but instead of hosting a permanent collection, it makes full use of the 14,000-square-metre exhibition space, the largest in Japan, for temporary shows. Architect Kisho Kurokawa describes his building as a 'gigantic display machine', designed as a large span with no columns to offer maximum flexibility.

Intended to accommodate the needs of various forms of exhibitions, it currently services more than 60 associations such as the Nitten Exhibition, which annually displays 12,000 artworks. The NACT's curatorial staff also organises their own program, exploring the latest contemporary art and creative media.

NACT is a giant plant that processes artworks by the wagon-load with industrial efficiency. The process of selecting the annual shows commences in the basement from where selected pieces are hoisted by lift to the appropriate exhibition area above while the rejects are trucked out. Each display area can easily be subdivided by partitions creating numerous space configurations.

In sharp contrast, the front of house domain contains a generous public parade with restaurant and museum shop. Public interface was very important to the architect, who wound the huge 200-square-metre complex and curvaceous glazing around his trademark cones. Kisho Kurokawa considered the National Art Center, completed in the final year of his life, as his finest building, providing the icing on the cake of his 50-year career.

Art Media in Context

My theme in this section is art in relation to architecture. I will be reviewing a range of art-media experiments in the urban context such as artistic landscapes, art programs as part of urban redevelopment and innovation in museum installations. The field studies include prestigious large-budget projects by the Tokyo Metropolitan Government, including the New City Hall, Tachikawa City, Iland Shinjuku Projects and the Tokyo International Forum.

One of the few independent architects to have worked with artists is Arata Isozaki, on his innovative installation gallery known as the Nagi Museum of Contemporary Art. Approached by the local mayor, who was seeking re-election, Isozaki was informed Nagi Cho had no particular art collection of its own. Isozaki proposed a radical solution that he describes as a third-generation art museum based on site-specific installations. As a result of Arata's idea, this small town was to become the recipient of an instant collection of cosmopolitan-status contemporary art that draws thousands of curious visitors each year.

To commission artists of such status, he had to pay them 'disproportionate amounts' to work with him. This meant, of course, that with so much money for this project coming out of his own fees, Isozaki's own remuneration was considerably reduced. So, his experimental concept of building artefacts into the program meant the buildings' own physical characteristics had to be achieved as economically as possible.

Further experiments in Art Museum productions can be seen at Marugame, Kanazawa and Naoshima. The 21st Century Museum of Contemporary Art, or Kanazawa 21, transcends its function as a museum and serves as a community resource bringing life back to the centre of the historic city. A catalyst for change, its purpose is to convey new forms of expression such as consciousness, collective intelligence, and co-existence. Focusing on these 'three Cs', the integration of design incorporates the concept of the art gallery, providing both information and experience to visitors and thus engineering their awareness. Kanazawa 21 encourages visitors to become the curator or initiator while offering community-gathering spaces. To develop a future audience, it educates children to understand contemporary art, and in the first quarter some 4000 children from 100 local schools attended. Because it is circular, the building has no 'front' or 'back' entrance, leaving it easily accessible and free to be explored in all directions.

Based on the notion that everyone is an artist, Kanazawa 21 welcomes a time when anyone can decide what is of artistic value and when anyone can become a curator. It is committed to a deep and strong involvement with society and the world at large, while continuing to generate different values that are about to be verified. The intention behind all of these elements is to revitalize and to stimulate the visitor's emerging awareness.

The Benesse Art Site Naoshima is a collective term for the contemporary art activities being developed by Benesse Corporation in Naoshima, Kagawa Prefecture. The metal refining industry on which the island's economy depended had

1

devastated the natural environment. Dreaming of transforming the situation, the President of Benesse Corporation, Soichiro Fukutake, wanted a site removed from the noise of the city that would overflow with materials and information, where people could truly reflect on the meaning of 'living well'. Naoshima now features the Benesse House, The Art House Project and the Chichu Art Museum, and these have revitalised the island into a world-class place for culture and nature. Many of the artworks are by internationally renowned artists who created them specifically for the island location. The latest addition is the underground Chichu Art Museum designed by Tadao Ando mentioned earlier.

1

Gardens and Nature

Benesse Art Sites, Outdoor Works, Naoshima

Since the opening of Benesse House in 1992, art sites have been established throughout Naoshima to offer places to encounter nature, architecture and history. The island is gradually being healed and regenerated by leading practitioners and the point of entry, the new ferry terminal, is designed by SANAA.

2

3

5

4

6

7

1–2 Pumpkin | Yayoi Kusama, 1994
For visitors encountering this brightly coloured giant vegetable against a calm view of the Seto Inland Sea, 'it signals the arrival into a dotty place'. Kusama has regularly experienced disturbing visions of polka-dots and net-like forms ever since she was a child. She uses these patterns in her art, filling surfaces or combining them with concrete images such as the pumpkin.

3–4 Cultural Melting Bath | Cai Guo-Qiang 1998
Thirty-six Chinese Taihu Lake stones surround a US-made Jacuzzi where guests bathe to cleanse their bodies and refresh their souls by washing themselves in this work of art. According to Cai, this is the spot where the qi (energy) flows best on the island.

5–7 Shipyard Works | Shinro Ohtake, 1990
This is part of a series of sculptures inspired by discarded fishing boats in Ehime Prefecture, near Ohtake's studio. Ohtake applied the process of casting plastic in a wooden mould to make the basic form of a boat that he then cut up into several parts. The elevation of this house installation is adorned with as-found recycled detritus. It belongs to the naïve genre of the 19th-century French Postman Ferdinand Cheval, whom the artist admires.

Canadian Embassy | Artist Shunmyo Masuno

Public buildings provide a new kind of space for gardens and the properties of stone offer particular sculptural qualities favoured by artists. Located opposite the Akasaka Palace in neighbouring buildings are two outstanding modern rock gardens. At the Sogetsu Gallery in 1978, Isamu Noguchi introduced scenery of stepped terraces whilst opposite at the Canadian Embassy there is an aerial geographical impression of landscape. In 1993 Shunmyo Masuno, a practicing Buddhist priest, introduced a three-dimensional interpretation of the geology and cultural contrasts of Canada and Japan. The horizontality suggests the spread of the prairies and the transverse granite sets on the northern side refer to the Rockies. To represent the land gouged out by the glaciers, Masuno left the rocks as they naturally split during the quarrying process. Masuno's regular stonemason is Masatoshi Izumi, a collaborator and partner of Isamu Noguchi. A master of stone, Izumi was able to expose the raw beauty and innate characteristics of the rocks. A precise chequerboard, the Zen stepping-stone garden at the rear is emblematic of the formality and control found in the Japanese personality.

Cerulean Tower, Tokyu Hotel, Shibuya Ward, Tokyo
To calm the minds of the guests, Shunmyo Masuno connected the lobby interior and outside terrace for a combined atmosphere. Completed in 2001, the dramatic rock garden can be appreciated from all points of the oval sunken lounge. With its concept of rolling waves, the hewn steps of white granite dominate the view of visitors sitting in the tranquillity of the hotel shore.

1

5

2

3

4

6

1–4 Birth of Sky Fountain, Livingston | Susumu Shingu

Susumu Shingu is described as a wizard who applies the poetics of construction to fully engage with both nature and the imagination of the observer. He is an artist who addresses the delicate balance between craft and technology, expanding our sensitivity towards the phenomena of nature, wind, water and light, so they can be experienced more. His works, like the 'shishi odoshi', tilting bamboo that strikes the rock, are devices that transmit and amplify physical occurrences and visual messages created by natural forces. Invited to animate the central plaza under the huge glass dome completed in 2001 at Livingston, the rippling fountain and ephemeral clouds captivate viewers by engaging them with visual grace, sound and thought.

5–6 Wind Kaleidoscope, Osaka

His objectives of creating space by fusing the natural and artificial qualities brought about initiatives to combine movement and building forms. The awareness that the artworks constituted environments and an understanding of architectural scale led him to realize the Wind Kaleidoscope Brain Centre.

Water Tree, Water Garden, Sanda
The water tree at Sanda follows on from previous
Watermills–Windmills 1984 fountains at laboratories
in Tsukuba. Incorporating the inherent parabolic
discharge, the twisted stainless steel conduits
spectacularly gyrate according to the water pressure
and changes in the wind.

Urban Redevelopment

Boundless Sky | Artist Susumu Shingu | Architect Renzo Piano Building Workshop

The Kansai International Airport, built on a man-made island, is an extraordinary program. The largest single-room building in the world, the curvaceous Air Passenger Terminal has the profile of a wing with a 72-metre internal span. Inside the 300-metre departure lounge, huge ventilation ducts blow cool air across the enormous aerofoil teflon sheets. According to the project architect, Noriaki Okabe, the clear space free of columns and obstacles provides an appropriately calm atmosphere. Renzo Piano wanted to express the airflow movement and Italian-speaking Kansai-based Shingu was uniquely placed to undertake the task. Piano was familiar with the artist's 1992 Columbus Wind mobiles in his home city of Genoa, and Shingu had previous experience with his 1987 Flying Cloud installation at the Logan International Airport in Boston. Shingu's earlier proposal for 'Kansai Fish that swim in air' was transformed into Boundless Sky micro light structures installed in 1994. The light, airy, curvaceous lounge combines with the mobiles gently flexing in the airstream to make the finest departure terminal in the world. Shingu's gentle crafts enable users to enjoy and feel confident in flying, something with which they can identify.

1

1 Tento Mushi Stainless Steel | Nabuo Miyamoto

2,5 My Sky Hole 91 Corten Steel | Inuoe Bikichi

3 Sanctuary Shrine of Water, Granite and Bronze |
Nabuo Sekine

4 Rotating stainless steel mobile | George Rickey

2

3

4

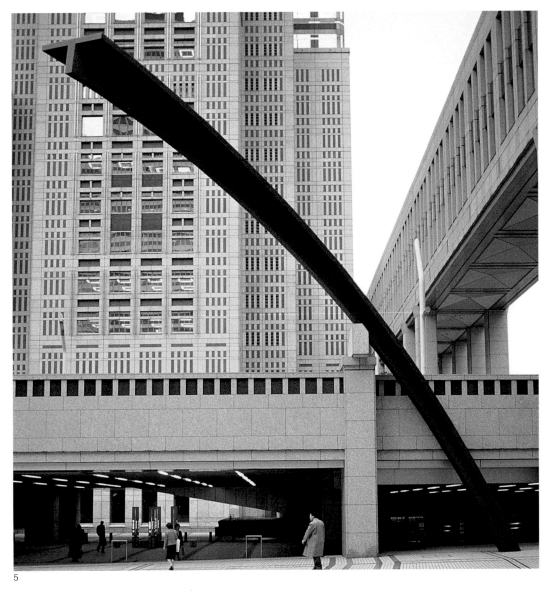

5

New City Hall, Shinjuku, Tokyo | Kenzo Tange

The seat of the Metropolitan Government, the New City Hall was designed by Kenzo Tange and completed in 1991. Many have questioned the appropriateness of such a monumental structure and see it as a legacy to the bubble economy. Facing the front, two extended wings arch over the Citizens of Tokyo Open Space. Criticised as a Western-style public circus at the heart of the city, it is sadly devoid of people, but contains an impressive collection of public sculptures. In a spirited attempt to humanize the plaza, the authorities organised a public art competition and spent £10.25 million on 36 artists. Consistent with an open competition process, the program is an interesting compromise between famous and less well-known artists. It contains two works by environmental artist Nobuo Sekine that have been reassembled from earlier versions at the Niigata Station and the Narashimo University Campus. The *Shrine of Water* is a 4.5-metre-high fountain of mainly black granite set upon an 11-square-metre stone tablet. A 3.6-metre-diameter ring of black granite, the other is a topographical concept known as the *Pedestal of the Sky*. There are two prominent structures by the Scottish-raised mobile artist George Rickey (1907–2002). Moving gracefully in the wind, the two kinetic works provide a human scale to the approach of the plaza. One consists of three horizontally jointed rotating rectangles, and in the other, four stainless steel squares pivot about a central spine. However, it is Takeyoshi Inoue's *My Sky Hole*, a T section rolled steel arch, that most dynamically engages the citizens of Tokyo Open Space.

1

1–2 Wall Drawing #772 | Sol LeWitt

3 Yunus II | Katsuhito Nishikawa

4 Pleiades | Hidetoshi Nagasawa

5 Love | Robert Indiana

2

3

5

ILand Shinjuku | Nihon Sekkei

Unlike the expansive environment of the local Tokyo government office, the approach to the nearby ILand Building incorporates a more compressed and frequently occupied sunken patio garden. Over a five-year period the curator Fumio Nanjo, on behalf of his client the Housing and Urban Development Corporation, enlisted the individual talents of internationally renowned artists with mature sensibilities. Following research and interviews, ten leading contemporary artists were selected and after lengthy discussions with the architects, Nihon Sekkei, each took a considered collaborative and integral approach to the spaces. The Shinjuku ILand Public Art Project cost £7.5 million, which was 0.5 percent of the construction costs or 0.3 percent of the overall development costs. Chief architect Rokushika Masahura described the need for a consistent concept for the collection, based around the themes of heaven, stars and earth, creating a loving and positive image to heal the emotions in the stressful Shinjuku business location. More at home with public squares than the Japanese, who are unaccustomed to such spaces, are the Italian sculptors Giulio Paolini, Luciano Fabro and Giuseppe Penone. The Americans brought colour and pop to the district, but Sol LeWitt's *Wall Drawing* through its theme, the power of the birth of a star, is sensitively integrated into the main lobby. The only two Japanese contributors were Hidetoshi Nagasawa, who worked in Milan for 25 years, and Katsuhito Nishikawa, who has resided in Dusseldorf since the 1970s. Consisting of seven pieces of marble installed in a pool of water, *Pleiades* by Nagasawa was taken for a crystal and suggests a constellation of stars. *Yanus II* consists of three 2-metre-high gracefully entwined mobius loops. According to Nishikawa, *Yanus* means 'dolphins' in Turkish.

4

1

1 Stairs to Utility Tunnel | Richard Wilson

2 Energy Barometer for a Zen Garden | Rebecca Horn

3 Polychromatic Cage | Kenjiro Okazaki

4 Loop | Makoto Ito

5 Vent | Makoto Ito

6 Bollard Bench | Kunio Yoda, Figure with Dog |
Esther Alberdane

2

3

4

5

6

Faret Tachikawa, Tama, 1995

The Tokyo Metropolitan area is decentralising its structure, and Tachikawa is the 'core' city for the western Tama area. To fulfil its function as a self-sufficient business city, the Housing and Urban Development Corporation wanted to establish an intelligent and humane city. Faret Tachikawa is a new commercial zone with eleven substantial buildings of unified height accommodating a working population of 100,000 and serving 300,000 visitors per day. Art planner specialist Fram Kitagawara, the director of the Art Front Gallery, devised three basic installation concepts: identity, functionality and Wonder Town. Mirroring the world at the end of the 20th century, the art is casually embedded in the cityscape, filling the town with wonder and discovery. By 1995, the art plan had introduced 109 artworks by 90 artists from 35 countries, costing £7.5 million. For many this was their first public commission and of the 43 Japanese artists involved, 30 are young emerging artists. Kitagawara rejects the insular Japanese art world, a closed shop of artists and critics secluded in ivory-towered art academies and the gallery system. Perceived as a village that welcomes visitors, it portrays the medieval concept of 'Dousojin' deities protecting travellers by displaying various gems the villagers were proud to show their visitors. With its rich diversity of expressiveness, the Wonder Town becomes a forest where the spirits of the art world live. Avoiding monumentality and adhering to Building Standards Law, the artists complement the functioning fixtures and street furniture. Turning objects into art works, the central axis is transformed into a street gallery containing 38 pavement bollards placed at equal distances. In a new city that lacked identity, Kitagawa introduced the personal voices of an arts minority, wishing to expand humanity by stimulating new areas of consciousness.

1

2

3

4

5

6

1 Utility Access Chamber | Tadashi Kawamata

2 Steel Bollard | Yasuhiko Koboyoshi

3 Central Bollard | Yasuhiro Takeda

4 Floral Vent | Kyotaro Hakamata

5 Stack in Frame | Takamasa Kuniyasu

6 Straw Shopping Bag | Tang Da Wu

Tokyo International Forum, Marunouchi

The last of the Metropolitan Government's grand projects, the mammoth Tokyo International Forum was one of the country's first major international competitions. This is highly significant as, according to winning architect Rafael Viñoly, Japan has long been perceived as a closed society and the competition was designed to counter the xenophobic image. A very dramatic concourse resembling the profile of a boat, the most striking feature is the 60-metre-high Glass Hall that uses 20,000 square metres of automobile windscreen glazing. Incorporating glass structures by UK engineer Tim Macfarlane, who produced the award-winning cantilevered laminated glass canopy for the Yurakucho subway station, the form itself is a blend of art and seismic civil engineering.

Complementing the architectural spaces, the artworks were similarly widely sourced and feature foreign talent. In a compromised attempt at consistency, the theme for the commissioned artworks was 'A Boat of Diversity', reflecting the hull-shaped hall. Costing £3.9 million, the collection consists of 100 pieces by 50 artists, including 20 two-dimensional works for the conference rooms. Sandwiched between two blocks, the granite-paved central plaza serves as an entry point and public parade with seating among zelkova trees. The sculptures include Kan Yasuda's *Ishinki* (1991), a stone circle (1996) by Richard Long and Anthony Caro's *Barcelona Ballad* (1983) from his major MOT retrospective. In a statement about the role of institutions in contemporary urban culture and addressing access, flexibility and civic responsibility, the forum and its many artworks are open 24 hours a day.

2

1

3

5

4

6

1 Glass Hall | Rafael Viñoly

2, 6 Ishinki, 1991 | Kan Yasuda

3 Barcelona Ballad | Antony Caro

4 "What could make me feel this way" Concourse |
 Richard Deacon, 1983

5 Hemisphere Circle | Richard Long

Marunouchi Area Redevelopment

With a working population of 250,000, Marunouchi Ichigoukan has long been Japan's premier business district and the gateway to Tokyo. Almost one million people flood the local stations daily on their way to employment or visiting the major company buildings. Following the completion of the Tokyo International Forum in 1998, the redevelopment covering the Otemachi, Marunouchi and Yurakucho areas commenced in earnest to breathe new life into the ageing estate – a 24/7 urban interface bustling with people. Because most of the buildings are more than 30 years old, the vision is to develop a sustainable urban environment and, unusually for Japan, to reconsider the historical legacy. Quite a number of cherished treasures already exist in the communal memory, such as the Meiji Seimei Kan Building and monumental carvings by artist Masayuki Nagai, both distinctive landmarks with considerable heritage value. The restoration of the Tokyo Station front plaza, considered a significant cultural asset, means that the public domain retains a human scale.

As the major landlord, Mitsubishi wishes to improve the quality of interaction within Marunouchi by introducing a bold public art and building program through

1

2

3

4

5

6

7

8

international art commissions. Appointed as artistic consultant to the 'Maru Biru' Building, London-based architect Kisa Kawakami introduced various artists through the office of art consultants Modus Operandi. For the latest gateway tower, the Shin-Marunouchi Building, the UK architect Michael Hopkins was appointed to introduce a 'stately elegance' reminiscent of classic British architectural taste. The Marunouchi Area redevelopment is a rapidly evolving creative strategy to meet the challenge of an increasingly competitive global marketplace.

1 Meiji Seimei Kan Building | Shinichiro Okada

2 Stone Whistle for the Wind | Masayuki Nagai

3 Nami-Kagura | Masayuki Nagai

4,5 'Interactive Wave', Maru Biru Building |
 Kisa Kawakami

6 Thirtysix Elements: Glass Wall, Maru Biru Building |
 Susanna Heron

7 Interactive Installation, Maru Biru Building

8 Series of Arc | Kisa Kawakami

MIMOCA Marugame, Genichiro-Inokuma Museum of Contemporary Art

Completed in 1991, MIMOCA was designed by Yoshio Taniguchi to commemorate the 90th anniversary of Marugame. A small city with no substantive historical collections, the museum is dedicated to the modern Western-style painter Genichiro-Inokuma (1902–1993) who spent his youth in the city and also assisted on the building. Encouraging individuality and personal expression, it also serves as a base for art appreciation and to promote the creative activities of the public. An elegant response to the urban site, the simple triple-level volume is articulated to provide an architectural focus to the large station plaza. The museum is announced by a cavernous gateway with a freestanding white marble elevation featuring a large tile mural by Inokuma providing a screen above, through which the daylight is filtered. Recessed under a deep canopy and flanking walls, the arrangement provides a semi-sheltered hard stand for urban art. The low-key museum entrance is extended longitudinally up the stairs to the Cascade Plaza, a rooftop terrace and café with a cascading wall of water offering a place for quiet introspection. A long permeable structure adjacent to the tracks, the ground floor contains the general library accessed from the south side of the building. The stairway extends the city within the boundary of the building providing access on various levels to the museum auditorium, studio and art library, offering a multilayered program allowing appropriation of the museum by the local population. On three floors, the interior spaces of the gallery openly connect, their qualities enhanced by the delicate introduction of diffused natural light. Favoured by Taniguchi, the concrete, limestone, aluminium and translucent glazing are cool, still and restrained. Providing an atmosphere especially suited to the works on show, the museum possesses 20,000 works from the artist's prolific 70-year career. The permanent collection of the gallery is located on the second and third floors, connected by an elegant double-height open staircase.

Nagi Museum of Contemporary Art

A program Isozaki describes as a third-generation art museum includes a number of bespoke and permanent works consisting of three containers representing the sun, moon and earth. Completed in 1994, Nagi MOCA has the appearance of an observatory compound embedded in the fields of an isolated rural town in the wilds of Okayama Prefecture. Containing a mysterious cargo, the alien vessel is a laboratory for the practice of site-specific contemporary art. Referring to the site plan, Nagi MOCA, the library and restaurant are located along Symbol Road, which is expected to become the cultural quarter of the small town. The main axis through the semi-buried earth chamber points to the sacred peak of Mount Nagi. The 'sun' canister is oriented north–south on a 1 in 8 incline, while the straight wall of the 'moon' gallery is pointed in the direction of the moon at 10 pm on the autumnal equinox.

For the three rooms, the artists were briefed to conceive works that cannot be exhibited in the conventional gallery. Collaborating with the architect to create distinct enclosures, each space is physically entered and absorbed. Astrological metaphors, the sun is clad with gold corrugated aluminium and the moon in silver. For the earth, artist Aiko Miyawaki wished to create a sculpture that has shed its weight and is as free as a bird in flight. Her main purpose is to relate to the ground and water and to express an unfettered spirit, which the Chinese call 'chi'. Sculptor Kazuo Okazaki introduces his theme 'Hisahi', based on the eaves of a building or natural canopy that provide shelter from the elements. The moon room combines Hisahi with a concept he calls 'supplement', a notion that the whole can be discovered through the part. 'The Sun' is a giant tilted time capsule designed by neo-dada artists Shusaku Arakawa and his partner Madeline Ginns who, by presenting the familiar but in a disturbing way, intend to disorientate and liberate people's perception of things. The artists invite the visitor to step into the 'Nagi's Ryoanji', the 'Ubiquitous site', where upon entering you are liberated from your past persona and from then on everything is new, there is 'nothing but the big now'.

1

2

3

4

5

6

7

1–6 Room 'Earth' Utsurohi – a moment of movement | Aiko Miyawaki

7 Nagi (MOCA) courtyard with stables | Aiko Miyawaki

The 21st Century Museum of Contemporary Art, Kanazawa | SANAA

Opened in October 2004, the museum received 1.5 million visitors in the first two years. Resembling a white flying saucer, it is a flexible multi-purpose art museum that can be adapted to suit future purposes. Circular in form with a diameter of 113 metres, the building has four or five entrances and offers community gathering spaces, such as a library, lecture hall and a children's workshop. While it has a deep footprint, with its transparent corridors the ambience is bright, open and welcoming. It is configured with the museum collection functions to the centre with an open fully accessible public area around, allowing visitors to penetrate the building. The model is based on the concept of a chain of islands, and the variously proportioned rooms are spread across the plan. With the fully glazed envelope, people can see inside and determine their routes in and out. The transparent circulation offers clear vistas through the entire depth of the museum and views throughout into the central core. A promenade just inside the curved glass of the exterior façade smoothly unfolds a 360-degree panorama of the park setting. Four fully glazed internal courtyards, each unique in its character, provide ample daylight and a fluent border between the public zone and charge zone. The gallery areas are arranged to encourage interaction with the public, and the circulation is designed to facilitate additional exhibition spaces. Adaptable to most types of media, the display area is fragmented into numerous galleries allowing visitors to choose their own route. Exhibition content will define spaces and sizes. The gallery heights range from 12 metres to 4 metres and various lighting conditions, natural light or darkened spaces accommodate a range of artworks. The type of display is variable with small boxes for incremental exhibitions that can open for large shows, an approach

1

2

4

6

3

5

7

that offers multiple options for expansion and division into smaller exhibitions. Artists work in residence to animate especially commissioned rooms, some permanent and some temporary. Located around the perimeter are tuba-shaped ear trumpet installations by sound artist Florian Claar piped underground so visitors, visible through the other end of the corridors, may wave and relay with each other. Among other permanent installations are James Turrell's Blue Planet Sky courtyard, the 'Kapoor Room' and swimming pool by Argentine artist Leandro Erlich. Important collection items include sketches by Atsuko Tanaka for her electric light dress first presented in 1955 at the second Gutai Art Exhibition in Hyogo.

8

Ubiquitous Art Installations, Tokyo Midtown

Conceived as a design hub for the creative industries, Tokyo Midtown is a $3 billion mixed development accommodated in six main buildings completed in March 2007. As well as commercial and residential, the program includes the relocated Suntory Museum of Art designed by Kengo Kuma and the 21_21 Design Site established by Issey Miyake and designed by architect Tadao Ando.

The grounds are punctuated by 20 internationally commissioned artworks and visitors are offered the 'Ubiquitous Art Tours', the latest in guided handset technology developed by the curatorial agency Toshio Shimizu Art Office. The main plaza features a black marble entrance landmark, *Shape of Mind* carved by Pietrasanta-based artist Kan Yasuda, who also produced the white marble monument for the main basement thoroughfare.

The 20-acre site, a former Japan Defence Agency property, was the last remaining open space available in central Tokyo. A most impressive contribution to the development is the rear public park created by landscape architects EDAW. Overshadowed by the 248-metre SOM and Nikken Sekkei Architect tower, this is a much-needed green oasis. The Midtown Gardens include the refreshing Ninikicho Park fashioned on a traditional lake landscape. Tokyo Midtown with the nearby Mori Art Centre and the recent National Art Centre present a triumvirate of creative excellence that is about to reinvigorate the tarnished image of the Roppongi Area.

1

2

3

4

6

5

7

8

Installation and Display

House of Stories, Bleddfa | Tono Mirai

The 2001 Japanese Festival provided Michael Nixon, curator of the rural Centre for the Arts, Bleddfa, an opportunity to invite two innovative designers to present their work in Mid Wales. The House of Stories was Tono Mirai's first outdoor work in landscape and is made from locally sourced straw and clay laid over a structure of wood and mesh. Reflecting the surrounding hills, the turf roof seamlessly spirals into the rest of the garden. The curved interior wall and integral seating around the nest area create an atmosphere that encourages imaginative thinking and story telling. The remote Bleddfa house was a development of his earlier organic 'nest project' that he had installed into his central Tokyo apartment.

Paper Tea House, Bleddfa | Shigeru Ban

The antithesis of Tono Mirai's approach, the paper tea house by architect Shigeru Ban is rectilinear, designed to a grid, pre-fabricated and delivered in a wooden crate. The tea house was made of horizontally laid, square-section carboard tubing with a wavy polycarbon roof and a Japanese oak floor. To protect them from the heavy rainfall, the tubes were coated in varnish but the horizontal rectangular tubes were more susceptible to damp than the more robust round sections. The furnishings were also made of cardboard. The gaps between the tubes acted as a screen, flooding the tea house interior with diffused light, creating a peaceful and contemplative atmosphere.

9

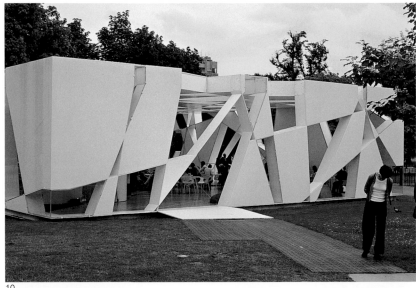

10

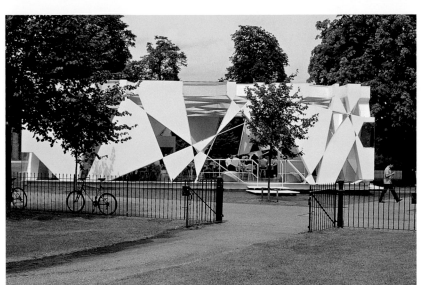

11

Serpentine Pavilion | Toyo Ito and Cecil Balmond

A temporary installation, the white diamond structure, according to Toyo Ito, 'was the greatest experiment of this kind' he had undertaken. He developed this flat plate section construction system jointly with Cecil Balmond, a leading engineer at Ove Arup. Segmenting myriad overlapping lines, plotted across a grid generated from an algorithm progression extrapolated from a single rotated square, they 'were able to create a space with geometry completely different from the conventional cube'. Applying these lines across the walls, floors and ceiling alone, they discarded columns, beams, corners, doors and windows and gave people the experience of a new sense of space. This varied abstracted quality set in Kensington Gardens made a startling contrast to the symmetry of the gallery.

1–5 House of Stories, Centre for the Arts, Bleddfa, Wales | Tono Mirai

6–8 Paper Tea House, Centre for the Arts, Bleddfa, Wales | Shigeru Ban

9–11 Serpentine Pavilion | Toyo Ito; Engineer: Cecil Balmond

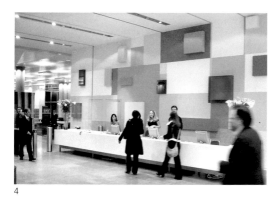

2

4

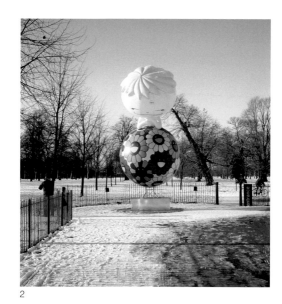

1

3

5

6

7

8

9

10

11

Urban Art Selection

1–3 Flower Ball Inflatable, Serpentine Gallery, London | Takashi Murakami

4 BBC Media Centre, reception installation | Yuko Shiraishi

5 Cities on the Move exhibition sound installation, Hayward Gallery, London | Yukio Fujimoto

6 Steel Sakura, Japan Tobacco Headquarters | Marta Pan

7 Kamo River Pillars, Sanjo Station, Kyoto | Minoru Tomikashi

8 Air Dance, RAF Museum, Hendon | Kisa Kamakura

9 Cool Garden, Longchamp Textiles, Kyoto | Hiroshi Murai

10 Wind Sign Post, Nakanoshima Green Path, Osaka | Hitoshi Saito

11 Steel sculpture, Tokyo Bay

Personal Account

During the last decade, there have been many exciting developments in contemporary Japanese architecture. Often radical, these buildings with their roots in Japanese tradition appear to be a manifestation of unique qualities in Japanese culture. My aim was to examine the ways and means by which artistic expression has contributed towards this new growth of significant structures. Do, for instance, the new generation of buildings engage a particularly interesting creative intervention or do the architectural volumes and spaces themselves demonstrate examples of artistry? Does the creativity simply manifest itself in the total quality detailing of Japanese construction techniques found within such features as lighting, flooring or graphics? Are the new iconic structures consistent with traditional architecture values of space, performance and harmony?

Guest Contributions

Project Japan is the result of a considerable journey researching and cataloguing contemporary practice in Japanese art and design that has introduced me to the issues, classifications, materials and approaches employed. I have expressed my findings through articles, DVD videos, and exhibitions that appear on the Listings page. The Review section includes a range of art-related articles and several personal studies, amongst which is the Kitano project, a photographic survey of the historic Nishijin street scene, in a district famous for weaving kimonos. This account was the subject of an internet exercise with assistant professor Atsushi Sasaki, through the Architecture Department of the Kyoto Institute of Technology, who was concerned about the disappearance of this unique form of urban lifestyle. There is also a brief account of the Tojoso cooperative program that has been prepared with designer Yasuto Kato, who kindly offered his flat in Osaka for the duration of the Japan Fellowship. I have also included a transcript of the Farringdon Exchange, a round-table discussion between artists and architects who were resident in the UK and a spread of images providing a snapshot of Tsukuda Island, one of the few remaining Edo Quarters of Tokyo.

Brief visits to Japan since 1993 have been a revelation, and I appreciate the extraordinary talents of contacts I have since established, which have allowed me to consider prevailing attitudes towards introducing art as an architectural form. First of all, I am most indebted to the support of the pioneering architect Dr Kisho Kurokawa who kindly offered me a base within his office and his considerable personal wisdom as guidance in the above program.

It is also has been a privilege to team up with my other guest contributors, Fumihiko Maki, Tadao Ando, Makoto Sei Watanabe and Kengo Kuma. I had the pleasure of working with Fumihiko Maki, enabling him to present a major exhibition at the V&A as part of the Japan 2001 festival, and I have with his assistance transcribed his 2005 RA lecture here. I am most grateful to Tadao Ando who has kindly prepared the preface for *Project Japan* and who is also the subject of several articles within, including an account of how the regeneration of Manchester Piccadilly Gardens transpired. I had the pleasure of working with Kengo Kuma when preparing the 4x4 DVD RIBA Exhibition where I met Makoto Sei Watanabe, one of the 16 participants, and both have kindly contributed short essays for use in *Project Japan*. It has been a privilege and joy to undertake this ambitious personal account with my guest contributors.

1

1 Hillside West, Tokyo | Fumihiko Maki

2 Spiral Building

Weaving: Thread and Strand
Fumihiko Maki

Fumihiko Maki was born in Tokyo in 1928 and was educated at the University of Tokyo and Harvard. He studied and taught under Jose Luis Sert and worked for SOM in the US, then in 1965 set up his own practice. His influences are Bauhaus and early modernism with a lightness associated with Japan, a contemporary condition, with sensibilities across cultures.

The following is a summary of Fumihiko Maki's thoughtful illustrated lecture at the Royal Academy of Arts, London, 2005, spoken in English and transcribed and later edited by the author.

A short introduction to Japan

An archipelago stretching north to south, Japan has a rich vegetation and different climates with a central spine of high mountains reaching up to 3000 metres. Along the waterfront, there are many gentle hills and there is much similar landscape across Japan. Perhaps the interest of Japanese architects in horizontality derives from this kind of landscape.

The modernisation of Japan commenced in the 1850s, and since then Tokyo has been transformed steadily. One of the differences between European cities and Tokyo was that after the war Europe tried to reconstruct the city of the past whereas in Tokyo, except for the Imperial Court and surrounding park, we don't really have anything remaining from the Edo period. During this period, the city was claimed to be one of the greatest garden cities of the 18th century. The memory of the past is still there in the small dark alleys and pockets of vegetation that you can still find hidden within the highly developed Tokyo, but of course these places are slowly disappearing and being replaced by artefacts. From when I was born, I remember Tokyo being very much covered in brown and green, but now it is white, grey and silver. The modernists came to Japan when I was a child, and I still remember very vividly the overtaking of the old city by modern buildings, houses and small pavilions, a sort of white in colour. Perhaps this kind of memory may have taken me to a modernist type of architecture.

Tokyo is the place where I was born in the late 1920s, where I was raised and where I have lived, except for several years I spent in the USA as a young student and teacher in academia. So, this evening I would like to talk about several issues that may have been important in the development of my architecture. One of them is the use of modern technology and the use of new materials. However, we have always felt that the product of architecture must always serve human beings and produce a humane environment.

2

Tokyo Metropolitan Gymnasium

In 1983, one of the first large buildings I designed was the Fujisawa Gymnasium, which is covered by thin, stainless steel strips all welded together. Without going into detail, this was an experimental architectural work in which not only very sophisticated structural systems, but also new materials like stainless steel were used. Then, several years later I designed the Tokyo Metropolitan Gymnasium. The building itself is depressed 6 metres below grade so that the entire profile would be comparable to the low-rise surroundings. The interior space is created with two gigantic girders supported by four columns, and the cantilevered spectator decks are tied up by a compression ring on which the roof sections sit. These are some of my early experimentations in the use of new technology and materials. I should also say that this was one of the last times when we used a compass, T-squares and pencil drawings. You can imagine that if we had been able to use computer graphics then, we could have done it much more easily. But I think 1990 was still a time when most of the architects used those classical tools for making buildings.

Makuhari Messe

At about this same time, we designed the very large Nippon Convention Centre at Makuhari Messe, a hybrid of structural sections also clad with stainless steel. Looking at the profile of these large structures and the main entrance with its red mushroom-type canopy, you can also see the medium size arena that resembles the two gymnasiums that I did.

Five years later we were asked to make an extension of the first phase, and we introduced a metaphor for this large space as a hill that you saw in the slide of countryside at the beginning. As a counter form, I decided to introduce a wave to be used as a metaphor for the second phase building. Now this particular structure is a kind of academy building, but in order to give height at the centre point we pushed the roof up, which

1

2

3

4

5

6

meant we had residual forces left on two points that we could balance by introducing tension wires to both ends.

Now the slide on the right (see page 21) is a famous image by one of the greatest woodblock print artists, Katsushika Hokusai, and you can see the fisherman is standing cantilevered from a rock on the water trying to pull off the fish. For the ukiyoe artist this might be a kind of form that gives a certain degree of equilibrium of forces in action, and this interests me very much since the human faculty is able to produce and see certain forces beautifully interacting.

Looking from the red canopy on the first space, the interior space is such and the tension wires are coming from a series of poles. In order to construct this particular form, we needed to have a series of cast-iron joints. First we designed all of them as mock-ups drawn on paper, and then we had a full-size version made up of wood from which we had iron parts cast in order to connect the critical joints. I think this is one of those industrial skills still now available and, as I remember, in England you have had a long tradition of cast iron craftsmanship. Now you can see interior spaces that display curves of a certain refined scale and the use of the casting details.

TV Asahi

This is the Roppongi Hills, well known for the latest redevelopment in Tokyo by the Mori Real Estate Company, and I did the TV Asahi headquarters, which happens to be low-rise against the two-high rise buildings. The building has four or five large studios surrounded by the supporting offices, so it required a fairly large footprint. The high-rise building was by William Pederson, the commercial place by John Jerde and Terence Conran did the exterior of the apartments. I was the only Japanese architect.

Although this is just a collection of homes, hotels and stores and a few other things, amazingly about 24 million people visited the place in the

7

8

9

1–3　National Gymnasium
4–6　Makuhari Messe
　7　Makuhari Messe sketch
8–9　TV Asahi

four months after it opened! Now, among the UN nations only 25 countries have a population of more than 24 million. Perhaps this shows that there are not so many interesting places for Japanese to visit. I do not know why it attracted so many people. Maybe we should call this the Disneyland syndrome! Because TV Asahi is open 24 hours a day, we wanted to make the building visible in the evening as well as in daylight, so the north side has a large glazed screen. This building has a double façade stretching about 126 metres, probably the largest such Vierendeel structure in the world. Then we have vertical louvres on both the east and west sides that in the dark give the effect of a Japanese lantern.

Coming back to the large atrium: it has two entrances with a rectilinear frame behind. We decided not to use ordinary welded connections here and, instead, we decided to use mechanical joints. Certainly some of the vertical ladders were made in factories and brought onto site, but then a different fabricator made those curved beams, the pins and also the hooks. Altogether 16 different fabricators worked together to make these frames, a tolerance of only 0.2 millimetres was allowed for each fabricator. Here again, industrial craftsmanship is still available in Japan although we cannot say the same resources will stay forever, since there is not so much demand. But for me as an architect, if the technology or technological craftsmanship is available then we have a certain responsibility to demonstrate it and leave it to the next generations as testimony of such performance.

Hillside West

This was a competition entry for the Salzburg Congress Hall way back in 1992. Although it did not win, sometimes competitions can provide a moment to test certain ideas. So, several years later in Hillside West Tokyo, we were able to use a similar notion of aluminium screening to form the front façade to the double-height penthouse with offices hidden behind. These are details of this screening, and it is interesting that under

1

2

3

4

certain light conditions this screen becomes a receiver of shadow from the tree in front. Depending on the weather and the time of day, the screen starts to change its own character and present different features while cutting off and shading the sun quite effectively.

Shimane Museum of Ancient Izumo

You are looking at the Great Izumo Shrine, one of the three most revered shrines in Japan. The others are the Ise Shrine and the Itsukushima Shrine near Hiroshima. The Izumo Shrine faces onto the Sea of Japan in the west, and since ancient times this area has been the arrival point of people and commodities via Korea from the Asian continent. Recently, some very rich archeological finds have been made in excavations here, and this particular museum is to house and display these findings.

Next to the Izumo Shrine is a very large place where we are developing both the gardens and the architecture. Now, you are looking again at this gentle background that is the construction site where we are hoping to complete the building early next year. We hope to signify the iron remains that were first introduced in this region by using a large corten steel wall. Then, this transparent protrusion of the glass box will divide the garden into a background and foreground, with the backdrop of gentle hills.

One of the most amazing findings has been that the original shrine was built in the 8th century in this manner using completely wooden columns and beams. The size of the column is made of three posts tied by iron bands. The height of the original 8th-century shrine was about 46 metres, and the recently found columns will be exhibited at the centre of the exhibition space. We also found a number of groins and fittings that will be held in storage and shown in the exhibition space. You approach here and enter through a very transparent threshold into an anteroom and the exhibition space. So, there is a sequence of spaces that I think is very characteristic of Japanese architecture.

5

6

1–4 Hillside West, Tokyo

5–6 Renderings of Shimane Museum of Ancient Izumo

You are looking again at a fairly modern transparent façade from the entry side. When we got the commission, we immediately erected scaffolding to determine the position and how much height is necessary to be able to see the skyline of the existing Izumo Shrine. By doing so, we tried to visually integrate the perception of the new museum to the shrine as well as to the beautiful mountain.

Kaze No Oka Crematorium

The final project I want to show is a crematorium I designed some years ago. It is in a small city of about 70,000 people in the south of Japan called Nakatsu. The idea was to develop both the park in the front and also a crematorium proper behind.

In the process of making the landscape we found a 7th-century burial ground, and our landscape architect traced this form in making the necropolis. Do you know that the necropolis was the beginning of the city in human history? The people gathered and protected the ancestor's soul and body in symmetry.

This particular crematorium is composed with three main areas. So, we decided to make the whole composition into a sequential event providing an element of time. By the way, the exterior was covered in brick made in England. We did quite a bit of research and found that British brick would best suit in this particular case.

You arrive at the crematorium by car, and after the coffin is taken out from the vehicle you walk through this small court and arrive at the entrance. You then walk through the entrance and into a small building where the first ritual of farewell takes place. The entrance is slightly to the side with symbolic columns, and the materials we used are very basic, such as brick, exposed concrete and corten steel. Here the grille also gives a hint that there will be a next place you should go in, and after you have gone in you turn right and you come to the first fairway. Again, light is very controlled. The wall is covered in stucco imported from Italy.

4

5

6

7

1-7 Kaze No Oka Crematorium | Fumihiko Maki

You then proceed into a large space with a central court, where you give your final farewell to the loved one. This is an absolutely quiet place with only the water and sky. After the coffin is taken into the incinerator, people are taken to a waiting area overlooking a sunken garden. It takes about an hour and a half for cremation, and in the meantime you will be waiting at this place. Beyond the sunken garden, there is the park with a number of small spaces created for waiting. The prayer hall can be used, so it is a sequential space composition again. After an hour or so the cremated body, now bones and ash, is taken into the enshrinement room and shared amongst the deceased's children and relatives, and then these remains are taken to their various homes in a small white pot.

In this view you can see how this particular crematorium was developed. You can see the rich landscape, and then further back you can notice the mountains. As you see it, the mound will move up slightly to meet the building but will effectively cut off the ordinary height of the elevations to make fragments like a large sculpture. Since it was built, large numbers of people have visited it and many of them have expressed their wish to be cremated there. This is the highest compliment I have ever received as an architect. Suppose you ran a restaurant as an owner or a chef and people requested to have their last supper there. Well, it's very similar to that!

This year my mother died. She passed away in Tokyo at the age of 97 years. We had her funeral and then after that I took my mother to one of the crematoriums. Tokyo is a megalopolis with a population of many old people. The crematoriums are particularly busy in winter, so the city authorities built a huge mega-crematorium. You arrive by car and suddenly you are in an area like a large air terminal from where you proceed to the gate through which the body will be taken and where it is waiting for you. There are a number of groups simultaneously cremating and you are ushered upstairs where there are a number of meeting rooms waiting. After about 45 minutes, they inform you that yours is ready. In order to make the crematorium more efficient they invested in a very technologically capable incinerator. It suggests our dark history in the very recent past. Somehow in our civilization, efficiency is becoming a priority. The whole floor is in polished marble so the caskets can move very smoothly, and that's it, you know! The other extreme is a very shabby community centre-type crematorium and, somehow, we have only these two kinds. So, the Kaze No Oka Crematorium is like neither of them.

I think that to give a form for people's collective unconsciousness seems to be, once again, a very important goal for architecture that I have learnt from this small exercise.

Thank you very much.

1

2

3

4

1 Nakagin Capsule Tower, Tokyo | Kisho Kurokawa

2 Sony Tower, Osaka

3–4 Nara City Museum of Photography

1

2

Age of Life
Kisho Kurokawa

*Notes from an interview in his Tokyo office,
a paper delivered at Kew Gardens and a review
of his book,* New Wave Japanese Architecture,
Academy Editions, London, 1994.

3

4

The day before I visited him in his 11th-floor office overlooking the lush grounds of the Akasaka Detached Palace, a rare patch of green in central Tokyo, Kisho Kurokawa had given a lecture to more than 800 influential business people on his views about future trends in the Japanese economy. His 30-year-old belief that mankind is about to leave the machine age and enter a new 'Age of Life' era has now been officially adopted by the Japanese government as its policy for the future. The name of this philosophical vehicle transporting the most technologically advanced nation in the world into the 21st century is tomoiki, meaning co-existent living. The English name for this philosophy is symbiosis.

Even by Japanese standards, this prolific architect and writer has worked with extraordinary commitment and devotion since the early 1960s. His book, *Intercultural Architecture* won the Grand Prix of Literature in Japan, and the English edition was last year voted best critics' book by the American Institute of Architects. He is particularly proud of a modest handbook based on Symbiosis that has been produced by a Buddhist order to teach Japanese monks – many of whom are devoted to the mighty yen and to selling their services – the meaning and relevance of Buddhist practice in contemporary society.

Dr Kisho Kurokawa, who was born in Nagoya and educated at the select Tokai Buddhist high school there, is now Professor of Architecture at Tingshau University in Beijing, China. He is known as a co-founder of the highly influential Metabolism movement in the early 1960s and for his famous

capsule hotels. He first came to public attention in Europe when he would have won the Pompidou Centre competition but for the veto of Pompidou himself, who disliked the idea of having 'yellow' architecture at the Beaubourg! Happily, Kisho Kurokawa Associates has since produced several buildings in France, at La Défense and Aix en Provence.

England has proved difficult, but Kurokawa did provide the outstanding installations for the Royal Academy's Great Japan Exhibition in 1982, and in June of this year he held the brief Four Museums Exhibition at the Sadler Gallery. At that time, his practice was about to commence the daunting task of designing a new wing for Rietveld's 1973 Van Gogh Museum in Amsterdam. The Exhibition Wing, in which rational Western geometry forms a symbiosis with Eastern asymmetry, was completed in 1999. Appropriately enough, van Gogh collected ukiyo-e prints and dreamt about visiting the floating world. His work is an early example of symbiosis in fine art. We are all the richer for his lust for life and his liking for sunflower yellow.

Eco Architecture/Eco Cities
Speaking at the launch of the Eco Architecture/Eco Cities *exhibition coordinated by the author at the Royal Botanic Gardens Kew in 2002, Kisho Kurokawa described his remarkable contribution to Metabolism. The following notes are extracted from the paper he delivered on sustainable architecture and his proposals for the Japan Centre in nearby Gunnersbury Park, London.*

In 1958, I wrote the short essay, "From the Age of the Machine to the Age of Life." Then in 1960, I founded the Metabolism Group. Metabolism is the most important principle of life.

Together with the other members of the Metabolism Group, I considered the 17th-century Katsura Imperial Villa to be a major historical example of Japanese Metabolist Architecture. Constructed in the early modern period, it was expanded twice in its 150-year history. Because the goal of Metabolism Architecture is architecture that can grow, the Katsura Imperial Villa – a masterpiece in itself – has throughout its history maintained its balance as an ideal example of an architecture that grows.

There are both visible traditions and invisible traditions in Japan. Sustainable architecture that changes and grows in harmony with its environment is one of the invisible traditions. Another aspect of Metabolist architecture is that it is sustainable and can be recycled. Architecture is reconstructed using a long-lasting structure – or megastructure – and its short-lived parts and equipment change in response to technological progress or to the changing times.

Capsule architecture features a long-lasting, steel-framed and reinforced core, while the plumbing and wiring are installed on the frame and the steel-framed and steel-plated capsules are installed on the core with two high-tension bolts. There they are all exposed on the outside of the core and can be removed and recycled at any time.

The Eco-City project on Lake Kasumigaura is a Helix City planned for the centre of the lake. The artificial land is a double helix constructed in three dimensions so that its inhabitants can enjoy the maximum benefits of natural winds, scenery, and sunlight.

The natural ground soil forms a garden, and people can freely construct their homes on this ground. The rooftop acts as a road for cars, and a harbour and piers are constructed on the lake's

surface to accommodate boats. An elevator is installed in the centre of the double helix structure and helical escalators were constructed at its ends. This is a plan for a metabolic and sustainable city that can be recycled to conform to the times and that is a city sustaining a symbiotic relationship with nature.

Its principles are based on those of recycling and sustainability that permit the overall lifetime of architecture to be lengthened by replacing and recycling short-lived parts. In 1960, I named this recycling principle the Principle of the Metabolic Cycle. In this sense, Metabolism Architecture is the world's first Eco-Architecture. It appeared 40 years ago as a sustainable architecture.

The concept of *kyosei*, or symbiosis, is also an important principle of life. The Japanese language includes words such as *chowa* (harmony), *kyozon* (coexistence), and *dakyo* (compromise), but in 1960 I coined the completely new Japanese word, *kyosei*. I defined *kyosei* as meaning a relationship of fundamental confrontation and contradiction between two entities that, nevertheless, need each other. The English word 'symbiosis' has the same meaning as the Japanese biological term *kyosei* (*~ji'*) and has been used as its English equivalent. Twenty years later, I wrote the book *Philosophy of Symbiosis*, published by Tokuma Shoten. The English translation was published as *Each One a Hero – Philosophy of Symbiosis*, published by Kodansha International.

The concept of symbiosis, a concept that requires the correction of the dualism that has played such a central role in Western thought through the ages, has now become widely accepted as an advanced research theme in various scholarly fields. The unique characteristic of Japanese culture can be defined as the culture of symbiosis. The Japanese people have eagerly incorporated new technologies and applied them in symbiotic relationships with tradition and nature. Through this process, we have nurtured a highly receptive system of thought that differs from dualism. It is the more sophisticated culture of symbiosis that

4

5

6

1–3 Hiroshima City Museum of Contemporary Art | Kisho Kurokawa
4–5 Nagoya City Art Museum
 6 Nagoya City Art Museum Pond | Isamu Noguchi

1

2

3

values the intermediate ground and the moment. For example, we think of architecture and cities as entities that are in symbiosis with nature and are created in conformity with nature rather than by conquering nature. This idea is shared by the Buddhist concept of co-living, *tomoiki*. Metabolist Architecture, as a form of the architecture of symbiosis, can easily change and adapt itself to nature and its environment.

Tokyo 2025 Eco-City is a plan for a doughnut-shaped artificial island created by gathering and recycling the colloidal sediment that has been deposited on the bed of Tokyo Bay. Forming this island will increase the depth of Tokyo Bay to 7 metres and improve its water quality. By ending the present waterfront reclamation work, the waterfront's valuable fish spawning area and tideland ecosystem can be preserved.

The Japan Centre Proposal

According to the plan for the Japanese Centre in Gunnersbury Park, the stable that has fallen into ruin will be restored as a new Japanese Centre. The principal façade on the main entrance side of the stable will be restored. The martial arts gymnasium, Japanese archery (*Kyudo*) range, the restaurant, and a tea ceremony room that will be added, will all be transparent buildings.

Emphasising the restoration of the former stable and conforming with the surrounding landscape, these transparent buildings will be greenhouse structures with solar panels used as roof and wall surfaces that admit light to the interior. Planters placed inside these transparent external walls will be planted with ivy that will shade interiors. This is an Eco-Architecture that will achieve symbiosis of nature with the buildings, the symbiosis of nature with high technology, and the symbiosis of history with the modern age.

Save the Nagakin Tower Campaign

The first capsule building, Nagakin Tower, is a rare example of Japanese Metabolism and a popular Tokyo landmark that is now facing demolition. Built in 1972, it was a visionary program that,

with its 4- by 2.5-metre capsules, was seen to provide a compact living solution to demands on spiralling land and property costs. The demand for demolition is coming from the tower residents who are complaining that the original capsules are obsolete, contain asbestos and are difficult to maintain. In a recent World Architecture News.com poll, more than 10,000 architects from 100 countries provided resounding support showing a 95 percent vote in favour of keeping Nagakin. The tower's management association has consequently postponed a decision to demolish the building, but the debate continues

In the meantime, new capsules have been proposed by Kisho Kurokawa and Taisei Construction that have exactly the same design as the current units, but have an expected lifetime of 60 years. Selecting this option of replacement will enable work to be completed in 12 months, is less expensive per unit than demolishing and rebuilding, immediately solves the problem of asbestos, and will allow the owners to move into their new capsules more than two years earlier than the option of reconstruction. This will enable the building's value as a cultural asset to be preserved.

Maggie's Centre, Swansea

A new Maggie's Centre in Swansea, Wales is being designed by Kisho Kurokawa for The Charles and Maggie Keswick Jencks Charity. This organisation creates centres all around the UK that provide non-residential support for people with cancer, in a non-hospitalised, domestic-scale way.

The design concept for the new Maggies Centre is based on the concept of the cosmic whirlpool, a strong symbol of life with everlasting forces swirling around a centre. These forces are materialised in different programmatic volumes used for the daily activities of the centre, each offering a range of various degrees of privacy. The volumes/forces are interchanged with swirling streams of water and separated by streaks of light. The core of this swirling manifestation is the calm meditation terrace, a glass greenhouse that

floats on water. The working drawings for this Maggies Centre were completed just before Kisho Kurokawa died in October 2007.

A review of Kurokawa's *New Wave Japanese Architecture* (Academy Editions: London, 1994)
Art & Architecture Journal, November, 1993.

Kurokawa, now in his sixtieth year, is an influential ambassador of culture. He commissioned the architects for the 1998 World Architectural Exposition held in the Japanese Railways station near Nara, the most beautiful and well-preserved city in Japan. As a panelist of numerous international competitions, he has a good vantage point – rather like the view from his window – for compiling a credible attempt to document the astonishing new developments which are blossoming in the land of the rising sun. His latest book, New Wave Japanese Architecture, is a unique account of these radical developments.

Kurokawa's essay introduces us to recent projects in the context of Japan's distinctive but sometimes mysterious cultural and spiritual traditions. He has selected 28 of the most vigorous contemporary Nippon architects, including such familiar names as Tadao Ando, Arata Isozaki and Shin Takamatsu. Two projects by each are featured, with drawings and excellent photographs and a brief text by the architect summarising the background and aspirations of each design. These architects are spread across the post-war generations but each has their roots in the "invisible" spiritual traditions of Japan. The book aims to provide a glimpse of buildings which may influence future generations worldwide.

The essay considers the culture of Japan, the character of the people, the importance and emphasis in Oriental culture on spiritual traditions of Buddhist philosophy, psychology, and conditioning. Kurokawa discusses provisionality, a doctrine of impermanence, the aesthetic of the temporary, dynamic floating world expressed in

4

5

1–2　Fukui City Museum | Kisho Kurokawa

3　Wakayama Museum of Modern Art

4–5　Helix City, 1951, a series of linked helical structures creating a three-dimensional organic vertical landscape. Describing the interconnectedness with shapes and forces revered in Shinto, it was inspired by Watson and Crick's discovery of the double helix structure of DNA.

asymmetrical, coreless architecture which rejects consistency. We read about the emphasis on materials, the way of tea "wabi", the natural splendour of the Zen gardens. In contrast to the Western convention of moving from the general to the particular, it is the Japanese way to examine the inherent quality of the details and move from the part to the whole. Uniquely, Japanese art and architecture do not reveal their strength and distinctive qualities when viewed as a whole but, rather, when we examine their details a whole new microcosm opens up.

In summarising the vast variety of talents offered by this book, Kurokawa gives a fascinating account of Japanese mentality and customs which he then expands to encompass architects of the New Wave to whom he concedes a separate category. His main analysis describes five themes: Tradition, Symbolism, Relation, Provisionality and the Poetic Realm. These five are the themes of architecture and cities after the modern period. They provide the key concepts for the analysis of contemporary Japanese

architecture and the New Wave that will grow to shape the architecture that will follow modem architecture, the architecture of the 21st century.

Symbiosis is the way forward to a new dynamic relationship between conflicting demands. This Kurokawa identifies as the special feature of Japanese new wave architecture which transcends individual talents and expression. Architects who fail to employ the richness of symbiosis, such as Tadao Ando with his extreme simplification, are accused of not working in the Japanese manner. Ando's minimalism and highly individual style is set in the Western ideological mode. He is even more scathing about Isozaki, who he describes as schizophrenic and sacrificing Oriental ways in favour of Occidental modernism.

This substantial book is an illustrated guide containing exceptional photographic documentation of buildings and models, including meticulously sketched schemes. Shin Takamatsu, a small Kyoto practice where the average age is 26, employs the skills of an industrial design

airbrush artist. High quality sketch schemes and video animations are used after the client presentation for exhibitions and publications. The neutrality of airbrush as a medium, despite its finesse, unfortunately gives results which appear impersonal and indifferent to human tactile sensibility. It is to be hoped that the actual buildings do not inherit this tendency towards slickness with the glossy appearance of metallic vessels.

Japan is the most advanced information technology nation, and in such a society the arts are pushed to the centre stage, creating a climate of great critical awareness. Developers engage up-and-coming architects whose distinctive designs produce added value in the information society. The added value productivity of the arts is recognised and ensures that design is as important as the functional elements of the building. The shift away from the image of the machine to the invisible information and micro-technologies has led to the elevation and autonomy of the façade. The façade has become independent of the mechanical and structural rationales.

When it comes to art in relation to architecture Kurokawa, as a member of the government's 2025 group looking into the future land use of Japan, regularly recommends that a percentage of the capital cost of a development should go to an artistic dimension. He recommends bold interaction with the building: "Hold the dagger firmly and make a strong intervention," he advises, "something which challenges the consistency of the building and creates dynamic tension."

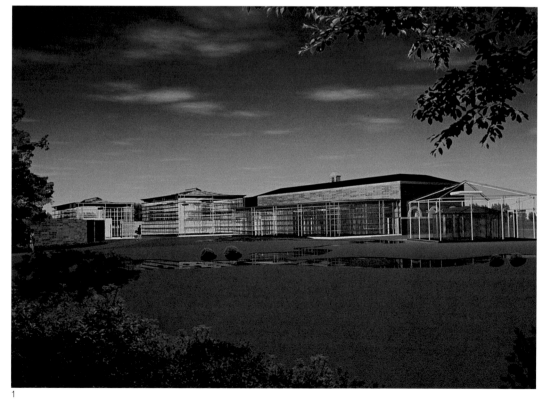

1

2

3

4

6

5

7

1–3 Proposals for the Japan Centre, Gunnersbury
Park, London

4 Nakagin Capsule Tower model

5–7 Nakagin Capsule Tower (1972) in Shimbashi
reflects the throw-away quality of Tokyo
architecture in a cluster of prefabricated capsule
dwellings units. A sculpture dedicated to the
inter-replaceability of its own parts, it refers to the
individual cell like structures as part of a larger
order such as the changing patterns of a city.

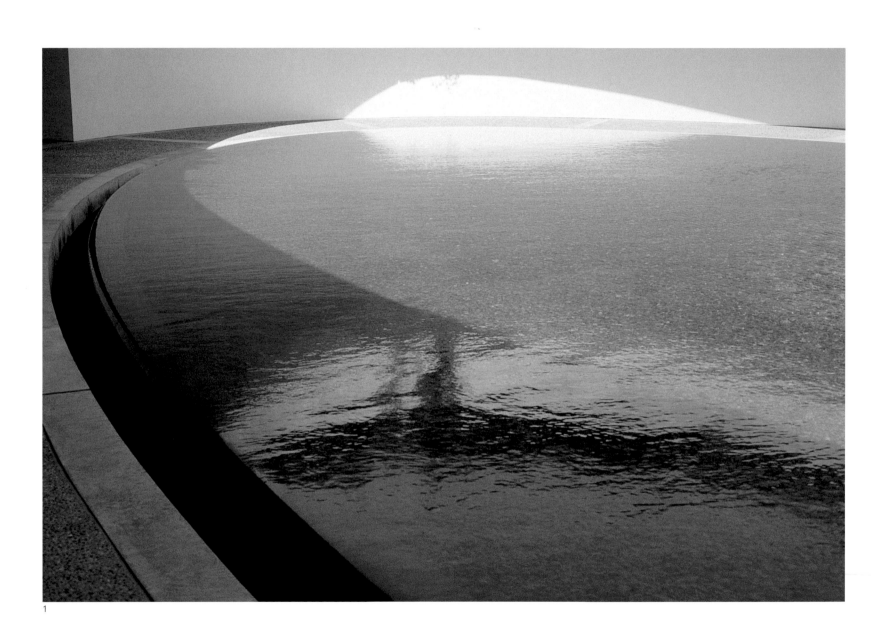

1

An Introduction to the Life and Work of Tadao Ando

The difference between Tadao Ando's work and modern architecture in the West lies in the understanding of nature. The Japanese accept nature and live with it, but in the West buildings protect the inhabitants from nature. Ando suggests that in our generation the advance of science and technology has been so significant we have become conditioned by it. However, he believes that in the next generation science will be balanced by nature. Opposed to the creeping menace of consumerism, he has a profound respect for nature, the influence of climate, the change of seasons, weather, wind and rain, based on the animistic national religion of Shinto. By his mid-thirties, Ando began to think of an international architecture that could only be conceived by a Japanese. In the future, he predicts, Eastern and Western preoccupations will overlap and open up a new world.

Tadao Ando is a native of Osaka, a historic port and an oriental Venice where commerce is combined with creativity. He is fond of the vigorous, but sadly disappearing, life of the old market arcades where people engage with each other with a passion reminiscent of Mediterranean cities. He studied the traditional architecture of nearby Kyoto and Nara and was impressed by the harmony of the temples, shrines and tea houses with their natural surroundings. His aggressive temperament, he says, found tranquillity in the rock gardens of the Roanji shrine. In Ando's opinion, contemporary buildings have not possessed the Japanese spirit since the disastrous war, and the nation has been influenced by the cultural imperialism of the USA.

2

3

4

5

1 Benesse House Annex | Tadao Ando

2–3 Atelier in Oyodo, Osaka

4 Time's Building, Kyoto | Tadao Ando

5 Rose Garden, Kobe

Many of the old customs have been lost, including a distinctive way of thinking. Ando wishes to revive these traditional conceptual values in architecture and to pass them on to future generations. He considers that the priority given to economy and function has obscured the real possibilities of modern architecture. Ease of construction and efficiency has been over-emphasised at the expense of spatial richness. "With the elimination of key principles such as symbolism and ornament you soon lose the quality of life," he says. He has studied these missing elements and tried to reinterpret them in his own designs.

Never formally trained as an architect, this rebellious ex-boxer claims that he did most of his learning from books. As a young man he was most influenced by a neighbouring master craftsman who taught him how to make things by carefully examining each stage of the process, considering all the possibilities and deciding on appropriate materials and tools. His first attempts at furniture, interiors and small wooden houses were modest in scale, but he began to experiment. Architecture in Japan relies on carpenters and craftsmanship. "You learn building with your body," Ando says. "You present your sketch proposals and then you build while making changes to the working drawings on the site." He wonders if he is happy as an architect. Perhaps he should have been a craftsman. He worries the moment he hands his drawings over and gives up his participation in the process. Not knowing what a building will look like until it is completed, he has never been satisfied with what he has built.

No matter how traditional the function, Ando uses modern materials and is influenced by the geometry of Le Corbusier, Louis Kahn and Frank Lloyd Wright. Inspired by Corbusier's Unites d'Habitation, concrete is his trademark, used in a rough dynamic way with the quality of construction dependent on the wooden formwork. Sukiya wooden houses have honed the skills of Japanese carpenters so that not a drop of water escapes from their formwork. This results in a hard,

smooth surface without the holes that would cause rapid deterioration. Concrete appears alien to the traditional sensibility, so he aims for a beautiful and sensual finish that is closer to the gentleness of paper or wood. Such a surface gives a fresh look, and the intense bleaching of Japanese sunlight favours the austere ivory finish of the material. However, the climate and pollution are harmful to concrete and so it is periodically brushed and coated with a matt preservative.

The interplay between solid and void, lightness and darkness brings Ando's buildings to life. A serene beauty is experienced in traditional paper architecture when spaces are illuminated by soft, dappled rays of translucent light. In Ando's buildings, nature is not embodied so much by physical matter as by the movement of light. He creates arrays of light and dark spaces by orienting rooms in different directions.

Introducing slotted windows into the roof and walls, he is able to manipulate the quality of daylight, direct and reflected. Sublime examples are the Ibaraki Church of Light and the Awaji Water Temple. According to Ando there are two forms of comfort: spiritual comfort, which is found in darkness and physical comfort, which is found in daylight. The body needs both, but comfort varies between nationalities. Architects trying to impose a universal level are mistaken.

Small-scale projects are still very important to Ando, even at this time of his life when he is engaged on large commissions. Then in his mid-50s, he says that should his creative life diminish he would return to little buildings and keep up the momentum of ideas that were expressed in early schemes, such as the iconic Row House in Sumiyoshi. Spaces should be for physical comfort and spiritual enrichment; the challenge is to create new spaces, rich in potential, that have not been experienced before. His potential contribution to the small home and to compact cities is enormous.

1

2

3

4

1 Children's Museum, Hyogo

2 Children's Seminar House, Hemiji

3 Oyamazaki Museum

4 Akka Gallery, Osaka

5 Gojo Municipal Museum

6 Chikatsu-Asuka Historical Museum

7 Nariwa Municipal Museum | Tadao Ando

5

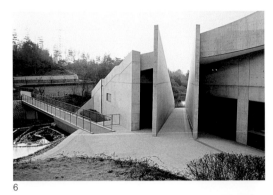

6

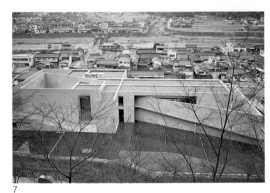

7

An interview with Tadao Ando

During my Japan Foundation artist fellowship, I was privileged to interview Tadao Ando in his cavernous Osaka office surrounded by exquisite architectural models and an enormous wall of books. I was assisted with translation by Suichiro Ogino, then Director of The Japan Foundation's Kyoto office.

Graham Cooper: One is very conscious of the attention you have given to the landscape outside your buildings and to the way you invite nature in the form of water into your buildings. Perhaps Ando san is becoming more of a garden designer?

Tadao Ando: I am very fond of the Alhambra, but water is also important in Japanese culture for cleansing and spiritual reasons. The tradition of gardens of an artificial nature is very strong. As the city becomes more monstrous, the demand to have trees and gardens grows. Nature and landscape make a fundamental contribution to my own buildings, and water has always played an important part in the Japanese psyche. I also wish to capture other climatic features such as the seasonal changes and the weather, allowing the user to experience the wind and the rain as part of their domestic routine.

GC: You appear to capture the surrounding nature and encapsulate it, as if it were interior space.

Ando: These external spaces are considered exterior rooms, an integral aspect of my design approach. A building should contain a balance between meaningful wasted space and efficiency.

[The blurring of intermediate space between interior and exterior, a feature of Ando's buildings, is part of a Japanese awareness known as *Ma*.]

GC: Your buildings explore the garden design concept of *shakkei*, the extension of foreground with borrowed views of the more distant landscape. On the other hand, you also create drama by denying the user's view.

Ando: My architecture acts as a conductor between man and nature, known in Japanese as shakkei.

Buildings always both deny and defy nature. However, such a denial can lead to a rebirth, a reformation or paradoxical way of life. To achieve sculptural integrity, denial is part of the normal process of aesthetic judgment. My architecture is quite restrictive, and I try to create freedom through confinement. Dramatic lighting, for instance, is very important; buildings can be animated with washes of borrowed light.

GC: In reducing the amount of doors and windows, eaves and roofs, you deliberately eliminate prosaic detailing. Entrances are very low profile, and interruption and clutter along surfaces are kept to a minimum.

Ando: I find long, uninterrupted walls very tranquil, especially in contrast to rolling landscape. Instead of separate doors and windows, I often employ large sliding patio doors.

GC: Most architects aspire to become form makers. However, rather than a modeller, you appear to carve your buildings like caves out of the ground.

Ando: Mainstream architecture is normally an additive process like modelling, but I take things away and in this respect I am a carver.

GC: Lightness is a popular preoccupation for many contemporary architects. Have you been tempted to make your buildings out of more lightweight materials?

Ando: There are some essentials to be learnt from all new trends in design. Lightness does not necessarily come from the use of light materials; rather, it comes from the strength of the architect's intentions. Many of my contemporaries are unfortunately led by post-modern commercial interests. This is not so much the fault of the architect, but is more concerned with the demands of the client who wishes to make the front pages of the journals. Recent trends to entertain the client result in commercial buildings that have no concern for human beings in society. There is a conflict between architecture as a physical

tool and human psychology. Houses are for people to live in, but they should also be 50 percent spiritual.

GC: You now have an extensive portfolio, but which of your buildings are your favourites?

Ando: Among my current favourites are the New Hall for the Oyamazaki Villa Museum, the UNESCO Chapel and the Fabrica United Colours Research Centre. Surprisingly, these are all circular yet contextual volumes that complement older, existing buildings, producing a tension between old and new. In order not to impose on the existing buildings, the Fabrica at Treviso and the New Hall at Oyamazaki are largely subterranean extensions, and the UNESCO Chapel in Paris is to be found in a rear location next to the Noguchi garden. The New Hall is in a prominent position in the mountains south of Kyoto where it contrasts with a Tudor–Alpine villa that was transformed into the Oyamazaki Museum. The Asahi collection housed there includes a Monet – *Water Lilies* – and 20th-century ceramics by artists including Bernard Leach and Hamada.

GC: What effect do you think last year's earthquake will have on architecture?

Ando: I do not expect it will have much effect on Japanese architects. In urban life, you are always living next to danger.

GC: You have worked with a number of important artists such as Isamu Noguchi, Anthony Caro and Susumu Shingu. Do you find this a rewarding experience?

Ando: I have also worked on an installation with the clothes designer Issey Miyake and I enjoy the challenge of such a partnership. True collaboration is only possible if there is no hierarchy between artist and architect. Without equal status and ability, they will not be able to freely express themselves.

A visit to the Garden of Fine Arts, Kyoto

Post Pompidou, many of the finest buildings around the world have been for the arts. Tadao Ando, neo-modernist and darling of the lovers of deconstructivist concrete, completed his Garden of Fine Art in 1994 in the fashionable district of Kitayama. This open-air gallery offers much to inspire. It occupies an infill location and, like Kurokawa's subterranean Photography Museum in Nara, the galleries are largely below pavement level. With an elevation no higher than the surrounding trees, it has an informal profile reminiscent of an archeological site. The sunken gardens display painted ceramic tile reproductions of the Old Masters.

Monet hired a landscape gardener from Japan, then newly released from isolation, to design his Heian-style lake at Giverny. He became increasingly engrossed in the private world of his garden paradise. His series of *Water Lilies* paintings was inspired by the two-dimensional reflections on the surface of the pond and was intended to envelope the viewer on all sides. Here at Kyoto, the compliment is returned with a full scale, photo-produced, ceramic tile copy of Monet's *Water Lilies – Morning* immersed flat in a pond like a roll of film in a processing tank. It forms part of a collection of copies of famous works of art, more orchestrated than displayed in this remarkable concrete cavern, including Michelangelo's *The Last Judgement*, da Vinci's *The Last Supper*, George Seurat's *La Grande Jatte*, Renoir's *Two Sisters*, Van Gogh's *Cypresses*, a Japanese handscroll, and a Chinese riverscape. Particularly light-fast pigments were used for the glazed panels. Faithful to the original in colour and form, they were based on photographic images transferred to ceramic biscuit. Each panel measures 3 metres x 0.6 metres and *The Last Judgement*, for example, needed 110 panels. Daikoku Electrics, the sponsors as well as the creators, hope the Fine Arts gardens of famous pictures will be enjoyed by the citizens of Kyoto who will now be in touch with internationally renowned art.

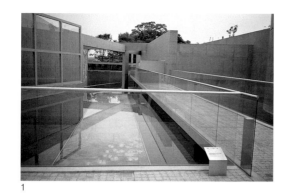

1

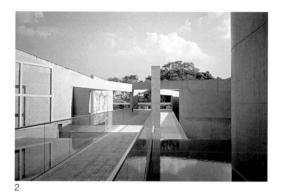

2

3

4

6

5

7

1–7 Garden of Fine Art, Kyoto | Tadao Ando

Glistening like the terraces of a rice field, Ando's garden is attracting visitors. In the manner of the strolling gardens of the late Edo period, sweeping frontal perspectives are denied in favour of asymmetrical and incremental views. The story of the infill unfolds as one strolls, like a series of glimpses at a storyboard. Visitors are made to follow a fixed route on which vistas of the garden are planes, intercepted by hard-edged restraint and control. This produces an effect of calm and reflection on the ramp to the basement where monastic sparseness is relieved by borrowed sunlight and exotic views. There, the monumental and monochrome massing of the architecture dissolves in the polychromy of the tile paintings. The modest garden is made to seem spacious with the interplay of water, light and reflection. In the bunker, optical illusions, transparency, the sky reflected in water and a variety of vistas are contrasted with the concrete reality. As in *Water Lilies*, illusions are produced by reflected light, and ethereal ripples shimmer across blank planes. One moment the visitor faces white cement, the next a history painting followed by a framed natural landscape of trees.

The Garden of Fine Art is a striking intervention in the urban scene and a delightful demonstration of Ando's exhibitionism, but it fuels the debate on the relationship of art and architecture and the intrusiveness of the architect's touch. Angular geometry exposed to harsh daylight results in deep shadows that impose themselves uncomfortably on the paintings that, anyway, were created for other surroundings in another time and a different context. The subtle palettes of the paintings look impoverished when drenched in the glare of the rising sun. Just as Monet borrowed Japanese ideas to break with the conventions of his day so Ando, at the heart of Japan's most sacred city, confidently disregards tradition and makes free with Western culture and the tenets of modernism.

Piccadilly Gardens Pavilion

While visiting western Japan in October of 1998, I was invited by Tadao Ando to stay a couple of weekends in his guest studio-apartment in Umeda, Osaka. My stay coincided with a visit to Japan by the Osaka–Manchester Forum (OMF), a delegation of industrial and business executives attempting to set up trade and cultural links between Kansai and the northwest of England. It occurred to me that perhaps the best way to symbolically cement such a relationship would be for the OMF to invite Osaka's most famous son, Ando, to design a public building for the centre of Manchester. I imagined a modest contribution, maybe a small café or garden of cherry trees such as in his Hyogo Green Network. With this idea firmly planted in my mind, upon my return to the UK I decided that I would visit Manchester in late November to attend the Kansai/NW England Business Forum 98.

Following the presentation and discussion at this Japan Society of North West England event, I earnestly networked my way around the reception determined to offer my Tadao Ando proposition to as many influential delegates as possible. I informed the Ove Arup & Partners Consulting Engineers representative that I personally knew Tadao Ando and his colleagues and felt that, if an appropriate opportunity arose, I could offer a vital conduit to his office in Osaka.

Several days later, following my return to Devon, I received a telephone call from Peter Budd, a director of Arup's Manchester office who had been a key member of the Kansai delegation, asking for clarification of my OMF debrief mission. I explained my idea of involving Ando

in the regeneration of the city and that I was confident I may be able to provide an introduction. Peter Budd elaborated on the potential of a major redevelopment of a public site in the city and described a forthcoming competition in which he would like to invite Ando to participate with Arup. He suggested Arup could contact Ando's office and I gave him the appropriate contact details, recommending they mention my name.

On December 14, Peter Budd sent a formal invitation from the directors of Arup to Tadao Ando to participate in a design competition. His fax stated it would be a fitting celebration of OMF that designers from Osaka and Manchester collaborate on a major project. He explained that the space was so significant to the city that only international designers of the highest quality would be considered for pre-qualification. They would therefore be honoured if Ando joined Arup and EDAW in submitting credentials. He hoped Ando would lead architecturally, EDAW would handle the planning and landscaping element,

2

3

1–5 Manchester Piccadilly Gardens Regeneration |
 Tadao Ando

1

and Arup the engineering. However, time was short and they would need to have the Ando office submission by the following week. Peter Budd added that he had long been an admirer of Ando's work and it would be exciting to work with him.

The following day I received a phone call from my friend Hiroshi Araki, the architect responsible for international affairs at Ando's office. Araki san was seeking reassurance about the authenticity of Arup's proposal and whether I knew anything about the proposed scheme. Bearing in mind Tadao Ando's huge commitments, he was concerned that the project should be of an appropriate status to warrant his attention and the inevitable outlay to meet Arup's request with such a short lead time. In order to maintain Ando's trust and as a form of recommendation for their involvement in the project, I sent a fax that same

day to Ando explaining my OMF proposal and the Manchester context. I described my initiative and added that I felt an Ando building in Manchester would complement the city's aims to make it a progressive international city. This was a very significant scheme for a most important public location in Manchester and I hoped that Ando would be able, despite the short notice, to contribute to the scheme. In the wake of the OMF discussions, I recommended he consider very carefully teaming up with Arup and EDAW. I finally added that I would be delighted to contribute in a small way to Ando's first work in the UK.

The industrious Ando office was able to meet the deadline, and in February I was informed by Arup that the team had been shortlisted for the project. The concept prepared by Ando and the team had to be submitted to the client, Manchester City, by

5

4

the beginning of March with interviews later that month. Arup said that they would be one of six submissions and were quite hopeful. Following this, I heard nothing more until I read the headline in *BD Building Design* magazine of May 14, 1999, "Ando to work in Manchester BD". Delighted, I sent a copy of the article and my congratulations to Ando's office, and they replied: "We have to thank you on this. You were the one recommended us for the competition in the first place". They hoped the project would be "well developed and successful."

So, Piccadilly Gardens in central Manchester was redeveloped to Ando's design in 2001–2002 to include new green space and fountains, with the original statues all remaining at a contract cost of around £10 million. By that time, the square had become quite run down and was considered unsafe. The redesign became, in fact, part of the massive construction process that covered Manchester in the build-up to the city hosting the 2002 Commonwealth Games. The Piccadilly Gardens renovation was shortlisted in 2003 for the Better Public Building Award.

Manchester Piccadilly Gardens

Project description by Tadao Ando

Together with Ove Arup & Partners and EDAW, we were chosen to undertake the regeneration of the heart of Piccadilly Gardens, located in the centre of Manchester City, a project planned for completion in 2002. At the time, the Piccadilly Park area could be said to have a somewhat dark and unapproachable image. This urban park formerly contained important historical monuments, and we wished to reintroduce it into the citizens' lives as a central focus for Manchester's future. The project is composed of an oval-shaped fountain plaza (Water Plaza), a multipurpose lawn plaza (Central Lawn), a curve-shaped citizens' information centre (Garden Pavilion), a number of trees laid out in a grid formation, and a monument to Queen Victoria preserved in the centre.

For the sake of the city's open space, we wished to avoid a large-scale development and to regenerate the park using as simple means as possible. The entire park space is controlled with a single wall that establishes order and may be further used to contain a variety of other facilities. With the premise of full 24-hour use by the locals, high priority was given to comfort, functionality, accessibility, safety, and the unification of architectural elements and landscaping elements.

Drawing of Manchester Picadilly Gardens by Tadao Ando

Manchester.

Green.

Street

Street
← Bus

木口

Bus terminal

Main Street.

1

3

5

2

4

1 View to Benesse House jetty

2 Lower Benesse House Gallery from jetty

3 Lower gallery

4 Time Exposed | Hiroshi Sugimoto

5 Cultural Melting Bath | Cai Guo-Qiang

6 Three Squares | George Rickey

7 Shipyard Works | Shinro Ohtake

8 The World Flag Ant Farm | Yukinori Yanagi

9 Full Moon Stone Circle | Richard Long

10 Inland Sea Driftwood and Mud Circles | Richard Long

The Big "A" Phenomenon at the RA

A few years ago The Royal Academy of Arts began sponsoring a series of lectures by high-flying architects, and the appearance by renowned Japanese architect Tadao Ando has been the most popular to date. His modest Royal Academy exhibition in 1998, highlighting the iconic cruciform window at the Ibaraki Church of Light, surprisingly attracted more visitors than the neighbouring Picasso Ceramics show. In recognition for the evident fascination in Ando's work, the RA later invited him to become an honorary academician and, supported by the Mori Foundation, arranged the inaugural celebration. Ando's maiden Royal Academy Lecture in 2004 presented the creative influences on his remarkable career based on a culture-related theme.

In his introduction, Sir Richard MacCormac described the architecture of Tadao Ando as deceptively simple. As his thoughtful presentation illustrated, the "Big A" employs a restricted palette for his deliberately understated and highly refined buildings. Ando's architecture, it was suggested, appears rooted in the classic Oriental spirit, but the designer himself is a far more complex figure, resistant to such stereotypes. Although subtleties were lost in translation, the snapshot review treated the 800 in attendance to a personal insight to his artistic preferences. True to form, the RA occasion was about Ando the celebrity, but architectural purists expecting to learn from his most recent repertoire would have left feeling denied. Nevertheless, for his London audience he introduced two highly significant creative programs: the Gutai Group and the Benesse Art Site.

Brought up in the western suburb of Nishinomiya city amongst the charred remnants of post-war Osaka, Ando was deprived by limited economic means of his aspirations for a formal education in architecture. Growing up in a community of small manufacturers and industrial workshops, he tried carpentry and trained as a draftsman. Applying an affinity for craftsmanship and an ethos of

6

7

8

9

10

devotion, he tutored himself, copybook style, from publications and by making model replicas.

Possessing an artisan's sense of beauty, he is steadfastly attached to the modernist aesthetic and vigorously refuses other passing trends. True to his roots, he kept his main office in Osaka and runs his operation with Confucian obedience and the sheer devotion of a traditional artisans' studio. Despite having no formal training, he is the recipient of major professional awards. Until recently, he was the Professor of Design at the elite University of Tokyo. From his Umeda studio, he has worked with many leading contemporary artists across the world.

To raise morale and encourage loyalty, Ando periodically gathers his colleagues for pep talks on design issues, professionalism or current affairs. Speaking on the evening following the 2004 US elections, having recently completed his gallery in Fort Worth and currently employed in Paris, the master referred to the intellectual advantages associated with the depth of culture in France. According to Ando, the Iraq conflict has reaffirmed his belief and passion for the importance of culture in the world. Speaking from experience, he was deeply concerned about widespread destruction, followed by urban corporate reconstruction in the image of the victor. In stark contrast to political unrest, he described how impressed he was by Van Gogh's power of expression and its importance to people. With a long-standing disdain for the effect of commercialism on his professional colleagues, Ando claims his concerns are driven by the positive effects that art and architecture have on the individual.

In his youth, he was struck by the buildings of early 20th-century modernists, such as Frank Lloyd Wright's Imperial Hotel, and he developed an appreciation of Le Corbusier's power to move the human spirit. He was also introduced to the influence of radical artists from the Gutai Group, who he likened to Jackson Pollock pushing the boundaries of freedom through art. The Gutai was

1–3 The Secret of the Sky | Kan Yasuda
 4 Yellow and Black Boats | Jennifer Bartlett
 5 The Forbidden Box | Yukinori Yanagi
 6 Minamidera Installation Art House Project |
 James Turrell and Tadao Ando

established in 1954 by a group of 20 Kansai-based artists under the inspiration of Jiro Yoshihara, who was resident in nearby Ashiya. Yoshihara proposed that new life could be found in the raw interaction between the human spirit and matter. Meaning 'concreteness,' gutai is an artform expressed through the chance occurrence between action and materials such as paint, earth and industrial detritus. Yoshihara himself, influenced by the immediacy of zen calligraphy, spontaneously drew large free-form circular shapes. A performance artist colleague, Kazuo Shiraga, painted with his feet and rolled around in the mud, random work that left a deep impression on an adolescent Ando. In 1955, the Gutai produced installations in Ashiya Park for the open-air exhibition *Challenge the Mid-day Sun* that was ahead of its time. Similar ideas and aspirations can be seen, for instance, in the work of UK sculptors of the 1980s.

A densely populated city, Greater Osaka has grown rapidly since the austerity of 1945. It has expanded chaotically, relatively free from city planning, out from the historical rectangular grain. When Tadao Ando set up his first office in his early 20s, the main railway station district of Umeda was still dominated by two-storey wooden row-houses. Liberated by the Gutai thinking, he was gifted with sufficient self-assuredness to prepare proposals of tree-laden edifices and greenery for the nature-starved city dwellers. Having learnt the Corbusier principle of always trying something fresh, his freedom permitted him to design for locations of his own choice, such as the submerged Nakanoshima Culture Park in central Osaka, a process he would repeat with occasional success throughout his cyclic career. Symbolising the newly found freedom of the era, and to exercise his creative license, his reconstruction sketches for the station vicinity would be topped with art museums. Subjected to the persistence of the audacious untrained upstart, the repressed elder planners at the City Hall of course remained unimpressed.

After opening up his office in 1969, his career commenced with the concrete Tomishima House for the family of a friend. Ten years later, he would purchase the restricted but centrally located site to enlarge it as his own atelier in Oyodo. Doubling the footprint in 1990, the atelier became a top-lit, seven-storey property with two basement floors for the junior staff. The atrium walls are decked with a spectacular array of quality art hardbacks. Applying his own office as a laboratory for the furtherance of his spatial explorations, Ando has plans for yet further reconfiguration and expansion.

The process of regeneration and continual commitment to quality control is exemplified in an evolving program located near Okayama on a small island in the Seto Inland Sea. Typical of many provincial communities, Naoshima has suffered from depopulation through economic migration, as the young depart for employment opportunities in the urban conurbations. In 1992, Ando was invited by the President of Benesse Textile Corporation, Soichiro Fukutake, who is a very free-thinking individual with considerable economic power, to lead a unique cultural experiment on the island. A well-connected

6

collector, Fukutake introduced Ando to famous international artists such as Richard Serra and Bruce Nauman. Based on a wish of Fukutake's father to create an island of dreams for children, the original vision was to transform the rocky cape into a series of open terraces for the installation of artifacts commissioned from his circle of creative friends.

So as not to disturb the national park setting, the first stage of the Benesse House gallery was sensitively carved out of the bare earth. Initially there was little in the way of a permanent collection for the semi-submerged development, but a sequence of commissions was coordinated with curator Yuji Akimoto. The refined concrete and glass elevations stubbornly resisted the hanging of pictures but occasionally concessions were tolerated. With a sense of irony, Ando explained his anxiety when sculptor Richard Long was let loose with local clay on one of his pristine walls. With a pair of ring motifs and Long's soiled handprints, Ando had to confess the artist was, after all, only working in the liberated manner associated with his Gutai mentors. Ando's next addition to the ocean landscape is a hilltop hotel above the gallery with its sunken pool reflecting the azure light into the guestroom accommodation. Unlike Isamu Noguchi's sunken garden at the Chase Manhattan Bank Plaza, the pool at this idyllic seascape location is an elegant oval shape in accordance with the sun's trajectory.

For a unique creative program in the nearby village of Honmaru, Ando emphasised his role as architect enabler and conservator. The Art House Project, to commission the installation of contemporary works by Tatsuo Miyajima, Hiroshi Sugimoto and Art Station among others, commenced in 1998. With the old houses restored to their former glory, the embedded art triggered interesting inferences, encouraging visitors to consider the lives of the previous occupants, their traditional customs and their way of life. Both masters in the use of light, on this occasion Ando teamed up with artist James Turrell for the newly created Minamidera projection room. Resembling a temple storehouse, the Minamidera is a container for total darkness. Once within the pitch-black, timbered void, visitors have a 20-minute wait in anticipation until their eyes adjust to perceive a faint, glowing rectangle of light. According to curator Akimoto, the Art House Project offers the possibility to encounter the unexpected. A collision course between the village's entity, the integrity of the artists and the regenerating forces of nature, the project simultaneously leads to the possibility of spontaneous and diverse experiences.

The latest addition to the island, the Chichu Art Museum, is largely cut into the bluff to the west of Benesse House. Immersed in the filtered daylight and carpet of white marble tessera, the Monet *Water Lilies* appears to float. For the triple *Sky Space*, Ando again teamed up with Turrell displaying a language of art and architecture only possible following their earlier Art House collaboration. Ando's intention is to challenge the visitors' perception and orientation as they stroll through the museum with its distinctive triangular spaces and diagonal slit windows. Following the drama of sequential scenes and events, the transformed visitor is meant to experience afresh the natural scenery, itself a creative process, as if seeing the world with the eyes of a child for the first time, each day discovering something new. The extended artistic association with this unique island regeneration scheme is a major achievement for the Benesse Art Site. A laboratory where practitioners have been allowed to extend the scope of their work and engage with the natural habitat, it has established Naoshima as a place of discovery, well beyond the individual intentions of each artist.

Ando provided a revealing insight into his extraordinary achievements. The main reason behind the Ando lecture was to provide a creative backdrop for the Benesse Art Site. Naoshima is an extraordinary program and must rate with the finest art museum experiences on the planet. Ando's flowing linear sketches encapsulate space at a stroke like no other living architect. His refined concrete elevations monumentalise interior space and animate the surroundings in a single gesture. It is no coincidence that the artists he admires – Nauman, Miyajima and Turrell – each monumentally fashion their creative energies in a similar fashion. The "Big A" phenomenon must be seen in relation to Tadao Ando's acute Japanese sensibilities, combined with a dogged determination to retain a late-modernist mantra for the pyramid of highly supportive staff and local construction giants.

1–6 Benesse House Annexe | Tadao Ando

Chichu Art Museum, Naoshima, Kagawa

Project description by Tadao Ando

The Chichu Art Museum has been built on Naoshima island, a place where I have been involved for over ten years now, starting with the International Camping Ground (1988) up to the Benesse House, Naoshima (1992) and its Annexe (1995).

The site of the Chichu Art Museum is located approximately 600 metres west of the Benesse House, Naoshima, on a hill covered with vestiges of saltpans. This museum houses a permanent exhibition of works by three artists: the impressionist Claude Monet and contemporary artists Walter De Maria and James Turrell.

Both previous designs for the Benesse House, Naoshima and its Annexe have reflected my idea of half-burying the buildings underground, out of consideration for the landscape. Here, the method is pushed even further by submerging the building's entire volume below the ground in order to preserve the beautiful scenery of the Seto Inland Sea, including the saltpans.

The overall structure consists of a gallery wing and an entrance wing, each having triangular and square sunken courts respectively in their centre, and a trench-like outdoor access way connecting the two wings. The geometrical figures shaped by these 'underground' external spaces are the only existences putting order to the structure in the ground, composed without axiality or directionality. The outlines of these voids emerge directly above ground. Gallery spaces have been planned in collaboration with the artist and the director of the museum.

Term of planning: 2000/08–2002/03
Term of construction work: 2002/04–2004/06
Site area: 9,990 square metres
Above-ground building area: 35 square metres
Total floor area: 2,573 square metres

Drawing of Chichu Art Museum by Tadao Ando

Chichu Art Museum, Naoshima

This underground art museum completed in 2005 is located on Naoshima, a 3.15-square-mile island southwest of Osaka accessible only by boat or ferry. It is an innovative three-floor work that considers the relationship between people and nature. Aptly named *chichu*, meaning within the earth, this museum is a collection of concrete volumes embedded in a hilly site overlooking Japan's Inland Sea. Here physical experience is stimulated intellectually and emotionally with the rhythms of the sea.

Ando created his art spaces for this specific site, using concrete, steel, glass and wood as his main construction materials. He refused to have any external elevation rising above the grade. The museum balances the concept of being architectural yet non-monumental. Largely configured around two austere courtyards, the accommodation is modelled to infuse the spaces

2

1

with natural daylight. Sunk deep into the earth, this unique, sanctuary-like museum features permanent installations by just three artists, Claude Monet, Walter De Maria and James Turrell. The works of the three artists are displayed around a triangular void, and the subterranean location removes extraneous distraction and focuses attention on light and sky. The Claude Monet room features five important paintings immersed only in diffused natural light. The size, design and materials of the room were selected to unite the Monet paintings with the space. The late Monet artworks, the largest of which measures 2 by 6 metres, are from the grand decoration of the Musee de L'Orangerie and are part of what is commonly known as the *Water Lily* series.

1–6 Chichu Art Museum

3

4

6

5

Ando collaborated to various degrees with artists Walter De Maria and James Turrell, with whom he had previously worked elsewhere on the island. Creating spaces defined by arithmetical progressions, Walter De Maria introduced a 2.2-metre-diameter sphere of ground granite and 27 wooden posts coated in gold leaf. By orienting the major axis east to west with an eastern entrance, the appearance of the installation is designed to be animated by solar occurrences between sunset and sunrise. James Turrell produces spaces that monumentalise the experience of light properties as an artform within itself. Viewers can experience the lighting conditions according to three different phases of Turrell's career.

Laid along the approaches to the museum, Chichu Garden contains plants that were cherished by Claude Monet in his Giverny garden. The selection of 150 types of plants and 40 kinds of shrubs was carefully researched according to Monet's paintings and archives to create a seasonal impression.

Generative Architecture: Towards a New Design Methodology

Makoto Sei Watanabe

Born in 1952, Makoto Sei Watanabe graduated from Yokohama National University in 1976 and joined Arata Isozaki & Associates in Tokyo. Setting up his own office in 1984, his Induction Design work at the Iidabashi Subway Station in Tokyo is claimed to be the first building to be generated by a computer program.

This essay introduces the design philosophy and methodology behind the Iidabashi Subway Station project in Tokyo. The purpose is not to discover form, but to discover ways of making cities and architecture provide better solutions to problems facing the world, while at the same time offering greater freedom for the imagination.

I have wondered for a long time whether something like an architectural 'seed' could not be created. A seed, given water and light, extends its roots, grows leaves and comes into flower. It spreads its roots in search of soft soil and places its leaves so they receive as much sunlight as possible. The structures of a plant's stems and leaves are designed in an optimal response to the relative economies of strength needed to withstand wind pressure versus available resources for nourishment. Plants find the limits of compromise between their own needs and the conditions of the environment, and grow accordingly. They grow, clumping thickly in some places, thinning out in others, gathering or dispersing as conditions allow. Should you watch this process carefully, you will notice the emergence there of something like 'architecture'. The origin of the architectural seed is the Web Frame at Iidabashi, intertwining stems of metal extending beneath the ground.

Web Frame

The significance of 'Induction Cities', an earlier study, lies in the search for better solutions to given conditions. The leading question concerned the specific conditions that the Web Frame had to solve.

There were three issues:
1. Restrictions on space.
2. Conditions imposed by each component.
3. The extension of the given space.

The first of these was an absolute condition allowing no margin for improvisation. As for the second, any variety of forms and quantities are available with computer graphic simulation but in reality, conditions are imposed restricting the kind of installation that can be undertaken. It is difficult, for example, to achieve an intersection at the same point of five frame tubes with an angular variation of one degree each. Individual parameters were established to allow for automated clearance of such specific conditions. This is essentially a similar task to designing structural frames for conventional engineering work. The third condition – spatial extension – became a further parameter. By specifying the approximate position and volume of component parts, the desired space is generated. This is a variable specification.

It took a considerable amount of work to develop a program that will satisfy just these three conditions, and several attempts were needed to get it right. The issues here are different from those of conventional space frames assembled in regular fashion from materials with fixed angles.

Simply because the degree of freedom is great, divergences can occur and lead in unpredictable directions. Of course, freedom can readily slip over into chaos, but an important element of this concept is to give the appearance of chaos while in fact obeying certain regularities. While the result may appear to be arbitrary and wilful, the necessary conditions are rigorously met. The same can be said of chaos and of all forms of complex phenomena.

Introducing Arbitrariness

With the Web Frame project, we moved forward from the first phase of Induction Cities into the field of 'aesthetic' evaluation, our fourth objective. In the first phase, we selected as the basis for our criteria of evaluation such quantifiable variables as exposure to sunlight, distance, gradients, wind speed and resistance. With the Web Frame project, however, we tried to go beyond the principle of randomness and bring into play some measure of arbitrariness. By arbitrary, I do not mean that we are directly inputting specifications for factors such as space or forms. What we intend, rather, is a program to satisfy 'fuzzy' subjective criteria such as 'enjoyable' or 'dynamic.' The designer's hands, tied up until now, will begin to move, just a little. But the hands in question are not human – they are artificial.

At this point, however, we ran into difficulty. The method used for the programs for the City of Generative Neighbourhoods allowed for the definition of 'enjoyable' on the basis of specific attributes, but the results did not meet our expectations. One reason for this was the complex three-dimensional spaces and hollow forms in which the Web Frame had to unfold. Another factor was apparently the rigid spatial limitations of the available site. It seems that methods based on complexity theory cannot become really effective without ample space for implementation. The practical results of natural selection, for example, can only begin to appear in wide savannas or large oceans where numerous species of life have room to live and compete.

1

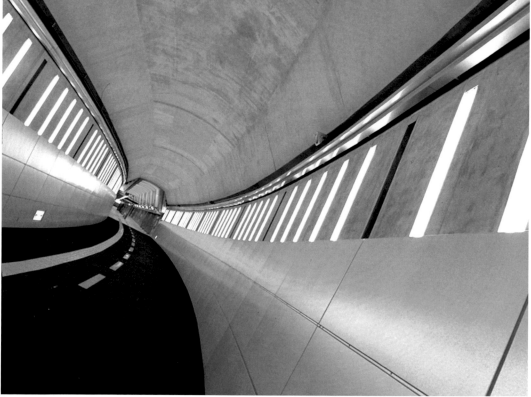

2

3

4

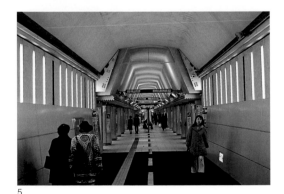

5

1–5 Iidabashi Subway Station | Makoto Sei Watanabe

Self-evolving Programs

At this point, we have to return to our earlier question, what is a 'good' quality thing? In City of the Sun Goddess, we chose as an index for evaluation exposure to sunlight, and the program generated an aggregate that looked like a natural colony. Naturalness is something that everyone can understand. By excluding the intentions of a designer and letting the criteria of the physical laws determine the outcome, a plan with all the 'persuasiveness' of a natural phenomenon was generated. Would it be unfair to call that persuasiveness 'beauty'? Let me put it this way: it is the physical laws underlying their regularity that cause us to feel that snowflakes or the waves on the surface of a river are beautiful.

The basic principles outlined above (1, 2 and 3) are employed in the Web Frame project, as well, but the results vary widely depending on how the parameters are established. There is a large margin for instability; close to chaos, 'naturalness' does not emerge. If a large number of parameters are combined and finely tuned in the pursuit of naturalness, an enormous amount of trial and error is required. In practice, such an approach is not feasible. We end up making the best of what turns out and giving up. In this respect, there is not much difference from designing the whole plan by hand.

One means of avoiding this kind of impasse is to incorporate laws of 'nature' in the program. Why not introduce some principle from nature – for example, the laws of motion governing the movement of waves – that gives such a sense of pleasure? But the literal application of natural laws can tediously resemble mere imitations of nature. Induction Cities is not seeking to reproduce natural phenomena. We began searching for an effective code that would be both more specific and simpler. We also started examining other approaches. The alternative approach was to enable the program to search for its own evaluative criteria.

The program is run, and then its output evaluated by researchers and the results are accessed to see if they are satisfactory or not. When this process is repeated often enough the program, instead of simply outputting yet more plans, begins to generate plans that are likely to receive higher scores. In theory, if you praise the program it learns and if the process continues for long enough, the solutions offered by the program should improve markedly. The idea is to create a program that is based on this mechanism. What is interesting about this is that the qualitative question of what is 'good' is never given a clear answer

Even though the criteria for evaluations are not clarified, in practice as if by magic 'good' plans are generated. This is our trump card for escaping the impasse of making a value judgment. Today, learning functions for software in simple form are built into word processors. Pursuing this idea further, to the point that the program learns to modify itself, there should be no objection to calling this an 'evolutionary function.' This program is still undergoing development.

Structure-generating Wing

Thirty-five metres below the city, the architectural seed germinates deep in the ground, seeking more water and light. After a while, its underground stem reaches the surface and there a flower blooms. This is called 'Wing,' a ventilation tower. The Wing houses the air-conditioning equipment for the entire subway station: a respirator for the space below the ground. Wing is the respiratory organ put forth above ground by an invisible, subterranean stem. For its structure, we sought a mechanism of auto-generation using a computer program. The program is not yet completed, and what we show here is a model of what the structure will perhaps look like once the program is operative.

To design a conventional structural frame, a simple grid-work is devised, weight is applied, and the effects are calculated. Appropriate materials are selected to meet the load requirements of those

1

2

3

4

portions under greatest stress. The same materials are then used throughout the frame. This is the case for both rigid frames and tubes, regardless of whether it is a box or curve shape. Should materials be selected, not by this uniform approach but varied from section to section as is actually necessary, a different form of frame will appear. And if we substitute the word 'design' for 'necessary,' still further forms will emerge.

The framework is bolstered where the forces are greatest and becomes thinner where forces are weaker. To withstand this, transmitted stress materials are fused at the joints. Instead of joining pillars to beams, the material extends, separates, rejoins and forms a single overall frame with no distinction between vertical and horizontal. Moreover, the arrangement of structure and material is optimised so nothing is superfluous. Its structure is that of living plants. Wing is a model for one form the frames will take when such structures can be generated automatically.

The Induction Cities project began 12 years ago as a research and development project into this type of Intelligent Design, or Program Aided Design. The first phase of the project was devoted to trials, and the second phase to developing a set of programs for making cities. In the third phase, it was applied to an actual architectural project, the web frame of the Iidabashi Subway Station. The fourth phase is currently underway, involving the development of programs to meet emotional and other conditions. This is applied in the new Stations project.

The Induction Cities methodology has a great deal in common with the workings of nature, but it does not imitate or copy the forms of plants. It has a structure close to a natural ecosystem because it sets values and programs a way to realise those values. The similarity to natural systems was unexpected but real. In this sense, architecture generated by the Induction Cities project could be called 'bi-organic' architecture. Closeness to nature does not, however, come from similarities in forms. The forms are alike because they were produced by similar systems that were a reasonable means to achieving goals under specific conditions. Forms are the result, not the starting point.

Computer programs cannot design everything. Computers are better than human brains for tasks like solving complex puzzles. On the other hand, they cannot imagine things that have never existed. Computers and people each have their own specialties, and we should receive improved answers when they cooperate in design. The human brain cannot perform at its best bound by a complex system of conditions, and freeing it from such constraints gives it the liberty to imagine. What we want is a method that is free, but that also comes up with satisfactory answers to the problems.

This essay is about a way of thinking and experimentation that is freer, but which paradoxically also comes up with more exact solutions to conditions. Unlike conventional design that tries to decide everything, Induction Cities is a method for inducing results that meet conditions and in this sense can be called Induction Design. Since it is born from preset conditions, it could also be called Generative Design, or Evolutionary Design since it has the characteristic of improved results over generations. It is an odyssey towards a new design method with the potential to make architecture and cities better.

1 Shin Minamata Station | Makoto Sei Watanabe

2 Minamata Gate Sculpture

3,5,6,8 Kashiwanoba Campus Station | Makoto Sei Watanabe

4,7 Kashiwa-Tanaka Station | Makoto Sei Watanabe

5

6

7

8

1

Dissolution of Objects and Evasion of the City

Kengo Kuma

Kengo Kuma is one of the most celebrated contemporary architects in Japan. His buildings have an ethereal quality, seeming to float in a world freed of the constraints of matter and gravity. Here, he explains why.

My aim is to create a similar 'condition' to fine particles floating over the earth. This does not mean I want to create particle-like works of architecture but a 'condition' that is as vague and ambiguous as drifting particles. The closest thing to such a condition is a rainbow. It is not an actual object, and that is what makes it attractive. A certain relationship is established between the particles of water vapour, the sun, and the observer (the subject) that generates the phenomenon we call a rainbow. In fact, all the things we perceive are phenomena. Nevertheless, we are persuaded or are under the illusion that perception is dependent on the existence of objects. As a result, we misunderstand the world to be a collection of objects. Furthermore, we ourselves attempt to produce and to possess that fiction called objects in order to recreate the world.

I believe the Japanese of the past realised that objects are fiction. At the Ise Shrine, for example, the ceremony of periodic reconstruction has been carried out every 20 years. Every generation, the buildings are dismantled and rebuilt. The shrine exists only as a phenomenon that is in the act of reconstruction. The ceremony shows that what appears to be a set of objects is, in fact, only an illusion. Today, however, it is by no means easy to dismantle objects. This is because we are surrounded by social systems and institutions

that are premised on territory and objects. For example, there is a system that demands architecture be constructed on plots called sites. The magnificent thing about the ceremony of periodic reconstruction at Ise is that it does not limit itself to a particular lot; it does away with the concept of a site. The new shrine buildings are reconstructed on a different piece of land. Every 20 years, Ise Shrine reminds us that, unless we do away with sites, we will find it difficult to free ourselves from the illusion of objects.

There are those who assert that to escape from such objects known as architecture we must adopt a larger frame of reference and consider things in an urban context. I do not have faith in the word 'city'. There is no word as sweet and as dangerous. Considering things in an urban context means controlling the particles called architecture from a meta-level. It means trying to control and condense the particles. City planning is only another name for this. There is a common misperception about the adoption of the larger frames of reference. There exists the illusion that no matter how much the frame of reference is enlarged, the composite totality can still be easily controlled through manipulation from the meta-level.

Taking an urban point of view is not the way to achieve this. We need to break up and dissolve the objects called architecture into ever-finer particles. In this way, a rainbow-like phenomenon will emerge. A phenomenon is not merely something induced by the subject; it is the vivid response of the object to the action of the

1

2

subject. The particles must therefore be kept small, freely scattered and responsive; they must avoid any sort of condensation.

In trying to evade objects as well as control of a meta-level (the city), I was confronted by two fundamental divisions. One was between the parts and the whole. Ordinarily the parts and the whole are bridged by an intermediate construct such as architecture (objects) or the city. In that way a hierarchy framework is generated. However, what happens when objects and the city are rejected? First, I make the particles sufficiently small. Beyond that, the whole cannot be seen unless I ascend to a meta-level. The visible particles, the parts and the whole, are decisively dissociated and there is no way of bridging them. The resulting division is not displeasing. However, I design merely the particles and the ground beneath my feet. I design the ground by creating a slight mound of earth, laying gravel or walking on thick soles. I am confident that without any further action the particles will behave freely and in diverse ways.

The other basic division is that between matter and consciousness. Objects are a form of bridging matter and consciousness in a comprehensible way. Matter exerts a powerful influence on consciousness by taking on the tangible form called objects. When that form is rejected, matter and consciousness become free, like a kite whose string has been cut. To the consciousness, matter or illusions or digital images are all information that all seems equally true. This division too is not at all displeasing to me. An architect is not a professional who deals only in matter. Illusions, images and rainbows are all within his domain.

3

4

5

1–2 Stone Museum, Nasu-gun | Kengo Kuma

3–6 Museum of Ando Hiroshige, Nasu-gun, Tochiga | Kengo Kuma

6

1

4

5

2

3

6

1–3 Making rice 'Mocha,' Nishijin Festival

4–12 The vanishing street scene, Nishijin, Kyoto

7

10

11

8

9

12

Nishijin Kyoto Internet Study

This project was a photographic survey account of the historic Nishijin street scene, in a district famous for weaving kimonos. It was the subject of an internet exercise with assistant professor Atsushi Sasaki through the architecture department of the Kyoto Institute of Technology, who were concerned about the disappearance of this unique form of urban life style.

Reviews

Akari – Out of the Shadows

An essay about the Japanese-American sculptor, Isamu Noguchi, whose work was being shown at the Design Museum in London.

Published in *Art & Landscape Network Journal*, December, 2001.

Whilst engaged on the Peace Memorial for the city of Hiroshima, Isamu Noguchi began work on his Akari lights. The globular paper lantern from this period was his most successful product and rarely has such a modernist icon received such widespread popular acclaim.

The threads to this story reach back to the beginning of the last century when many scholars were intrigued by a Far Eastern country emerging out of centuries of virtual isolation. At the time, many famous artists were to discover and be influenced by the refined simplicity of the wood block print. Frank Lloyd Wright himself was a *ukiyo-e* collector and was inspired by the organic and open-plan forms of the Japanese house. The first poet from Japan to have his work translated into English was a certain Yone Noguchi. Not only did he introduce the West to its first taste of Japanese poetry but he also left his calling card in the form of his offspring, who was to become the new world's finest public artist. Like his father, Isamu with his sunken garden creations and his later remarkable rock carvings was destined to be an artistic interpreter between Japan and the West. Disowned by his father, Isamu spent his long career trying to reconcile his semi-oriental ethnicity, and in recent times we have all benefited from his personal and artistic identity crisis.

Although relatively unknown in the UK, Isamu Noguchi was part of the New York post-war artistic elite. In 1927, Noguchi travelled to Paris where he worked for six months as a studio assistant to the sculptor Constantin Brancusi, who would remain his mentor through his long career. Returning to Japan in 1931, Noguchi spent his formative years there, frequently finding solace in the gardens of Kyoto. Later, he went to New York where he became exceptionally well connected. Amongst his friends were such 20th-century luminaries as Ezra Pound, Ashile Gorky, Jose Clemente Orozco and Buckminster Fuller. Influenced by the elegant reductionism of Brancusi, Noguchi was a thorough modernist who spent the later years of his life between the United States, Italy and the Japanese Inland Sea island of Shikoku. An artist whose hybrid style was contextual, he was committed to a purposeful and socially conscious art form. Inspired by traditional Japanese craftsmanship and the exposed skeleton structures of the house carpenters, he also applied his sculptural sensibility to furniture, landscape architecture and stage design. However, Isamu Noguchi is probably best known for the Akari mulberry paper light sculptures that he developed in the 1950s for the city of Gifu.

1 Hiroshima Peace Cenotaph | Kenzo Tange

2 Haniwa Terracota Funerary House, National Museum, Tokyo

3 Flame of Peace | Kenzo Tange

4–6 Hiroshima Peace Park Bridge | Isamu Noguchi

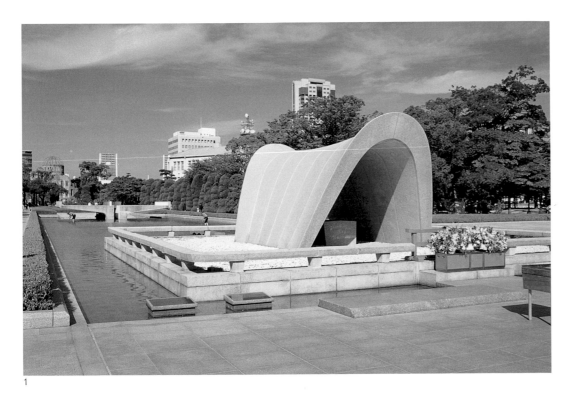

1

4

5

2

3

6

7

8

At that time, some twenty years had passed since Isamu Noguchi had last visited Japan. He was to return to a devastated and demoralised country in the aftermath of its most disastrous war. Born in Los Angeles in 1904 to an American mother, Leonie Gilmour, and a Japanese poet father, Noguchi was naturally ambivalent about his cultural identity. After experiencing internment at a relocation camp in Arizona, news of the atomic bomb attacks on the beautiful cities of Hiroshima

and Nagasaki had left Noguchi in a serious state of depression, fearing the eventual nuclear annihilation of mankind. In 1950, however, he was treated to a hero's welcome by prominent Japanese artists, a very different event to his bitter reunion with his father in 1931. At his reception, Noguchi met Kenzo Tange and was told about the plan for the Hiroshima Peace Memorial Park. To produce something for Hiroshima appealed deeply to Noguchi. As an American of Japanese descent, he had a particularly strong feeling of guilt about the destruction of the city. Anti-war and peace memorials would, in fact, pre-occupy Noguchi for most of his long career.

The first work Noguchi envisaged for the Hiroshima Peace Memorial was the 20-metre-high Bell Tower. His Mitsukoshi Department Store exhibition provided an opportunity to show his proposal in the form of a wood and ceramic model. Based on his 1943 Monuments to Heroes, lamenting the victims of war, the tower makes strong allegorical references to the human debris caused by the A Bomb. A number of figures are mounted or suspended from the lattice-like frame within the tower and these grotesque, anamorphic shapes appear to be screaming or decapitated. To have been cast in bell bronze, this would unfortunately remain an unrealised attempt to recognise the atrocities suffered by the innocent of Hiroshima.

When Kenzo Tange was commissioned to plan the entire Peace Memorial Park in 1951, he officially requested, on behalf of the Mayor of Hiroshima, that Noguchi design the parapets of two bridges spanning the Ota River which splendidly arcs the park's circumference. Quickly establishing a theme of life and death, one end of the bridge was entitled 'Passing Away' and the other end in the image of the rising sun was entitled 'Creation'. Against his wishes, for financial reasons, the parapet was eventually cast in concrete instead of being created in stone, and the whole construction program then went ahead without Noguchi's further participation.

Upon completion of the bridges, he was asked to design a Cenotaph for the city's atom bomb victims. To be erected as the centre piece of the Park, it would have an underground repository to enshrine the names of the victims, symbolizing a safe womb where new life is born. Noguchi plunged himself wholeheartedly into the project and constructed a model for the cenotaph in Tange's laboratory at the University of Tokyo. He described it as, "A challenging subject, a sculpture as a concentration of energies. The symbolism came from the prehistoric roof of a Haniwa earthen sculpture. Like an abode for small children, it is a symbol for life and death. An arch of peace with the dome of destruction. The materials were to be black granite, supported by concrete columns enclosing a tomb for viewing the names of the world's first atomic bomb victims."

Unfortunately, the Peace Memorial Park City Construction Special Committee turned down his proposal, offering no official reason. It may have been too somber and powerful, but it was rumoured the true reason for rejection was the unwillingness of key committee members to award the commission of the cenotaph to an American. In the end, the cenotaph was speedily constructed to a design by his friend Tange of a saddle-shaped Haniwa roof just in time for the Park's opening ceremony.

Undeterred, Noguchi went on from this most intensive period of creative enquiry to collaborate with a number of notable architects such as Louis Kahn, Marcel Breuer, Gordon Bunshaft SOM, Arata Isozaki, Kisho Kurokawa, and Yoshio Taniguchi. It is claimed that he designed his prototype Akari paper lanterns, which became available for retail sale the following year, on his way to the Hiroshima commission in 1951. By far the most popular of Noguchi's interior products, they are based on the chochin lanterns, a traditional craftwork. With their perilous contrast between the mulberry bark paper and their thin spiral bamboo skeleton, Akari shades have

9

10

11

a wondrous power. Their uniquely delicate nature embodied in their tentative light and movement creates a poetic and ephemeral mood. This rigorously refined craftwork must be amongst the most understated yet successful modern classics to penetrate the mainstream of everyday life.

It is ironic indeed that the Akari, with their glowing essence of light, should share a close human relationship to Noguchi's body of work responding to the darkest single event of the 20th century. Many regard the featherweight Akari, which express such fragility and economy, as Isamu Noguchi's finest monuments to the frailty of the human existence.

The shadow of the H bomb shrouded the world in fear, feeding the suspicion and the polarisation of the Cold War era. As in the upsurge of early European aesthetic sensibilities following the First World War, many in Japan felt it appropriate to jettison their isolationist inheritance and Edo values in favour of the pre-Tokugawan rule. Similar to the search for innocence in the West, the fifties artists of Japan sought inspiration from the deeper past, the native Haniwa terracotta funerary and ancient indigenous stone forms of the Jomon period. Noguchi produced the Akari light in the middle of his career before he developed a distinctive style of his own. Rather than a translation of the Orient, his Akari shades were examples of the West superimposing itself on the traditional Japanese crafts. Cleverly, he applied the less-is-more aesthetic learned from Japonisme to simplify an iconic artifact of the floating world. The Akari is an East-meets-West object, a symbiotic combination of the modern reductionism rationale and Oriental organic material sensibilities. His avant-garde traditionalist contradictions were nevertheless to become very influential in lifestyles both in Japan and throughout the rest of the planet. Despite the divisions of the world at large and his own upbringing, Isamu Noguchi is no less than the original global artist.

7–11 Sogetsu Art Centre, Tokyo | Isamu Noguchi and Kenzo Tange

Site of Reversible Destiny – Yoro Park

'Architectural experiment by Arakawa in Gifu Prefecture prompts fantasy'.

Art and Architecture Journal, July, 1996.

"Instead of being fearful of losing your balance, look forward to it." This instruction is part of the enigmatic advice for users of the Site of Reversible Destiny, perhaps the most idiosyncratic and sensational environmental installation in Japan. Opened in October, 1995, it is an enormous and imposing artistic theme park in Gifu Prefecture, near the Yoro Waterfall where according to legend the water once turned into wine.

The offspring of artist Shusaku Arakawa and his poet partner in New York, Madeline Gin, this installation includes a series of extraordinary projects which must be entered at the visitor's own risk with titles such as 'Zone of Clearest Confusion', 'Geographical Ghost', 'Mono no Aware Transformer', 'Critical Resemblance House', and 'Cleaving Hall'. In many of these structures, the visitor has limited light visibility or is walking on a sloping or uneven floor surface.

The site consists of a bowl-shaped strolling garden – called the Elliptical Field – in Shakkei style that incorporates elements of each of the five Japans and makes use of the ancient stretch of the Yoro hills as a backdrop. A series of mounds and trenches give it the appearance of a mystical mountain range in miniature, a scene from a scroll painting, animated and turned into a three-dimensional yet calligraphic equivalent of the Japanese archipelago. Visitors are invited to wander through a strangely undulating and tilted landscape, almost extra-terrestrial in character. A landing site, perhaps, for an alien UFO encounter, it is venturesome terrain within an elliptical crater-like dish shaped into the earth's crust. A labyrinth of garden paths web their way across the enclosure linking a variety of honeycombed shelters. These tilted buildings with their criss-cross sections are virtually inaccessible. It is a helter-skelter landscape where the private realm of

domestic furniture is pitched out into the open public domain. An extravagant adventure playground, it overthrows the commonplace by transforming the familiar environment into the unfamiliar. Arakawa is a neo-Dadaist who attempts to operate in a state of controlled insanity. Although he employs an accessible language of everyday objects, his true intentions remain obscure. Like a mushroom farmer, he keeps his subjects in the dark.

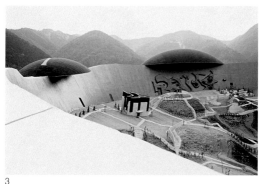

Maybe it's the questions that are, after all, more interesting than the answers. Marcel Duchamp once said that, "The public has its part to play. The creative act is not performed by the artist alone. The spectator brings the work of art into contact with the external world by deciphering and interpreting and thus adds his contribution to the creative act." Like Duchamp, Arakawa invites the viewer to participate in the creative act but circumscribes their experience. The strange

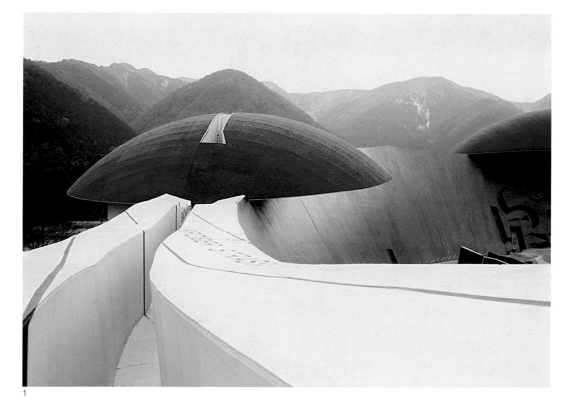

juxtapositions at Yoro Park are an assault course on the senses where Arakawa sets out to disturb the viewer's standpoint to a hazardous degree. He believes that 'constructing the perceiver' is a necessary intervention to create a fresh view of the world. The artist must jolt the viewer out of his routine aesthetic existence. To avoid the predictable, visitors must first experience a state of physical insecurity and vulnerability. Making them lose their balance is to discharge the body from the inertia of its routine.

Arakawa and Gin's Containers of the Mind Foundation wants to offer mankind an alternative direction for the future, and this should be welcomed. He has said that, "A radical alteration of the viewer's attitude – physical and mental – will in turn change our cognitive and psychological perspective and so rescue mankind from its destiny." Arakawa claims to have abandoned art; if so, he seems to have landed in the field of human psychology and perception. Perhaps the enjoyment of seeing and feeling things as if for the first time is the essence of the art and architecture experience. Arakawa's fantasy returns us to our childhood, briefly rejuvenated by the joy of the unexpected.

In Japan, the art of garden landscaping is traditionally of equal status to painting and sculpture. The Site of Reversible Destiny will enter the history books as another step in the development of the Japanese garden. Although some may say it is a 21st-century version of, say, the 17th-century Katsura Detached Palace Gardens in nearby Kyoto by Koberi Ensbu, it is not. There is also a genuine, as opposed to metaphorical, safety risk at the site. A few visitors have fallen victim to unfenced holes, so consequently the park is staffed by attendants who, like mountain herdsmen, steer visitors from harm's way. To bypass regulations, it is officially classified as a work of art, but art like this can seriously damage your health.

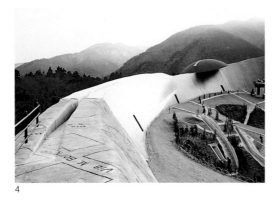

4

6

5

7

1–5 Elliptical Field Site of Reversible Destiny | Shusaku Arakawa and Madeline Gin

6–7 Critical Resemblance House, Site of Reversible Destiny

Inside Out – Tadashi Kawamata

Art and Architecture Journal, September, 1997

Following in the wake of this summer's Art and Architecture series of Japan lectures were a wave of significant artistic interventions in London with three separate displays by the artists Tatsuo Miyajima, Katsuhito Nishikawa and Tadashi Kawamata.

Miyajima's sensational re-run of his LED time-counters installations emerged out of the shadows of a cavernous Hayward Gallery blackout. RIBA played host to the Hombroich exhibition, an important cultural regeneration program near Dusseldorf that includes models of a twin-domed rotunda by the sculptor Nishikawa. Kawamata stormed London with his temporary pavilion as part of the Serpentine's Inside Out program during the renovation of the gallery.

Tadashi Kawamata rejects attempts to associate his work with his native Japan. He believes artists must resist being placed in boxes, as pigeon-holing encourages marginalisation.

His work straddles the boundaries between installation art and organic architecture. For his set pieces, he wraps derelict and neglected old buildings in timber jackets. His structures are temporary and, as with scaffolding or building-site fences, he ritualises both erection and dismantling. Due to his mistrust of measured drawings he assembles intricate working models, so it is only photographs and these delicious tilting models resembling informal lollypop-stick forts that are in the end left to posterity. Given its ephemeral nature, it was the opportunity to experience first-hand this nomad artist's work that made a visit to Kensington Gardens so special.

Kawamata's temporary installation threatened to be a more ambitious achievement than the modification to the gallery underway behind the barriers. With its irregular structure of loosely and informally assembled screens, the art of packaging the construction site has clearly gained significance. Kawamata likes to work in amongst buildings in disrepair, especially those that have been abandoned. He dresses his structures with both new and recycled timber in an apparently chaotic and haphazard fashion, describing them as 'single closed-circuit.' Although his structures appear to be randomly assembled, they are actually logistically planned, erected and dismantled with considerable efficiency.

Deliberately never quite complete, his work follows a self-perpetuating principle, an incremental process where columns and elevation screens are counter-balanced with their own cross-bracing and intuitive carpentry. At the Serpentine, the pitch-roof rafts were poised in dynamic equilibrium by flying buttresses that appeared to give the whole procedure a life of its own. Though laid to a rectangular grid-base, the upper decks become increasingly ramshackle, the shafts of wood scattered like branches of the trees from whence they came.

Formerly a tearoom, the ostentatious Serpentine building offers a theatrical setting. For contractual reasons, however, Kawamata wasn't allowed to penetrate the gallery reconstruction itself. He couldn't therefore proceed with his customary crazy scaffold composites of skip ready-mades and discarded wood-yard timber. Here he proceeded in the manner of teahouse construction, providing a depository for the bric-a-brac of the old gallery. The whole crazy, reckless process is reminiscent of *shime*, the practice of tying ropes around natural objects to form distinct places through which the spirits are encouraged to pass. The Kensington installation similarly elevated the old rejected door and window frames to a special status. It is magical how discarded relics can suddenly become elegant objects of desire when placed in the benign museum atmosphere of the gallery. The whole splendidly absurd process created a strange aura around the front lawn, a temporary shrine to contemplate the future of the Gallery.

Kawamata likes to occupy the space between demolition and reconstruction. At the Serpentine, with its duplicated elevations, the design and size of his installation reflected the actual gallery itself. Fixtures and fittings were salvaged from the gallery prior to renovation to create a full-size carbon copy. It's as if the gallery building itself was shedding its skin, undergoing the urban equivalent of nature's recycling process. This twinning mirrors the Shinto ritual of *shukunen shengu*. This is the process involved in the recycling every 20 years of the Ise Shrine, the most sacred Shinto place of worship in Japan. Rather than preserving the original shrine, it is the craftsmanship skills and building techniques that have been preserved since the seventh century which are transferred from generation to generation. Each 20th New Year anniversary the two shrines, old and new, stand side-by-side and the transfer takes place during mysterious overnight rituals of the Shinto hierarchy. Before midnight, the priests offer their thanksgiving to the deity for protecting the old structure. After midnight,

they pray for the next 20 years and the protection of their new shrine and its worshippers from evil spirits. It would appear to be an unintentional but happy accident that this ritual that spans the space linking the past to the future has been applied to the Serpentine, surely a master stroke of good fortune for the Gallery.

Running Time – Tatsuo Miyajima

East begins at Greenwich: Running Time, Queens House, Greenwich, February, 1995

Art and Architecture Journal, July, 1995

Tatsuo Miyajima's *Running Time* creates a choreography of chance within the perfect cube of the Queen's House, a silent and sublime picture of time. This installation is the result of yet another collaboration between Artangle and the Becks Beer corporation. Designed and built between 1614 and 1617, the Queen's House is architect Inigo Jones's best surviving building. It became the central building of the Royal Hospital School and was eventually included in the new National Maritime Museum complex at Greenwich. Now also used for public and private events, it provided on this occasion a unique setting for Miyajima's installation.

Within the darkness of the winter evening lurked the automata, the alien culture of *karakuri*, the Japanese tradition of machines and robotics. Forty-five electric toy cars randomly roamed the floor of the darkened Great Hall. The battery-driven vehicles kept changing their direction and speed. Each displayed its own digital time on luminous LED (light emitting diode) counters, alike but pulsing differently. Charging and discharging like fireflies at the river's edge, the digital vehicles wove a glowing, silk kimono-like pattern through the inky blackness.

The visual display was stunning, but not quite sufficient to abandon disbelief to the extent of the claims that accompanied it. The changing web of chance events alluded, we were told, to the time zones of extra-terrestrial travel. As soon as chance is mentioned, any conceptual artist worth his salt will reach for the (almost certainly unread) Heisenberg for uncertainty and Einstein for relativity. With their sacred names onboard, *Running Time* turns out to be a model of the cosmos or a microcosm of atoms, pick 'n' mix. Are these connections post- creative anecdotes or do they determine the work? Is this creative enquiry or an overdose of artistic license?

Re-entering the surreal outside world on an empty and driverless Docklands Light Railway train, passing the automatic beacon on Canary Wharf silently flashing to aircraft on auto-pilot in the city's night sky, one is able to identify with the artist's interpretation of our communication-based times. Was *Running Time* a metaphor for earthly mortals gliding like lost souls in isolated containers across alien space? According to Miyajima, the theme behind this ballet of supercharged canisters is paradoxically, and perhaps reassuringly, that 'Art is Nature.'

Tojuso City Centre Living

The Tojuso Urban Housing Cooperative is an innovative and economic approach to achieving city centre living. Organised within a period of excessive property prices, Tojuso was introduced as a means of achieving affordable housing for those who wanted the convenience of living in the middle of Osaka. Reducing costs further by removing the developers from the process, the owner-clients briefed the architects directly. This collective approach offered applicants a means to achieve live-work opportunities in a lifestyle of their choice. The cooperative framework facilitated a dialogue between the individual clients' desires and the architects' aspirations.

By stacking homes and offices of different plans and characteristics, Tojuso has established a 'funky' hybrid type of accommodation. There are 20 Tojuso buildings, mainly in central Osaka, and there are a dozen apartment buildings within close proximity in the Tanimachi district just west of Osaka Castle. The Osaka Tojuso cooperative was coordinated through Hexa architects, established by the late Nakasuji Osamu, an architect with considerable knowledge of European housing. The original members who participated in the Tojuso program intended to live there for a long time. Everyone met together and separately to discuss plans with Hexa architects.

As a result of the generosity of cooperative members, Yasuto Kato and his mother Harumi, we were able to experience Tojuso city centre

1

2

living for five months from October 1995. My friend Kato san describes the Tojuso process as follows: "At first the Tojuso Office persuades a local landowner to sell his/her land. After the landowner agrees to sell, the Tojuso Office develops an overall plan for the building. When the outline plan is fixed, they advertise for participants (the future residents) through word of mouth and other means. The participants form a cooperative for construction. The cooperative buys the land from the landowner, and orders Hexa to design apartments. After the construction is completed, the cooperative for construction is dissolved, and a cooperative for maintenance is formed. The briefing and construction process usually took two to three years. A typical Tojuso building has approximately 15 homes and offices. The first Tojuso, Matuyamachi Jutaku, was completed in 1977, and in 1988 Osamu Nakasuji and his colleagues received an Architectural Institute of Japan (AIJ) prize for the Tojuso buildings."

Japan 2000: Architecture and Design for the Japanese Public, Prestel: Munich, 1997
World Architecture, April, 1998

This fascinating book, published in conjunction with the Japan 2000 exhibition at the Art Institute of Chicago, claims to focus on design for the public, but what are the main problems facing the Japanese? Despite ten years of recession, with land prices falling threefold, Japan remains the world's second richest country.

A century ago, at the Columbian Exposition in Chicago, the exotic content and atmosphere of the Japanese Pavilion left an indelible impression on the American public, in particular a young Frank Lloyd Wright. *Japan 2000* (both the book and exhibition) invites the reader/visitor to speculate about what the next century may produce, and what the young aspiring Lloyd Wrights would make of the current display.

The book's main thrust is to feature the commissioning of the country's top architects and designers on such edifices as police stations,

bridges, dams and crematoriums. This also forms the crux of the exhibition, where the emphasis is on the individual response to the content, and its interpretation by independent architects.

Naomi Pollock expands the theme of designing for the Japanese public through a portfolio of 17 projects, explaining that Japanese architects in the post-bubble economy period of the 1990s appear to have developed a sense of social responsibility. Gone are the days of exciting private excess, obsessions and exhibitionism resulting in buildings as sculptural forms at the expense of space. After the bubble burst, the public agencies were required to pick up the slack, designing everything from Koban police boxes and public toilets, to prefectural art centres and World Cup 2002 stadiums. Japan's 47 prefectures have significant public projects underway. One architect who has gained from a track record in public commissions is Yoshio Taniguchi who has designed the Gallery of the Horyuji Treasures located in Tokyo's Ueno Park, one of the most elegant building in recent times. He remarks, "If you have relationships and experience, you can control the work if you are working for the government."

In Japan, however, most of the urban environment is produced by the giant construction companies, many of which have historical links or are owned by the leading *zaibatsus*, the financial institutions. Although public commissions are decreasing, government officials are more relaxed than previously and place a higher value on design. Employing the creative talents of Kisho Kurokawa and Arata Isozaki as advisers and consultants is evidence that the seeds of change are planted.

Of all the architects selected here, perhaps the greatest expectations fall on the shoulders of Kazuyo Sejima, with her radical but expensive mass housing concept. Disappointingly, the very real problem of social infrastructure provision such as affordable homes receives scant coverage in Japan 2000. Sejima's Gifu Kitagata apartments straddle the angular perimeter of the

new international competition development like a Japanese screen painting. Sejima has minimised the width of the block, and her simple but clever concept turns each unit and the garden terraces to the side so the main rooms enjoy a dual aspect. The garden terraces puncture the elevations, providing exterior space sunlight and natural draft ventilation as in traditional buildings. The highly glazed elevations provide a snapshot of the daily domestic drama within as imagery. One-third of the 107 apartments are made of maisonettes, but whether a ten-storey block in an isolated suburban setting can succeed as a convivial home remains to be seen.

Despite its polished appearance and individual merits, the overall impression is that contemporary Japanese architecture lacks spark and ingenuity, and it is left to Masayuki Kurokawa (Kisho's brother), to sum up the need to humanise technology and architecture. Designers have to make things that humans can love and fit in with their lifestyles. Aspiring Lloyd Wrights take note.

3

The Farringdon Exchange

This is an edited version of the transcript of a round-table dialogue that began with a slide presentation of recent projects in Japan. Taking part were Hiko Takeda, architect; Yosuke Futiki, architect; Mako Sugiura, installation artist; Nobuaki Date, artist; Tetsuya Ukai, architect; Nana Shiomi, printmaker; Isao Miura, painter; Peter M Cook, photographer; Shin Egashira, architect; Taeko Matsumoto, architect; Iwao Saito, film art director, Hiroko Imada, printmaker; and Toko Harris, public artist. The chairperson was the author, Graham Cooper.

Graham Cooper: This event follows on from the Tokyo and Kansai Exchange where last year I held similar round-table events between artists, architects and curators. I would like to take the opportunity of exploring art and architecture from the perspective of Japanese artists and designers resident in the London area.

Peter Cook: I trained as an architect, but the idea of an architect talking to an artist is not obvious.

Shin Egashira: Boundaries between artists in Japan, despite name-card definitions, are very unclear.

Toko Harris: In Japan there is no conflict between art and architecture because the Japanese have no concept of public space and therefore no public art culture. Japanese do not need the monuments.

Peter Cook: Public art in Europe is associated with monuments to the Empires and to the dead.

Shin Egashira: A critic described the most successful and popular contemporary public artwork in Japan as 'Tachiko the Shibuya Dog'. The dog is easy to understand and very useful.

Toko Harris: The concept behind the Japanese approach is completely different and difficult for Westerners to analyse. How come? We Japanese share communal ideas while other students don't. It is the cultural difference.

Isao Miura: Individually, Japanese people do not know who they are; they are individually immature. Who am I? The Japanese education system does not address this. The individual artist has to identify concepts from their life and background. We catch onto an idea from abroad, but individually we are not sure what it is. It may make business sense but is nonsense to the individual. I was shocked after watching the slides in the presentation. I felt so shocked that this architecture is public art. I thought it was very ugly. I can understand the basic idea of following a concept through, but spiritually I feel it is very unfriendly. I found all the buildings shown visually shocking. Yes, I can understand the concepts of using concrete but the outcome is like living in a concrete jungle within a very uncomfortable prison, not made for human habitation.

Shin Egashira: In Japan, it is much more common to use a concept in generating form. In Japanese history, art was never used as propaganda or as a tool for change. Art produced life blood. It is the concept itself that can be history. As a student, you produce forms and concepts and introduce your personal narrative.

Yosuke Futiki: The concept is not very important for architecture design because the concept cannot be translated into actual space; for example, Archigram conceptual architecture compared with the actual architecture of Peter Cook or Ron Heron. It is almost impossible to translate. The categorisation of art and architecture is not necessary, for example Corbusier. The most important thing is personal ability. If someone has ability, they can do everything. Shin's work is not architecture, but given the chance to build architecture he probably can do it. Why do we have to categorise art and architecture?

Hiko Takeda: There was no distinction in traditional Japanese buildings between the garden and the house; it's all the same! The only difference is in the technology. Architecture contains the science of building and environment,

which is essentially why it is categorised. Frank Lloyd Wright's innovative graphics and stained glass are artistic. However, it would be difficult because of the technicalities to achieve the reverse situation: the artist as architect. Disciplines are classified as a technical necessity. We live in a scientific culture that wants to rationalise things. For commercial and economic reasons, things tend to get classified and you can't do anything about it.

Shin Egashira: As soon as you separate subjects, everything becomes dialectic! Still, you recognise art is an object and that architecture is another object, that is to say the effect of something. It would be interesting to know what would be the public response to a building produced by an artist. It was interesting to see the juxtaposition of slides of Tokyo. Perhaps there is no need for collaboration. Maybe the solution is the juxtaposition of the artist's images. It would be interesting to know how you perceive there is public value in your choice of imagery. If there is value, then there is some collaboration happening.

Isao Miura: Do you want to say Japanese buildings are a monument to technology?

Shin Egashira: You are trying to collaborate with different objects in your view. That's how I see Tokyo when I go back; it's full of collaboration. Collaboration is a kind of phenomenon. What does it mean?

Peter Cook: Tokyo is not necessarily the most beautiful city in the world but one of the most interesting. It's very organic. There's not much green stuff; it is like an ant's nest.

Shin Egashira: We are now moving away from the aesthetic or beautiful object to interesting phenomena, the organisation of conditions you can identify like the condition of art and architecture. Maybe there is no boundary between, but perhaps that is the essence of form.

Toko Harris: In Osaka it is very common to find artists working on post-modern building sites.

Mako Sugiura: I was working with architects on an office building. It was a technical program and I found it too difficult to produce work in this public situation. I have never before produced installation work to be permanently located in a given space.

Taeko Matsumoto: Kobe Apartments invited artists to give added value to the building, which created lots of interest. The role of the architects in Japan is really changing.

Hiko Takeda: Architecture is about space and is not object based. Traditionally buildings were built by carpenters. There is a role of collaboration for public space filled with artifacts or music. Kisho Kurokawa indicated Japan has an invisible culture! Traditional buildings were a manifestation of the invisible culture. Shin's art currently has similar qualities to architecture.

Hiroko Imada: The difference between art and architecture is the technical complexity of architecture. My work involves rather primitive techniques. It's a question of who takes the lead, not simply the architect providing a nice container. We are now living in a borderless world.

Hiko Takeda: Art and architecture are essentially visual arts. Now there is an expanding area of thinking. Acoustics are now expanding beyond spatial and the object. In Japan this cross-over is easier.

Iwao Saito: Collaboration in the field of films is very important. The circumstances for set designers in Japan are difficult. A shortage of budget means directors rationalise and leave out designers. In the West they need production designers for consistency with responsibility. It is impossible to adopt a Western system in Japan for all objects. Collaboration is between people with responsibility for processes. Nowadays, we imitate the studio age of film production. Use of virtual imagery is restricted by budget: it takes too much time; only architects have the means to use it. He is concerned about architectural detailing in films, such as columns painted black rather than left natural. He is driven by script; it is his bible.

Nana Shiomi: Installations like Imada san's are space-based, but architecture usually has a longer duration. Treatment is therefore different, hence the difference between art and architecture. When we see architecture in film it becomes art, so under certain conditions it is the criteria of time that matters. An object in time is a visible image in time. Time is really important. Similarly, it could be art from an outsider's point of view.

Tetsuya Ukai: The slides showed a collection of strange buildings, but we have to consider 99 percent of ordinary buildings. Quantity is important. There are 250,000 architects in Japan with 10,000 qualifying every year. Most buildings are ugly but like Sony designs they are also very neutral. Most clients want a Takana Corporation type of design, very neutral or uniform. The slide show was like journalism. In Japan, it's the ordinary buildings that are more important. All clients represented by chairmen are rather autocratic. They don't ask atelier architects; they ask construction companies. Art is very individual. Isozaki wants to import art and architecture, but it doesn't fit into the mainstream.

Isao Miura: I feel shocked and uncomfortable. I feel there must be some control. There is a difficult relationship, too much contrast between the buildings.

Tetsuya Ukai: It is the pity of individuality. The beautiful landscape of Tokyo is not dependant on each building, so introducing art in a Western way does not work.

Yosuke Futiki: The personal perspective is very important. What is your favourite? Choice is most important.

Shin Egashira: There is, however, something in common between definition of art or architecture. You build or reveal something of an alternative reality that reflects on something which is really happening, to show how things are working. However, you may discover something that is hard to understand. First there is activity by the individual, then you decide whether you like it or not!

Yosuke Futiki: We probably cannot manipulate space. Space just exists; objects just exist. We simply fill the space. I can't explain architecture or art. They just exist.

Hiko Takeda: Art is a very big word. You are going out on a limb if you see art as a limited discipline.

Shin Egashira: Semantics, the classification of word meanings such as those for the word art, does not define what art is but rather what is not art!

Tsukudashima, Tokyo

At the heart of Central Tokyo, just across the Sumida River, Tsukuda Island is a little enclave of row houses and small shops. A tight-knit community, it dates back to the beginning of the Tokugawa Period when a group of Osaka fishermen were resettled on the island by the first Shogunate. A rare pocket of Edo townscape, it is a highly compact, fine grain of narrow streets clustered around a picturesque harbour. Surrounded by the River City 21 tower block apartments, it is extraordinary how Tsukuda has survived, remarkably intact, despite the fires, commercial development, building and planning regulations in such an ever-changing metropolis.

References

1 Evelyn Schulz, "A Confusion Critique of Modern Tokyo and Its Future," *Japan: At the Cutting Edge* (New Architecture Series, No.3), Botond Bognar & Andreas Papadakis (Eds), Papadakis Publisher: London, 1999, p. 28.

2 David Stewart, *The Making of a Modern Japanese Architecture*, Kodansha International: Tokyo, 2002, p. 101.

3 Arata Isozaki, "A mimicry of Origin: Emperor Tenmu's Ise Jingu," *Japan-ness in Architecture*, MIT Press: Cambridge, Massachusetts, 2006, pp. 139,161.

4 Kakuzo Okakura, *The Book of Tea*, Kodansha Bilingual Books: Tokyo, 1991, p. 64.

5 Penny Sparke, *Japanese Design*, Michael Joseph: London, 1987, p. 13.

6 Richard Lane, *Hokusai Life and Work*, Barrie & Jenkins: London, 1989, p. 266.

7 Michael Fitzpatrick, "The most modern city in the world," *Daily Telegraph*, (Connected Magazine) January, 1998, p. 2.

8 *Introduction to the World Heritage in Japan*, The Japan Foundation, Touring Exhibition at the Embassy of Japan, 2006.

9 Yasushi Nagasawa, "Situation in Japan – Scrap and Build," *Art and Nature: Healing Health Care Design in UK and Japan*, Book Art/GB Sasakawa: London, 2006, p. 76.

10 Fumihiko Maki, "Stillness and Plenitude: The Architecture of Yoshio Taniguchi," *The Japan Architect* JA21, Spring, 1996.

11 Gunter Nitschke, "Chinju no mori: Urban Deity Groves," *Japan: At the Cutting Edge* (New Architecture Series No. 3), Botond Bognar & Andreas Papadakis (Eds), Papadakis Publisher: London, 1999, p. 24.

12 Toyo Ito, "The Lessons of Sendai Mediatheque." *The Japan Architect* JA 41, Spring, 2001, p. 6.

13 "On Japan: Interview with Toyo Ito," *The Embassy of Japan Newsletter London*, Issue No. 736, Spring 2006.

14 Rafael Viñoly, "The Tokyo International Forum: The Making of Public Space," John Dinkeloo Memorial Lecture, 1997, University of Michigan.

15 Herbert Muschamp, "Review of the Tokyo International Forum," *The New York Times*, 12 January, 1997.

Published Papers, Articles, Reviews

Articles

"Isamu Noguchi Akari: Out of the Shadows," *Art & Landscape Network Journal*, December, 2001.

"An Interview with Tadao Ando," *Art & Architecture Journal*, March, 1997, p. 10.

"New Wave Japanese Architecture by Kisho Kurokawa," *Art & Architecture Journal*, November, 1993.

Papers

"Art in a Public Context," Public Art Scene 2, Aichi Prefecture Art Centre Nagoya, February, 1996, p. 25.

"Art & Contemporary Architecture in Japan," *The Japan Society Proceedings*, Summer, 1998, p. 43.

"Selection and Adaptation," *The Daiwa Anglo-Japan Foundation Series*, 1998, p. 151.

Reviews

"Japan 2000 Exhibition at the Art Institute of Chicago," *World Architecture Magazine Review*, April, 1998, p. 28.

"Tadashi Kawamata: Inside Out, Serpentine Gallery," *Art & Architecture Journal*, September, 1997, p. 17.

"Site of Reversible Destiny Arakawa," *Art & Architecture Journal*, July, 1996, p. 3.

"Miyajima Tatsuo Running Time Installation London," *Art & Architecture Journal*. July, 1995, p. 12.

"Garden of Fine Art Tadao Ando," *Art & Architecture Journal*, October, 1994, p. 2.

Bibliography

The following books have offered guidance in compiling Project Japan *and they are recommended for further reference:*

Akimoto, Yuji, *Remains in Naoshima Catalogue*, Bennesse House: Naoshima, 2000.

Bognar, Botond and Andreas Papadakis (Eds), *Japan: At the Cutting Edge*, Papadakis Publisher: London, 1999.

Bognar, Botond, *The Japan Guide*, Princetown Architectural Press: New York, 1995.

Hozumi, Nishi, *What is Japanese Architecture?* Kodansha: Tokyo, 1996.

Inaba, Kazuya, *Japanese Homes and Lifestyles*, Kodansha: Tokyo, 2000.

Isozaki, Arata, *Japan-ness in Architecture*, MIT Press: Cambridge, Massachusetts, 2006.

Jodidio, Philip, *Tadao Ando at Naoshima*, Rizzoli International Publications Inc.: New York, 2006.

Kurokawa, Kisho, *Each One A Hero*, Kodansha: Tokyo, 1997.

Miyakie, Richi, "Shigeru Ban," *The Japan Architect* JA 30, 1998.

Munroe, Alexandra, *Scream Against the Sun: Japan Art After 1945*, Harry N Abrams Inc.: New York, 1994.

Nitschke, Gunter, *Japanese Gardens*, Taschen: Cologne, 1993.

Okakura, Kakuzo, *The Book of Tea*, Kodansha: Tokyo, 1991.

Sparke, Penny, *Japanese Design*, Michael Joseph Publishers: London, 1981.

Stewart, David, *The Making of a Modern Japanese Architecture*, Kodansha: Tokyo, 2002.

Watanabe, Makoto Sei, *Induction Design A Method for Evolutionary Design*, Birkhauser: Basle, 2002.

Historical Influence
Books in English from the author's collection which are also recommended include the following:

Bicknell, Julian, *Hiroshige in Tokyo*, Pomegranate Artbooks: San Francisco, 1994.

Caiza, Gian Carlo, *Japan Style*, Phaidon Press: London, 2007.

Coaldrake, William H., *Architecture and Authority in Japan*, Routledge: London, 1996.

Delay, Nelly, *Japan The Fleeting Spirit*, Thames & Hudson: London, 1999.

Guth, Christine, *Japanese Art of the Edo Period*, Everyman Art Library Orion: London, 1996.

Harada, Jiro, *The Lesson of Japanese Architecture*, Dover: New York, 1985.

Hvas, Svend M., *Ise Shrine: Ancient Yet New*, Aristo: Copenhagen, 1998.

Lane, Richard, *Hokusai Life and Work*, Barrie & Jenkins: London, 1989.

Maki, Fumihiko, *The Form of Japanese Windows*, Forward Flat Glass Association of Japan: Tokyo, 1997.

Morse, Edward S., *Japanese Homes and Their Surroundings*, Dover: New York, 1961.

Nitschke, Gunter, *From Shinto to Ando*, Academy Editions: London, 1993.

Sato, Tomoko, *Japan and Britain: An aesthetic dialogue 1850–1930*, Lund Humphries: London, 1991.

Tanizaki, Junichiro, *In Praise of Shadows*, Leete's Island Books: Stony Creek, USA, 1977.

Watson, William, *The Great Japan Exhibition Catalogue Royal Academy*, Weidenfeld and Nicholson: London, 1981.

Yamamoto, Kenzo, *Invitation to the Kyoto Gardens*, Suiko Books: Kyoto, 1989.

Building Design

Ashihara, Yoshinobu, *The Hidden Order: Tokyo Through the Twentieth Century*, Kodansha: Tokyo, 1989.

Boyd, Robin, *New Directions in Japanese Architecture*, Studio Vista: London, 1968.

Frampton, Kenneth, *Nikken Sekkei: Building Modern Japan 1900–1990*, Princeton Architectural Press: New York, 1990.

Kiro, Mariko, and Mariko Terado, *Japan: Towards Total Scape*, Netherlands Architecture Institute: Rotterdam, 2001.

Jodidio, Philip, *Architecture in Japan*, Taschen: Cologne, 2006.

Jodidio, Philip, *Contemporary Japanese Architects Vol 2*, Taschen: Cologne, 1997.

Kaijima, Kuroba, *Tsukamoto Made in Tokyo*, Takaaki Iida/Kajima: Tokyo, 2001.

Knabe, Christopher, and Joerg, Rainer Noennig, *Shaking the Foundations: Japanese Architects in Dialogue*, Prestel: Munich, 1999.

Kurokawa, Kisho, *Intercultural Architecture*, Academy Design AD: London, 1991.

Kurokawa, Kisho, *New Wave Japanese Architecture*, Academy Editions: London, 1994.

Kurokawa, Kisho, *Rediscovering Japan Space*, Weatherhill: New York, 1988.

Maki, Eiji, and William A. McDonough, *Sustainable Architecture in Japan: The Green Buildings of Nikken Sekkei*, Wiley Academy: London, 2000.

Meyhofer, Dirk, *Contemporary Japanese Architects Vol. 1*, Taschen: Cologne, 1993.

Mori, Minoru, Hiroo Yamagata and Bruce Mau, *New Tokyo Life Style Think Zone*, Mori Building Co.: Tokyo, 2001.

Noguchi, Masao, and Tom Heneghan, *Invisible Language: Tokyo 1990s*, Architectural Association: London, 1993.

Nute, Kevin, *Frank Lloyd Wright and Japan*, Routledge: London, 1993.

Plummer, Henry, *Light in Japan: Architecture and Urbanism*, A+U Special Edition: Tokyo, 1995.

Pollock, Naomi R., and Tetsuyuki Hirano, and Tetsuro Hakamada, *Japan 2000: Architecture and Design for the Japanese Public*, Prestel: Munich, 1997.

Rico, Nose Michiko, *The Modern Japanese Garden*, Mitchell Beazley: London, 2002.

Suzuki, Akira, *Do Android Crows Fly Over the Skies of Electronic Tokyo?* Architectural Association: London, 2001.

Takahashi, Masaaki, Japan: *The New Mix*, The Images Publishing Group: Mulgrave, Victoria, 2007.

Art

Arakawa, Gins Madeline, *Site of Reversible Destiny Yoro Catalogue*, The Mainichi Newspaper, 1995

Altshuler, Bruce, *Noguchi*, Abbeville Press: New York, 1994.

Clark, Thomas A, and Viviane Eheli, *Yuko Shiraishi: Catalogue*, Cantz Ostfildern/Ruit, 1996.

Francis, Richard A., *Cabinet of Signs: Contemporary Art in Post Modern Japan*, Tate Gallery: Liverpool, 1991.

Groom, Simon, *Mono Ha School of Things* (Catalogue), Kettle's Yard: Cambridge, 2001.

Isozaki, Arata, *Nagi MOCA Catalogue*, Nagi Museum of Contemporary Art: Nagi, 1994.

Kaido, Kazu, and Elliott David, *Reconstructions: Avant-Garde Art in Japan 1945–1965 Catalogue*, Museum of Modern Art: Oxford, 1985.

Laursen, Steingrim, *Japan Today Catalogue*, Louisiana Revy: Copenhagen, 1995.

Masuno, Shunmyo, "Landscape in the Spirit of Zen," *Process Architecture Special Issue 7*, Tokyo, 1995.

Nakahara, Yusuke, *Shingu Rhythm of Nature*, Brain Center: Osaka, 1991.

Okada, Takahiko, *Isamu Noguchi: Space of Akari and Stone*, Chronicle Books: San Francisco, 1985.

Segawa, Ritsuko, *Shiraishi Masami Public Art Proposals International Contemporary Art Fair*, Tokyo, 1992.

Sekine Nobuo, *Sekine: A Message from Environmental Art Studio*, Process Architecture Ltd:.Tokyo, 1992.

Terada, Toru, *Japanese Art in World Perspective*, Weatherhill: New York, 1976.

Threlfall, Tim, *Isamu Noguchi: Aspect of a Sculptor's Practice*, Seagull Books: Lewes, Sussex, 1992.

Watkins, Jonathan, "Nakamura Nobuo: Facts of Life," *Contemporary Japanese Art Catalogue*, Hayward Gallery: London, 2001.

Watson, Oliver, "Shoji Hamada: Master Potter," *Ditchling Museum Catalogue*, Lund Humphries Publishers: London, 1998.

Zelevansky, Lynn, Love Forever: Yayoi Kusama, *1958–68* LACMA , The Museum of Modern Art: New York, 1998.

Monographs

Aikawa, Koji, "Kenzo Tange Associates SD Space Design," *Journal of Art and Architecture No. 372*, Tokyo, 1995.

Bognar, Botand, "Shin Takamatsu," *The Japan Architect JA Library1*, Tokyo, 1993.

Bognar, Botand, Takasaki Masaharu: *An Architecture of Cosmology*, Princeton Architectural Press: New York, 1998.

Dal Co, Francesco, *Tadao Ando: Complete Works*, Phaidon Press: London, 1995.

Futagawa, Yukio, *GA Architect 19: Kengo Kuma*, ADA Edita: Tokyo, 2006.

Girard, Christian, *Makoto sei Watanabe*, Edilstampa: Rome, 2006.

Hawley, Christine, and Peter Cook, *Itsuko Hasegawa 1985–1995*, SD Space Design: Tokyo, 1995.

Iannacci, Anthony, *Kisho Kurokawa Architects and Associates*, Edizione Press: New York, 2001.

Jencks, Charles, *Toyo Ito Architectural Monograph 41*, Academy Editions: London, 1995.

Jodidio, Philip, *Tadao Ando*, Taschen: Cologne, 1999.

Kamemoto, Gary, *Fumihiko Maki Buildings and Projects*, Thames & Hudson: London, 1997.

Koshalek, Richard, *Arata Isozaki: Four Decades of Architecture*, Thames & Hudson: London, 1998.

Matsuba, Kazukiyo, *Ando Architect*, Kodansha: Tokyo, 1998.

Miyakie Richi, "Atsushi Kitagawara Associates," *The Japan Architect JA 8*, Tokyo, 1992.

Nishizawa, Taira, and Toyohiko Kobayash, "Toyo Ito 2001: The Lessons of Sendai Mediatheque," *The Japan Architect*, *JA 41*, Tokyo, 2001.

Oshima, Ken, "Tadashi Projected Realities," *Waro Kishi Gallery*, Ma Toto: Tokyo, 2000.

Riley, Terence, *Yoshio Taniguchi Nine Museums Catalogue*, The Museum of Modern Art, New York, 2005.

Stewart, David B., *Fumihiko Maki 1993 – 1999*, SD Space Design: Tokyo, 2000.

Suzuki, Masaru, *Breathing the City: Kiyoshi Sey Takeyama*, Libroport: Tokyo, 1994.

Suzuki, Yuichi, and Jennifer Taylor, "Toyo Ito: Section 1997," *2G International Architecture Review*, Barcelona, 1997.

Vitta, Maurizio, *Makoto Sei Watanabe: Conceiving the City*, Arcaedizioni: Italy, 1998.

Cultural Milestones in Japan

Archaic period before 552AD

From the age of hunting to the age of rice cultivation, people live by hunting and gathering.

Jomon Period

Permanent settlement begins.
*Pit dwellings 4000BC.
*Use of polished stone tools and earthenware.

Haniwa Period

Start of rice cultivation and use of metal utensils.
*Terracotta Haniwa figurines.

Kofun Period

300 Tomb culture.
*Burial mounds built around the country.

Asuka Period 552–645

Chinese characters, new technologies, and other culture brought to Japan from the continent.
552 Buddhism introduced.
*577 Temple carpenter arrives from Korea.

Nara Period 645–794

Age of city building and nobility.
593 Prince Shotoku becomes regent.
* 600 First Ise Shrine construction.
* 607 Horyuji Temple, rebuilt 670, the oldest surviving wooden structure in the world.
710 Capital moves to Nara.
712 Kojiki written record of ancient matters.
*752 Great Buddha bronze 16-metre statue for Todaiji.
*760 Todaiji Temple, Grand Hall depository for statue is completed and rebuilt 1195 (remains largest wooden structure in the world).

Heian Period 794–1185

The nobility becomes more powerful.
Use of Japanese kana syllables begins.
794 Capital moves to Kyoto.
*1053 Shinden zukuri buildings and garden estates e.g. Phoenix Hall Ho odo at Uji.
Genji Monogatari (The Tale of Genji) by Murasaki Shikibu 978–1031, the world's oldest novel.
1088 Emergence of warrior samurai.

Kamakura Period 1185–1333

From the age of nobility to the age of warriors.
* New style of Zen architecture, e.g. Daitoku ji, Nanzen ji.
1192 Minamoto no Yoritomo establishes the Kamakura shogunate.
1274 Mongols attack Japan (and again in 1281, when Japan aided by typhoons – kame kazi/ divine winds).

Ashikaga or Muromachi period 1333–1568

Ashikaga Takauji establishes the Muromachi (Kyoto) shogunate ~ Kitayama Culture 1367–1408.
*1397 Temple of the Golden Pavilion is built in Kyoto.
*1489 Temple of the Silver Pavilion is built in Kyoto.
*Zen inspired paintings Sesshu 1420–1506.
* Kano School of Painting established.
*1499 Roanji garden.
*1513 Daisen In garden.
*Tea Ceremony Rules as laid down by Sen no Rikyu 1521–91.

Wars among feudal lords spread throughout the country.

1543 Portuguese introduce the first firearms to Japan.

1549 Christianity introduced to Japan by Francis Xavier.

Moyoyama Period 1568–1615

*New Types of Castle – Himeji White Heron Castle.

*Gold leaf screen and wall painting | Kano Eitoku.

1590 Toyotomi Hideyoshi unifies Japan.

*1601 Inuyama Castle.

*1615 Joan Teahouse.

*1615 Katsura began.

*1624 Nishi Honganji Temple.

*1626 Nijo Nomaru Palce

1603 Tokugawa Ieyasu establishes military rule known as the Edo Shogunate.

Control of local feudal lords, the Diamyo by enforced periodic attendance on the Shogun.

Edo or Tokugawa Period 1615–1868

From the age of warriors to the age of merchants. Merchants become more powerful as commerce flourishes.

1615 Defeat of Toyomoti clan at Osaka Castle.

*1634 Nikko Toshogo began with polychromatic carvings at the Nikko shrines.

1639 last of the seclusion edicts, Japan becomes completely closed to the world.

*1659 Shugakuin Palace.

Genroku Culture Merchant phenomena 1688–1703

The number of temple schools increases; reading, writing, abacus, morals and other subjects are widely taught.

*Matsuo Basho 1644–94 Master of Haiiku.

1732 Great Famine.

*Ukiyo-e colour wood block printing. Utamaro 1753, Sharaku c1790, Hokusai 1780–1849, Hiroshige 1797–1858 etc.

1853 US Navy Commodore Matthew Perry arrives in Uraga to demand that Japan reopens to the world.

1854 Japan and the United States conclude the Treaty of Peace and Amity, ending Japan's seclusion.

*1855 Kyoto Imperial Palace.

1867 Edo Shogunate falls, and the emperor becomes central to politics.

Meiji and Modern period 1868–1945

Big changes in political and social class systems and people's lifestyles

1868 The young Emperor Meiji ascends throne and the 'enlightened' Restoration commences.

1869 Transfer of capital from Kyoto to Edo, which is renamed as Tokyo, the eastern capital.

Abolition of feudal fiefdoms the country divided into prefectures. Compulsory education system is established; construction of elementary schools begins around the country.

*1875 Kaichi Primary School, Matsumoto | Seiju Tateishi

1889 Based on the German system, the Constitution of the Empire of Japan is issued.

1890 First Imperial Diet is held.

1894 Sino-Japanese War.

1904 Russo-Japanese War; silk industry develops.

Taisho Period

1914 World War 1, Japan enters with Britain, France and Russia.

*1914 Tokyo Station completed.

Heavy industries develop.

*Imperial Hotel completed Frank Lloyd Wright.

1923 Great Kanto Earthquake, about 140,000 victims.

Showa Period

1928 Accession of Hirohito.

*1930 Ohara Museum of Western Art.

1931 Japan invades Manchuria.

*1933 Bruno Taut arrives in Japan.

*Tokyo Imperial Museum | Watanabe

1941 Pearl Harbor starts Pacific war.

1945 The atomic bomb is dropped on Hiroshima, 8.15 a.m., 6 August. About 80,000 killed instantly and a further 60,000 by the end of the war. At 11 a.m., 9 August, a second atomic bomb meant for Kokura was instead dropped on Nagasaki, killing an estimated 73,000, rising to 140,000 by 1950.

Post-War Reconstruction, 1945 to present

Towards a new post-war Japan.

1946 Constitution of Japan is issued.

1947 Social reforms are carried out, women get vote.

1951 Peace treaties are concluded.

*1951 Kamakura Museum of Art | Junzo Sakakura

1952 End of American occupation.

1956 Japan becomes a member of the United Nations.

*Hiroshima Peace Centre | Kenzo Tange.

*1958 Sky House | Kiyonori Kikutake.

Economic growth proceeds.

Tokaido Shinkansen begins operating.

1964 Olympic Games are held in Tokyo, stadiums designed by Kenzo Tange.

*1969 Hillside Terrace commences | Fumihiko Maki.

1970 World Exposition is held in Osaka.

*1972 Nakagin Capsule Tower | Kisho Kurokawa.

*1976 Azuma Row House | Tadao Ando.

*1980 Imperial Hotel entrance concourse rebuilt at Meiji Mura.

Heisei Period

1989 Death of Emperor Hirohito and Heisei Period begins.

*1991 New City Hall Tokyo | Kenzo Tange.

*1993 Umeda Sky Tower | Hiroshi Hara.

*1994 Kansai International Airport | Renzo Piano.

1995 Great Hanshin Awaji Earthquake at 5:47 a.m., 17 January, 6,434 perish.

Participant Biographies

Fumihiko Maki

Born 1928, Tokyo, Japan.

The principal of Maki and Associates of Tokyo, which has an extensive international practice.

Studied and taught at the University of Tokyo and the Graduate School of Design, Harvard University.

Maki's representative works include the Hillside Terrace Complex, Spiral, Makuhari Messe and Kaze no Oka Crematorium. The latest projects include Tower 4 at World Trade Center site, Media Arts and Science building at MIT, Republic Polytechnic in Singapore and Museum of Ancient Izumo.

He is the recipient of the Pritzker Prize, the UIA Gold Medal and Praemium Imperiale.

Tower 4 (white) WTC by Maki & Associates; drawing by RRP

Kisho Kurokawa FAIA, FRIBA

Born 1934, Nagoya, Japan; died 2007, Tokyo.

Architect, Academician of Japan Art Academy.

Education: B. Arch. Kyoto University (1957), M. and Doctoral course, Graduate School of Architecture, Tokyo University (1964).

Honorary Fellow, Royal Institute of British Architects, U.K.; Honorary Fellow, American Institute of Architects, USA; Life Fellow, Royal Society of Arts, UK.

Major works:

(Japan) National Ethnological Museum, Hiroshima City Museum of Contemporary Art, Nagoya City Art Museum, Nara City Museum of Photography, Museum of Modern Art, Wakayama, Osaka International Convention Center, Oita Stadium, Toyota Stadium. (Abroad) Melbourne Central, Australia, Republic Plaza, Singapore, Kuala Lumpur International Airport, Malaysia, New Wing of the Van Gogh Museum, the Netherlands.

Ongoing projects:

Astana New Capital Planning of the Republic of Kazakhstan, Zhengdong New City Plan for the Zhengzhou City (China), the National Art Center (Tokyo, Japan), and Fusionpolis @one-north Development (Singapore).

Awards:

Architectural Institute of Japan Prize, Cultural Honorary Award for Tokyoite, and the 48th Japan Art Academy Award. International Architecture Award from FIABCI, France, Officier de l'Ordre des Arts et des Lettres from le Ministere de la Culture, France. Green Globe 21 Certification for Kuala Lumpur International Airport in Malaysia.

The architectural department of the Art Institute of Chicago named its gallery the 'Kisho Kurokawa Gallery of Architecture'.

Tadao Ando

Born 1941, Osaka, Japan

Self-educated in architecture, 1962–69. Travelled in USA, Europe and Africa.

Established Tadao Ando Architect & Associates in 1969.

Awards:

1979 Annual Prize, Architectural Institute of Japan 'Row House, Sumiyoshi'; 1985 The 5th Alvar Aalto Medal, The Finnish Association of Architects, Finland; 1989 Gold Medal of Architecture, Académie d'Architecture (French Academy of Architecture); 1993 Japan Art Academy Prize, Japan; 1995 The Pritzker Architecture Prize, USA; 2002 Gold Medal of the American Institute of Architects, USA; 2003 Person of Cultural Merit, Japan; 2005 Gold Medal of Union Internationale des Architectes, Chevalier de l'Ordre National de la Legion d'Honneur, France.

Affiliations:

2002 Honorary Academician, The Royal Academy of Arts in London

Academic activities:

Emeritus Professor, The University of Tokyo, 2003–

Major works:

1983 Rokko Housing I, II (1993), III (1999) Kobe, Hyogo.1989 Church of the Light, Ibaraki, Osaka.

1992 Benesse House Museum, Benesse House Oval/Naoshima (1995), Naoshima, Kagawa.

1994 Chikatsu-Asuka Historical Museum, Kanan, Osaka.

2000 Awaji-Yumebutai (Awaji Island Project), Higashiura, Hyogo Komyo-ji Temple, Saijo, Ehime FABRICA (Benetton Communications Research Center), Treviso, Italy.

2001 Pulitzer Foundation for the Arts, St. Louis, USA, Armani Teatro, Milan, Italy Sayamaike Historical Museum, Osaka-Sayama, Osaka.

2002 Hyogo Prefectural Museum of Art, Kobe, Hyogo, The International Library of Children's Literature, Taito, Tokyo Modern Art Museum of Fort Worth, USA.

2003 4 x 4 House, Kobe, Hyogo.

2004 Chichu Art Museum/Naoshima, Kagawa, Langen Foundation/Hombroich Museum, Neuss, Germany

2006 Omotesando Hills (Omotesando regeneration Project), Shibuya, Tokyo Palazzo Grassi Renovation, Venice, Italy 21_21 Design Sight, Tokyo.

Makoto Sei Watanabe
Born 1952, Yokohama, Japan.

His work is characterised by a feeling of movement and tactile qualities while theoretically it is informed by a continuing investigation into verbalisation of the act of design and its translation into computer programs.

Web Frame (2000), created according to this new 'Induction Design' methodology, was the world's first work of architecture to be generated by using a computer program to solve specified conditions.

His work has received numerous awards, including The Prize of AIJ 2002 (Japan) and ASLA Awards 1997 (USA). He is Chair Professor at Tam Kang University, Taiwan.

Major works:
1989 Aoyama Technical College

1995 Mura No Terrace

1996 K-Museum

1995–2006 Fiber Wave (Japan, USA, Austria, Italy, Spain)

2000 Iidabashi Subway Station, Shin Minamata Station Kyushu Shinkansen, Shanghai House (China)

2005 Kashiwa no ha Campus Station, Kashiwa Tanaka station /Tsukuba Express

2005 Shin Minamata Mon

2006 Tokyo House

Kengo Kuma
Born 1954, Kanagawa Prefecture, Japan.

Master Course, Dept of Architecture, University of Tokyo; 1985–86 Visiting Scholar, Columbia University, USA; 2001 Professor at the Faculty of Science and Technology, Keio University.

Awards:
Architectural Institute of Japan Award for 'Noh Stage in the Forest'; Togo Murano Award and Architectural Institute Award for 'Bato-machi Hiroshige Museum'; Spirit of Nature Wood Architecture Award, Finland.

Major works:
1994 Yusuhara Visitor's Center, Kiro-san Observatory.

1995 Water/Glass, Space Design of Venice Biennale Japanese Pavilion, Noh Stage in the Forest, Kitakami Canal Museum.

2000 Bato-machi Hiroshige Museum, Stone Museum, Ginzan Bath House.

2002 Great (Bamboo) Wall, Plastic House, Baiso Buddhist Temple, One Omotesando.

2004 Shinonome Apartment Building, LVMH Osaka.

2005 Fukusaki Hanging Garden, Nagasaki Prefectural Art Museum Lotus House.

2006 Yusuhara Town Hall.

Graham Cooper, Author

Born Bury, Lancashire, UK

An art practitioner and protagonist with a special interest in Japan, Graham is currently an adviser for Japan – UK150, celebrating the 150th anniversary of relations between the two countries. He was the architectural coordinator for the Japan 2001 festival. He graduated from the Royal College of Art Painting School in 1978. In 1995–96 he was awarded The Japan Foundation Art Fellowship, and in 1998 received a GB Sasakawa Foundation bursary to explore ways artists and designers were contributing towards health care in Japan. In 1998 he introduced Tadao Ando to the Manchester Piccadilly Gardens regeneration, the first major building in the UK by a Japanese architect. He recently published a book, *Art and Nature: Healing Design for Health* in the UK & Japan and has been the chairperson of Art & Architecture 1994–2008.

Exhibitions coordinated for Japan 2001

'Modernity and the Construction of Scenery: Architecture of Fumihiko Maki', Victoria & Albert Museum, London.

'Eco Architecture, Eco City: Kisho Kurokawa', Royal Botanical Gardens Kew, London.

'4x4 Apartment Avant-Garde': featured 16 architects in a DVD interactive project shown simultaneously at RIBA Gallery, London, The Lighthouse, Glasgow, The Architecture Centre, Bristol, and the Cube, Manchester.

'Celebration and Contradiction: New Art Museums and Japanese Culture': three-day symposium, Tate Britain.

Art Media in Japan Exhibitions

'Artscape DVD Select', The Architecture Centre, Bristol.

'Rendering The Unseen', Volume Gallery, London; The Holden Gallery, Manchester, 2002.

'Engaging Nature', Daiwa Anglo-Japan Foundation Gallery, London, 1998.

Health Design Exhibitions Curator

'UK Healing Art', Hospex Big Sight ,Tokyo, 2003.

'Nature of Healing Art in the UK & Japan', Dorchester, Bristol, The Lighthouse, Glasgow. Capital Health London's New Health Care Estate Building Centre, London, 1995.

Author with Hachiko the Shibuya Dog, Tokyo.

The most famous public art object and meeting place in Tokyo. Based on the true story of Hachiko the obedient dog, who each evening would meet its owner at the Shibuya Station. In 1925 the owner sadly died at work, but still Hachiko continued to wait patiently everyday until the locals were moved to make a bronze cast in recognition of the dog's devotion.

Author's Statement

Following brief visits from September 1993, *Project Japan* commenced in earnest two years later when I was awarded The Japan Foundation Artist Fellowship. The brief was 'Art in the context of Contemporary Architecture in Japan', and the fellowship was hosted by the pioneering architect, Dr Kisho Kurokawa.

This survey is a record of personal assignments and captures the many sites I have had the privilege to visit during the Japan Fellowship and many years since. During this period, I discovered a distinct lack of understanding and awareness in the wealth of creativity currently on display in Japan. Conscious of this gap in our knowledge, my increasing curiosity fed the need for a more structured look at architecture and art media in context. Prompted by how little is known, I have expressed my findings through exhibitions, video and articles (see listings) and now this book. Along with many fellow admirers of the Orient, I anticipate this resource will be of interest to artists, architects, design students, and the creative and construction industries in general.

This study has offered enormous personal insight enabling me to gain a better understanding of architectural forms in Japan. In my capacity as the Chairman of Art and Architecture, a national network in the UK that promotes the integration of ideas and skills within the building process, the experience has impacted considerably on my own practice. As a consequence, in addition to personal aspirations, *Project Japan* has more importantly opened up further channels of communication between interested parties in both Japan and the UK. In 1995, for example, I introduced a party of 25 leading UK health design experts to their professional peers in Tokyo.

This field-study will, I believe, foster a better understanding and further personal links in the new trans-cultural generation of art media developments in the years to come.

Project Japan would not have been possible without the generous support of contacts and friends in Japan, many of whom appear within the following acknowledgements. Finally, my thanks to Japan Rail for many thousands of miles of safe, clean, and punctual suburban and high-speed bullet train travel. A hundred years ago, British engineers introduced the railways to Japan. Now it is the turn of the Japanese to teach efficient mass rail transportation to the West, and I welcome the recent Railway Technology Forum in London exploring the Hybrid Train experiments.